The Desert Southwest

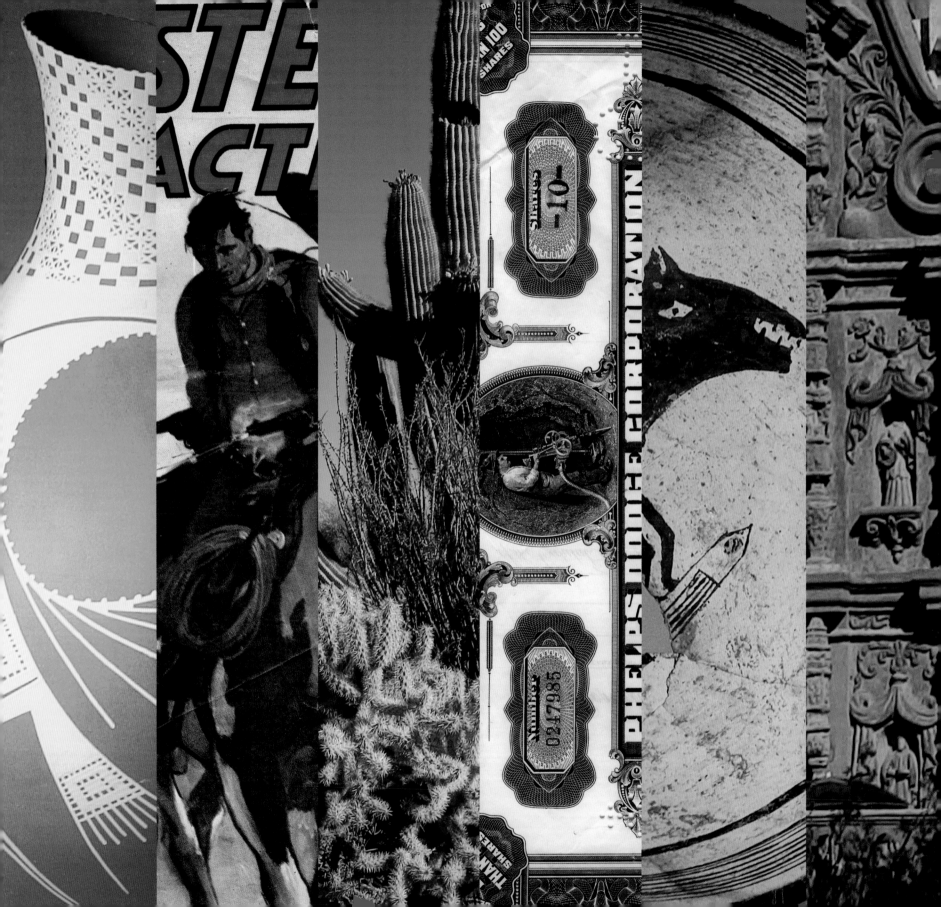

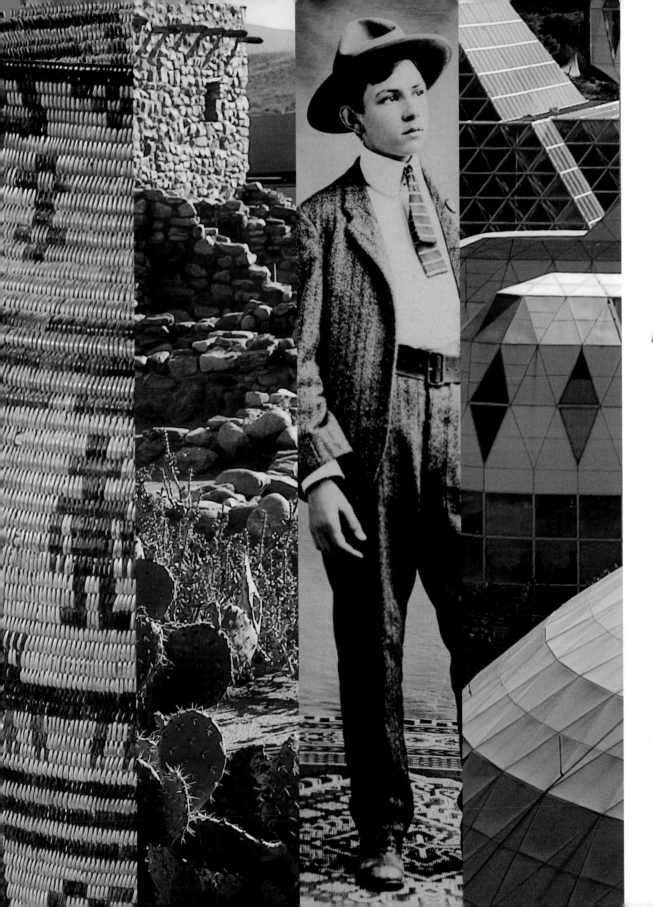

The Desert
Southwest

*Four Thousand Years
of Life and Art*

Allan and Carol Hayes

photographs by John Blom

foreword by Anne Woosley, Ph.D.

TEN SPEED PRESS
Berkeley | Toronto

To Evelyn Hayes (1908-2004),
who stayed with us long enough
to give us her two cents worth
on a full draft.

Ten Speed Press
P.O. Box 7123
Berkeley, California 94707
www.tenspeed.com

Distributed in Australia by Simon and Schuster Australia,
in Canada by Ten Speed Press Canada, in New Zealand
by Southern Publishers Group, in South Africa by Real Books,
and in the United Kingdom and Europe by Airlift Book Company.

Cover and Interior Design by Allan Hayes

Library of Congress Cataloging-in-Publication Data
is on file with the publisher.

ISBN-13: 978-1-58008-769-8 (hardcover)
ISBN-10: 1-58008-769-8 (hardcover)

ISBN-13: 978-1-58008-767-4 (softcover)
ISBN-10: 1-58008-767-1 (softcover)

First printing, 2006

Printed in China
1 2 3 4 5 6 7 8 9 10 - 10 09 08 07 06

FRONTISPIECE, LEFT TO RIGHT:

Mata Ortiz olla, Ivone Olivas, 13" high, 2003
Cover, Western Action *magazine, February 1946*
Britton Desert Botanical Gardens, Park of the Canals,
 Mesa, Arizona, 2003
Stock certificate, Phelps Dodge Corporation, dated 1951
Mimbres Classic Bowl (coatimundi standing on its own tail),
 8½" diameter, circa 1050
Mission San Xavier del Bac, Tucson, 2002
Apache olla, 14" high, circa 1915 (courtesy of Sandra Horn)
Besh-Ba-Gowah Ruins, Globe, Arizona, 2002
Unidentified young man, circa 1890
Biosphere 2, Oracle, Arizona, 2002

"INDIANS" AND "NATIVE AMERICANS"

As we become more conscious of the implications of language, words
that once were comfortable come under fire.

Indians is an easy target. It's in the language because of a
navigational error. (Columbus never found India, he just thought he
did.) As native names replace European-imposed ones—Navajo to
Diné, Papago and Pima to O'Odham, Diegueño to Kumeyaay—
dumping *Indians* seems logical.

However, we don't have a perfect substitute. Native Americans
have told us that they don't like *Native American*, the usual choice,
because it applies to everyone born between Tierra del Fuego and the
Aleutians, Indians and non-Indians alike. The alternatives seem worse.
Indigenous Peoples and *Aboriginal Peoples* sound like academics
studying specimens.

Indians has hardly disappeared. The National Museum of the
American Indian has a Native American director and a largely Native
American staff, and there's no move to change its name. *American
Indian Art* and *Indian Artist* remain highly respected magazines. When
we spot-checked tribal-prepared web sites of groups mentioned in this
book, all the ones we found still used the word.

We use both terms. When it came to naming Chapter 5, Indians won.

Contents

Acknowledgments

OVER THE LAST TEN YEARS, perhaps a hundred people set aside whatever they were doing at the time and stepped in to help us with this book. First, thanks to Claire and Ron Demaray, who started us on this road and watched us all the way, and to Phil Wood, who believed in what we were doing.

Next, our thanks go to Anne Woosley, who was kind enough to take us seriously even before we began this book and even before she came to the Arizona Historical Society. Anne's cohorts at the Historical Society—Tom Peterson, Deborah Ortiz, Deborah Shelton, Armen Benneian, Lee Pierce, Carol Brooks and especially Laraine Jones—tracked down more than forty rare items and images for us.

For this book to tell its story, we needed advice from and access to collections all over the desert. We had help from Jonathan Mabry of Desert Archaeology, Inc., Sharon Lien of the Deming Luna Mimbres Museum and her volunteer crew, Shirley Schaufel and Verna Smith of the Marin Museum of the American Indian, Karen Collins of the Imperial Valley College Desert Museum, Jim Boll of Gran Quivira National Monument, and Bud Lueck of the Heritage of Americas Museum in El Cajon.

Private collections played a big role as well. Forrest Fenn in Santa Fe, Rick and MaryBeth Rosenthal in Tucson (with help from Gray McInroy and Phoebe McDermott), Bob and Pat Brown in Silver City, Victor Ochoa in Casa Grande and Californians Sandy Horn in Mill Valley, John Rauzy in Orangevale, Don Colby in Rohnert Park, Jerry Weisberg in El Cerrito, Mark Hayes in San Francisco and Ned and Jody Martin in Nicasio all contributed items for photography. Ned and Jody, Claire Demaray and Sara Taft each gave us

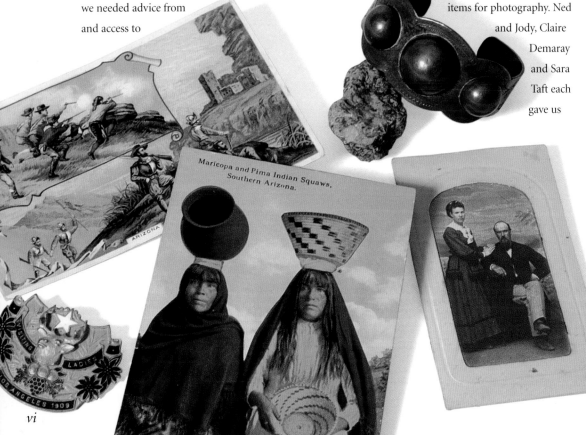

one of their photos to use, and all helped way beyond the call of duty.

Many others caught our mistakes and challenged and supported us: Bernard Fontana, Walter Parks, Spencer MacCallum, Mary Fernald, José Rivera, Betty and Lew Barrackman, Bill Abright, Tom Genther, Yolanda Stevens, Lisa Cooper, Ron Foreman, Paul Campbell, Jerry Howard of the Mesa Southwest Museum, Cynthia Bettison of the Museum of the University of Western New Mexico and especially our diligent editor, Annie Nelson, and proofreader, Kim Catanzarite, who found all the glitches.

Then there were the dealers who found us treasures and pointed us to new resources: J.B. Kingery and Eva Salazar, Debbie and Alston Neal, John Hill, Mark Sublette, Ron and Allen Milam, Merlin Carlson, Terry Schurmeier, Carl Vincent, Mark Arrowsmith, Gary Linscott, Bob Gallegos, Roy Oswalt, Frank Hill, Dace Hyatt, Herb Puffer, Ellen Woods, Ron Munn, Gary and Patty Klepper, Dean Barnes, Jeff Hammond, Bob Hickman, Marion Hamilton, Tina Miller, Kim Martindale, the late Ron Messick, Gene Lang and Michael Kastner, and many others who helped us over the years.

Art Olivas of the Museum of New Mexico, Karen Cole of the Los Angeles Public Library, Erin Chase of the Huntington Library, Ann Marie Donoghue of the Buffalo Bill Historical Center and Abby Bridge of the California Historical Society helped us with hard-to-find images. Ted Davis did much of the Photoshop and image management. And finally, the biggest hat tip of all to Mark Hayes for creating all the maps and putting in countless hours to make sure our images and files were the best they could be.

Thanks, guys. Without you, this wouldn't be a book.

Foreword

YEARS AGO, the legendary archaeologist Emil Haury told about a small incident that speaks volumes about the content of this book.

He was on a dig in Arizona when he noticed three men standing aside, quietly watching the activity. He approached them, and one said they'd walked from Santo Domingo Pueblo, three hundred miles away in northern New Mexico, looking to trade their craft items. This little moment brought home a lot of history and a lot of archaeology. It was a modern demonstration of why artifacts from hundreds of miles away appear in archaeological sites.

Cultures evolve because people from somewhere else show up and introduce new ideas. When people travel, objects travel even farther, traded and traded again—an explanation of why archaeologists are constantly confounded when they discover artifacts in places where they shouldn't be.

This exchange of objects and ideas teaches and broadens and is probably directly responsible for the fact that this book exists at all. As far as the desert is concerned, Allan and Carol Hayes and John Blom are products of a remote culture. They came from the hills and fog of Northern California, and until a pottery collection intruded on their lives, they were unaware of almost everything that's in this book.

Al summed up his knowledge of California Indians as taught to him through years spent in a fine California preparatory school and a fine California university: "California had Indians who ate acorns and made baskets

THE FIRST SANTA FE TRAIN

THE GREAT SOUTHWEST

until the nice padres came along and built the missions. They haven't been heard from since." He freely acknowledges that he might have believed that for the rest of his life if he hadn't started buying Indian pots.

After ten years of collecting, the education from those pots had become so fascinating that he and John Blom wrote two books about them, and Carol, John and Al had all become deeply involved with a California Indian Museum. They gradually came to recognize that the pots told a clear story about a progression of ideas and cultures. The more they learned, the more a question grew in their minds. How had they managed to go so far in life without having been exposed to all this?

Of course, what they'd discovered was hardly new information. It was almost all published and available in libraries, often in obscure and difficult books. When Allan Hayes and John Blom began working on *Southwestern Pottery, Anasazi to Zuni* ten years ago, they sought out those books, and were almost intimidated out of continuing. After reading the books, they weren't sure they had a right to attempt a book on a subject that scholars had covered exhaustively. They did it anyway, and *Southwestern Pottery* found an immediate audience.

As it worked its way toward minor classic status, Al and John came to realize that they'd actually had excellent credentials for writing it. They were authentic beginners, and, as such, they knew what beginners needed to know to understand the subject.

When I was at the Amerind Foundation, I was more focused on prehistory than I am in my current role at the Arizona Historical Society, and people would ask me if there was a book that made sense out of Arizona's diverse and complicated prehistory and connected it to modern times. The book didn't exist, and the lack of it bothered me for years.

I understand why it wasn't there. History books are normally written by historians and archaeology books by archaeologists, and few attempt to cross the lines. The book that pulls it all together almost has to be written by people who are willing to tell the story from a layperson's viewpoint instead of an academic one.

Allan and Carol Hayes, neither historians nor archaeologists, took on the task. They brought much the same set of credentials that John and Al brought to that first book. They just wanted to share a history that no one had ever told them about and they'd taken the time to discover for themselves.

When Carol told others that she and Al were working on a book called "The Desert Southwest: Four Thousand Years of Life and Art," she'd laugh and add "Never accuse us of lack of arrogance."

Allan, the journalism major, polished his writing skills and learned graphics in advertising agencies. Carol, the art major, learned to detect the age and integrity of objects through years as an antiques dealer and amateur restorer. John Blom, the art collector, learned photography as a way to create art of his own.

Together, the three friends sought out objects, artifacts and images that could teach them the history of the desert, and they used the images to tell as much of the story as possible. Because they weren't confined to an academic approach, they could fill in the gaps about the comings and goings of ancient peoples with plausible speculations that make prehistoric happenings seem as vivid as modern events.

They searched auctions, archives and junk shops. They bought many items and photographed others through the courtesy of great collections. In the same way that the historical and archaeological writings that provide source material for this book are buried in obscure places, so were many of the objects and images they found. Museum people constantly lament their lack of strorage space, and most museums have more worthy objects buried in the basement than they have on public view. This book shows more than forty objects and images from the Museums of the Arizona Historical Society, and at this writing, fewer than ten are on display.

As a result of their ten-year quest, Al, Carol and John have put together a book that comes very close to being the book that people have been asking me about for years: a fresh and highly readable story of the desert.

It's history, it's archaeology, and it brings the story up to the present. Because this book puts everything in context, it even offers a tiny glimpse of what can happen in the future.

—*Anne I. Woosley, Ph.D.*
Executive Director
Arizona Historical Society
September, 2005

Prologue

A few years back, we discovered the Southwest.

It's a land totally unlike any other part of America, with an art and a culture that makes it almost foreign to the rest of the country.

Its pottery captured our imagination.

We began collecting, and our over-the-top enthusiasm got us so deep into the subject that we wrote a couple of books about it.

It introduced us to the American desert and to places and events we never learned about in school. After a while, it began to reveal an even deeper layer of history—the seldom-told continuous and continuing saga of a region that most of us think has very little history at all.

This is the story of four thousand years of America's desert Southwest: its people, its conflicts, its immense human accomplishments and its enduring art.

Local history:
Salado Red four-legged censer, ca. 1300
and Maricopa three-legged jar, ca. 1930.
Both are 5" in diameter.

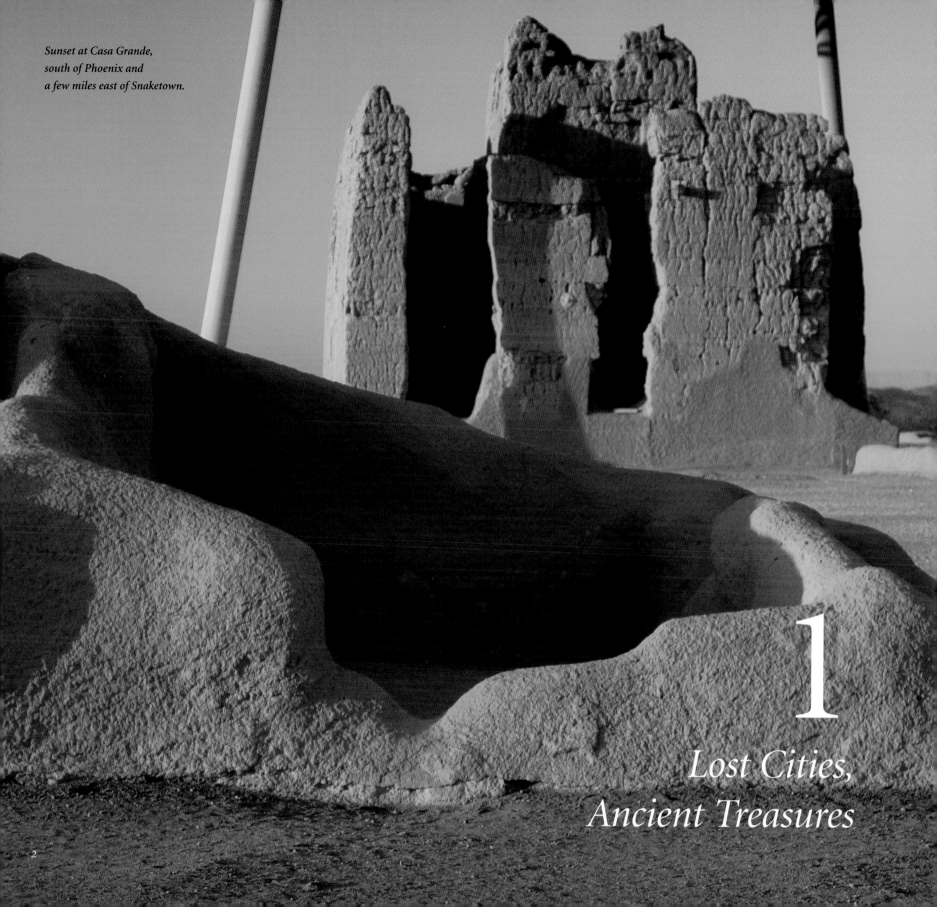

Sunset at Casa Grande,
south of Phoenix and
a few miles east of Snaketown.

1

*Lost Cities,
Ancient Treasures*

2

THERE'S A FASCINATING LOST CITY that lies unmarked, buried in scrub brush and sandy soil on the outskirts of one of America's biggest metropolitan areas. The archaeologists who explored Snaketown found evidence of a thousand years of occupation by people who left it long before any European ever saw it. Most of the world has never heard of it, and even people who live nearby scarcely know it's there.

This is an injustice. In school, we learned that the valleys of the Nile, the Tigris and the Euphrates were "the cradles of civilization." However, the schoolbooks never said a word about what looks like the cradle of civilization in the United States: the Southern Arizona desert.

It's not at the top of the list of places where you'd think great numbers of people would build colossal works for thousands of years. Most of us think of green meadows, rolling hills, shade trees and a gentle stream when we think of a pleasant place to settle down. The desert is the 180° opposite, dry, hard-edged and hostile, and yet four million of us choose to live in the Phoenix and Tucson basins, and another thirteen million live in the Los Angeles/San Diego complex that now almost totally covers the desert underneath.

We wouldn't have thought much about how all this happened if we hadn't bought a few Indian pots and become curious about the people who made them. The more curious we became, the more we were fascinated by the improbable and impressive things people have done to build a life in the desert.

This book is that story, told as much as possible by the art, artifacts and visual records those people left behind.

The Buried Past Modern Phoenix was built right on top of thousand-year-old cities and it obliterated almost every trace of their existence. Most of the developers never even noticed what they destroyed, and because the evidence of previous settlement wasn't obvious, downtown Phoenix will never be revered like Luxor or Macchu Pichu. We equate monumental architecture with high civilization, and the people who lived in prehistoric Phoenix left few monuments standing.

Their flat-topped pyramids may once have been as impressive as the spectacular cliff dwellings we see on Southwestern postcards, but they were nowhere near as permanent. In the desert, they were short of rocks, so they built with mud and sticks. Instead of surviving the centuries, their great buildings slowly melted once they were no longer maintained. You can spend a whole life living and working in Phoenix without ever realizing that your neighborhood sits on a network of sophisticated irrigation canals built by people who lived there for more than a thousand years and whose descendants still live on the edge of town.

The Phoenix Basin canal network was more ambitious than any other prehistoric agricultural irrigation system in North America. In fact, it was just about as extensive as the ones along the Tigris and the Euphrates that, according to your history book, made the Mesopotamian civilization possible.

The Arizona canal builders plastered the canal beds to retard seepage, built check dams and headgates with woven-mat valves and cut through lava rock to depths of as much as 25 feet for more than 3 miles. Although they moved away perhaps seven hundred years ago, their canals were still irrigating the fields of Mormon settlers in the early twentieth century.

In a 1930 aerial survey, archaeologist Walter Judd viewed what was left of a system that

Sample treasure: Ramos Polychrome hooded effigy, Casas Grandes culture, ca. 1350, 10" high.

as recently as 1880 had included over 300 miles of canals, including one more than 60 feet wide and 8 feet deep that ran for miles across the valley. He marveled at the fact that the ancient canal builders dug them entirely by hand and had no beasts of burden to remove the clay. His report pointed out that the modern irrigation canals that were replacing them—18 to 90 feet across, 5 to 8 feet deep—cost $22,000 a mile to build. It also lamented that land was then being reclaimed for farming at the rate of twenty acres a day and that steam shovels were no respecters of prehistoric canals.

That, of course, was in 1930, when Phoenix was still a sleepy desert town.

You don't need to know a whole lot more to guess what happened to all those canals in the three-quarters of a century that followed.

The Great City

Great civilizations have cities, and you'd expect to find one near the center of this massive hydraulic complex.

Hop in your car, drive down I-10 south of Phoenix, look west over the flat sagebrush on the Gila Indian Reservation near the Sacaton turnoff, and take a deep breath. You're looking at the outskirts of Snaketown, perhaps the most civilized city in the United States in A.D. 500. There's no monument marking it, no historical marker spelling out its glory, no tour bus. You have to have done a bit of reading to know that it was built and populated by the largely forgotten Hohokam people of the Phoenix basin. If you drive into the Reservation and poke around the area, you'll find no evidence that Snaketown ever existed. If you ask

Snaketown relic: Gila Butte Red on buff dish, ca. 750, 8" diameter.

about visiting it at the Gila Indian Center, you'll be told that the area is closed. If you try to find it anyway, you'll see very little, and you'll probably be chased off by a tribal cop. But that's the status of a lot of history in the desert. There's so little left to see that the few who know where it is go to great lengths to protect it, and protection definitely includes discouraging curiosity-seekers.

The problem goes way beyond artifact-looting. Every person who walks across the site dislodges another fragment of history. Archaeologists excavated the site in the 1930s and again in the 1960s, but after the excavations were complete, all traces of the ruins were carefully reburied.

Even the places in the Phoenix basin that are "preserved" are disappointing. The best known, and the only postcard-worthy one, is Casa Grande, a massive twelfth-century ruin a few miles from Snaketown. A landmark to early Southwestern travelers, it now sits under a graceless steel roof built to keep it from dissolving in the rain.

Casa Grande probably showed more ties to ancient Mexico when it was built. Some experts think the excavations were too enthusiastic, and that they removed most of an earlier truncated pyramid. Early restorers were

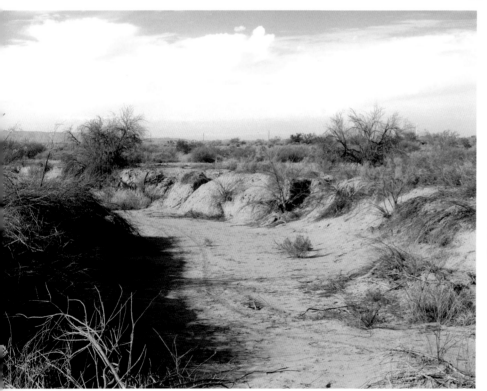

Snaketown today, as seen from the bed of the bone-dry Gila River.

focused on saving the one ruin in the Phoenix basin that looked like the large-scale prehistoric architecture in other parts of the Southwest. It's been suggested that they kept digging away at the pyramid until the complex looked like more what the Pueblo cliff dwellers built.

If that's true, you can't even blame them. Correct thinking of the 1920s dismissed connection between Casa Grande's builders and the Aztecs as an obsolete concept. According to their theory, Casa Grande was a pure American pueblo, not a hybridized Mexican pyramid.

There's a more respectfully restored ruin right in Phoenix with an excellent museum nearby, but unless you can do some heavy-duty visualization, you'll walk through Pueblo Grande and conclude that it looks like little more than a large lump of baked yellow clay.

Mesa Grande, the third major ruin in the area, is in the next town. The city of Mesa bought the site to preserve it, and it's a big task. Whatever funds the city can spare go to an ongoing restoration project headed by the nearby Mesa Southwest Museum. In 2005, after years of effort, it sits behind an elegant fence, still closed to the public.

Eventually, an interpretive walk will show

glimpses of the perimeter walls, gatehouse, passages and chambers of the pyramid. Archaeologists know that a complete excavation and an attempt to rebuild it in its original materials would doom it. Without the kind of daily maintenance the Hohokam gave it when they lived in it, it would be helpless against the monsoon rains.

A couple of miles northeast, you'll find Mesa's Park of the Canals, where you can walk in eroded dry ditches that once brought water to Hohokam. When you're done, you'll have seen about all that's left to see of Hohokam prehistory.

Why (and What) We Forgot This lack of surviving architecture is a major reason for the lack of general attention paid to the early people of the desert. The Pueblo Indians of New Mexico and Arizona and their prehistoric ancestors get all the publicity and have for years.

For more than a century, scientists and art historians have been finding, analyzing and writing about Southwestern Indian artifacts, modern and prehistoric. Mostly, they focus on wares from northern New Mexico and Arizona. Book after book shows Anasazi pieces and pieces from the pueblos—Hopi and Santa Clara, San Ildefonso, Acoma and Zuni and the rest.

Below-the-Rim esthetics: Hohokam, Sacaton Red-on-buff bird effigy jar, 5½" long, and dog effigy jar, 3¼" long, both ca. 1050.

Those books, even the ones we've written ourselves, spend much less time examining the subject of this one: the elusive, almost-ignored other Southwest. Its art looks different, made in a different way and different philosophically. It's from a much different land, and it's a largely unrecognized national treasure.

The modern history of the Southwest was shaped by the route the railroad chose. If you've spent any time in Arizona and New Mexico, you know that the two states aren't really divided left and right like the map of the United States shows. They're split top and bottom, highlands to the north and lowlands to the south, separated by a great shelf called the Mogollon Rim.

The Santa Fe railroad stayed above the Rim on its way to Los Angeles. The railroad's poster artists romanticized the scenery, and the Fred Harvey hotels took the tourists to the Grand Canyon and the cliff dwellings and sold them Pueblo pots and Navajo rugs. For more than a hundred years, the history and culture of north-of-the-Rim Arizona and New Mexico has been broadcast to the world by an aggressive publicity machine and kept vital by a constant flow of tourists.

Below the Rim the people lived a totally different life, the pottery has a different beauty and its history tells an even longer story. To appreciate the difference, drive a couple of hundred miles on I-17, starting at Flagstaff in the north. You'll drop through about seven ecological zones, leaving a snowy alpine landscape and arriving in a parched cactus

desert. By the time you hit the outskirts of Phoenix, you'll begin to understand.

When the railroads came to the desert, they weren't courting tourists. They served copper mines, cattle ranches, cotton farms and the occasional northerner seeking clean air for troubled lungs. What little tourist attraction the desert offered was concentrated around Tucson, built by the Spanish as a mission and later expanded as a military outpost in the 1700s. Today, you can find a fabulous eighteenth-century mission and a city that, if you look for it, shows a lot more age than Phoenix.

But the mission wasn't the beginning of culture in Tucson, either. By our definition, the first steps toward civilization begin when peoples band together into communities, settle into an agriculture-based lifestyle and start making pottery and creating architecture.

Recent excavations indicate that all the above began occuring in the Tucson basin four thousand years ago, two thousand years before we've seen evidence of them in Phoenix and, as a package, earlier than anywhere else that we know of west of the Mississippi.

This is all new knowledge, and it upset the standard thinking about the origins of agriculture and village life in the Southwest. In the then-current *The Archaeology of North America*, published in 1989, Dean R. Snow gave the beginning dates of village life in Arizona as

600 A.D., but acknowledged that archaeologists had traditionally dated the beginning of maize cultivation at 1000 B.C. This created a dilemma, since agriculture on any kind of scale requires a cooperative society, but Dr. Snow was able to resolve the time gap by reporting that "recent reanalysis of radiocarbon dating indicates that maize may have been introduced as recently as A.D. 750."

According to the latest findings, those dates were off by more than three thousand years on the maize introduction and by nearly that much on the beginnings of village life. We're now looking at a four thousand-year evolution of the history of Southwestern civilization concentrated in a single narrow area, We can trace a faint trail for the first two thousand and track the next two thousand through artifacts, right up to the present.

Prehistoric Corn, actual size.
Not exactly like your local super.

The Gran Chichimeca

The Gran Chichimeca Piecing together the precontact history of the desert Southwest is no easy matter. You can sift through thousands of scholarly pages and come away with no clear idea at all of who went where or made what. It's not that there aren't theories. It's just that matching theory and reality doesn't always work.

Archaeologists deal with minutia, painstakingly excavating sites and cataloging

sherds and tiny artifacts. Perhaps as a reaction to their constricted world, the more imaginative members of the fraternity occasionally visualize great patterns of connection, and once these concepts get published, they influence thinking for years after.

Perhaps the grandest and most influential of these concepts to come along in recent years came from Charles Di Peso, the director of the Amerind Foundation in Dragoon, Arizona, during the 1960s and 1970s. In an eight-volume study of the ruins at Paquimé in Northern Chihuahua, one of the great culture centers of the prehistoric Southwest, Di Peso described the *Gran Chichimeca*, a name used by Spanish chroniclers in the 1500s. It refers to the land of the Chichimecs, mythical northern ancestors of the Aztecs.

Di Peso's Gran Chichimeca extended from the Tropic of Cancer in the south to the thirty-eighth parallel in the north. It included everything in the United States south of San Francisco and central Kansas and everything in Mexico north of the bottom of Baja California.

His concept described it as the area in which traders from the greater civilizations to the south brought goods and social concepts to the less-advanced north. The Gran Chichimeca included the occupation areas of all the major prehistoric peoples who populated the Southwest. These included the Anasazi, the Hohokam, the Mogollon and Mimbres, the Salado, the Sinagua, the Chihuahuans, the Sonorans and the Patayan.

Paquimé, in Di Peso's vision, was the great

distribution center, and the complex of ruins in and around Chaco Canyon in northern New Mexico was its chief cultural outpost.

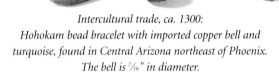

Intercultural trade, ca. 1300: Hohokam bead bracelet with imported copper bell and turquoise, found in Central Arizona northeast of Phoenix. The bell is ⁷/₁₆" in diameter.

There's a lot of fodder for Di Peso's concept. The evidence of trade is everywhere. Parrots from Mexican jungles and copper bells from Mexico's west coast show up at Chaco and in the Arizona desert, while turquoise from mines in New Mexico graces ceremonial artifacts from central Mexico.

However, as Anne Woosley and Allan McIntyre pointed out in the the Amerind Foundation's own 1995 *Mimbres Mogollon Archaeology*, Di Peso's proof-of-the-concept excavation at Wind Mountain in southern New Mexico never provided the verification he wanted. The people of Wind Mountain had far more contact with the people from the surrounding areas than they did with great international social and political movements.

One of the problems with modern thought is that we place labels on cultures—Mogollon, Anasazi, Hohokam and the like—and think of them as behaving like nations with armies. The Southwestern desert seems to have been much more a place of small towns populated by families who spent their time tending to the tasks of the day and visiting with their neighbors over the hill.

Culture probably spread the old-fashioned way, through intermarriage, small migrations and exposure to the occasional itinerant trader. Don't underestimate the enterprise of the latter group. They traveled far afield. Archaeologists working in a single prehistoric ruin will often turn up fragments of pottery made all over the Southwest, some from as far as 200 miles away.

The Myth of Aztlan A spectacular exhibition that opened in 2001 at the Los Angeles Museum of Art gave us another cosmic view of culture spread. Its central theme was that Aztlan, the mythic home of the Aztecs, was an earthly paradise in the north.

The Aztecs lived there until Huitzilopochtli, a powerful deity, led them on a twelfth-century migration to central Mexico. They arrived in 1325, founded Tenochtitlan on an island in a mountain lake and were still there when the Spanish decided to call it Ciudad de Mexico and made it the capital of Nueva España.

A hundred years before the Spanish came

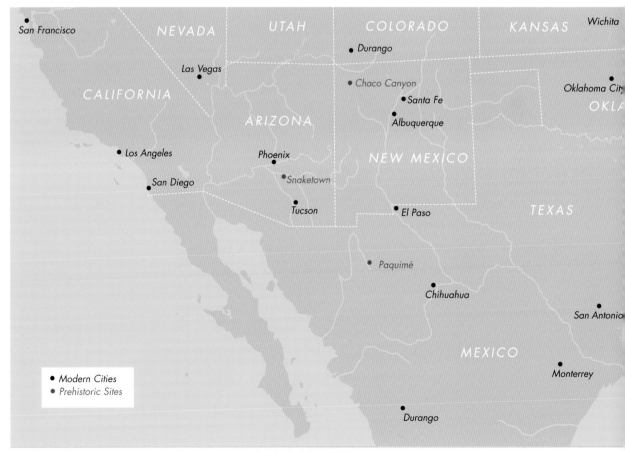

Di Peso's Gran Chichimeca.

to Mexico City, according to the Aztec legends, emperor Moctezuma Ihuilcamina wanted to find his spiritual roots in Aztlan and sent emissaries who arrived there only by managing to transform themselves into birds and other animals (a fact that might explain why later efforts to determine the exact location of Aztlan have been generally unsuccessful).

The myth places Aztlan in northern Mexico or the American Southwest. The religion of the Southwestern Pueblos dovetails neatly. Their own creation myths place each community at the center of the world, the place where their ancestors came after years of search.

Once you turn your imagination loose, that earthly paradise of the Pueblos starts looking like the same one the gods made the Aztecs abandon back in the twelfth century.

That idea achieved some popularity in the 1960s. To the Chicano movement, it provided a tidy explanation and entitlement. The presence of Mexican natives in the United States couldn't be challenged by society or by immigration laws if, after all, United States territory was their ancestral home.

This thought of an ancient Pueblo-to-Aztec migration doesn't fit nearly as neatly with current archaeological thinking, even though true believers can point to all kinds of corroborating data.

The museum exhibit acknowledged but didn't dwell on the fact that modern Hopi and Aztecan are considered part of the same broad language group. Instead, it concentrated on artifacts and the connections those artifacts made. It displayed Aztec pottery and carvings

Parrot pots from the north.
Behind: Hopi, Bidahochi Polychrome bowl, 9½" diameter. In front:
Mogollon, Cedar Creek Polychrome bowl, 6" in diameter.
Both bowls were made about 1350 well north of the Mogollon Rim.

along with pottery, art and artifacts from the Hohokam, Salado, Mogollon, Mimbres, Anasazi and the modern Pueblos. We saw the principal trade items over and over. Corn, parrots and turquoise appear on artifacts from everywhere across the Southwest to the limits of the Gran Chichimeca and beyond.

All of these tantalizing clues lead to a broadened view of the Southwest, one much greater than the limited, above-the-rim world of the railroad promotions. And, in the case of the desert, far beyond Phoenix and Tucson where it seems to begin.

However, the whole Gran Chichimeca is way too much for this book. We shrank it, and our first territorial reduction was to leave most of what's happened above the Mogollon Rim in the last five-hundred years or so to other books. Not that it isn't connected—events in the desert influenced the world above the Rim, and we'll show how these influences crept in.

Also, since this is a book about the art and history of the United States, we're not paying much attention to anything that happened more than a hundred miles below the Mexican border. We've taken a lateral swipe across Di Peso's land and created our own Little Chichimeca, the relatively unexplored (in comparison to the lands of the Anasazi and the Puebloans) band across the middle.

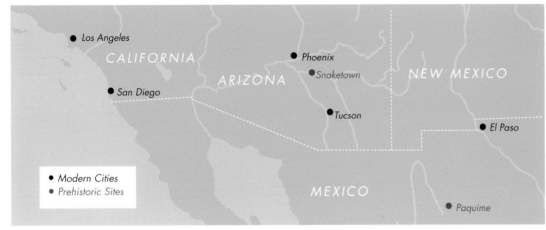

Our Little Chichimeca.

The Little Chichimeca In this book's voyage of discovery, we'll examine the art, artifacts and events of the Little Chichimeca from the beginning.

It won't be a simple, linear journey. Where we're going, much of the pottery made at one time in one place looks a lot like the pottery that shows up at another time in another place. Those similarities have generated thousands of pages of expert speculation about the movements and relationships of peoples.

When those pages deal with above-the-Rim people and events, there are substantial areas of agreement between archaeologists and Indians about who went where and built what. The answers are much less clear in the patch of real estate this book is about, and it opens the door for long-shot speculations like the one about the Aztecs having once occupied the northern pueblos.

Alfred Kroeber first examined the pottery of the Mojave Indians more than a hundred years ago. He wrote about the obvious resemblance between modern Mojave pottery and prehistoric Hohokam pottery and felt there was a probable connection.

However, if you want to make traditional Mojaves go ballistic, just suggest that they might be descended from the Hohokam. We were dumb enough, and uninformed enough, to do that a few years ago, and our ears are still burning.

Today, we hope, we're a bit more enlightened. Tribes have creation myths and oral histories that are the foundation of their religious beliefs, and challenging them creates friction without providing answers. Tribal, state and federal politics compound the issue. Water rights and land possession are major issues in the Southwest, and saying anything that might weaken a claim to ancestral lands puts you on dangerous ground.

So we won't step out of line and volunteer elaborate new theories about migrations and connections. We will, however, point out the things that look like each other and put them side by side.

We'll also pass along the suggestions others have made, but we leave it to you to connect the dots. It's a fascinating game, and playing it is one of the things that drew us into this pursuit in the beginning. Have fun, and speculate all you want.

But while you're speculating, consider this. It's quite possible for people who never encountered each other at all to arrive at the same creative solutions, as we were reminded when we saw some four-thousand-year-old Egyptian pottery that looked almost exactly like that Mojave/Hohokam pottery that captured Kroeber's attention. The obvious answers aren't always the correct ones.

Bearing all this in mind, we'll begin our adventure at the beginning.

Hohokam, Sacaton Red-on-buff scoop, 4¾" long, ca. 1050, and Mojave Red on buff scoop, 5" long, ca. 1910.

9

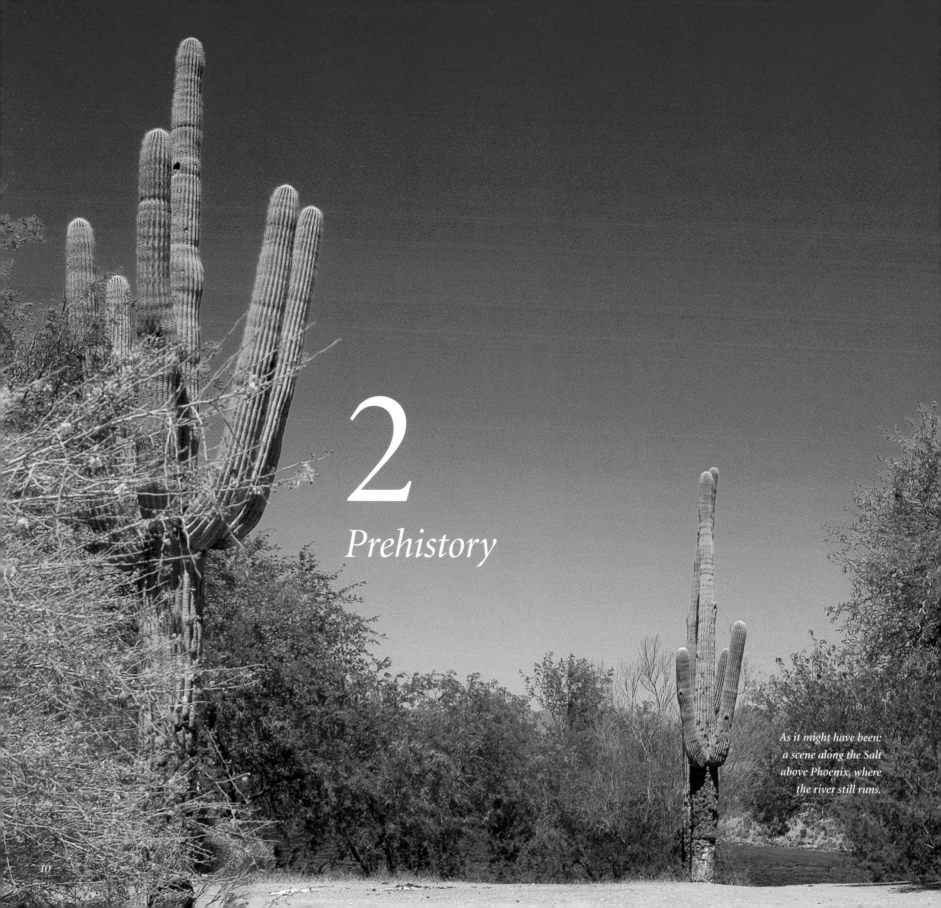

2
Prehistory

As it might have been:
a scene along the Salt
above Phoenix, where
the river still runs.

The Tucson Farmers

UNTIL WELL INTO THE 1990s, archaeological wisdom said you could flip a coin over whether the Hohokam of southern Arizona or the Mogollon of the mountains to the east were the first Southwestern potters, and the date usually given for the first crude plainware was 200 to 400 A.D.

To a scholar, that starting date is big-time important, because it's key to understanding the flow of history. Pottery is one of the first indicators of a sedentary lifestyle.

If you think about it a bit, it makes sense that if you're spending your days wandering about hunting and gathering, you'll need the lightest possible vessels for carrying things. That's why weaving and basketry will precede pottery as utilitarian crafts. Heavy, permanent, breakable vessels only become useful when you leave the nomadic life behind, settle down in one place and start the journey towards civilization.

That trip to civilization requires a lot

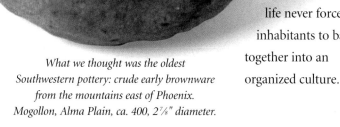

What we thought was the oldest Southwestern pottery: crude early brownware from the mountains east of Phoenix. Mogollon, Alma Plain, ca. 400, 2⅞" diameter.

of steps, and according to academic definition, the precontact cultures of the Southwest never achieved it. An anthropologist will tell you that "civilization" requires architecture, permanent communities, agriculture, a hierarchical, stratified society and—oops—a written language. To our knowledge, the cultures of the desert achieved everything but writing, and they achieved it at a surprisingly early date.

Before 200 A.D., according to the traditional model, everyone in the Southwestern United States lived according to the lifestyles of the Archaic period. They were subsistence hunter-gatherers, nomadic family groups without any of the trappings that might qualify them as civilized according to anybody's definition.

Back then, the Arizona desert was a friendlier place than it is today. Archaic peoples could wander along lush riverbanks, never worrying about a supply of water. The desert probably looked much the way it looks today in the cultivated lowlands along the Colorado to the west. The usual academic conclusion is that prehistoric desert life never forced its inhabitants to band together into an organized culture.

Discovery and More Discoveries

In the 1990s, Tucson decided it was time to do some downtown redevelopment and widen I-10, and all the theories went out the window. Whenever a major building project gets underway in the Southwest, the probability of digging up a ruin or two is so great that the authorities automatically call out the archaeologists. On this one, the archaeologist Jonathan Mabry and the contract firm of Desert Archaeology Inc. struck a scientific bonanza.

Now, to the best of our knowledge, the beginnings of civilization (and pottery) in the desert first appeared along the Santa Cruz River, a few minutes from downtown Tucson. These discoveries introduced us to a newly recognized, as yet unnamed culture.

Between 1993 and 1998, the firm found seven sites in a 3-mile stretch that included 730 dwellings, what appears to be a central plaza, and an organized group of structures around a 25-foot diameter great building.

They also found several miles of water-control canals, including a primary and secondary system, a quantity of maize remnants that indicated floodwater farming, evidence of tobacco and cotton farming and shell bracelets, beads and pendants. They also found potsherds from small bowls and fragments of small figurines. The sites showed evidence of occupancies as short as fifty years and as long as three hundred years.

In short, the archaeologists found just about all the elements of an established early

civilization except for the writing and the hard evidence of a formal, stratified society.

When they carbon-dated the vegetal remains, the results were staggering: a thousand-year push back in time. The structures, the artifacts and the pottery all were created between 800 and 400 B.C.

Shortly after this discovery, the dates of the beginnings of civilization in our desert Southwest bumped back even further. Archaeologists J. R. Romey of the U.S. Bureau of Land Management and Robert J. Hard of the University of Texas, San Antonio, reported the excavation of a 25-acre site along the Rio Casas Grandes just below the U.S. border, south of Deming, New Mexico.

They found corncobs and squash seeds dating between 1100 and 1500 B.C. and elaborate agricultural terracing apparently built by the same peoples who populated Tucson. The archaeological team suggested the complex may have supported as many as a thousand people and estimated that the earth-moving involved a displacement of 20,000 metric tons, or sixteen man-years of effort.

Then, in the summer of 2001, Mabry found an even earlier cache. His discoveries

800 B.C., the first leap back: Fragments of figurines from the 1996 excavations by Desert Archaeology, Inc. on the Santa Cruz River north of Tucson, shown actual size. The one at lower right has a pigtail down its back, the other two feature staring eyes.

along the Santa Cruz in Tucson have shaken up Southwestern archaeology much the way the Leakeys' discoveries in the Olduvai Gorge shook up our thinking about the dawn of man. The date for pottery in Tucson shot back to 2000 B.C.

No one seems ready to name these peoples, but one thing seems certain. The archaeological community will state flatly that these people weren't the Hohokam, whom tradition credits with providing the area's first proto-civilization.

The Tucson people had different funerary customs—they buried their dead while the Hohokam cremated—and they had very different artifacts. They only made small-size pottery: smoking pipes, figurines, spindle whorls and pinch-pot bowls no bigger than the palm of your hand. Mabry feels that the pottery was ceremonial rather than utilitarian and points out that rather than making storage jars, they dug carefully shaped storage pits and plastered the walls with desert clay.

In this book, we're not quite ready to dismiss all connection with the Hohokam, simply because the more we look at history, the more

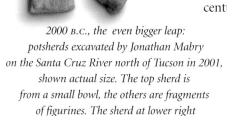

2000 B.C., the even bigger leap: potsherds excavated by Jonathan Mabry on the Santa Cruz River north of Tucson in 2001, shown actual size. The top sherd is from a small bowl, the others are fragments of figurines. The sherd at lower right still has a remarkably preserved high polish.

we think changes in custom and material culture were most likely to occur gradually, through mixtures of people.

It's pretty well-established, however, that the cultural history of the Southwestern desert took a big turn around 1 A.D. The easiest explanation is immigration from the south, and these southern immigrants are the people the archaeologists label Hohokam. By 400 A.D. or so, south central Arizona had a pronounced Mesoamerican look, and there was a large Hohokam-style village on the Tucson sites along the Santa Cruz. Mabry's early Tucson farmers were history.

Their disappearance may have been helped along. Mabry finds significance in the fact that all the artifacts he's uncovered along the Santa Cruz appear to have been deliberately broken. There are more than a few possible explanations. They could have been broken by custom at the end of a ceremony or as their owners died. They could have been smashed by a new culture looking to eradicate whatever magic their predecessors might have left behind, or they could have been broken up when the Tucson people met a new group and adopted their customs. They could simply have been crunched up by traffic over the centuries. Or none of the above.

Whatever happened, the Hohokam were in place, agrarians who,

as the years progressed, built irrigation systems that far outstripped the ambitious Tucson canals and created a semiurban culture.

The Hohokam's hydraulic engineering might even have begun the slow destruction of their rivers, but whatever damage the Hohokam did only began the process.

It took twentieth-century greed for water to turn deterioration into devastation. Today, the water gets pulled off miles upstream and goes directly to agribusiness and urban water supplies. Those once-great rivers are now mostly empty, flood briefly after a rare heavy rain, then dry back to parched adobe within hours after the rain ends.

When the Hohokam settled at Snaketown almost two thousand years ago, however, the Gila, the Salt, the Santa Cruz and the San Pedro flowed year-round. And a bend in the Gila a few miles south of Phoenix gave them an ideal place to build one of America's earliest cities.

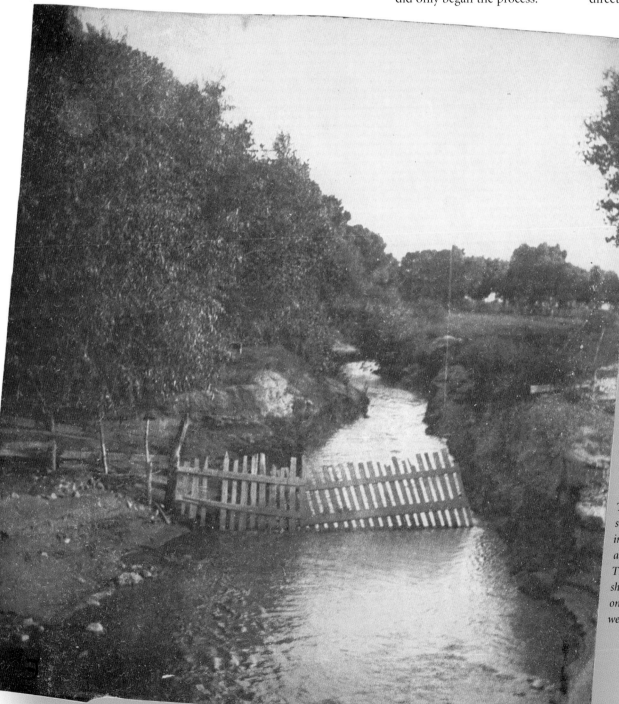

1899

There was still some water left in the canals a hundred years ago. This 1899 photograph shows an old canal on the Santa Cruz west of Tucson.

The Hohokam: Snaketown Begins

Of all the highly examined peoples of the precontact Southwest, the Hohokam of Snaketown remain among the most enigmatic. Even their name speaks to the enigma. It's taken from a Piman word variously translated as "those who have vanished" or "all used up." Exactly who they were, where they came from and where they went are questions that the archaeological community has argued for decades.

Somewhere around 200 A.D., give or take a century or two, the Hohokam settled along the Gila in flat country south of Phoenix and built a town or, more accurately, a low-density community, that lasted for more than a thousand years.

At its peak, its population reached two thousand, according to Emil Haury, the archaeologist who excavated it first in 1934 and again in 1964. Others state a more cautious population figure of one thousand, but the point is made. It was probably the closest thing to a city in the United States at the time.

At Snaketown, the Gila ran about 6 feet deep and about 50 feet wide. Just 3 feet above

the Gila's marshy green flood plain, the Hohokam grew crops on a lower terrace that would flood every fifty years or so, providing refreshed topsoil. Six feet above, an upper terrace of the valley plain provided permanently dry land for housing along with more good soil that lent itself to irrigation by upstream canals.

The name Snaketown sounds like one of those wisecracking Wild West names, but there's real substance to it. Beginning in the 1870s, Akimel O'odham Indians reoccupied the site, and their names for it translated into "Many Rattlesnakes" or "Place of the Snakes." To a great degree, Snaketown attracted the snakes because of what the Hohokam left behind. A tidy people, they piled their trash into localized mounds. When a mound reached a sufficient, or perhaps merely an inconvenient, height, they plastered it over.

As the centuries passed, the plaster washed away. Organic waste within the mounds decomposed into a soft soil that gave small rodents easy burrowing in a pleasant raised place where they could keep their feet dry in wet weather. As the Indians reoccupied the site, the rodent population grew, and all those mice provided a quick dinner source for the local snakes.

The first homes at Snaketown were built of what Southwesterners call *jacal* and academic textbooks call wattle-and-daub. They were

mud and stick structures built over a pit in the desert sand and plastered with clay.

In the desert, the surface is covered with a beige sand that packs firm when it's damp and crumbles into dust in dry weather. Under the sand, there's a layer called *caliche*. Mostly calcium, it's rock-hard unless it's wet. In early pithouses, the Hohokam pushed the sandy layer aside and dug down to the caliche, a foot or two or three, built the shell inside the pit, and plastered the floor. When they were ready for the housewarming, their cozy family castle occupied about a 15 x 15 foot space.

In this pleasant, unfortified world, the Hohokam lived a peaceful and apparently abundant life. Not that the pleasantness was uninterrupted. Winter weather at Snaketown can drop to more than 20 degrees below freezing and summer heat can shoot up to 115 degrees or more.

Droughts and floods create their own problems, and perhaps as a result of the Hohokam's centuries of tinkering with the water supply, the salinity of the Gila and the soil itself might have gradually increased, making farming more and more difficult. Haury reported a mineral crust in a fourteenth-century canal at Snaketown that wasn't present in earlier ditches.

Pottery at Snaketown probably doesn't go back before

How they lived: an early Hohokam pithouse, as recreated at the Gila Indian Center.

the second century A.D., if that far. However, it would be naive to think that pottery-making was fresh news to Snaketown's earliest settlers. After all, they'd been making pots down in Tucson for a couple of thousand years, and if the theories are right, the Hohokam came from Mesoamerica where they'd made pottery for centuries.

Snaketown's oldest pottery supports that conclusion. Normally, you'd think of primitive pottery as lumpy, crude brown stuff, and there was plenty of that made around the same time in the mountains to the east, but the oldest pottery at Snaketown is well-fired, smooth, carefully shaped, thin and surprisingly sophisticated. The early types disappeared by 500 A.D. or so, but one type, Gila Plain, persisted through the whole of Hohokam existence.

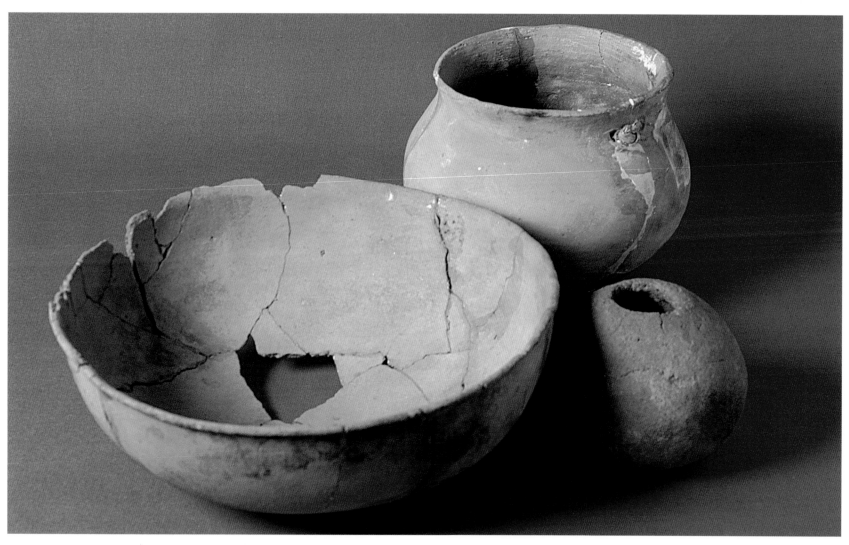

FROM LEFT: Vahki Plain bowl, 10¼" diameter, ca. 400; Gila Plain jar, 6¼" diameter, ca. 700; Gila Plain heavy-wall jar, 4" diameter, ca. 1000.

The two pieces on the left are typical early Snaketown pottery, well-finished with a uniform ⅛" overall thickness. The earliest potters used a pinkish clay, but after 500 A.D. or so, Hohokam pottery was yellowish buff like the jar at center.

The third piece is unusual. "Heavy-wall" is an understatement. When you pick it up, it feels like a rock with a 1" diameter hole drilled partway through. In his 1976 work, The Hohokam: Desert Farmers & Craftsmen, Emil Haury discussed whole specimens and fragments of pots like these from Snaketown and dated them at around A.D. 1000. He concluded, based on the fact that several had contained pitch, that they were used as crucibles to "give off light, heat or aroma." This particular piece is clean inside and seems never to have been put to any of those uses.

Colonial Times

Some years back, the archaeologists agreed on a chronology that divides the Hohokam timeline into four periods: Pioneer, Colonial, Sedentary and Classic. The scientific community tinkers constantly with the start and stop dates, but the most recent chronology we've seen for the developed periods of their culture looks like this:

Pioneer:	*300 – 750*
Colonial	*750 – 950*
Sedentary	*950 – 1150*
Classic	*1150 – 1450*

The names of the periods carry a lot of baggage. According to current thinking, the Hohokam nation behaved differently in each phase. During the Pioneer period, so the theory goes, they entered the savage wasteland from Mexico and established settlements, the most important of which was Snaketown. Toward the end of it, they started decorating their buff-colored pottery with crude, broad-line designs in red and, although the design sophistication increased, it remained almost entirely red on buff for five hundred years or so.

After 750, their Mesoamerican-inspired

Mesquite game ball, 3¼" diameter, of uncertain age. Rubber and wood balls show up all over the Chichimeca.

culture began its geographic spread, which explains the name Colonial period. During their Colonial days, they built Mesoamerican-style ball courts over much of southern Arizona, one of the key links between the Hohokam and the cultures to the south. They also left pottery north into the mountains, west into the desert, south to the Mexican border and east to the New Mexico border.

When you look closely at southern Arizona and northern Sonora, you encounter the names of a lot of other cultures who made pottery that looked more or less like what the Hohokam made. You'll read about the Trincheras culture in Sonora, the Dragoon culture east of Tucson, the San Simon culture still farther east and the Babocomari culture out west and down near the border. Up north, the Hohokam confuse with the Sinagua and the Salado, and further east, they bump into the Mogollon and the Mimbres. In the sparsely populated west, they probably met up with the Patayan as well, leaving archaeologists with a high proportion of mixed sites rather than pure ones.

The scientists have even come up with a different timeline and a set of different period names for the Tucson Basin, and fastidious scholars start getting uncomfortable when you call the Tucson Basin culture Hohokam. If you buy into this ethnic partitioning all the way, the Hohokam dwindle back almost to Snaketown, the Phoenix basin and little else.

The prehistory of the Southwestern desert is easier to understand when you lump what early archaeologists called the "red on buff" cultures together and call them Hohokam. Between these cultures, there's much overlap in pottery styles, burial customs and architecture, and it's certain that they all knew each other and traded with each other.

It makes sense to say that a culture advanced enough to build Snaketown and the Phoenix basin canal system influenced the people around it. It follows that there would logically be differences in art, craft and customs between sophisticated "urban" Snaketown and the "rural" outlying provinces. It also follows that, considering the ephemeral nature of Hohokam architecture, there are many more undiscovered Hohokam sites, pure and impure, great and small, to help settle these and future arguments.

One thing is clear, however. During the Colonial period, the Hohokam of Snaketown and beyond really learned how to make pottery.

During their entire existence, the Hohokam never made better-fired, better-painted, better-designed and better-finished ware than they did during Colonial days, and Santa Cruz and Gila Butte Red-on-buff pottery shows up over the full area of Hohokam expansion, or, if you're more comfortable with the ethnic partitions, the full area where all those other cultures traded with the Hohokam.

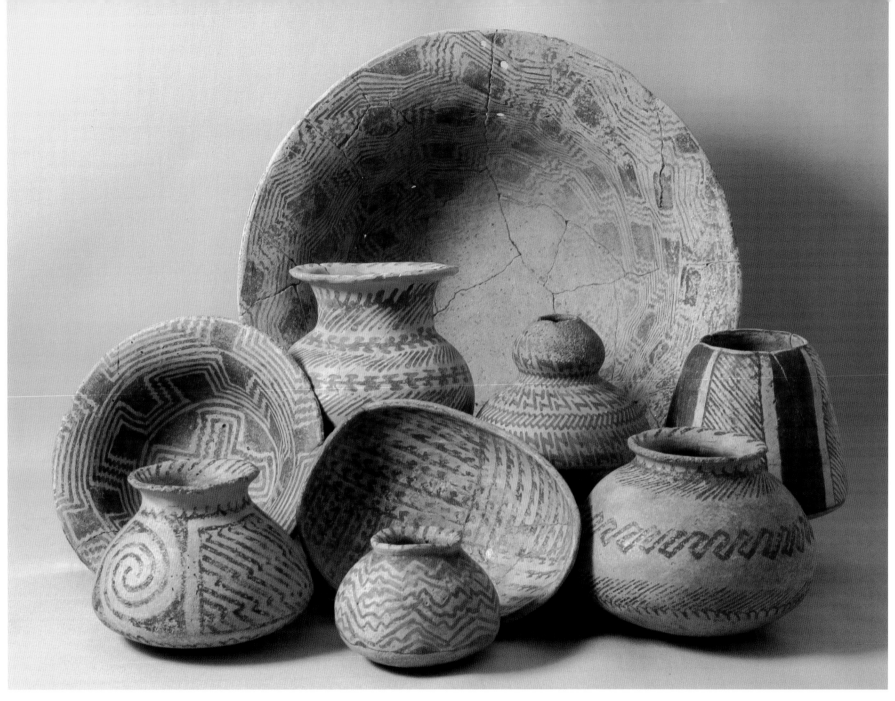

BACK ROW: *Santa Cruz Red-on-buff bowl, 14½" diameter, ca. 900.*

MIDDLE ROW: *Santa Cruz Red-on-buff bowl, 7¾" diameter, ca. 900; Santa Cruz Red-on-buff jar, 5⅝" diameter, ca. 900; Santa Cruz Red-on-buff double jar, 5½" diameter, ca. 900; Gila Butte Red-on-buff jar, 5½" diameter, ca. 800.*

FRONT ROW: *Santa Cruz Red-on-buff jar,* *5⅜" diameter, ca. 875; Santa Cruz Red-on-buff scoop, 7¾" long, ca. 900; Gila Butte Red-on-buff jar, 4" diameter, ca. 800; Santa Cruz Red on buff jar, 6½" diameter, ca. 900.*

Here, you're looking at Hohokam pottery at the peak of the art. It was polished and carefully finished, but it wasn't totally *smooth. The surface feels more like an orange than like a plum.*

The names Gila Butte and Santa Cruz warrant a bit of explanation. Type names for pottery are almost always geographic, based on the site where the pottery was first identified and made. Many type names preceded the formal classification system adopted in the early 1930s. Since so much of *the research on Hohokam pottery is based on findings in and around Snaketown, many Hohokam type names—Gila Butte, Sacaton, Estrella, Gila, Casa Grande—refer to sites within a few miles of Snaketown. Santa Cruz might seem like a mild exception, but it isn't. Although the Santa Cruz is Tucson's river, it flows into the Gila just a short distance from Snaketown.*

Figurines and Funerals

The Hohokam made more little figurines and odd-shaped little pottery vessels than any other group in the Southwest. At Snaketown, Haury reported "1,072 whole and fragmentary specimens" of human figurines alone. Most were in trash mounds from the Pioneer period, but from Colonial days on, they seemed to be associated with cremations.

When archaeologists assign a ruin to a culture, they base their call on architecture, pottery and burial customs, and on the latter score, the Hohokam differed from their neighbors. The Anasazi and the Sinagua to the north, the Salado to the northeast, the Patayan to the west and the Mogollon to the east all buried their dead, as did the earlier Tucson farmers. Only the Hohokam and the allied cultures who made Hohokam-style pottery preferred cremation. They may have done it for religious reasons, or they may have done it for a reason as simple as the caliche layer. Digging deep enough for proper burial may have been so difficult that they had to find a better answer.

Throughout the Southwest, artifacts have been associated with the dead often enough to grow the myth that "all prehistoric pottery is burial-related." The facts are different. Pottery was heavy and breakable and it was relatively easy to make, so when people moved, they left it behind. People in the prehistoric Southwest moved a lot for many reasons—crop failure, warfare, plague and often fire.

The scorched little figure to the left may well have suffered through a Hohokam cremation. However, its history is long gone, and the fact that it's been burned isn't conclusive. All we know about this little puppy is that it came from private land on the Santa Cruz river just north of Tucson.

Archaeologists are always fascinated by burials, and much of that fascination has to do with the social implications. When they define the character of a culture, they look for signs of social stratification. As civilizations emerge, formal leadership follows, delegation of power begins and social classes develop. One of the clearest clues of this is social inequity in

Sacaton fire-damaged animal figurine, 2" high, ca. 1000.

burials. If some individuals received special burial treatment, it follows in Orwellian terms that those individuals were more equal than the others. Hohokam funeral practices seem relatively egalitarian. Their aristocrats didn't get elaborate arrays like the ones that surrounded nobility in Mesoamerican cultures to the south and in Anasazi cultures to the north.

Censers like the ones on the next page, may also have had some ritual connection with the dead but not according to Haury. He felt that they were incense-burners, and the fact that most don't seem to have had anything burned in them didn't bother him. He explained the lack of fire evidence by suggesting that their use might have been symbolic. If these three censers ever burned anything, there's no trace of it now.

Censers have a bit of mystery of their own. At Snaketown, Haury found caches of deliberately broken or burned figurines and censers with no apparent connection to cremation. He considered two explanations. They might have been used in rituals and destroyed after the clan died out because no one else could use them, or they might have been the personal possessions of shamans and contained too much power to be passed on to someone else. He didn't suggest another possibility. Religious leaders are quick to dismiss paraphernalia from competing sects as pagan and dangerous, and book-burning and idol-smashing follow quickly.

Another, more mundane question puzzles us. Many of the censers in Haury's book are labeled as "stone (?)." With heavy Hohokam pieces, it's often hard to tell whether you're looking at a rock or a pot. Certainly, some Hohokam censers were carved stone while others were pottery. Why two kinds? One suggestion we're fond of says that the rich people had stone ones, while middleclass Hohokam who aspired to the finer things had clay replicas that looked like the fancy ones. Sometimes speculations like this align so beautifully with universal human behavior that it's hard to dismiss them.

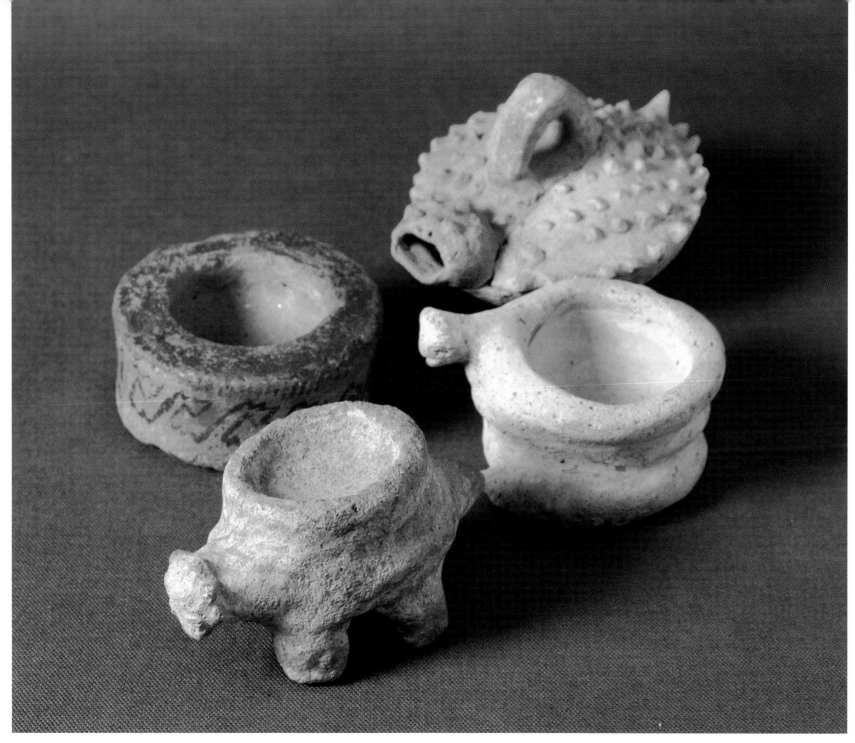

CLOCKWISE FROM LEFT: *Santa Cruz Red-on-Buff censer, 3⅜" diameter, ca. 900; Santa Cruz Red-on-buff horned toad effigy jar, 5" long, ca. 900; Sacaton (?) snake effigy censer, 3¼" diameter, ca. 1000; Sacaton Red-on-buff animal effigy censer, 4¼" long, ca. 1000.*

We share Dr. Haury's conservatism about saying flatly that these are all pottery. We wouldn't be surprised if any or all of the three censers in the picture turned out to be stone after all.

The one farthest left is the most typical. Most of the censers in Haury's book have this simple shape. Animal and human effigy censers weren't rare, and the book has pictures of snake censers much like the one on the right.

Curiously, both the snake and the four-legged animal censer have heads that look like horned toads, a desert creature whose likeness occurs over and over in desert pottery and in the pages of this book. There's no confusion about the figurine in the back, however. It's a pure horned toad, definitely a pot, and the only thing unclear about it is what it was used for. Your guess is as good as ours.

Sedentary Days

Archaeologists call the Hohokam years between 950 and 1150 the Sedentary period. The name suggests a time when the Hohokam sat around and did little.

In this book, we're letting the art tell as much of the story as we can, and during this period, most of the art tells an unexciting story. The pottery stepped backwards from its high point during Colonial days. Now it was a little cruder and thicker, the decoration was a little coarser and it had a bit more of a mass-produced feel.

There are modern parallels. In comfortable times, art gets popularized, and it appears that's what happened with the Hohokam. Snaketown's population grew, and the outlying, Hohokam-like cultures throughout southern Arizona flourished.

Canal technology was burgeoning. In the 1991 title, *The Hohokam, Ancient People of the Desert,* David E. Doyel reported that the Hohokam dug more than 500 miles of main canals with hundreds of additional smaller ditches in the Salt River valley alone. Throw in the canals in the Gila Valley and the number is probably closer to a thousand miles, all to irrigate tens of thousands of acres.

The Hohokam farm workers didn't all live in Snaketown, of course. There were important settlements all along the Salt and the Gila. A map drawn by canal expert Jerry Howard appears alongside Doyel's article, and it shows two different canal systems along the Salt that served the Hohokam communities of Las Colinas, Casa Chica, La Ciudad, Pueblo Grande, Pueblo Viejo, Las Conopas, Los Hornos, Plaza Tempe, Las Acequias, Los Guanocos and the major settlements of Casa Buena and Los Muertos. If those names aren't as familiar as they should be, there's a reason. All but part of Pueblo Grande, which is connected to a museum, were paved over as Phoenix grew.

The sites along the Gila, however, disappeared under modern irrigated agriculture. The later Classic period ruin, Casa Grande, is a national monument, but much of the adjacent Grewe Site, a settlement whose population and affluence rivaled Snaketown's, is now a cotton field.

A 1930 excavation at Grewe revealed the kind of treasures that occur only in sophisticated societies. They found elaborately carved, finely detailed shell jewelry and bone hairpins with bird and snake motifs. Perhaps even more noteworthy, they found mirrors made of sandstone, encrusted with reflective pyrite on the face and decorated on the reverse with Mesoamerican-looking parrots and deities rendered in inlaid pigment—a technique that archaeologists call pseudo-cloisonne which shows up on upscale artifacts from central Mexico.

The same pattern of increased affluence and comfort seems to appear generally across the whole Hohokam extended empire during Sedentary times. Current excavations at Grewe have turned up not one but three ball courts. One gets the feeling, in much the same way every small town in today's America has its ballpark, every Hohokam settlement of any size had its ball court. They came in two sizes, 80 x 50 feet and 200 x 100 feet, surrounded by raised berm embankments that could accomodate a few hundred spectators. Archaeologists have turned up more than two hundred of them in more than 160 sites.

There's been a lot of debate over the religious versus the recreational significance of the ball courts, but whatever games or rituals they held, they prove one thing: During Sedentary times, the Hohokam had built a society affluent enough to afford time for spectacle and games for its field-workers.

By 1150, however, the Sedentary period was over. Great accomplishments lay ahead, accompanied by even greater changes.

Sedentary times, Tucson-style. The shapes are different, but the idea is the same. The 8½" diameter bowl is Rincon Red-on-brown, ca. 1050, the 5½" jar is Rillito Red-on-brown, ca. 1000.

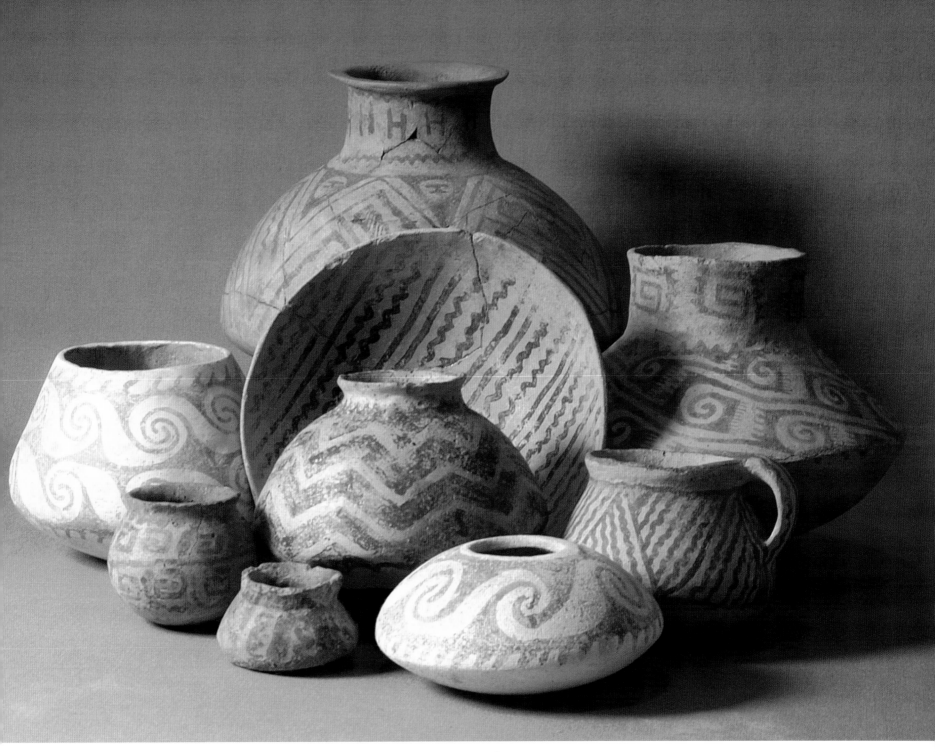

BACK ROW: *Sacaton Red-on-buff olla, 9½" diameter, ca. 1050.*
MIDDLE ROW: *Sacaton Red-on-buff jar, 5½" diameter, ca. 1050; Sacaton Red-on-buff dish, 8" diameter, ca. 1050; Sacaton Red-on-buff jar, 6¼" diameter, ca. 1050; Sacaton* *Red-on-buff olla, 8¾" diameter, ca. 1050.*
FRONT ROW: *Sacaton Red-on-buff jar, 3" diameter, ca. 1050; Sacaton Red-on-buff jar, 2¼" diameter, ca. 1050; Sacaton Red-on-buff seed jar, 6" diameter, ca. 1050; Sacaton Red-on-Buff pitcher, 4¾" diameter, ca. 1050.*

Six of these pieces have one characteristic generally associated with Sedentary times. The Gila shoulder, a sharp break between the upper body and a shallow underbody, did show up earlier (see page 17) and the Salado and Sinagua used it in later years. These pieces show connections with the past and the future. The wiggly lines on the pitcher and the dish look back to earlier times, the breaking-wave swirls are pure Sacaton, and the geometric "textile" pattern on the big olla foreshadows pottery types to come.

The Salado: Interlopers

For five hundred years or so, the Hohokam had produced red on buff pottery, elaborately decorated, carefully fired and almost never discolored with fire marks.

Then, sometime around 1100, they started making something entirely different. The new pots were red, almost never had painted decoration, displayed shiny black interiors and often had fire smudges on the exterior.

The pots weren't even made the same way. Where the Hohokam had always shaped their jars and bowls from large coils and paddled them into smoothness, the new pots were made from tiny coils wrapped around and around. It was a style called corrugated ware, and it was a technique popular with the Anasazi to the north and the Mogollon to the east.

It's hard to dismiss a change this dramatic as a simple shift in fashion. Next door, there was a group of people called the Salado who'd been making coiled red pottery from about 900 on. Their name came from the *Rio Salado*, the Spanish name for the Salt River.

Suddenly, downstream in Hohokam country, fewer and fewer people were making red on buff, and more and more of them were making the new redware.

The easiest explanation is that the Salado moved into the neighborhood. As we've said before, the easy answers aren't always the correct ones, and archaeologists have been arguing about this for seventy years.

Akimel O'odham oral history offers a corroboration of sorts. It suggests that the followers of Elder Brother came down from the mountains in the east and vanquished the Hohokam leader, the arrogant Sivany, destroying his villages along the Salt and the Gila.

Back in the 1940s, Emil Haury and the archaeologists of the Gila Pueblo Archaeological Foundation looked long and hard at the period after 1100, not just at the pottery but at the fact

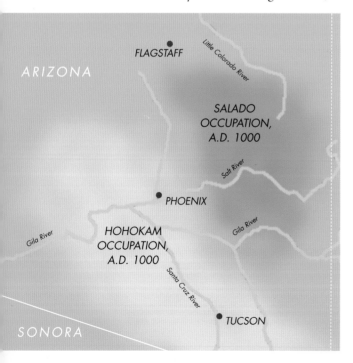

How the Salado saw it: two Salado Red bird effigies, both ca. 1350. The one in the front is 6½" long.

that all at once some of the Hohokam were burying rather than cremating their dead and building aboveground structures instead of pithouses. They developed a migration theory that suggested the Salado moved in and lived peacefully alongside the Hohokam in the same communities.

The pottery agrees, but quite a few archaeologists saw it otherwise. For much of the twentieth century, correct thinking said the Salado didn't exist at all but were simply another breed of Hohokam.

However, Elder Brother is staging a comeback. In 2000, Stephanie Whittlesey and Robert Heckman wrote, "Today the pendulum of archaeological thinking has begun to swing again, coming full circle back to the original Gila Pueblo model of migration."

There's evidence of coexistence, or at least of sequential occupation of sites. Claire Demaray, working the Antler Site in the heart of Salado country in the Tonto Forest, excavated rooms with walls of Salado-style masonry intersecting with walls of Mogollon-style masonry, with evidence of Hohokam habitation in the same room group.

If the pottery is telling the truth, cross-culturation was under way, and it was spreading rapidly.

FLAGSTAFF

Little Colorado River

ARIZONA

SALADO OCCUPATION, A.D. 1000

Salt River

PHOENIX

Gila River

HOHOKAM OCCUPATION, A.D. 1000

Gila River

Santa Cruz River

TUCSON

SONORA

BACK ROW: *Salado Red jar, 6⅜" diameter, ca. 1075; Salado Red jar, 6⅛" diameter, ca. 1075.*
MIDDLE ROW: *Salt Red bowl, 9½" diameter, ca. 1200; Gila Red jar, 6¼" diameter, ca. 1200; Salt Red jar, 6½" long, ca. 1200.*
FRONT ROW: *Salado Red horned toad effigy canteen, 6½" diameter, ca. 1100; Gila Red bowl, 6½" diameter, ca. 1275;*

Salado Red jar, 4¾" diameter, ca. 1075.

Here, the pots have a red slip (a thin coat of fine clay applied before polishing and firing). The deep red color came from the Salado, but these pots show culture mixture in all forms. The bowl at middle left and the submarine-shaped jar at right are Hohokam, but in the new Salado style with a shiny black carbon-smudged interior. The two jars at the top and the one at front right are pure Salado, with smudged interiors and corrugated construction. The Salado burnished the corrugation so it nearly disappeared on the vessel's exterior and polished it smooth on the interior. The jar in the middle is Hohokam—no smudging on the inside and a Mesoamerican melon (or, more likely, squash) shape that looks south more than it looks to the Salado's mountains. The bowl at lower center has the smudged interior and fire clouding but has a Gila shoulder that shows its Hohokam origin. The canteen is Salado obliterated corrugated, but it's a very Hohokam horned toad effigy—confirmed when we saw an almost identical one standing on four legs, ready to hop away.

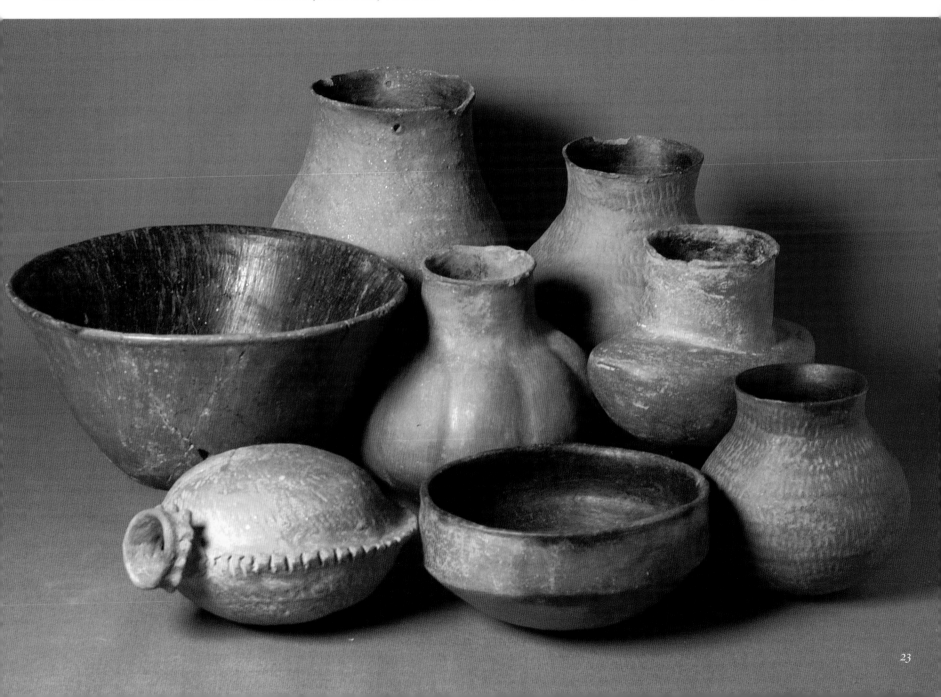

Bounceback

Cultural migration wasn't on a one-way street. A few hundred years earlier, the Hohokam had been in their colonial period, and they'd settled sites up in Salado country. Archaeologists turned up a quantity of Gila Butte Red-on-buff, made around 800 in the piney woods just north of Pleasant Valley, a mountain meadow in the heart of the Tonto wilderness.

But those intrusions didn't influence the Salado the way events after 1150 did. Now, a new pottery type appeared: San Carlos Red-on-brown. It used to be called a late Hohokam style, but it increasingly appears to be a pure Salado pottery made in frank imitation of the Hohokam. Even the name San Carlos places it out of Hohokam country. The San Carlos Apache reservation is northeast of Phoenix, up in the mountains of the Tonto forest, where the Salt River runs through what locals call the Little Grand Canyon.

At first glance, San Carlos Red-on-brown looks like late red on buff Hohokam pottery, but it has two big differences. Most pieces, like the ones shown here, have the polished, deep black smudged interiors that the Salado loved but were never popular with the Hohokam. Even more telling, San Carlos pieces have a suede-smooth surface totally unlike the orange-peel texture of standard Hohokam ware.

Although the pots look Hohokam, they were made by people who lived very differently from the Hohokam. They didn't live in desert pithouses, they lived in forests and green meadows in pueblo-style stone apartments that looked much more like Anasazi structures to the north. They saw snow every winter, while the flatland Hohokam might not see it in a lifetime.

By 1300, the Tonto Forest was increasingly cosmopolitan, even more so than the Hohokam lands in the low desert. You could find pottery imports from all over—White Mountain redware from above the Mogollon Rim, Anasazi Black-on-white from the Four Corners where Arizona, New Mexico, Utah and Colorado meet, and even, as the effigies on page 23 suggest, input from the burgeoning culture centered at Paquimé in northern Chihuahua.

In a multicultural setting like the Tonto, you'd expect to find some Hohokam pottery as well. However, the consistency and quantity of San Carlos Red-on-brown makes an emphatic argument for its acceptance as a homegrown Salado ware. Whether or not there's any doubt about a Salado incursion into Hohokam country, it's pretty clear that it worked the other way. Hohokam ideas made it far enough up the hill to influence Salado thinking.

Nothing like the Hohokam: Besh-Ba-Gowah, a Salado ruin 90 miles up the hill from Phoenix in Globe, Arizona.

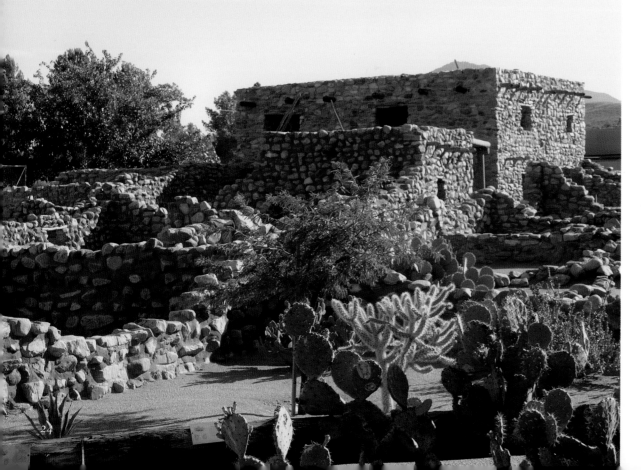

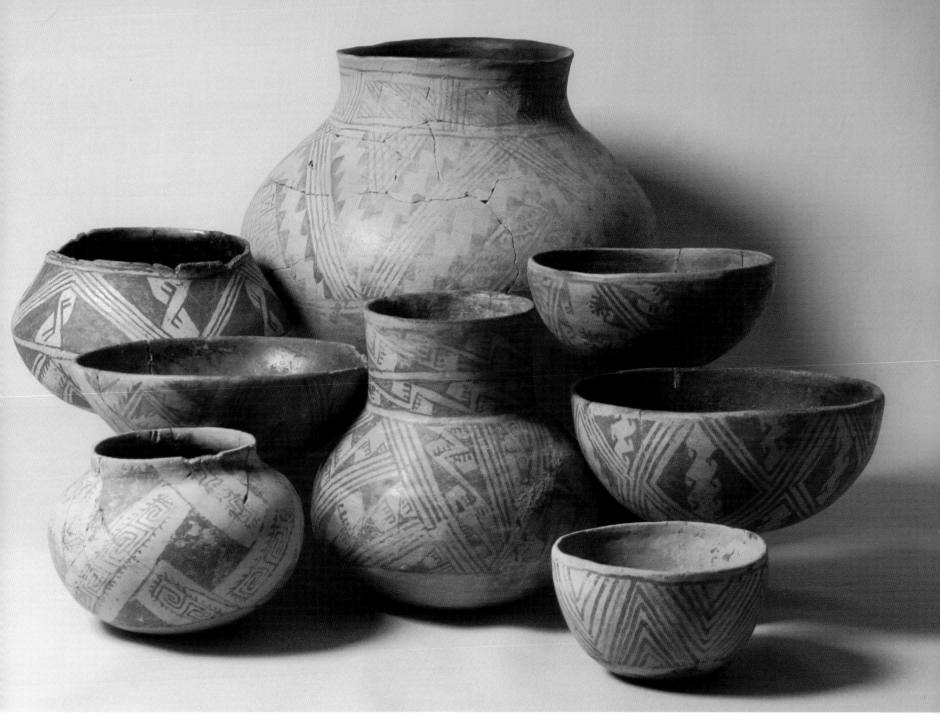

BACK ROW: *San Carlos Red-on-brown jar, 7" diameter, ca. 1350; San Carlos Red-on-brown bowl, 7¼" diameter, ca. 1350; San Carlos Red-on-brown olla, 11¾" diameter, ca. 1325; San Carlos Red-on-brown bowl, 6¼" diameter, ca. 1350.*
FRONT ROW: *San Carlos Red-on-brown jar, 5¼" diameter, ca. 1300; San Carlos Red-*

on-brown jar, 6½" diameter, ca. 1300; San Carlos Red-on-brown bowl, 4" diameter, ca. 1350; San Carlos Red-on-brown bowl, 7⅛" diameter, ca. 1350.

On San Carlos pottery, the designs remind you of strips of decorated fabric laid out in a basketweave pattern—what archaeologists

call a textile design. All these pieces show elements of the idea, but the small jar at bottom left explains the idea completely.

All but the little bowl in front show a remarkably strict adherence to conventions of shape and design in light of the fact that they came from small woodland communities scattered over a fairly wide

area. Collections like this illustrate the power of cultural pressure. Seven pots from seven different sources could never have looked so much alike if there weren't an agreed-upon "right" way of making them, handed down from mother to daughter and, most likely through intermarriage, from community to community.

New Beauty

Artistically, at least, the Salado were a restless sort. They weren't content to keep churning out their old-fashioned redware and decorated pots that copied the Hohokam. A whole new idea started up in the mountains to the north, and the Salado not only jumped on the bandwagon, they ran up front and led the parade.

Somewhere late in the twelfth century, the Mogollon in the Arizona White Mountains, perhaps 100 miles north of Salado country, got bored with their black-decorated redware and started putting white paint on the outside of their bowls. Now, instead of single-color decoration, we had polychromes.

St. Johns and Wingate Polychromes, the earliest styles, kept to that simple plan, and although their designs occasionally achieved wonderful intricacy, those early experimenters never had the courage to put the colors side by side.

By 1200, the Salado had picked up on the idea. The first Salado pieces put a different spin on it. They painted the whole inside of the bowl white, then put on a black design (often swiped from the Mogollon and Anasazi pottery that inspired their efforts) and left the outside of the bowl red. The bowl with the square in the middle at right center of the big picture on the next page is a textbook example of an early Salado polychrome. If it didn't have a red exterior, it could pass for any one of several Anasazi black on white pottery types.

The Salado weren't content with stolen designs, however, and they soon branched out. The bowl on the far left has a free-spirited asymmetrical design, and the smaller bowl in front of it has sophisticated, carefully conceived geometric swirls that suggest parrots.

The innovations kept coming. By 1250, they were applying their ideas to jars, and by 1350, they made their big conceptual breakthrough. They started using all the colors in the design.

The bowl in the middle of the front row shows the new idea beginning to take hold. The inside of the bowl stays properly black on white, but now the black and white creep over the edge and establish a coexistence with the red exterior. The experiments didn't stay tentative for long. By 1300, Salado polychromes hit full stride.

The big bowl at top right and the shallow bowl at front right are relatively restrained examples of the final Salado style, Tonto Polychrome. The jar at the left middle is more exuberant, and the small pitcher down in front goes even further. Its color play is so scrambled and intricate it looks more like it came from Peru instead of just up the hill from the Arizona desert.

Late Salado pottery was so emphatic in its use of color that more than one purist has dismissed it out of hand as garish and offensive to refined tastes.

It didn't offend the citizens of the desert at the time, however. Salado polychromes were some of the most widely traded of all prehistoric pottery types. It wouldn't be too much of a stretch to characterize them as highly marketable art.

It's no accident that pottery design became more and more dramatic as the years went by. If, in your little town, you were short of parrot feathers but you could make nicer pottery than the town across the river, you could work out a deal. Trade pottery occurred all over the Southwest. In New Mexico, one-way pottery-for-food trade still existed between Zia pueblo and its land-rich neighbors, Jemez and Santa Ana pueblos, throughout the nineteenth century.

In the desert economy, the Hohokam, with their canals, ran the agribusiness side. The Salado, with equal enterprise, grabbed the art market.

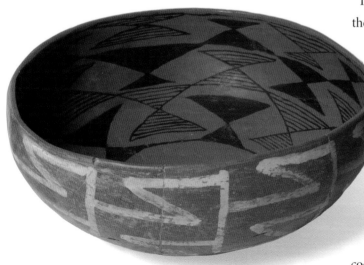

How we think this idea began: St. Johns Polychrome, from the Arizona/New Mexico border, near Zuni. 12" diameter, ca. 1200.

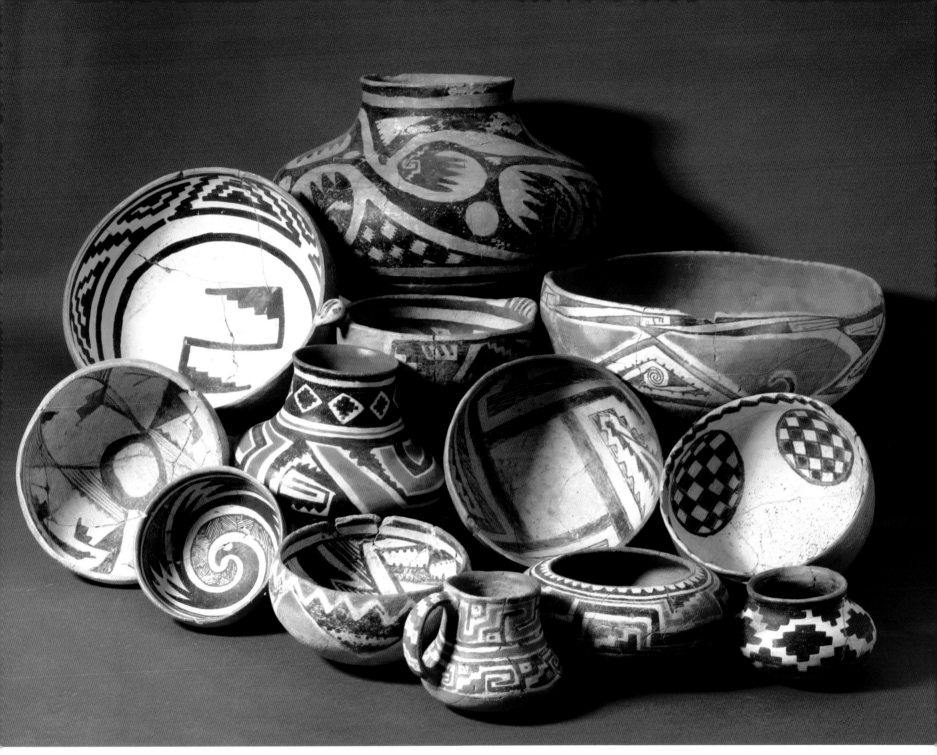

BACK ROW: *Gila Polychrome bowl, 8"
diameter, ca. 1350; Gila Polychrome olla,
14½" diameter, ca. 1325; Gila/Tonto
Polychrome bird effigy bowl, 7½" diameter,
ca. 1350; Tonto Polychrome bowl, 13½"
diameter, ca. 1400.*

MIDDLE ROW: *Pinto Polychrome bowl,
7¾" diameter, ca. 1275; Tonto Polychrome
jar, 6¼" high, ca. 1400; Pinto Polychrome
bowl, 8" diameter, ca. 1250; Pinto Polychrome
bowl, 7½" diameter, ca. 1275.*
FRONT ROW: *Pinto Polychrome bowl,*

*5½" diameter, ca. 1300; Gila/Tonto
Polychrome bowl, 7" diameter, ca. 1350;
Tonto Polychrome pitcher, 4¾" diameter,
ca. 1425; Tonto Polychrome bowl, 7½"
diameter, ca. 1400; Gila Polychrome jar,
5" diameter, ca. 1350.*

Here, you're looking at the 150-year history
of Salado polychromes in all its types and all
its splendor. Enjoy the sight, because from all
indications, that's exactly what residents
from all over the desert did back when they
were made.

27

The Sinagua: Contact up North

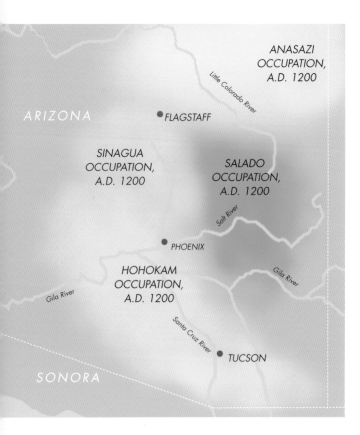

By 1300, cultural lines were blurring over the desert and the adjacent hills. The people due north of the Hohokam, the Sinagua, seemed to have even more far-flung trade connections than their eastern neighbors, the Salado.

Sinagua architecture, burial customs and settlement patterns ally them closely with the cliff-dwelling Anasazi, who lived up near the Utah border. Their pottery, however, bore almost no resemblance to Anasazi pottery. The Anasazi made black on white pots and redware decorated with fussy black and polychrome geometric designs, while the Sinagua made redware much closer to Salado ware but with some Hohokam elements.

Sinagua pottery doesn't attract a lot of immediate attention. At first glance, it seems like undecorated utilitarian ware, but the contributions and innovations are there. Three elements stand out, and whether or not the Sinagua invented them, they impressed others.

The first thing you notice when you examine Sinagua ware is the high polish. The Mogollon of southern New Mexico had made shiny pots for seven hundred years or so, but the Sinagua brought the idea into the Hohokam world.

On a small percentage of pieces, the Sinagua picked up on the idea of adding white linear decoration. Whether they did it first or the Salado did it first, it was just about the only painted decoration the Sinagua ever put on their pottery, and the idea shows up on late period Hohokam ware as well.

The Hohokam also adopted the third Sinagua pottery characteristic, intentional fire clouding. Placing carefully selected substances against a pot's surface during firing creates chemical reactions that produce striking multicolored designs, as on the big Sinagua bowl opposite. The Hohokam used the technique on large late-period storage jars, sometimes controlling it so well that they created carefully designed symmetrical patterns.

Sinagua pottery actually has a clear place in helping us understand the history of the desert. It shows that, by 1300, everybody was talking to everybody else.

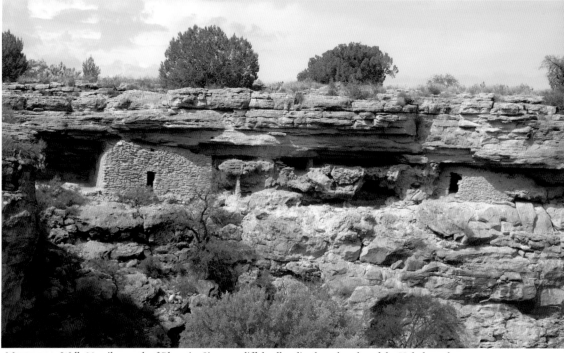

Montezuma Well, 90 miles north of Phoenix. Sinagua cliff dwellers lived on the edge of the Hohokam desert.

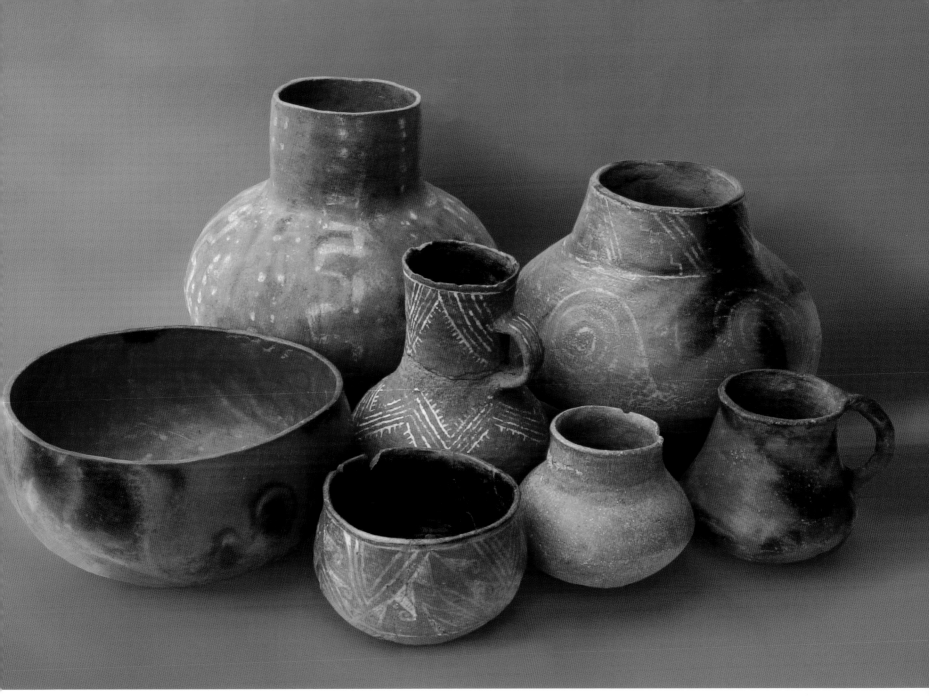

BACK ROW: *Gila or Tuzigoot White-on-red jar, 11¼" diameter, ca. 1400; Salado White-on-red pitcher, 6½" diameter, ca. 1350; Tuzigoot White-on-red jar, 11¼" diameter, ca. 1400.*
FRONT ROW: *Tuzigoot Red bowl 11" diameter, ca. 1300; Tuzigoot Red jar, 5¾" diameter, ca. 1200; Salt White-on-red bowl, 6" diameter, ca. 1350; Tuzigoot Red pitcher, 6" diameter, ca. 1300.*

These seven pieces indicate how Sinagua pottery confounds anyone who wants clear ethnic pigeonholes for prehistoric Southwestern artifacts. The big jar on the right, the big bowl and the smaller pitcher have all the Sinagua characteristics: decorative fire clouds, high polish and the right color.

The two big jars in the back row, the one on the right clearly Sinagua and the other

either Sinagua or Hohokam, add what could be a Sinagua innovation, white decoration. The small jar at front right center is an earlier ancestor, not as highly polished. It has a Gila shoulder, which points south to the Hohokam, but the Sinagua used them as well. The big jar at right and the small pitcher have one, too.

The bowl second from left in front has the Sinagua color, the Sinagua polish, the

Sinagua fire clouds and white decoration, but it also has a Salado-type smudged interior and the white decoration owes more to a Hohokam/San Carlos inspiration than to anything the Sinagua ever did. And the big pitcher is pure Salado—smudged interior, obliterated corrugated surface, purple-red color—but with Sinagua white line decoration. To us, all this shows three different cultures on one wavelength.

The Mogollon:
Neighbors a Few Miles East

From our twenty-first-century vantage point, prehistory gets fuzzy as we leave Tucson and move east. We know that as we cross the New Mexico border and approach Deming, we're clearly out of Hohokam country and into the land of the Mogollon and the Mimbres.

We also know that to get there, we've passed through lands that archaeologists assign to other cultures. As we head from Phoenix to Deming on I-10, we pass through the Tucson Culture and the Dragoon Culture, skirt the Trincheras and the Babocomari Cultures and cross the San Simon Culture before we're sure we've reached Mogollon territory.

Those minor cultures all share one common characteristic, red on buff pottery, some of which looks a lot like Hohokam pottery and some of which looks a lot like the red on brown that the Mogollon made, which also looks a lot like Hohokam pottery.

That's why the pot to the right is so confusing.

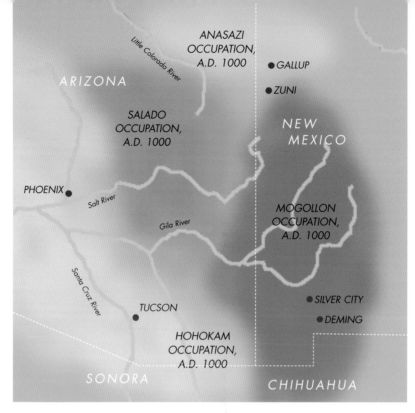

The Mogollon started making their brownware pots around 400 A.D. (the rough little pot on page 11 is an example), and they started decorating with incised patterns soon after. By 500, they polished and decorated with red paint.

By 900, they were masters of plainware, and by 1000, they traded north and west. It didn't take long for those evidences of trade to show up in their pottery.

Their utility ware was finely corrugated, something they either invented or swiped from the Anasazi. Early on, their painted ware had red linear decoration, and later on, red decoration on a whitish slip. Each development occurred at about the same time it showed up on Hohokam ware. And, just to confuse us more, they slipped some of their wares red, like the Salado.

Beyond the obvious fact that it was culturally diverse, we know very little about the prehistory of southeastern Arizona. There hasn't been much archaeological study or much written about it compared to the wealth of material on the Phoenix and Tucson basins and on the Mogollon areas of New Mexico.

In this area of the desert, the answers don't come easy. Even the pots argue about who made what.

It's incised on the outside, like the earliest Hohokam red on buff pottery. It's slipped red on the upper portion of the exterior, like Salado pottery. Yet it's fine-textured brown clay, like Mogollon pottery. It could be from the Casas Grandes culture, south of Deming in Chihuahua. It could be from the west coast of Mexico.

It could be anywhere from six hundred to thirteen hundred years old.

Various experts have given us all these suggestions, and there's very little agreement between them.

We do know this much.

The mystery pot.
So far, nobody has been able to pin down
exactly who made it. Unknown red on brown type,
7" diameter, ca. 700–1400.

Map labels:
ARIZONA
NEW MEXICO
SONORA
CHIHUAHUA
Little Colorado River
ANASAZI OCCUPATION, A.D. 1000
GALLUP
ZUNI
SALADO OCCUPATION, A.D. 1000
PHOENIX
Salt River
Gila River
MOGOLLON OCCUPATION, A.D. 1000
Santa Cruz River
SILVER CITY
DEMING
TUCSON
HOHOKAM OCCUPATION, A.D. 1000

BACK ROW: *Tularosa Patterned Corrugated bowl, 7" diameter, ca. 1000; McDonald Corrugated bowl, 10" diameter, ca. 1100; Reserve Corrugated Neck Banded Jar, 5½" diameter, ca. 950.*

MIDDLE ROW: *Unknown red on brown type, 7" diameter, ca. 1275; Tularosa Corrugated jar, 6½" diameter, ca. 1000; McDonald Corrugated bowl, 7" diameter, ca. 1100.*

FRONT ROW: *San Francisco Red Neck-Banded jar, 4½" diameter, ca. 700; Reserve Plain bowl, Starkweather variety, 6" diameter, ca. 1100; Three Circle Neck-Banded jar, 6" diameter, ca. 600.*

Here, you see it in all its confusion. The pot at front right shows how the Mogollon perfected high polish early in the game.

Mixed in with all this brownware, there's a red-slipped version of it at front left. Between the two, there's what looks like a standard brown Mogollon bowl with a smudged interior—except that it has a matte black on polished black design, the technique that made San Ildefonso potter Maria Martinez world-famous when she reinvented it eight hundred years later. At the top and at right center, standard corrugated bowls feature white decoration like the Sinagua and Salado used. And at left front, a truly confounding pot from Salado country with a strange primitive design. It seems like an early Mogollon Red on brown, but it has a pure Salado red-slipped obliterated corrugated exterior. As we said earlier, it's up to you to connect the dots.

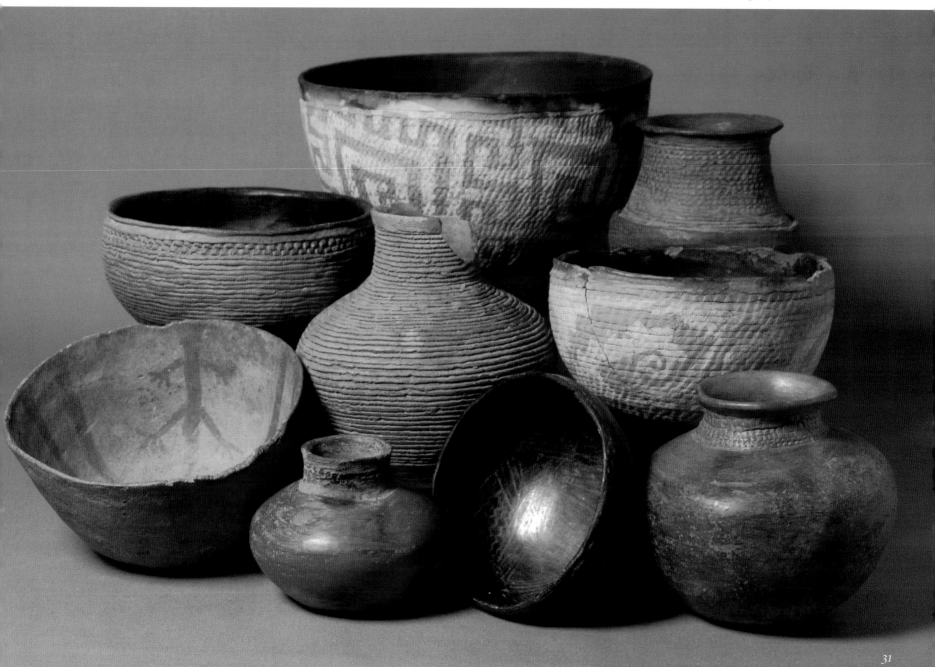

31

Moving Toward Mimbres

A new culture took shape in the south end of Mogollon country. In its formative years, it had contact with the Hohokam, or at least with the red on buff people who lived to the west, and eventually, with the Anasazi to the north who ultimately influenced their art.

In the years between 850 and 1150, the Mimbres emerged, shaped their culture and coalesced into a strange and insular society unlike any other in the prehistoric Southwest.

During those years, the Mimbres and the rest of the Mogollon converted to a puebloan existence, unlike the Hohokam and their allied cultures. Where the early Hohokam built their reed-and-mud family compounds a good distance away from their neighbors, the puebloans built stone complexes of adjoining rooms—apartment living as opposed to life in the suburbs, one-acre lot minimum.

Because the Mogollon lived there for a thousand years, Wind Mountain in southern New Mexico gave us a nearly seamless picture

of the transition. Charles Di Peso excavated it in the 1970s and, after his death in 1982, Anne Woosley and Allan McIntyre compiled his data in a massive volume, *Mimbres Mogollon Archeology.*

The older homes at Wind Mountain, dating from 200 to about 850, are pithouses. The earliest were round, the later ones were square, and as the years passed, Wind Mountain began to look more like the cohesive communities up in Anasazi country rather than the loose groupings of homes typical of the desert.

The Mimbres stage at Wind Mountain began within a few years of 1000, but it didn't happen all at once. The changes show up in the pottery.

Around 800, the Mogollon took an Anasazi idea and began putting a white slip on their pots. However, the pots they made that way, didn't look Anasazi. The designs were more apt to look like what their red on buff neighbors did.

Gradually, the designs took on their own personality. From 800 on, excavations turned up enough

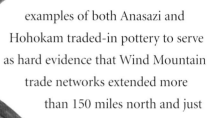

New influences: an untyped "Hohokam" jar from southeast Arizona with Anasazi design elements , 6½" tall, ca. 1000.

examples of both Anasazi and Hohokam traded-in pottery to serve as hard evidence that Wind Mountain trade networks extended more than 150 miles north and just as far west. Bearing this in mind, it's not surprising that Mogollon/Mimbres pottery took on borrowed characteristics. To us, in our world of cars and airplanes, this kind of mobility in a population that didn't even have horses seems remarkable.

To them, mobility was a matter of course. They ran to a degree we never even consider. Even today, Tarahumara Indians (thought to be one of the last Mogollon cultures) in Copper Canyon, 300 miles south of the Arizona border, will run 100 miles across rough terrain in 16 hours. Regular contact with distant groups becomes easier to understand once you think of a hundred miles away as one day away.

There was another more vital and less obvious reason for culture contact. When we talked to historian and educator José Rivera, Apache-Nahuatl himself, he pointed out something that we'd never considered. Among North American Indian tribes, there's an almost universal taboo against incest. If you don't have a car or a horse, and if you're living in a community that's made up of a handful of families who've always lived there, how do you find a mate who isn't a relative?

Answer. You run to the next town.

Early idea exchange: a 7¼" diameter Mogollon Three Circle Red-on-white bowl and a 6" diameter Hohokam Sacaton Red-on-buff dish, both ca. 900.

IN BACK: *Mogollon Red-on-Brown jar, 15½" diameter, ca. 750.*

FRONT ROW: *Mimbres Boldface bowl, 8¾" diameter, ca. 950; Mimbres Boldface bowl, 7½" diameter, ca. 925; Mogollon Red-on-Brown jar, 4¼" diameter, ca. 700; Mimbres*

Transitional bowl, 7" diameter, ca. 975.

Three development stages, all with a Hohokam spin. The earliest Mogollon decorated ware was red on polished brown, like the little jar at right front and the big piece in the back,

probably as fine an example as exists. Around 800, they put a white slip over the brown and added decoration. The Three Circle Red-on-white bowl on the opposite page is an early effort. By 950, the designs were more sophisticated, and the people who

classify pottery started calling them Mimbres. Everything quickly became more refined, the slips turned whiter and the designs turned blacker. By the time they made the bowl on the right, the transition was almost complete. The Classic years were right ahead.

Classic Mimbres

By 1000, the Mimbres Valley of southwestern New Mexico had its own distinct culture, the only culture we can think of in our desert, either prehistoric or modern, that's widely known for its art and little else.

The Mimbres made fabulous pottery. When miners and ranchers first stumbled on it in the late nineteenth century, they began a century-long quest to dig up every scrap of it they could find.

It was the thinnest, finest, most elegant painted ware in all of Southwestern prehistory, and the clear linear descendant of the pottery on the previous page.

One big difference separated it from all other precontact

Geometric Mimbres, early to late Classic period, circa 1050–1100, including a rare polychrome at lower right. The jar at top is 10¼" high, the largest bowl is 10" in diameter, and the smallest is 3¼".

pottery. The Hohokam had played around with the idea of pottery with painted images of animal and human forms for a few hundred years, and the Anasazi had done some tentative experimentation. But this was the only prehistoric pottery that celebrated, or even emphasized, life forms.

The celebration wasn't random and free. The Mimbres conventions of figurative portrayal were realized so completely that, in the 1930s, the Santa Fe railroad created dishware for its dining cars that featured nine-hundred-year-old Mimbres designs, and nobody looked at it and said, "What's that?"

It wasn't just the figurative designs that set Mimbres pottery apart. In an area with a basic red on brown pottery tradition, they learned to make stark white pottery with pure black decoration, and they learned to paint their decoration more accurately and with finer lines than anyone in their world had ever seen before.

Mimbres pottery also has a dark side, and it attracts almost as much attention as the obvious appeal of its designs. The Mimbres buried a significant amount of pottery with its owners, and as part of the burial ritual, they laid a bowl over the face of the departed and punched a hole in the bottom, "killing" the pot, supposedly to allow the spirit to escape.

For more than a hundred years, collectors have found this combination of obvious beauty and a mystical, ghostly aura irresistible. It's also been irresistible to anthropologists, art historians and popular writers. Libraries are filled with hundreds of pages of expert and amateur speculation on what made these people tick.

The standard answer is that the Mimbres raised pottery to a profoundly sacred level, which explains why their pottery was almost never traded outside their own settlements.

Another answer was first suggested to us by Cynthia Bettison of the Western New Mexico University Museum in Silver City, home of one of the great Mimbres collections. If, instead of being simply antisocial, the Mimbres were actually outcasts, their insularity makes even more sense.

In an earlier book, we floated an idea that may not be correct, but at least hasn't yet been challenged. The very nature of Mimbres figurative decoration could have been a signal flag to the rest of the Southwest that these were people to be avoided. The vast majority of decorated pottery for miles around used designs that were conventional and polite, usually geometric and almost oppressively traditional. You made pots the way your grandmother did, and if you experimented, you ran the risk of getting into trouble.

However, there were these strange people

clustered in a valley down in southwest New Mexico who put drawings on their pots of things that shouldn't be drawn. They didn't just draw fishes and birds, they drew birds killing fishes, people making love and people killing other people as well. In short, their art reveled in what might have seemed shocking, even pornographic to their neighbors.

It's easy to find parallels in our own society. A small group, physical isolation, radical art, and presto!, a place where nice people don't go.

These Mimbres Classic Black-on-white bowls were all made circa 1050, including the ones that look red. Black mineral paint can turn red depending on how it's fired.
BACK ROW: *Dancing couple, 9" diameter; horned devil-creature, 9½" diameter;*

angry cat, 10¼" diameter.
MIDDLE ROW: *Flying bird, 7¾" diameter; birds and flower, 9" diameter; baby, 9" diameter; bighorn sheep, 9½" diameter; frog, 9" diameter.*
FRONT ROW: *Man with detached arm,*

6¾" diameter; fish, 7" diameter; rabbit, 8¼" diameter; mystery creature, 6¾" diameter; turkey, 8¼" diameter.

This is the Mimbres pottery of legend, with its elegant geometry, crisp black and white

painting and graceful shaping. And with those spooky kill holes and, at least at top and bottom left, hints of strange behavior. The designs speak for themselves, explaining clearly why artists have copied them over and over for a hundred years.

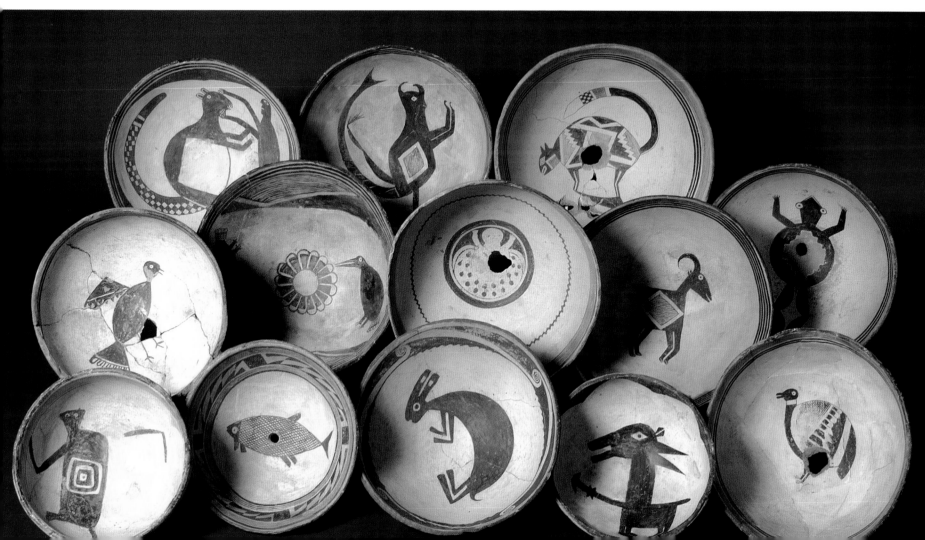

The Mimbres Evaporate

By 1150, the Mimbres had left the building.

Mimbres sites were abandoned, and nobody made the pottery anymore. From where we sit today, it seems like they were all whisked off the planet by aliens.

They were the forerunners of what was to become a recurring phenomena in the Southwest: disappearance. Writers have milked this for years, pondering the fate of the Anasazi, the Hohokam and just about everyone else.

We propose a simpler answer. They moved.

If we're correct in our guess that the Mimbres were social outcasts and if our guess about one of the reasons for migration holds up, it wasn't all that easy being a Mimbres. If you went to another village looking for a mate and you said, "Oh, by the way, I'm Mimbres," there's a good chance you left that town in a hurry.

If, however, you kept your mouth shut and took on the ways of your new village, you did just fine. And, if you knew a few tricks about pottery-making that improved the quality of the local art, so much the better.

We think that's what happened north and east of the Mimbres Valley. The picture on the next page shows two pottery types, Tularosa Black-on-white and Chupadero Black-on-white. They overlap Mimbres Classic in time,

to our most recent (and ever-changing) reference sources, Tularosa Black-on-white dates from 1150 to 1300 and Chupadero Black-on-white dates from 1200 to 1350.

The Tularosa mountains are about 90 miles due north of Silver City and the Mimbres Valley. The town of Chupadero is northeast of the valley, about the same distance away.

We feel there's a real connection to the Mimbres in these two pottery types, simply because they're more finely executed than any of the Anasazi black on white types from the areas north of the Tularosa arc.

The fact that they're black on white at all is significant.

Up in the White Mountains, where the bulk of the Mogollon lived by then, pottery fashions had changed. The Anasazi had made small amounts of black on red pottery for years, and around 1050, the White Mountain Mogollon started painting on redware.

The idea caught hold, and a few years later, the St. Johns Polychrome that we talked about a few pages back set a trend that almost everyone followed.

By 1200, just about all the pottery from northern and central Arizona was redware,

Like every other Southwestern culture, the Mogollon made miniatures. Both are Tularosa Black-on-white, ca 1225. The pitcher is 1⅜" high, the dog is 1⅞" long.

decorated in black and white, and showy graphics like the Salado potters favored became the order of the day.

But up at Tularosa and over at Chupadero, the Mogollon were ignoring the fashion of the day and making some of the best black on white pottery anybody other than the Mimbres ever made.

Like the Mimbres, they killed their pots with burial, but they no longer used the Mimbres hole-in-the-bottom kill. Now it was just a simple bite out of the rim, like the one on the far side of the rim on the little jar at the left of the picture on the next page.

To the Mogollon, it was just a matter of reverting to the usual practice. There was nothing out of the ordinary about killing a pot with a rim chip. They'd always done it that way everywhere except in the Mimbres Valley.

Until recently, there hasn't been a lot of academic support for the idea that the Mimbres might slowly have moved north and east and, instead of vanishing, had given up their edgy lifestyle and assimilated. Since the mid 1990s, however, thinking has been swinging in our direction.

To us, it makes sense. It matches what the

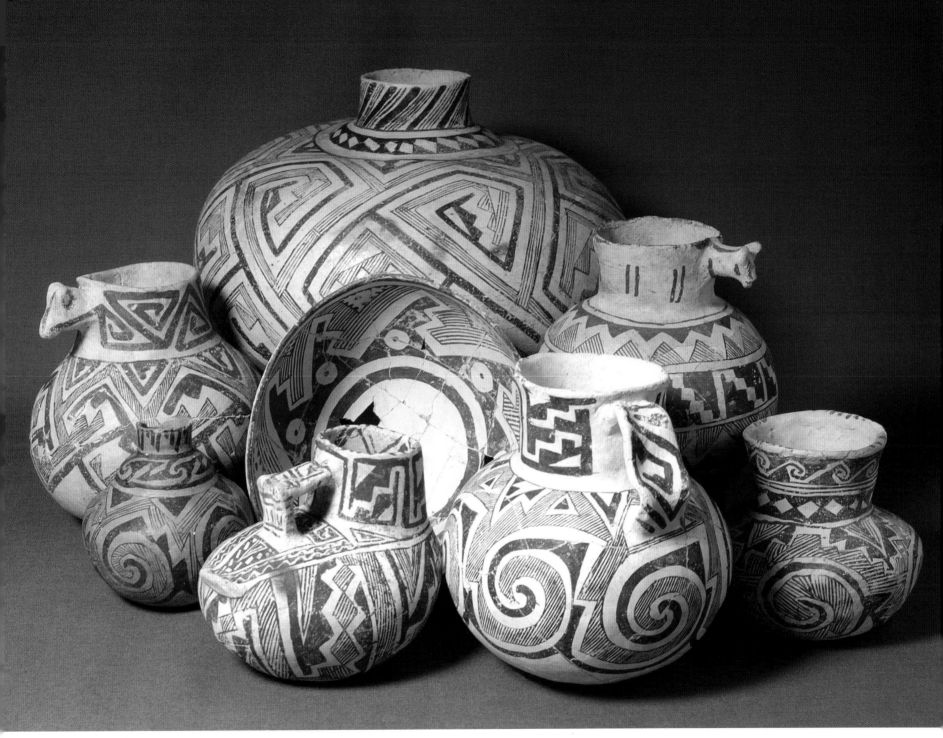

IN BACK: *Tularosa Black-on-white olla, 12"
diameter, ca. 1225.*
MIDDLE ROW: *Tularosa Black-on-white
pitcher with effigy handle, 7" diameter,
ca. 1225; Chupadero Black-on-white
bowl, 7¼" diameter, ca. 1275; Tularosa
Black-on-white pitcher with dog effigy*

handle, 6½" diameter, ca. 1225.
FRONT ROW: *Tularosa Black-on-white jar,
4¼" diameter, ca. 1225; Tularosa Black-
on-white duck effigy, 5¾" long, ca. 1225;
Tularosa Black-on-white pitcher, 7½"
diameter, ca. 1225; Tularosa Black-on-white
pitcher, 5½" diameter, ca. 1225.*

When you set aside the Mimbres birds and
rabbits and just think about the fine line
work and pure black on white execution,
there isn't much distance between Tularosa
and the Mimbres Valley.

The Tularosa Swirl, which you see on
three of the pieces in the front row, was one

of the most copied designs over the whole
Southwest. You see it on St. Johns and
Pinedale ware from the White Mountains of
Northern Arizona, and it persists right up to
the present on pottery from Acoma and
Laguna Pueblos, 40 miles north of the
Tularosa mountains.

Casas Grandes: Uncharted Viejo

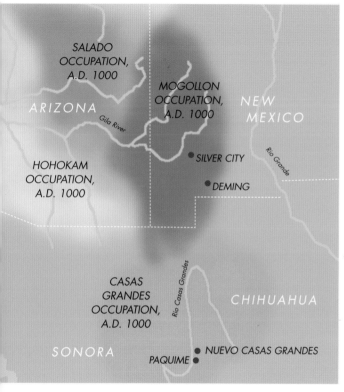

The last great culture of the prehistoric Southwest took shape south of the Mimbres Valley in the Chihuahuan desert.

This was Casas Grandes, the culture of Charles Di Peso's Paquimé, the hub of the Gran Chichimeca. It didn't start off like a great cultural force, however. When you add up all the archaeological evidence, it looks like they spent the years up to 1200 or so, and perhaps even later, as something of a backwoods society. That all changed, spectacularly, and the area around Paquimé eventually flourished.

But until the breakthrough years, the records are problematical. Up to 1000 and beyond, in what Di Peso called the Viejo period, the people who were to build the Casas Grandes at Paquimé lived a primitive pithouse life.

The art created by their sophisticated neighbors up north has received attention for years, but it's hard to find much attention paid to early Casas Grandes pottery anywhere but in Di Peso's eight volumes. Even so, the pots on these pages raise interesting questions.

The red on brown pot on the opposite page looks a whole lot like decorated pots made by the Tarahumara in the twentieth century. This, of course, proves nothing, but it does serve to remind you that the Casas Grandes people were Mogollon and that the Tarahumara of Copper Canyon are supposed to be the surviving remnants of the Mogollon culture.

The incised redware pots raise other questions. To us, they don't look much like any other pottery made in our area of the Southwest, but they do look a lot like the brownware made on the other side of Texas by the Mississippian cultures during the same time period. It's one more confusing cultural element.

On the other hand, the hooded effigy seems to be a pure Casas invention. The Hohokam made effigies, but theirs had arms and legs and fully rounded heads. The three on the opposite page are done the Casas way: a simple jar with half a head. These red ones seem a bit earlier on the evolutionary scale than the spectacular ones that came along later, like the owl on page 3.

Because the little man in front is also an extremely lightweight, thin-walled specimen (the walls of his body are a uniform ¹⁄₃₂" thick), he brings to mind a general question about the art of the Southwest.

Bill Abright, a career ceramicist and head of the ceramics department at College of Marin in Northern California, looked at a Mimbres bowl and mused, "Why did they make them so thin? You'd think they'd lose too many of them during firing." He answered his own question by saying, "because they could," based on the local clays. Then he added another reason, "and because the clay was so precious."

To us, that makes sense. Good clay is scarce, and, if you have to carry it back home in a weaving or basket you made yourself, perhaps for many miles, you don't waste it. Instead, you learn to make pottery that's so exquisitely thin that master potters marvel at it a thousand years later.

More unanswered questions.
This came from halfway between the Mimbres Valley and Casas Grandes, and we can't find a place for it in anybody's pottery evolutionary scheme.
Untyped white on tan jar, 6⅜" diameter, ca. 800.

BACK ROW: *Playas Red Incised jar, 5¼" diameter, ca. 1200; Madera Red badger hooded effigy, 6" diameter, ca. 1300; Playas Red Incised jar, 6¾" diameter, ca. 1200.*
MIDDLE ROW: *Playas Red Incised jar, 6" diameter, ca. 1200; Anchondo Red on brown jar, 6¼" diameter, ca. 750; Madera Red gourd hooded effigy, 5¾" diameter, ca. 1300.*

FRONT ROW: *Madera Red hooded effigy, 4¼" diameter, ca. 1300; Playas Red Incised jar, 5" diameter, ca. 1200.*

*In early Casas Grandes pottery, decoration took two paths. The first was red on brown, almost universal throughout the desert, as on the jar in the middle. Anchondo Red-on-*brown was the earliest Casas decorated type, and this example is textbook early decoration —broad lines and a quartered format. The second style of decoration was incising, as on the four Playas redware jars. The Mogollon and the Hohokam had done a bit of it in early days, but so did the Mississippian cultures, and, if these were brown or gray instead of red, they'd look a lot like pottery that came from quite a bit farther east.

The Casas culture also introduced the hooded effigy, and it came in many forms. Here, we have a badger, a gourd and an earnest-looking, if nearsighted, little man. These effigies proliferated, and on the next pages, we'll see a few more.

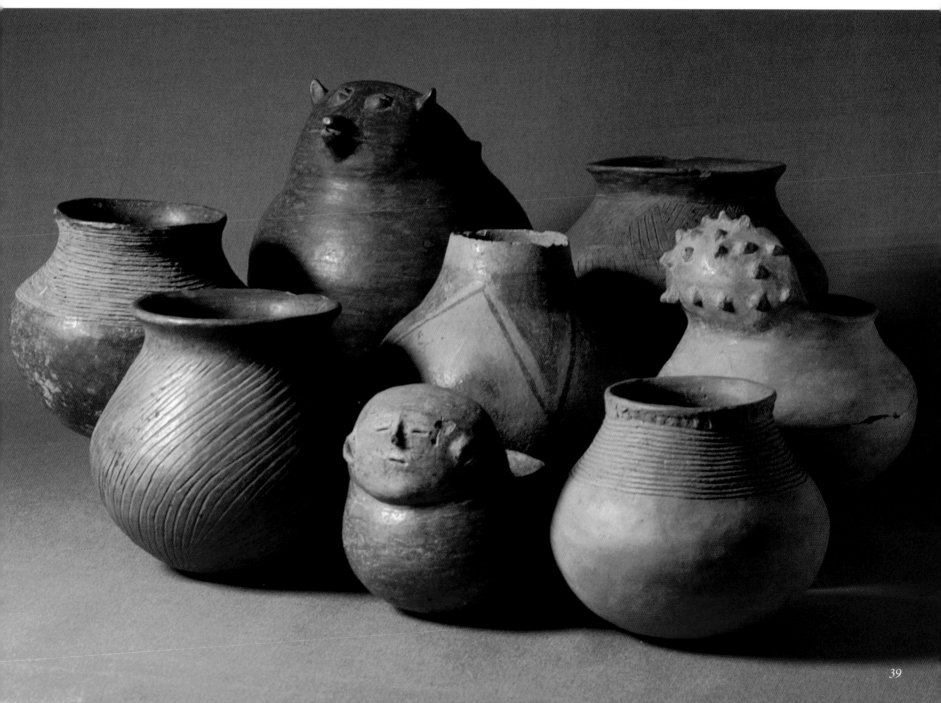

The Glory of Medio

After 1300, Paquimé grew. This was Di Peso's Medio period, when the dirt farmers turned their culture around and built the "big houses" that served as the headquarters of the Gran Chichimeca.

Paquimé was impressive by anyone's standards, and its extravagance served as tacit proof of the theory that outsiders from a more advanced culture must have helped build it.

It's certainly true that nothing else in our desert area of the Southwest rivaled Paquimé for opulence. The only thing close was the Anasazi complex at Chaco Canyon, built 400 miles to the north and two hundred years earlier.

Writers and scholars have connected Chaco and Paquimé for years, and there are many architectural parallels. You'd expect art parallels as well, but they were few and far between. There were certainly Mesoamerican touches at Chaco—turquoise and copper jewelry and parrot feathers in burials—but the pottery bore no resemblance. At Chaco, pottery was standard black on white and somewhat unimaginative by comparison.

Medio period Paquimé pottery looked like nothing else in the desert or otherwise. The shapes were different, it used different colors and designs and, when you stand back from it, it seems to have had a whole different philosophy.

It reminds you more of pottery from much farther south, from central Mexico and below. This suggestion of central Mexico is at the core of the Gran Chichimeca theory.

Basic Medio: a big Ramos Polychrome jar, the kind that inspired Mata Ortiz potters six hundred years later. 9⅛" diameter, ca. 1350.

Di Peso felt that small groups of powerful traders (he used the word *puchtecas*, in reference to an Aztec merchant class) came north and influenced culture all over the Southwest, bringing Mesoamerican ideas of art, architecture and religion to the backwards north.

Certainly, the art had a Mesoamerican flavor during Paquimé's years, but it was nothing new. Mesoamerica had been influencing the desert for hundreds of years, all the way back to Snaketown and its ball courts. At Paquimé, however, Mesoamerica stepped forward. There was more evidence of a stratified society of overlords, managers and workers, more elaborate burials and, of course, different pottery.

There were also undertones of darker, more sophisticated magic. Look in the front row of the picture on the opposite page. The evil in that death's-head hooded effigy at the right projects more raw menace than anything the Mimbres ever showed us.

But the art also suggests that the Mesoamerican hold on the culture of Paquimé, if it ever existed, was in trouble. The pots tell us that strong influences were appearing from other places and that the pressure was growing. Medio couldn't last forever.

Paquimé today: a portion of what's left of 19 square miles of prehistoric Southwestern culture at its peak.

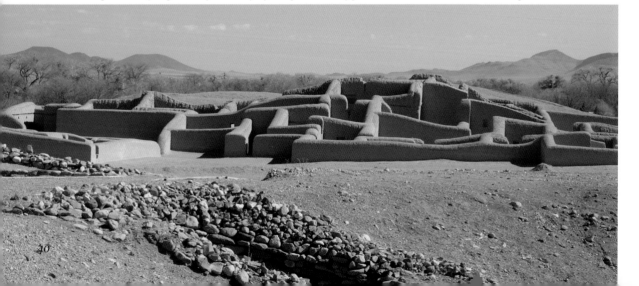

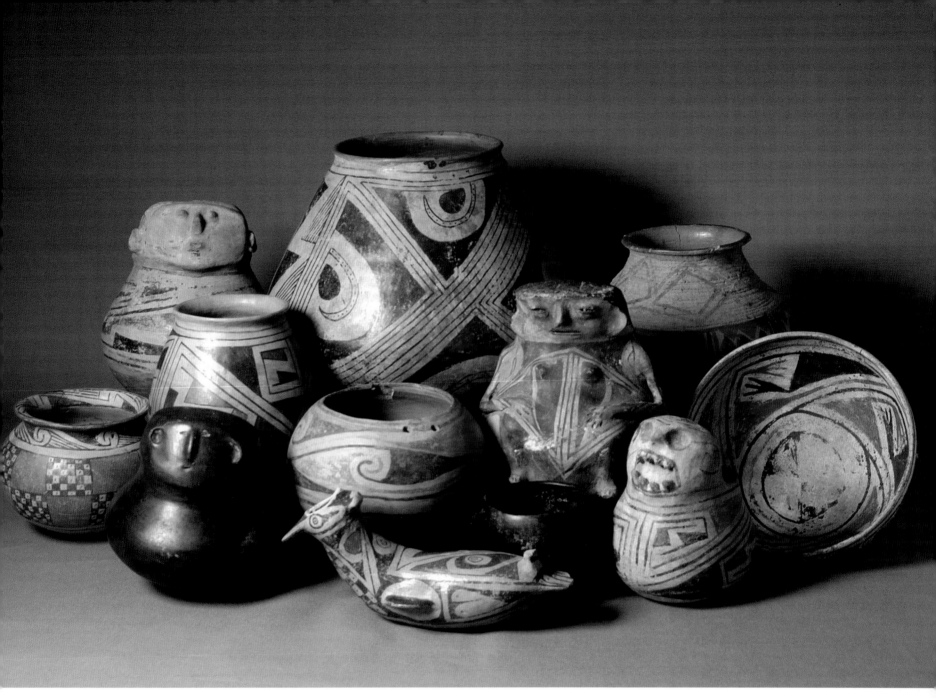

BACK ROW: *Villa Ahumada Polychrome effigy, 7" diameter, ca. 1400; Ramos Polychrome jar, 9" diameter, ca. 1400; Dublan Polychrome jar, 7½" diameter, ca. 1350.*

MIDDLE ROW: *Escondida Polychrome bowl, 5" diameter, ca. 1400; Ramos Polychrome jar, 5¾" high, ca. 1400; Huerigos Polychrome Jar, 6⅝" diameter, ca. 1450; Ramos Polychrome effigy, 7½" high, ca. 1400;*

Villa Ahumada Polychrome bowl, 7½" diameter, ca. 1400.

FRONT ROW: *Ramos Black effigy, 5½" high, ca. 1400; Ramos Polychrome bird effigy, 8½" long, ca. 1450; Ramos Black Bowl, 3⅝" diameter, ca. 1375; Villa Ahumada Polychrome effigy, 4½" diameter, ca. 1400.*

The small hooded effigy on the right in the front row serves as a startling reminder that

all was not sweetness and light at Paquimé.

If a good number of the Mimbres went to Tularosa and Chupadero, there's evidence that some also went south and joined the Casas Grandes people.

There are Mimbres sites near Paquimé, and Mimbres Classic pottery turns up there—one of the few areas outside of the Mimbres Valley where it shows up at all. Di Peso suggests that, through trade and

intellectual conquest, Paquimé brought culture to the Mimbres. From where we sit, it looks like the pottery suggests the reverse. Although Mimbres-style figurative drawings never show up on Casas pottery, other Mimbres traits such as kill holes do.

It's as if the Mimbres who accepted the conventions of the north went one way, while the ones who held to the old ways went south.

41

Cultural Dilution

Like all the prehistoric cities of the southwest, Paquimé was abandoned. Its end was more violent than most. Around 1500, Paquimé suffered a torching and a large-scale massacre, and to our knowledge, no one has yet identified the culprits. Recently immigrated Apache could have been nearby. The ferocious, sacrifice-happy Aztecs remain possible suspects.

Perhaps the violence came from within. In this book, we're trying to let the art tell as much of the story as possible, and the art seems to hint at conflicting styles, perhaps even at religious undertones of the sort that, in our day, cause people to blow each other up.

We know there were Mimbres sites in and around Paquimé. On the other hand, there's very little evidence of a Casas Grandes presence at Mimbres sites—Di Peso found none at Wind Mountain, which is on the road between Paquimé and the Mimbres Valley. If our earlier speculations hold, it looks like the mellower Mimbres went north to Tularosa, while the fundamentalists went south toward Paquimé.

There's a late pottery type at Paquimé called Carretas Polychrome, and guess what? Quite a few specimens have Mimbres-style kill holes in the bottom.

We also know the Salado traded into Paquimé with a frequency that has made some observers conclude that the Salado served as a Gran Chichimecan outpost and that the Gila and Tonto Polychrome, the showy fourteenth-century Salado pottery styles on page 27, were local variants of Casas Grandes ware.

The dates don't work out quite right, however. From all current evidence, Escondida Polychrome, the Casas Grandes style that's closest to Gila and Tonto, is a rarer style and a later one. (There are five pieces in the picture on the next page.) It's much easier to accept that Escondida was a Casas copy of Salado ware rather than the other way around. They certainly had enough Salado ware to copy. The excavations at Paquimé turned up a lot of Gila Polychrome imported from the north.

The third cultural incursion that interests us is the least investigated of the three. There were Mogollon to the northeast along the Rio Grande who made a black on red style called

A Madera Polychrome double jar. If it weren't for the classic Casas Grandes shape, we'd have called it an El Paso Polychrome and assumed it was made 200 miles away from Paquimé. 13¼" long, ca. 1400.

El Paso Polychrome, and their connections with Casas Grandes and the Mimbres Valley seem more than casual.

The El Paso people made pottery that looked a lot like Paquimé pottery, and you can see how similar they were by looking at the big pot in the top row in the right hand picture and the double jar at left.

El Paso Polychrome shows up in strange places. It turns up at Paquimé, and, even more puzzling, it turns up all over the Mimbres Valley. The Gila Cliff Dwellings, about 50 miles up from Silver City in the hills north of the valley, is less than a day's run away from Salado country, just over the hill. Yet excavations turned up Mimbres pottery and El Paso Polychrome, but no evidence of contact with the Salado.

What does it all mean? Nothing we can prove, and nothing we can make a strong case for. But it's not hard to guess that it wasn't all peaceful and pleasant at Paquimé and that there might have been more than a little religious discomfort.

There were certainly signs of discontent all over the Southwest during those years. The Anasazi, the Salado and even the Hohokam were moving from comfortable sites by the water to inconvenient and defensible sites on cliffs and hillsides.

We do know this. Paquimé, the great city in the valley, fell. And fifty or so years later, Spanish explorers looked at its state of destruction and wrote about the fabulous abandoned city of what they assumed was an ancient civilization.

BACK ROW: *Escondida Polychrome jar, 7½" diameter, ca. 1350; El Paso Polychrome jar, 10¼" diameter, ca. 1400; Escondida Polychrome jar, 6¼" diameter, ca. 1350.*
MIDDLE ROW: *Carretas Polychrome bowl, 8" diameter, ca. 1500; Carretas Black-on-yellow jar, 6¾" diameter, ca. 1500; El Paso Polychrome jar, 5¼" diameter, ca. 1400.*
FRONT ROW: *Carretas Polychrome bowl,*

6¾" diameter, ca. 1500; Escondida Polychrome bowl, 5¾" diameter, ca. 1350; Escondida Polychrome jar, 6" diameter, ca. 1350; Escondida Polychrome bowl, 5¾" diameter, ca. 1350.

Here, you see the three styles that, from one point of view, show the deterioration of the Casas Grandes culture. You could also, if you wanted, define them as the culture's outreach and assimilation.

El Paso Polychrome looks to the east and shows up in post-Mimbres sites in and around the Mimbres Valley with a frequency that the geographically closer Salado pottery never did. Escondida Polychrome, on the other hand, evokes Salado ware, and they saw quite a bit of it all around Paquimé,

where Salado Gila Polychrome shows up often. Di Peso felt that Escondida was a parent style to Gila polychrome, but recent thinking points the other way around. Carretas Polychrome is even more mystifying. It features glaze paint, which appears to be a Zuni invention, and Mimbres-style kill holes in bowl bottoms.

To be continued overleaf.

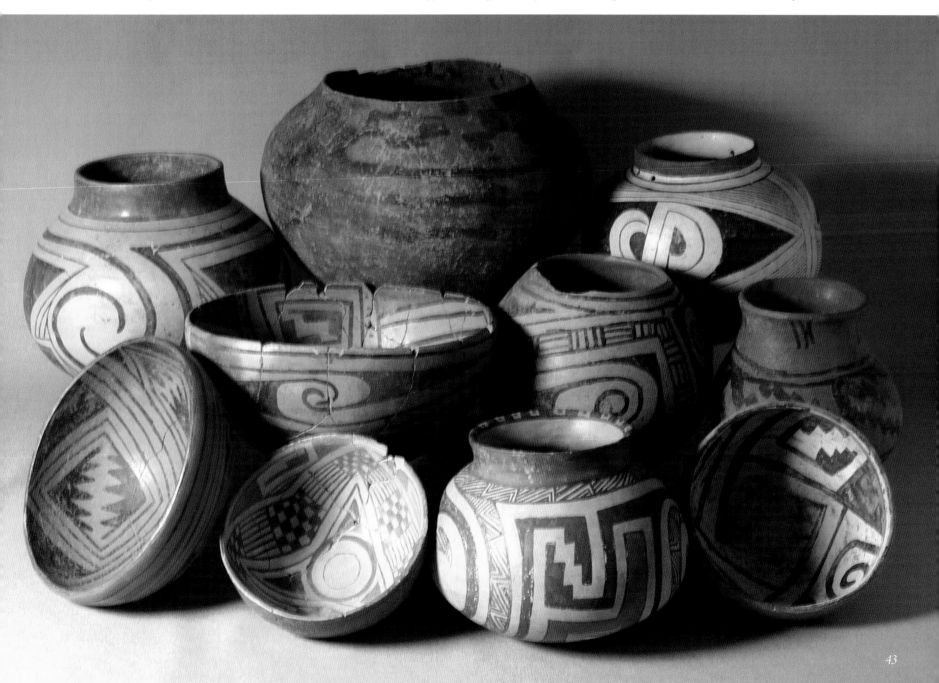

Exit East: The Melting Pot

If there was a Crossroads of the World in our Southwest, it was on the north edge of the area this book is about. Between 1400 and 1600, Zuni Pueblo sat at the confluence of four cultures.

Up to the northwest, the Sinagua and the western Anasazi had become the Hopi. The eastern branch of the Anasazi still occupied the northeast. The Mogollon lived to the southeast, and the Salado lived in the southwest.

Most books connect the Zuni with the Anasazi, point out that the new, politically correct name for the Anasazi is Ancestral Puebloans (*Anasazi* means ancient enemies in Navajo) and remind us that there was a prehistoric road between Zuni and the great Anasazi settlement at Chaco Canyon.

But the fit isn't quite that tidy. The Zuni language falls so far outside all the Southwestern language groups that Nancy Yaw Davis, a Ph.D. anthropologist, wrote a book called *The Zuni Enigma*. She suggests that both the Zuni language and glaze paint, a peculiar Zuni contribution to the art of pottery, came about because a group of monks sailed from Japan in the thirteenth century and somehow found their way from California to Zuni.

Hard-nosed academics dismiss books that strain to connect prehistoric America with Europe and Asia as diffusionist and grumble about pseudoarchaeology, but *The Zuni Enigma* brought to mind little things we've wondered about. In Gallup, I-40 crosses Miyamura Drive, and it's not named after a Japanese. It's named after a Zuni World War II hero.

You don't have to look across the Pacific to find cross-culturation in Zuni art. Just look at the next page. Zuni pottery took influences from Anasazi, Salado, Hopi and Mogollon alike, and influenced them right back, starting with the glaze paint.

Southwestern pottery isn't glazed like commercial ceramics. Its shine comes from polishing. A bit before 1400, the Zuni started using a thick copper-based black paint that fired into a shiny glaze. Copper or lead glaze paint only shows up on pots from Zuni, from the Rio Grande centered around Albuquerque, and down in Casas Grandes on that Carretas Polychrome we discussed on the previous page.

Glazes were almost gone by 1650, which probably improved the health of the potters, who no longer had to work with lead- or mercury-contaminated paintbrushes. Before and since, pottery paints were nontoxic boiled-down plants and earth colors.

There's a Zuni-Mimbres connection as well. The Mimbres had scattered by 1250, but the kill holes stuck around, not only on Carretas ware from Casas Grandes but also at Zuni on a sixteenth-century style called Matsaki Polychrome, an imitation of the yellow pottery the Hopi have made for a thousand years. The pots may look Hopi, but the kill holes are highly un-Hopi.

We're left with enigmatic questions. Like why an outlying Zuni pueblo is named Matsaki.

Around 1400, the Zuni started putting white linear decoration on redware, just like the Salado pitcher on page 29. They were still doing it five hundred years later when they made these. All are ca. 1900. The big jar is 7" in diameter.

Map labels:
HOPI OCCUPATION, A.D. 1400
ANASAZI OCCUPATION, A.D. 1400
SALADO OCCUPATION, A.D. 1400
MOGOLLON OCCUPATION, A.D. 1400
Little Colorado River
GALLUP
ZUNI
Salt River
Gila River
Rio Grande
NEW MEXICO
ARIZONA
SILVER CITY
DEMING

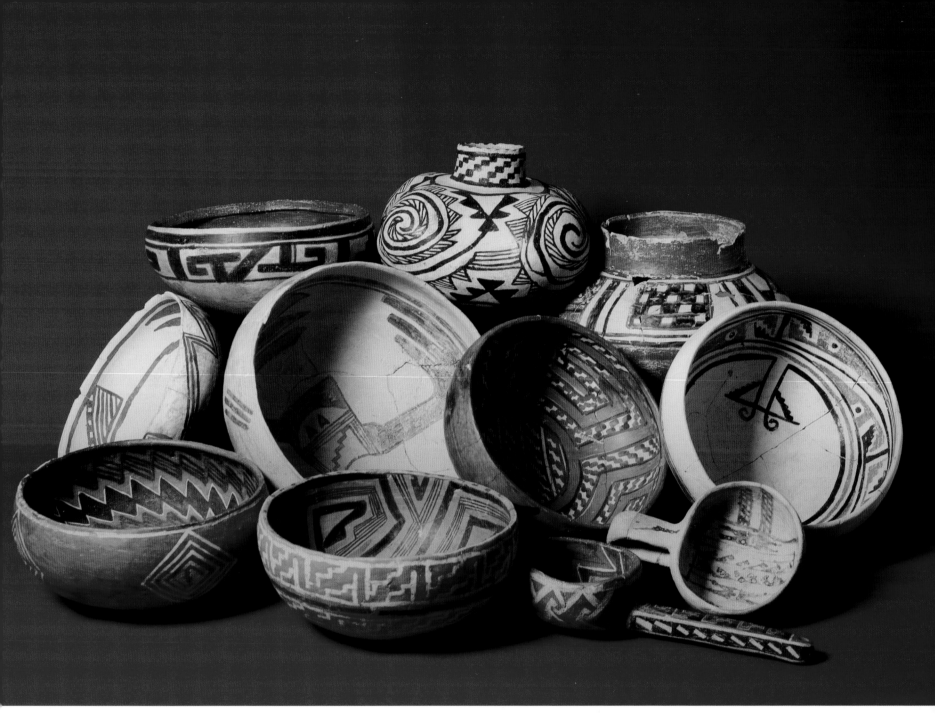

BACK ROW: *Hawikuh Glaze Polychrome bowl, 9" diameter, ca. 1650; Kechipawan Glaze Polychrome four-lobed jar, 9½" diameter, ca. 1425; Kwakina Glaze Polychrome jar, 9¾" diameter, ca. 1450.*
MIDDLE ROW: *Kechipawan Glaze Polychrome bowl, 8" diameter, ca. 1450; Matsaki Polychrome bowl, 11½" diameter, ca. 1550; Heshotauthla Glaze Polychrome bowl,*

8½" diameter, ca. 1350; Kechipawan Glaze Polychrome bowl, 9" diameter, ca. 1450.
FRONT ROW: *Heshotauthla Glaze Polychrome bowl, 9" diameter, ca. 1350; Springerville Polychrome bowl, 8½" diameter, ca. 1300; Heshotauthla Polychrome ladle, 10" long, ca. 1300; Kechipawan Glaze Polychrome ladle, 6½" long, ca. 1400.*

Here's Zuni, all over the cultural lot. In the front row, three of the earliest glazes, sophisticated polychromes with Mogollon and Salado design elements. On top, a jar with Tularosa swirls, but in glaze paint and, just so you know it's not one of those old-fashioned Tularosa Black-on-whites, a discreet red stripe around the base. To its right, glaze paint at its drippiest on a jar that

evokes Salado polychromes. The small ladle in front and the bowls at the either end of the middle row have an Anasazi feel, but the black turns green or red because of copper in the glaze. In the middle, a sixteenth-century switch in direction—no glaze paint and a Hopi look, but Mimbres-style kill holes. And at top left, the last Zuni glaze—a brief seventeenth-century reversion to an older style.

Over and Out

So far in these pages, we've tried to follow the art of the desert wherever it leads us.

Its connections took us from the Phoenix Basin east to Texas and south into Chihuahua. It bounced us north to Zuni. From there, it took us east again, across the Rio Grande and into a valley where it disappears.

By 1500, the Zunis had abandoned their glaze paint in favor of their side trip to Hopi and yellow pottery, but glaze was hitting stride among the pueblos along the central Rio Grande. Zuni glaze paint was copper-based and turned green, while Rio Grande glaze was apt to be lead-based and fire to a thick, messy, super-shiny black. As one observer who examined an array of late Rio Grande glazeware told us, "They were great potters, but they were lousy painters."

Glaze paint gradually disappeared as populations diminished in the glazeware pueblos. We can't be positive that the lead glazes contributed to the population shrinkage

The last of the Chupadero/Tularosa black on whites: Tabirá Black-on-white from the Salinas Pueblos, circa 1575. The canteen is 17" in diameter, the olla is 16".

at now-deserted pueblos like Pecos and San Lazaro, but it seems like a safe bet that they didn't help. Glazes persisted here and there throughout the 1500s and were finally gone sometime after 1600.

From our vantage point, the prehistoric desert art trail comes to its eastern end at a seldom-visited national monument in the Estancia Valley in central New Mexico. When the Spanish built the Salinas Pueblo Missions in the 1620s to take advantage of the salt flats nearby, they appropriated the lands of a relatively isolated pocket of people.

They were in Chupadero country, and the resident Indians made Chupadero Black-on-white pottery in the post-Mimbres Mogollon manner. As late as 1550, they came up with a new black on white style that brought back figurative images, an indication that they were hardly following the latest trends. They also traded with their linguistic cousins to the north in the pueblos near what became Albuquerque, where they acquired their share of glazeware.

About 1550, they converted to cremation from burial—an idea that bears little resemblance to any thinking that came from the north. *Salinas Pueblo*

Missions, the Southwest Parks and Monuments publication, suggests that the cremation idea may have arrived "with a group of immigrants from the Zuni-Cibola area, two hundred miles west through Abó Pass."

The residents of the Estancia Valley never had it easy. They suffered frequent smash-and-grab attacks from the Apaches in the area. The land and water supply weren't rich enough to support the population in dry years, and seventeenth-century droughts brought starvation. The Salinas Pueblos were abandoned by 1677, and most of the surviving Indians moved in with their relatives up north.

Summary: Zuni immigrants, black on white pottery with strange figurative images, cremation, glazeware on the premises, everybody gone. End of the trail.

BACK ROW: *Espinosa Glaze Polychrome bowl, 13" diameter, ca. 1475; Kotyiti Glaze-on-white olla, 11½" high, ca. 1600; San Lazaro Glaze Polychrome olla, 14½" diameter, ca. 1530.*

MIDDLE ROW: *Escondido Glaze Polychrome bowl, 8" diameter, ca. 1600; Puaray Glaze Polychrome bowl, 9¾" diameter, ca. 1575; Espinosa Glaze Polychrome effigy bowl, 7¼" long, ca. 1475.*

FRONT ROW: *Kotyiti Glaze Black on white effigy bowl, 8" diameter, ca. 1600; Tabirá Black on white jar, 2¼" high, ca. 1575; Escondido Glaze Polychrome bowl, 5" diameter, ca. 1450; Kotyiti Glaze on white kiva bowl, 8½" long, ca. 1600; Puaray Glaze Polychrome jar, 2¾" high, ca. 1580; Kotyiti Glaze Polychrome kiva bowl, 7½" square, ca. 1600; Kotyiti Glaze on yellow jar, 2¼" high, ca. 1600.*

Here, examples from the end of the glaze paint era (along with one of the very last black on whites, the little jar at the left of the front row) and what seem to be the last link between the art of the desert and the art of the Pueblo Indians of the north. The latest glaze pieces (the type is correctly called Kotyiti Glaze-on-yellow, but two of the pieces here and a big one at Gran Quivira are very white) show up from north of Albuquerque and south to Gran Quivira.

By 1600, the Spanish government was established in New Mexico, the Indians were building missions, and what pottery was being made was increasingly made to northern traditions. *The black on white kiva bowl in the middle of the front row seems to incorporate a bit of new magic along with the old: what looks like a Christian cross on the left inside.*

Glazeware gave way to a matte black on gray, low-fired style called biscuitware that owed its ancestry to the northern Anasazi, and the desert trail died out. To find a connection between prehistoric desert art and the present, we had to backtrack and head west.

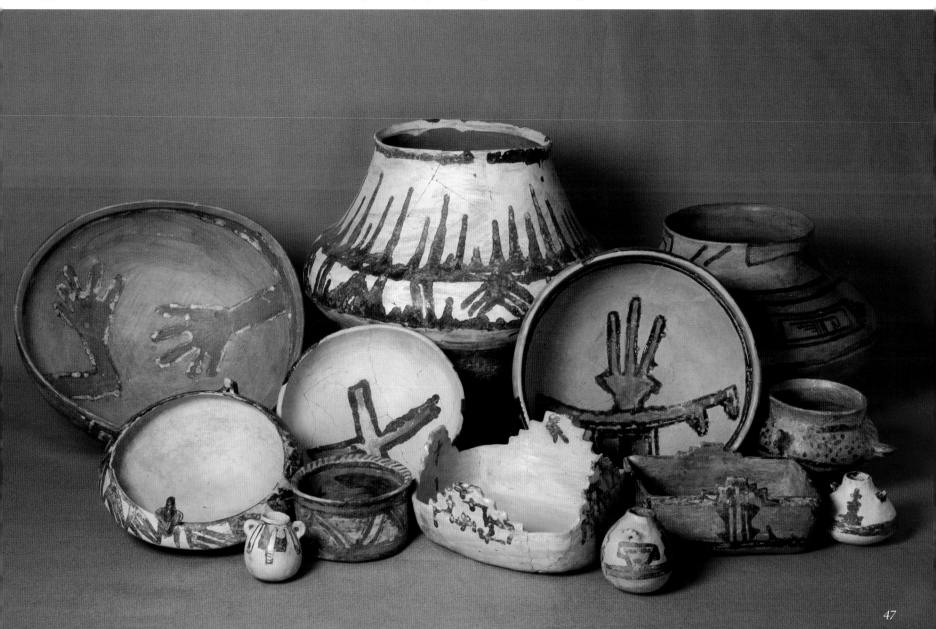

Heading West:
To the Colorado

We found a clearer path to the present in desert art when we looked west from Hohokam country.

The first couple of hundred miles of the trail aren't well marked. The desert west of Phoenix is forbidding country and offers almost no evidence of settlement.

There's evidence of a changing world, however. About 60 miles west of Snaketown, 15 miles north of I-8 west of Gila Bend, the petroglyphs at the Painted Rocks site offer an overwhelming record of traffic through the area, both pre- and post-Spanish contact.

There's a late Hohokam site near Gila Bend that expands on the story. The Fortaleza site isn't typical Hohokam. It's built-up stone

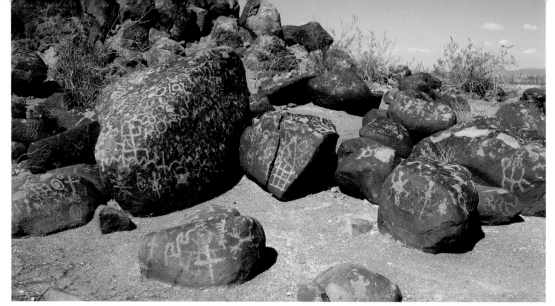

Painted Rocks Monument: These petroglyphs (carved, not actually painted) in a remote spot halfway across the desert record hundreds of years of native migration. The rock in the foreground with the cross is about 18" wide.

on a defensible hilltop, not pithouses near the arable fields by the river where the Hohokam lived earlier.

By 1450, the Hohokam had abandoned their main areas of settlement. Archaeologists tend to blame drought and increasing salinization of the Gila and Salt rivers. The fortress site implies something else.

Fortaleza hints of unrest and flight, perhaps brought on by increasing friction between the Salado and the Hohokam. Or the friction could have come from raids by early Athapaskan immigrants, ancestors of the Apaches, who had become the principal tormentors of the area residents by the 1600s.

A third possibility is the least understood prehistoric culture of the southwest. In *The Archeology of Ancient Arizona*, Jefferson Reid and

Stephanie Whittlesey tell how, in the 1930s, archaeologist Malcom Rogers described the Patayan, who occupied the desert from southern California to Phoenix. They're the presumable ancestors of the modern Yuman-speaking Colorado River and southern California tribes. He saw the Patayan divided into upland and lowland divisions, with the Pai group—Yavapai, Hualapai and Havasupai—as the uplanders and the downstream Cocopah, Quechan, Mojave, and Kumeyaay as the lowland group.

Today, the archaeological community generally accepts the Patayan as a discrete group, but the research is scant. Rogers's broad studies developed a chronology, but an unhappy sequence of events wiped out much of his effort. He did his work at the Museum of Man in San Diego, and when the military took over

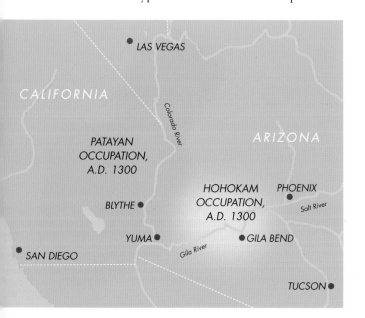

Patayan plainware sherds, ca. 1500.
The big assembled fragment is 8¼" long.

the building during World War II, they lost his reports and scrambled his specimens. When Rogers died in a car crash in 1960, any hope of reconstructing his research ended. What was left served as the basis for Patayan scholarship.

Today, we can't look at modern and historic Colorado River pottery without noticing how much it looks like prehistoric Hohokam pottery. Rogers would have cut off any discussion of the subject. He was sure the Patayan learned pottery technology from Yuman-speaking peoples in southern California or Sonora around 700, and that the Hohokam were nowhere near. We can't dispute him, but we still think that culture traveled the way it always seems to travel. It's hard to ignore the possibility of Hohokam migration and intermarriage.

The resemblance goes back to early historic times. Patayan pottery is made with the Hohokam paddle-and-anvil technique. (There's a pottery anvil and a mesquite paddle in the picture on page 51.) There's even evidence that the Patayan coexisted with the Hohokam so comfortably that they lived in the same neighborhood at the village of Las Colinas, which now rests under downtown Phoenix.

However, one facet of Patayan art has nothing whatever to do with the Hohokam or any other southwestern culture. The surface of the desert in Patayan country is covered with "desert pavement," pebbles coated with desert varnish, a coating made by alkaline soils, dust storms and no rain. In this pavement, the Patayan etched gigantic figures of humans,

animals and stars. They don't look like anything else anyone else did nearby or, for that matter, anywhere else north of Peru. Most archaeologists believe they were made fairly late in Patayan prehistory. There's a minority opinion that they were made by a much earlier,

pre-ceramic culture. And no, they weren't so gigantic that they served as beacons to alien spaceships. They're about half the size of a football field.

The pots may look Hohokam, but the Patayan were into bigger things.

Time stands still in the desert: The Patayan intaglios near Blythe, California, still criscrossed by tracks left by off-road vehicles and World War II military maneuvers. Today, chain-link fences protect them.

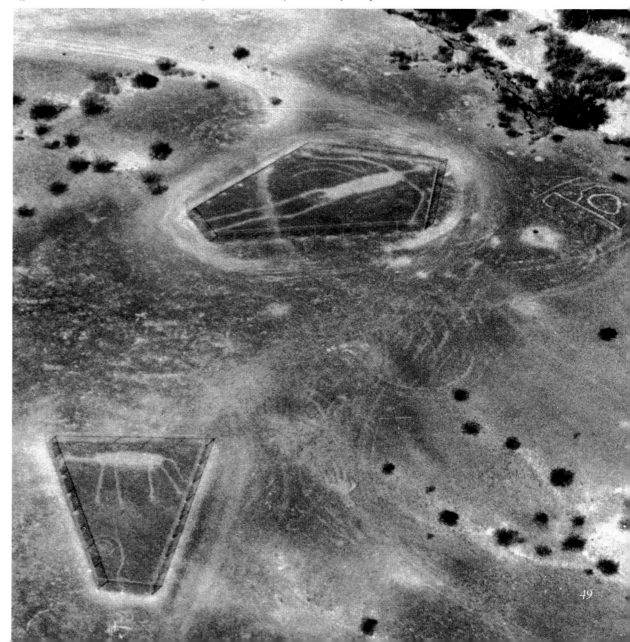

Lakes That Went Away

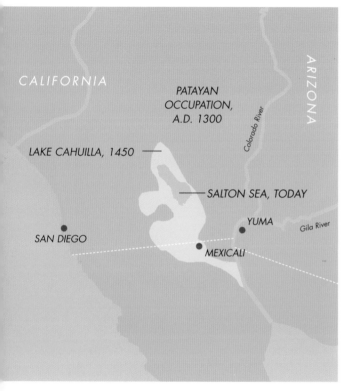

CALIFORNIA

ARIZONA

PATAYAN
OCCUPATION,
A.D. 1300

Colorado River

LAKE CAHUILLA, 1450 —

— SALTON SEA, TODAY

YUMA
Gila River

SAN DIEGO

MEXICALI

If you know anything about southern California geography, you know about the Salton Sea, a 380-square-mile body of brackish water near the Mexican border.

You may even know how it was was created. In 1904, the California Development Commission cut into the Colorado River to bypass a blockage in a three-year-old irrigation canal that brought water to the newly developed Imperial Valley. The spring floods of 1905 surged through the cut, down a couple of sleepy riverbeds and poured into the valley over a 28-foot-high waterfall. It took until 1907 for workers to divert the Colorado back to the gulf. The new sea was 45 miles long and 17 miles wide. Since then, it's lost 30 percent of its area through evaporation.

But this new, gigantic sea was as nothing compared to what it used to be. These days, Hoover Dam upstream on the Colorado controls the floods and silt deposits that used to fill the Colorado Basin. In prehistoric times, the silt would build until it rerouted the Colorado, and the entire Imperial Valley filled up to become Lake Cahuilla, a body of water that dwarfed today's Salton Sea. After a few hundred years, silt blocked the alternate channel, the Colorado returned to its regular course and Cahuilla dried up.

As near as science can tell, Lake Cahuilla was full from the years 300 to 600, 900 to 1200 and 1350 to 1500. It partially refilled around 1600 and still held water into the 1700s. If we'd left it up to nature instead of building dams, it probably would have filled in 1905 as well.

There was plenty of good water to support a culture or two in southern California, and there's plenty of evidence that the cultures were there.

If Malcom Rogers was right, those southern Californians were definitely the Patayan and not the Hohokam or anyone else from the east. One thing that made Rogers so sure that there was no connection was what seems like a Patayan national characteristic. When the Hohokam faced adversity, they dug in. They built more canals and stayed put so long that Snaketown shows a thousand years of continuous occupation. The Patayan were nowhere near as stubborn, or more likely, nowhere near as lucky. They lived near water and moved whenever they were flooded out, which happened often. They disdained elaborate architecture, probably because they disliked constant rebuilding, and left a sparse archaeological record.

During most of the Lake Cahuilla years in southern California, it wasn't hard to find new pleasant places, and traces of settlements show up all along the advancing and receding shorelines. Our friend Claire Demaray told us about a long-gone lake a few miles north and east of Lake Cahuilla. She parked her car by an overpass, walked a few feet off the Interstate and shot pictures of the potsherds and artifacts of day-to-day life resting on the surface, exposed by the occasional deluge.

The fact that records are sparse doesn't mean that art is nonexistent. The Colorado River peoples and their neighbors made their own brand of red on buff bowls and storage jars, and their seldom-seen pottery gives us more clues to the puzzle.

Potsherds and worked stone fragments along the shores of Claire Demaray's dry lake, brought to the surface by desert rains.

BACK ROW: *(on its side) Tizon Brown water jar, 8½" high, Colorado Red on buff water jar, 15" high, Colorado Red on buff (polychrome variant) water jar, 15" high with pine resin repair, Colorado Red on buff water jar, 17½" high, Salton Brown or Tizon Brown cookpot, 10" diameter.*
FRONT ROW: *Unknown type miniature jar, 2½" diameter, Colorado Buff pottery anvil, 7" diameter, Colorado Buff miniature jar, 2½" high, Colorado Buff canteen jar, 6¼" high, mesquite pottery paddle, 17½" long, all dates unknown, with the highest probability around 1500.*

Prehistoric Patayan pottery is difficult to document. Most of it was picked up by farmers and ranchers in the area and found its way into collections without enough supporting archaeological information to pin down exactly who made it and when.

Any of the nine pots in this picture could be 1200 years old or 100 years old, and the ability of the desert to sit unchanged for years is no help (witness the perfectly preserved tire tracks on page 49).

These pots were made west of the Colorado, and some of their design characteristics persist to the present in Yuman, Cahuilla and Kumeyaay pottery.

The decoration looks vaguely Hohokam, but the water jar shapes are pure Southern California.

Steve Lucas, a Kumeyaay anthropologist, enlightened us on one aspect. He told us how you could tell a water jar from a dry storage jar, as explained to him by an older Kumeyaay potter. "If you can stick your hand in it, it's dry storage. If you can't, it's water."

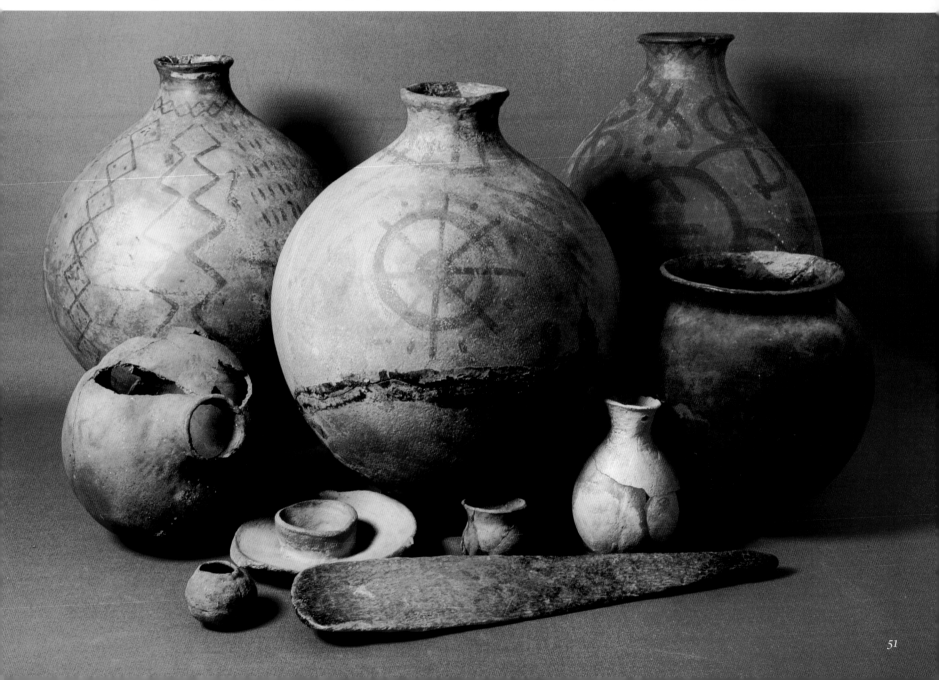

Canadian Immigrants: The Apache Arrive

A lot started to happen in the late part of the fourteenth century. There were droughts, there were wars and there were religious movements. There could also have been newcomers who managed to infuriate just about all of the original residents.

By 1300, pretty much the whole desert had settled into a reasonably sedentary, agrarian lifestyle. There had always been bands of hunter-gatherers roaming between the settlements, but they weren't running things.

Then nomadic Athapaskans started coming down in large numbers from what's now Canada. They spread out all over Arizona and New Mexico, dividing into two bands. The Navajo stayed mainly north of the Mogollon Rim, but the Apache came south.

The date of the Apache arrival in the desert is open to debate. One recent authoritative book has them showing up around 1600. Other books get much more vague, using sentences like "a long migration that took place between a thousand and five hundred years ago."

If the first wave did arrive as early as seven hundred years ago, it would answer some questions. They almost certainly would have contributed to the general unrest of the period from 1300 to 1450. The phrase *hunter-gatherer* says a lot, and to an agrarian society, not much

Prehistoric basket fragments from Apache country. They've been dated between 1000 and 500 years old, and they may or may not have been made by Apaches. The big one is 14" in diameter and sure looks Apache.

that it says brings a smile. If you live in an agrarian society, you're tied to the land, and the world around you tends to be peaceful and law-abiding, for practical reasons.

If you bash your neighbors over the head and steal their food, you gain little. They know who you are and where you live, and they'll be at your house the next day to bash you back.

If you're a nomadic hunter-gatherer living in a place where food isn't abundant, you live by a different set of rules.

Migrating into an area with peaceful, sedentary, widely spaced agrarian communities is like finding the door to the bank left unlocked. Hunting and gathering in a harsh environment is hard work compared to raiding and stealing from people who've made it clear that they think of you as the enemy. Their food is fair game, and grabbing it is your way of life.

Not surprisingly, the Apache found the desert to their liking, and not surprisingly, the affection wasn't returned. The word *Apache* comes from a Zuni word meaning enemies. During the Apaches' early days in the desert, they moved around a lot. If they built anything at all, they built temporary structures called wickiups. As a result, they left behind far less archaeological record than their sedentary neighbors.

They also left almost no enduring art. Most of what survived was simple, stashed in caves, perhaps stored away for retrieval on the next run. The elegant design of the basket fragment in the picture above probably wasn't typical.

Later on, as Apaches settled into the areas in the Tonto Basin abandoned by the Salado and the Mogollon, they made some nondescript brownware pots, but their significant contributions to desert art didn't come until the nineteenth century.

In the prehistoric period, if Apaches were in the desert at all, their presence probably discouraged regional art rather than fostering it.

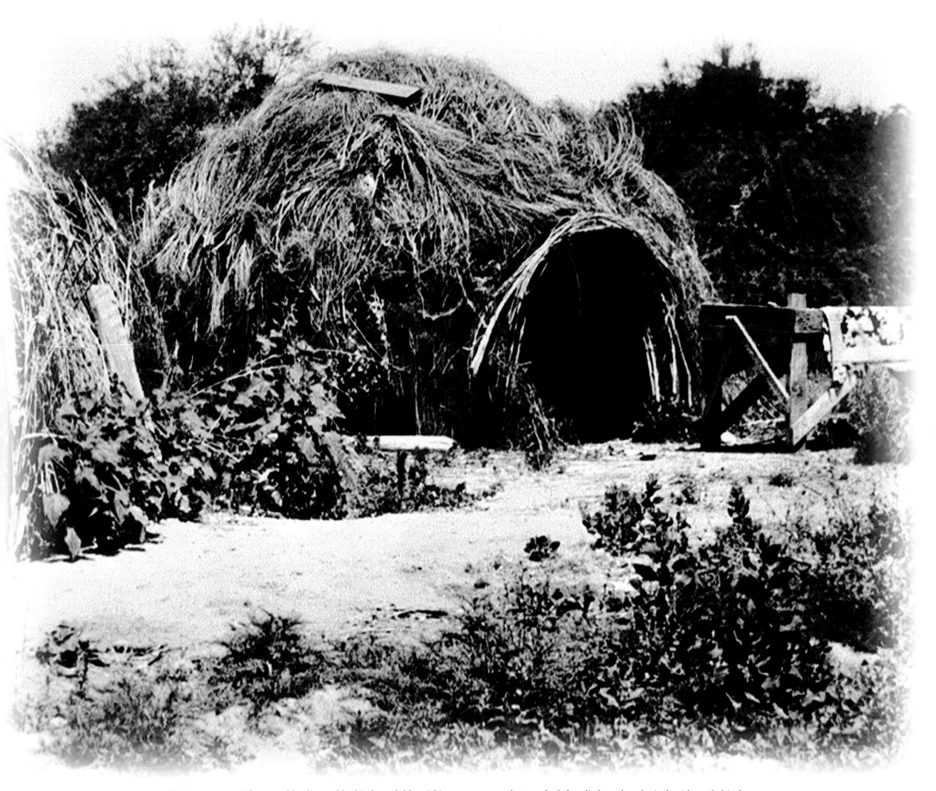

Living quarters: The portable, disposable, biodegradable wickiup, one reason the Apache left so little archaeological evidence behind.

Prehistory Ends: The Hohokam Leave

When we left the Hohokam about 30 pages ago, they'd enjoyed prosperous days and were moving into an uncertain involvement with their Salado neighbors up the hill. In the twelfth, thirteenth and fourteenth centuries, cultures clashed around the Hohokam, but they hung in. It was the time of their greatest works.

Casa Grande, the big house which served as a landmark for desert travelers from the earliest Spanish days, is the most obvious of those works but not the most ambitious. That honor falls to the Casa Grande canal, built around 1250. It runs 20 miles along the Gila past the Casa Grande complex.

A study by Douglas B. Craig of Northland Research estimated that building the canal took 60,000 person-days—two years of full-time work by a crew of one hundred who moved almost 200,000 cubic yards of earth.

There's little evidence that these last great civic works made life any happier for the Hohokam.

It's not hard to project a scenario for the last days of the Hohokam. For hundreds of years, they'd been milking the Salt and the Gila, and populations had grown and thrived. When a town grows in our time, more and more of the land around it gets put to use, and we're pretty sure the Hohokam weren't all that different from the rest of us.

However, the more land you put to work growing things, the more water you need. To get more water, you need bigger canals, and really big canals don't happen unless important people want them. Big public works projects need planners, supervisors and administrators. Now the Hohokam had a bureaucracy.

Then, around 1325, the Hohokam indulged in some Mesoamerican grandeur. They built a building big enough to rival anything at Paquimé and unlike anything else for hundreds of miles around. No one is quite sure why they built it, but a building that big in that place makes us think more about government ego than about practical use.

Meanwhile, in our scenario, the demand for water kept increasing, and the downstream people started to complain that the upstream people who ran the water district were pulling out more than their share. Before long, the system got overloaded. Then the canals started pulling off so much

The last Hohokam red on buff:
Casa Grande Red-on-buff, made ca. 1350.
The bigger jar is 8¼" in diameter.

water that the river levels dropped and the water that was left was less capable of washing away minerals. The river that supported the Phoenix people for centuries developed such a high mineral content that when the Spanish put a name to it a couple of hundred years later, they call it the *Rio Salado*— the Salt River.

Despite their hydraulic engineering, the Hohokam couldn't control everything that nature threw at them. A big flood hit about 1350, and it probably wiped out peripheral canals, which meant more public works projects, more administrators and more bureaucrats.

Our scenario aside, archaeologists agree that Casa Grande and the rest of the Hohokam settlements were abandoned by 1450, and there's evidence of a major fire at Casa Grande around that time.

Then there were those pesky Salado. When you visit the Casa Grande National Monument today and look at the pottery in the Visitor's Center, you'll see examples of Casa Grande Red on buff, but those won't be the pots you'll remember. You'll see Salado polychromes and fabulous big, red, fire-clouded jars that bring to mind Akimel oral history. Elder Brother would have liked them far better than the ones made to the tastes of the arrogant and now-vanquished Hohokam leader Sivany.

Many accounts puzzle over the mysterious "vanishing" of the Hohokam. In our scenario, there's little mystery. They had a system that once worked, but it used up their natural resources. In the 1400s, they'd had a few

drought years, suffered an expanding government, a polluted water supply and undesirable immigrants next door, and faced ever-more-difficult hardscrabble farming.

Ever read any Steinbeck? It wouldn't surprise us if a lot of them left the dust bowl and went to California.

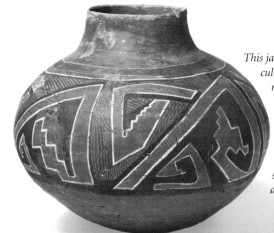

This jar represents what might have been the most surprising cross-culturation of them all. In the fourteenth century, as the Hohokam were nearing the end of the line, a group of Kayenta Anasazi moved from Arizona's northwest corner and settled near Tucson for a while. They were only a handful of years short of being classified as Hopi. One way we know they were there is that they made Tucson Polychrome. It looks almost exactly like Kiet Siel Polychrome, the pottery they made up by the Grand Canyon during the same period. This imposing piece is 14½" in diameter and was made ca. 1350.

Casa Grande as you see it today: hot and dry.

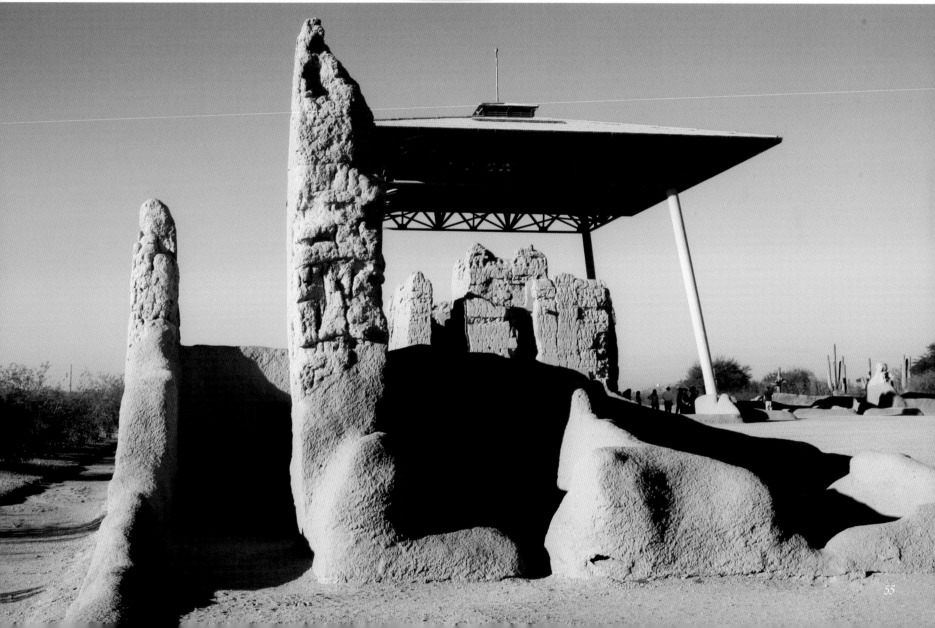

Reorganization

By the time the Spanish arrived in the mid-sixteenth century, the desert population had changed.

There weren't any more Sinagua, there weren't any more Anasazi, there weren't any more Salado, there weren't any more Mimbres, there weren't any more Mogollon, there weren't any more Hohokam. Or at least, that's what the books say.

To us, it seems implausible that they all vanished. It seems quite reasonable that they all evolved and that most of them found other places to live. Let's take a look at them one by one.

During much of their existence, the Sinagua bounced back and forth between the Verde Valley, just north of Hohokam country, and the area around Flagstaff, where Sunset Crater erupted in 1064 and blanketed the countryside with volcanic dust that created fertile farming lands. They gave up on Flagstaff around 1350, presumably to return to the Verde Valley settlements, but they didn't abandon their northern connections. The major Sinagua sites of Montezuma's Castle and Montezuma's Well are at the southern end of the Palatkwapi Trail, a direct trade route to the Hopi Mesas. When the Sinagua left the Verde Valley about the time the Hohokam left the Phoenix and Tucson

basins, some most likely went north, joined the Anasazi and assimilated to become the Hopi.

With the Mogollon, the answers are less clear. Through most of the twentieth century, archaeologists believed there were no known descendants of the Mogollon in the U.S. pueblos, or, for that matter, in any U.S. tribes. The Tarahumara of Copper Canyon, 300 miles south of the U.S.-Mexican border, are the only large group generally conceded to be Mogollon. Scholars had plenty of archaeological evidence to connect the Mogollon of Paquimé to the south and little to connect them north.

Today, archaeologists are looking at those Paquimé-to-Mimbres-to-Tularosa-to-Zuni pottery connections and finding more connections with the north. There's another interesting connection, even more tenuous archaeologically but (perhaps deceptively) obvious in terms of pottery styles. The northern pottery-producing pueblos, descended from the ancestral puebloan Anasazi, have two language groups. Most of the eastern

Children of the Salado?
Sobaipuri redware catfish effigy,
found near Douglas, Arizona, 10½" long,
date unknown, but we're guessing ca. 1600.

pueblos, lined up on a north-south axis from Taos to Isleta, just south of Albuquerque, speak one of the three Tanoan dialects. Another group, on a roughly east-west axis from Cochiti near Santa Fe to Acoma in west-central New Mexico, speak Keresan.

Acoma, just north of the Tularosa mountains, makes pottery that features the stark black and whites of Tularosa pottery and has shared the same designs for years. It's tempting to move some of those Tularosa and Chupadero Mogollon up to Acoma, wondering all the while if the differences between Keresan and Tanoan might not have evolved from the differences between Mogollon and Anasazi.

The Salado are harder to trace. They left the Tonto during the 1300s and 1400s, abandoning it to its eventual takeover by the Apaches. Because later Salado polychrome pottery shows up all over Hohokam country and down to Paquimé, it looks like they fanned out over a wide area to the south. Their influence also appears up north in Zuni pottery. Di Peso felt that the Sobaipuri, a group that made redware pottery across southeastern Arizona and had seventeenth-century contact with the Spanish, were the Salado's descendants.

Sobaipuri pottery, like the fish at left, is generally primitive. Zuni pottery is highly refined. If we're going to let the art tell the story and brush aside the mountain of confusing archaeological evidence that surrounds the end of the prehistoric era, we come to a conclusion something like the one

we suggested for the Mimbres. It looks like the sophisticates went north and the plain folk went south, all to be assimilated into the local cultures.

The fate of the Patayan, on the other hand, doesn't seem problematical at all. They stayed where they were, or at least nearby, and became the Colorado River and southern California tribes of today.

Which leaves the Hohokam. In their case, archaeologists speak of a "time gap"—the period between 1450, when the Hohokam all but abandoned their settlements, and 1680, when Spanish accounts first clearly mention contact with the O'odham Indians who still live there.

Early O'odham pottery, like the storage jar to the right, has enough similarities to late period Hohokam pottery to satisfy anyone looking for a pottery connection. In fact, it looks more like Casa Grande Red-on-buff than any other pottery ever made anywhere else in the whole Southwest. The problem is that there are almost no dated archaeological sites in the time gap that show any continuity at all.

Instead, it seems that the whole Hohokam area was virtually deserted for two hundred years. In a 1977 article published in *The Artifact*, Gordon Fritz put some archaeological truths together with historical accounts to support the idea of desertion followed by immigration or reentry.

He related a 1697 account by one Juan Mateo Manje. It told of a pile of bighorn sheep horns on the Gila between Casa Grande and Snaketown that was taller than the houses of the Indians. Manje estimated that the pile contained more than a hundred thousand horns. Fritz did some research on bighorn sheep, reporting on their populations, on the decay rate of their horns (they aren't bone matter, they're hardened protein and, like cow horns, they decay after a few decades of exposure in a natural environment) and on O'odham hunting traditions.

Since bighorns don't shed their horns but keep their pair for life, Manje's pile of a

Children of the Hohokam?
O'odham Red-on-buff storage jar,
from the Tohono O'odham reservation,
14½" high, date unknown, but we're guessing ca. 1650.

hundred thousand horns meant fifty thousand sheep. Today, bighorn populations are in the low hundreds over large areas, their numbers depleted by hunting and human encroachment. Early twentieth-century Akimel O'odham hunters had an old tradition of removing the horns from bighorns and ceremonially piling them by water holes, smaller versions of Manje's piles. Fritz did the math and figured that, in order for seventeenth-century O'odham hunters to be able to kill tens of thousands of bighorns in a few decades, the area would have to have been free of humans for a long period to allow the herds to build to that size.

Fritz drew no conclusions about whether the seventeenth-century immigrants were simply Hohokam coming back to the old family estate or were a different group. But his arguments for abandonment and repopulation rather than a continuum seem hard to dispute.

If the Apaches began raiding before the Hohokam and Salado left, it could have hastened the end of the old ways of life. The Apaches were known to kidnap and enslave men, women and children. More than a few Hohokam and Salado could have ended up naturalized Apache citizens.

It's hard to pin down exactly what happened to all those peoples in the 1400s, but a lot of researchers are looking for answers. There's no shortage of patterns and tantalizing possibilities, and each new discovery helps sort it all out.

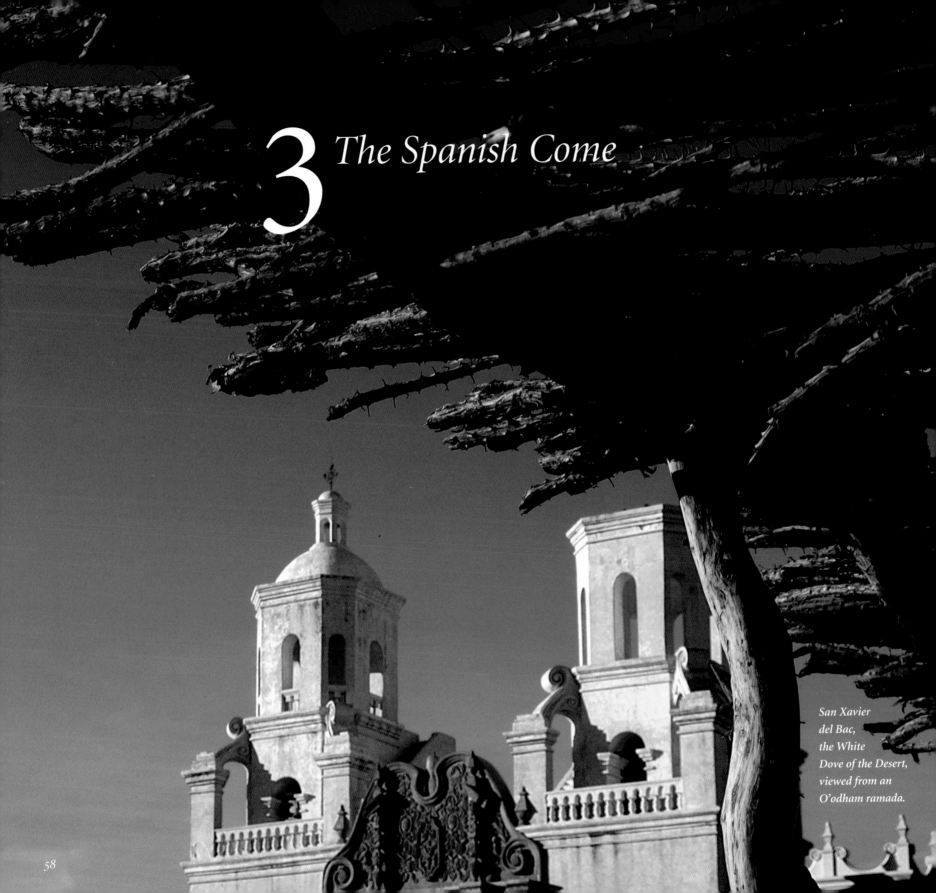

3 *The Spanish Come*

*San Xavier
del Bac,
the White
Dove of the Desert,
viewed from an
O'odham ramada.*

First Contact

IN THE DESERT, PREHISTORY ENDED and recorded history began in August of 1539 when Fray Marcos de Niza reported back to Mexico City.

His written records, mostly fabricated, of his observations and adventures in locating the gold-laden Seven Cities of Cíbola across the desert and up near Zuni told the government of New Spain what they'd hoped to hear.

The Spanish administration was on an aggressive quest for El Dorado, looking for cities where the streets were paved with gold. The impetus for the quest went way beyond local politics. The orders came straight from headquarters.

In Spain, King Ferdinand and Queen Isabella, who'd sponsored Columbus along with the Inquisition and other great works, were gone. Now their daughter Juana and her Hapsburg husband, Philip, sat briefly on the throne, ultimately followed by their son Carlos I.

He took over in 1516, but he was already Emperor Charles V, ruler of a large chunk of Europe, and he'd held that job for ten years, since he was six years old. When he ascended to the Spanish throne, he ruled over more land than any other European monarch before or since. He was German to the core, and his loyalties reflected his upbringing. His view of colonial expansion was simple. It was a practical source of gold to finance the needs of his German principalities and, if there was any left, to spend on Spain.

By the time the first Spanish entered our strip of the desert, the message to colonial governors was clear: Send back gold and don't trouble us with details.

The Florida Refugees
By 1536, Hernan Cortez had defeated the Aztecs, set up a Spanish colonial government in Tenochtitlan and renamed it Ciudad de Mexico. (The Aztecs called themselves the Mexica. *Aztec* was what the Mayans, who had little use for them, called them.)

It had been fifteen years since Cortez had landed. Pizarro was making headlines in Peru with his Inca treasures, and the authorities in Nueva España were getting impatient for a gold strike closer to home.

What seemed to be the big break came when a ragged party of refugees showed up. Three minor Spanish noblemen and a Moorish slave were all that was left of a three-hundred-man expedition that had arrived in Florida eight years before. The *hidalgos*, Alvar Nuñez Cabeza de Vaca, Alonzo del Castillo and Andrés Dorantes and the slave Estéban, had wandered west for eight years, much of the time in captivity.

They escaped massacre in Florida, tried to sail to Mexico on a raft, blew onto the Gulf shore in a storm and ultimately found their way through Texas into Chihuahua and Sonora. They made it to the Sea of Cortez, where they encountered an Indian wearing a Spanish belt buckle and eventually, four conquistadores out on a slave-gathering patrol. Despite their now ignoble appearance, they talked their way out of slavery or death because they spoke Spanish and told the precise stories the authorities wanted to hear.

An account of the riches and the approximate location of the Seven Cities of Cíbola had been kicking around official circles in Nueva España since 1530. A conquistador named Nuño Guzmán pried it out of an Indian who told him the cities were "forty days travel" north from his home 100 miles or so north of Mexico City. The Spanish had already heard about the riches of Aztlan,

Yuman pottery beads (Quechan, Mojave or Cocopah) ca. 1500, found in the sands along the Colorado. The beads average ¹⁄₁₆" in diameter.

1540

ZUNI

Phoenix •

Tucson •

Paquimé •

CULIACAN

COMPOSTELA

→ CORONADO
→ DE ALARCON
→ DIAZ

MEXICO CITY

and an old European legend told of seven Portuguese bishops founding cities in a far-off, gold-rich land.

The four wanderers were escorted to Culiacán, some 400 miles south of Di Peso's Paquimé, where the Lord Mayor was quite taken with their hints of fertile lands and marvelous cities in the north. Ultimately, their tales bought them a ticket to Mexico City. In 1539, they told them to Antonio de Mendoza, the first Viceroy of Nueva España. He bought enough of their stories to send out a cautious little party to investigate. Estéban served as the guide, Fray Marcos de Niza, a Franciscan missionary, led the expedition, and the three gentlemen remained in Ciudad de Mexico, busying themselves with more suitable matters.

Fray Marcos Reports Marcos de Niza was already known as a seasoned explorer who'd served with Pizarro in Peru. He was soon to become known as a liar of Munchausean proportions.

After a few months on the road, Fray Marcos returned to New Spain without Estéban (he'd been done in by the Zunis) and with a report of his viewing of the first of the cities of Cíbola. "The houses are all in stone, built in stories and with flat roofs. Judging from what I could see from the height where I had placed myself to observe it, the settlement is larger than the City of Mexico." If you've seen Zuni, you might have a hard time imagining any part of it being as large as Mexico City, even the primitive Mexico City of 1539.

To give Fray Marcos his due, and most historians don't, there might be some basis or at least some excuse for his reports. Estéban most likely met his end at Hawikuh, near present-day Zuni, and Fray Marcos continued north, where he viewed his great city across a valley. Walpi at Hopi (northwest of Zuni) and Acoma (east, not north) are both situated on tall, sheer-walled mesas, and he could have overestimated their size. Also, yellow pottery was fashionable at both Hopi and Zuni in 1539. Although he didn't actually mention any firsthand viewing of treasures in his official report, he or his men may well have seen some "vessels of gold" along the way.

His stories encouraged Viceroy Mendoza to dispatch the young, handsome, brave Vásquez de Coronado at the head of a major

expedition to plunder the gold of Cíbola in the spring of 1540.

Coronado Goes North Things went wrong for Coronado from the beginning. The expedition left the west coast town of Compostela with great pomp and ceremony, more than three hundred Spanish soldiers, thirteen hundred natives, fifteen hundred horses and mules and enough cattle and sheep to feed them all. Two naval vessels under the command of Hernando de Alarcón were there to support the glorious conquest of the Golden Cities.

By the time the grand processional reached Culiacán, 300 miles up the coast, reality was setting in. The numbers shrank as some of the gentry who'd come along for the glory decided that the campaign was going to be less fun than they anticipated. The group that left for Cíbola had had its shakedown, and it was tougher and more professional.

Neither Coronado nor Marcos de Niza, accompanying the mission as both spiritual and geographical guide, tarried in the desert country this book is about, and since the desert was in all likelihood virtually abandoned during those years, there was little reason they should have.

They just rode north through Sonora and eastern Arizona until they reached Zuni, then went to more interesting lands farther on. When they were done annoying and occasionally slaughtering the natives from Hopi to present-day Kansas, they rode back

without ever having found the gold they were looking for.

Coronado did, however, find out about his spiritual guide. He wrote about Fray Marcos to the Viceroy, saying, "About the Seven Cities, the kingdom and province of which the Father Provincial gave your Lordship an account, I can assure you he has not told the truth in a single thing he said, except the name of the cities and the large stone houses."

Alarcón Goes Diagonally Coronado's navy had a more significant contact in the desert. In May 1540, Hernando de Alarcón's two ships sailed up the Sea of Cortez from Acapulco filled with provisions. In theory, they were to rendezvous a few hundred miles north. Coronado's troops did go due north from Culiacán, but unfortunately, the Gulf of California points northwest. By the time Alarcón reached the mouth of the Colorado, he was about 300 miles west of Coronado's route. He sailed his ships as far up the river as he dared, then took his longboats and went farther. (Important to bear in mind: Lake Cahuilla was dry in 1540, and the Colorado reached the Sea of Cortez the same way it does today.)

Alarcón encountered the Cocopa, a people he described as tall and physically powerful. He may have made it all the way up to the Yuma Crossing, the confluence of the Gila and the Colorado, a place that played a major role in the history of the Southwest for most of four centuries. Then, realizing he'd never find Coronado, he went home to Culiacán, but not before he took care of business.

He buried letters reporting his progress under a tree, confident that others from the expedition would find them. Surprisingly, he was right.

Díaz Goes Laterally The first known overland exploration of Arizona's desert by Europeans took place a few weeks later. Coronado realized he was getting farther and farther from the Sea of Cortez and sent one of his captains, Melchior Díaz, to meet Alarcón. Díaz left the expedition and headed west across the Sonoran desert to the Sea of Cortez, then north to connect with Alarcón, who had already left.

He met the Cocopa, found the tree and read the letters. He sent messengers to report to Coronado, and those messengers might have followed the Gila east and become the first Europeans to cross Arizona's desert.

Díaz and the rest of his company poked around the area for a while and actually looked at California, at least until Díaz died when he fell off his horse and onto his lance. The rest of his men packed up and went back to Culiacán. Meanwhile, hopes for Coronado's adventure evaporated. He came back to Mexico City in 1542 with nothing good to report.

The Spanish found no profit of any sort in the desert, and they didn't hurry back.

Vessels of gold from the cities of Cíbola: Zuni, Matsaki Polychrome, ca. 1550. The larger bowl is 13½" in diameter, the smaller is 7½".

Early Days: Oñate

The Spanish conquest of the desert was hardly conducted at lightning speed. In 1582, Antonio de Espejo traveled up the Rio Grande to today's Albuquerque, then turned left through Cíbola in search of the treasures that had evaded Coronado. He found his way to Hopi and down to the Verde Valley, contributed a massacre along the way and continued what was becoming a tradition. He told the officials in Mexico City about a lake of gold in northern Arizona.

There were abortive expeditions over the next few years, but the big authorized one came in 1598. Governor Captain General Don Juan de Oñate took over a pueblo in north central New Mexico, then made a quick November run across Espejo's route to check out that golden lake.

Affairs of state called him back to the Rio Grande, however, and he established a provincial government at what is now San Juan Pueblo, across the Rio Grande from where he first settled. He named his colony Nuevo México, and steady European travel between Spanish Mexico and the new settlements began almost immediately. The Rio Grande became the highway north.

Conquest had its rocky moments. Stories of the region's fabled wealth still lingered, and Oñate's fruitless military expeditions in search of riches depleted the treasury and brought him a permanent reputation for cruelty. His behavior still makes many New Mexicans wince four hundred years later.

In 1599, Oñate sent one of his lieutenants to subdue a less-than-cooperative Acoma Pueblo. The Pueblo sits on a 300-foot-high sheer-walled mesa that even the greedy Coronado felt was beyond attack. Somehow, the Spanish managed to get a cannon up to the top and, to make the point, killed six hundred Acomas, took another six hundred prisoners,

The glories of conquest, as depicted on a nineteenth-century Arbuckle's Coffee advertising card.

sentenced the surviving women to slavery and cut one foot off every surviving adult male.

By 1604, Oñate's political star was falling rapidly, and he needed a serious public relations boost. He decided to answer a question that had puzzled mapmakers for nearly a century. From the time of Cortez, soldiers, missionaries and explorers had looked at the Sea of Cortez and the thin strip of land across it and decided that California had to be

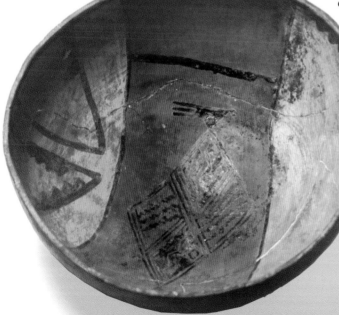

When he arrived in New Mexico, evidences of Aztlan may have given Oñate hope. Here, another tantalizing hint: parrots on a 12¾" diameter Agua Fria Glaze Polychrome bowl from the Santa Fe area, ca. 1525.

an island. Although Alarcón had come to the head of the gulf, found a river rather than an ocean and, according to Coronado's historian, reported that California wasn't an island, the island theory persisted.

Oñate, along with thirty soldiers and two padres, set out to settle the matter once and for all. He marched past Cíbola and reached the Colorado about 150 miles upstream from the Yuma Crossing. Fourteen months after he started, he reached the mouth of the Colorado. The reason for the glacial pace of the expedition, according to the padre who documented it, was that Oñate always had time to listen to any tall tales he encountered along the way.

One upriver chief named Otate offered reports that put Fray Marcos de Niza to shame.

Oñate's calling card: his 1605 signature carved at El Morro.

He insisted that California was in fact an island and populated by monsters. He told Oñate of tribe after tribe who would have strained credulity in *Gulliver's Travels*. Two examples: a nation of savages whose ears were so long they dragged on the ground and, if supported on poles, could shade six people, and a tribe of one-legged people who were half man and half fish and slept underwater.

Based on this and other testimony, Oñate concluded that his research was complete, went back to Santa Fe and announced that his exploration had proven that California was an island. He left a record of the excursion carved on Inscription Rock at El Morro National Monument just east of Zuni. It's still there for everyone to see, conveniently blacked in by the Park Service to make it more legible, and it declares that he discovered the "Sea of the South." It took another hundred years to put California back firmly on the American mainland.

As there's a weak defense, or at least a possible explanation, for de Niza's bizarre reports that prompted Governor Mendoza to send Coronado to look for Cíbola, there's also a defense of sorts for Oñate's belief that California was an island.

It's quite true that de Alarcón found the mouth of the Colorado and drew an accurate conclusion. However, that was in 1540, and there's evidence that the Colorado river did its periodic parlor trick around 1600.

In 1604, Lake Cahuilla could have been refilling, and if Oñate really did reach the mouth of the Colorado, it might no longer have been where Alarcón said it was. Although Lake Cahuilla didn't fill all the way this time, Oñate could have seen endless sea to the north and what looked like the island of California in the distance.

The great expedition didn't revive Oñate's flagging career. Food was scarce, winters were harsh and the Franciscan padres were disgusted with his atrocities. In 1609, they managed to get him recalled to Mexico City. A new governor moved the seat of government 30 miles south and, in 1610, established Santa Fe as the capital of Nuevo México. It still is.

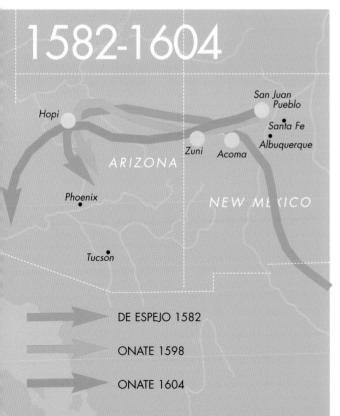

1582-1604

Hopi

San Juan
Pueblo

Santa Fe

Zuni Acoma Albuquerque

ARIZONA

Phoenix

NEW MEXICO

Tucson

DE ESPEJO 1582

ONATE 1598

ONATE 1604

Vida en la Frontera

During the sixteenth and seventeenth centuries, Spanish occupation slowly edged northward, always driven by the ongoing search for the treasures of Aztlan.

Coronado, Espejo and Oñate focused their attention on the Rio Grande and northern Arizona, but the real productive finds were farther south. That was where Oñate found the riches that provided most of the financing for the expedition that appropriated the land of Nuevo México.

Silver strikes in Zacatecas, Durango and Chihuahua paid handsomely during the middle years of the sixteenth century. The government of Nueva España established a northern frontier state called Nueva Vizcaya, and treasure hunters poured into the area.

These treasure hunters didn't follow the model of the grizzled Old West pick-and-pan prospectors. They envisioned a full-scale mining industry supported by fully staffed sheep and cattle ranches. In their business plan, slaves did the hard work, and the best sources of slaves were the local Indian villages.

It was a greed-driven economy, and conditions got so unpleasant that the authorities in Mexico City couldn't look the other way. Despite efforts to see that what happened in Nueva Vizcaya

Unmistakeable symbol of authority: a conquistador's sword of Toledo steel.

stayed in Nueva Vizcaya, the news got out, and in 1575, the Spanish government enacted new legislation that forbade attacks on Indians and assigned the responsibility for pacification of new areas to the missionaries.

The new laws weren't able to correct all the abuses, as Oñate, who'd earned his fortune and learned how to deal with the natives as a miner in Nueva Vizcaya, demonstrated in New Mexico. One can only wonder how he might have behaved if he hadn't had Franciscan padres at his side throughout his administration.

Part of the problem resulted from the *encomienda* system. Under it, the government granted individuals the right to collect taxes, tribute and forced labor from whole pueblos and even whole tribes. Someone like Oñate could go a long distance with this sort of legal sanction.

By 1610, cooler heads in Spain had shifted the emphasis for conquest. Instead of sending armies to conquer Indian nations and seize their treasures, it seemed to make more sense to send missionaries to make good Christians out of the Indians, teaching them language, carpentry and religion, and keeping them occupied building missions.

Soldiers still maintained order, enforcing the law with horses, muskets and Spanish steel. By 1630, the missions fanned out for more than 500 miles, from Pecos, east of Santa Fe, to Hopi, in the mountains of central Arizona.

Sadly, the pacifying priests weren't always completely pacific. The Indians were generally

impressed with Christianity, at least in the beginning, and showed considerable willingness to incorporate the padres' rituals into their own religions.

This, of course, outraged the padres. They forbade any practice whatever of the idolatrous, hell-bound native religions and, to make sure their orders were followed, they imprisoned native shamans and religious leaders or had them killed.

To complete the task, they sent soldiers into the kivas (the Indian worship chambers) to destroy any religious articles they might come across.

During the 1600s, the second modern U.S. city began developing in our Little Chichimeca, and its growth owed much to Indian impatience with Spanish policies. Santa Fe was a thriving community by 1630 but getting there was definitely not half the fun.

Travelers had to negotiate the stretch where the Rio Grande turns north through southern New Mexico, and the terrain, climate and likelihood of Apache attacks made it so unpleasant that they called it the *Jornada del Muerto*, the Journey of Death.

The Spanish established *El Paso del Norte*, The Pass to the North, on the Rio Grande in 1659. It served as a provisioning base for colonists on their way to Santa Fe. El Paso's fortunes got a boost when it became the seat of government for Nuevo México in 1680.

Pueblo Indians had become so annoyed with Oñate and his successors that they drove the Spanish out of Santa Fe and all the way down the Rio Grande to El Paso, where they stayed for twelve years gathering strength for the reconquest.

In 1692, troops led by Don Diego de Vargas managed to subdue the Pueblos and the provincial government moved back to Santa Fe. Nuevo México had been tamed. Commerce resumed between the two cities.

More unmistakeable symbols of authority: the conquistador's helmet and wheelock pistol. It's not hard to understand how a few Spanish managed to turn thousands of Indians into good Catholics, loyal subjects of the crown and hardworking employees.

The Missionaries: Kino Opens the Door

When Diego de Vargas retook Santa Fe, he faced a problem with the Hopis. They'd joined the Pueblo Revolt of 1680 and had done in their missionaries, as had most of the other Pueblo Indians.

Since Vargas sat in Santa Fe, 400 miles away from the Hopi mesas, enforcement was difficult. He settled the matter in a statesmanlike way, promising no reprisals if the Hopis pledged allegiance to King Carlos.

Since it cost them nothing, they did. But they also refused from that day on to allow the Spanish to cross their land, and since, to the Spanish, crossing it wasn't worth the trouble, everything worked out.

The detente had historic implications. It meant that Arizona would be settled from the south rather than from Santa Fe, and it took a long time for the next important modern U.S. city to appear in the desert. If Santa Fe existed largely because of Oñate, a man whom historians generally portray as one of the least-likeable early settlers, Tucson owes its modern rebirth to perhaps the saintliest of all the early missionary/explorers, the Jesuit Padre Eusebio Francisco Kino.

Between 1687 and his death in 1711, Father Kino rode thousands of miles across the northern Sonora desert that includes most of Southern Arizona. This was no easy country. If you didn't care for the Jornada del Muerto along the Rio Grande in southern New Mexico, there was always the *Camino del Diablo*, or Road of the Devil, the hellish, vaguely defined route west. It crossed from north-central Sonora to the Colorado River. Díaz took it in 1540, and Kino traveled it again and again during his mission-building years.

Kino had an unusual approach for the times. He believed that feeding and healing Indians was a better idea than whipping and enslaving them. He introduced new crops and drove the first beef cattle into southern Arizona, brought the natives small presents when he visited, doctored their children and spoke long and respectfully with their elders.

He built missions and outposts in the San Pedro and Santa Cruz valleys and, in 1700, built a mission in a Papago village named Bac. Rebuilt over the years and finally finished in 1797, San Xavier del Bac stands today on the outskirts of Tucson as the single most glorious architectural achievement of the entire Mission period. The next year, he built Guevavi Mission near modern Nogales and a small chapel at Tumacacori.

A footnote might be in order here about the words *Papago* and *Pima*, Spanish names for the two most prominent native tribes of southern Arizona. They called Sonora and Chihuahua northward *Alta Pimeria*, and called a subregion west to the Colorado the *Papagueria*. The tribes, who share a common language, refer to themselves as the O'odham—the Papago, Tohono O'odham, or Desert People and the Pima, Akimel O'odham, or River People.

Contemporary reports applauded Kino's saintly behavior. In *Arizona: A Short History*, Odie B. Faulk quotes a fellow padre's description of Kino's probity: "He prayed much, and was considered without vice. He neither smoked, nor took snuff, nor wine, nor slept in a bed. . . . He never had more than two coarse shirts, because he gave everything as alms to the Indians."

To some degree, he was also a product of his times. In 1700, in the middle of his career, there were dramatic political changes in Spain. For a hundred years, Spain had had Hapsburg kings, the last rulers of the Holy Roman

1687-1711

YUMA — Gila River — ARIZONA
Santa Cruz River
SAN XAVIER DEL BAC
TUMACACORI
GUEVAVI
SANTA MARIA
TUBUTAMA
COCOSPERA
CABORCA
REMEDIOS
DOLORES
SONORA

KINO'S TRAVELS
● MAJOR KINO MISSION ・ KINO CHURCH

Empire. Then Carlos II expired childless (our encyclopedia dismisses him with the word "imbecile"), designating Philip IV, a grandson of Louis XIV of France, as the next king. After a century of Germans, Spain was ruled by a Frenchman with a new agenda. The Hapsburgs wanted gold, the Bourbons wanted commerce. Instead of mines, they saw more future in farms and cattle ranches.

Father Kino also ended the arguments about whether or not California was an island. He made three trips along the Devil's Highway before he finally found the proof he needed. In 1702, he climbed an inland mountain east of the Colorado and saw the panorama as the sun rose over the head of the gulf. The Colorado, behaving itself again, poured into the Sea of Cortez as it does today. He had visual proof that the sea ended at the mainland rather than continuing on to meet the ocean, and wrote: "*California no es isla sino peninsula.*" Baja California was now a peninsula, not an island.

Alarcón had seen the mouth of the Colorado, but he hadn't convinced anyone. Kino saw the full picture, mapped it and became a hero of New Spain. Mission-building had begun in Baja California, and the only way to bring food and supplies was by a treacherous sea passage. Now, Kino had met the Quechan Indians and, according to one account, charmed them enough so that they built him a *visita*, or small retreat, at the Yuma Crossing.

From then on, it was clear that cattle and supplies could reach California simply by crossing a river instead of an ocean.

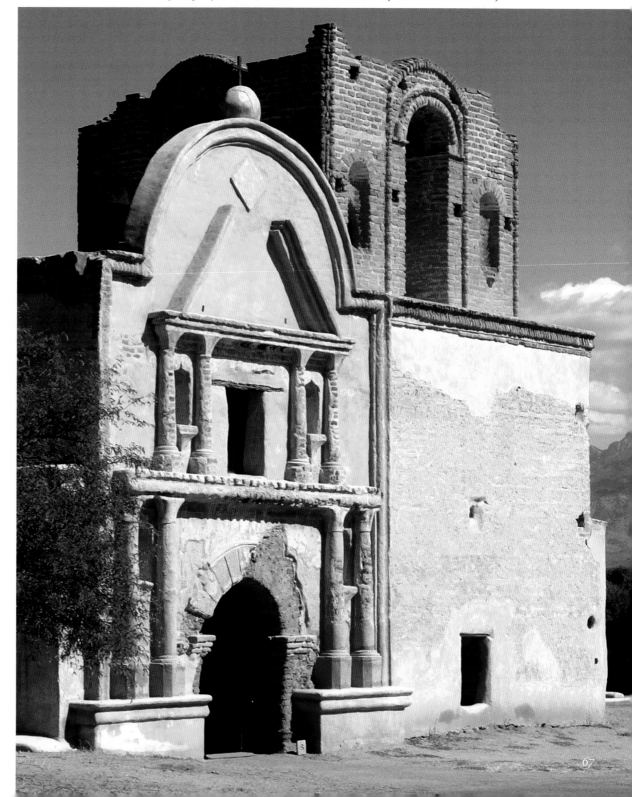

Kino's missions were barely more than mud huts, but over the years, his successors rebuilt them into imposing edifices. Here, Tumacacori, 60 miles south of Tucson, as it looks today.

Germans, Silver, Revolt

Kino never built the Missions he'd planned along the Gila and the Colorado. He died in 1711 at the age of sixty-five, and Spain pretty much ignored Alta Pimería.

The government continued to send Jesuit missionaries. Now they were practical Germans and Swiss with names like Kappus, Och, Grazhoffer, Middendorf, Nentvig, Sedelmayr, Ruhen, Steinhoffer, Segesser and Pfefferkorn, and they brooked no nonsense from the Indians, who in turn paid little attention to them.

Padre Och was particularly annoyed by what he saw as the laziness of the Spanish colonists and Indians and wrote, "if industrious Germans were in the country, matters would certainly be handled differently."

Unlike the Franciscans in Nuevo México, the Jesuit padres of Alta Pimería didn't have enough military control to make sure the natives stayed focused on their lecturing. These new padres also lacked Father Kino's communications skills.

It didn't take long for discontent to settle in. At Guevavi in 1733, the Indians lost patience with activities at the local parish and shortly after, Father Grazhoffer became the first of the martyred German Jesuits.

They weren't all as unsuccessful at parishoner relationships as Father Grazhoffer. Pfefferkorn played the violin and charmed the natives. Segesser admitted he couldn't sleep while the Indians were singing and dancing, so he worked out a compromise. When he couldn't stand it any longer, he'd ring the church bell and they'd stop. And Padre Ignaz Keller got along so well with the O'odham that, when his superiors recalled him in the 1750s, the Indians complained so strongly that the authorities relented and reinstated him.

A few years later, Don Pedro Alonzo O'Crouley, a Spanish merchant, wrote *A Full Description of the Kingdom of New Spain*. In it, he described the lot of the Indians and gave what was probably a reasonably accurate insight into the prevailing attitudes of the day, which probably extended in some part to the Jesuit missionaries.

O'Crouley discussed a royal pronouncement from Philip IV decreeing fair treatment for all subjects of the kingdom, then went on to say, "The truth, however, is far otherwise; for the mayors and judges who should put these laws into practice are intent only on benefiting by the labours of these unfortunate people."

He states, "I have been amazed to hear people say that comfort and mild treatment are bad for the Indians, that in order to get them to work, one must drive them like animals, and that consideration and kindness spoil them and are detrimental to their health."

In 1736, the Spanish finally found a bit of treasure on the road to Cíbola. They made a silver strike at Planchas de Plata, and a silver town named Arissona sprang up about a hundred miles west of Tucson near today's Arizona/Sonora border. It didn't last long— it doesn't show up on Don Joseph Antonio de Alzate y Ramirez's highly detailed 1768 map of Nueva España—but it made enough of an impression to give the territory its ultimate name.

The discovery brought an influx of miners, and the newcomers disrupted the tranquil lives of the local Indians. An O'odham headman named Luis helped the miners fight off the nearby Seri Indians, and the grateful Spanish appointed him Captain General of all the Pimas. He took his position too seriously for Spanish tastes, and relations steadily worsened.

Eventually, he decided to drive the Spanish out and take control of the ranches, mines and missions for the O'odham. In 1751, he lured twenty Spaniards

Spanish silver: coins from the 1770s, shaped into conchos, perhaps by a modern Navajo.

to his home on the pretext of providing them shelter against Apache raids, then set fire to the place. They were all burned or killed trying to escape, and Arizona had its first broadscale Indian uprising. More than a hundred Spanish were killed in the next few days, along with Padre Ruhen, the next German martyr. Eventually, Spanish soldiers cornered the O'odham warriors in the Santa Catalina mountains north of Tucson, and Nueva España was forced to regard Alta Pimería, and Arissona, with new respect.

The next year, the Spanish established a garrison at Tubac. Five years later, the population had grown to four hundred men, women and children. Arizona had the beginnings of its first true town.

In his description of Nueva España, O'Crouley volunteered drawings of the three classes of Indians as he observed them in 1774. The dress for "civic officials and men of substance . . . is rather like our own," while common wear was more casual. Meanwhile, "The poorest Indians (which means practically all of them, of both sexes) go half-clad in skins."

Paz Aguardiente

In 1767, Carlos III of Spain, apparently concerned with heavy doings in Europe and wary of international conspiracies, rounded up all the Jesuit padres in Nueva España and called them back to Spain. He sent Franciscan replacements, and in their first years, they took the lead.

In 1774, one of their number, Padre Francisco Garcés, had begun the process of opening a passage to California at the Yuma Crossing of the Colorado. Despite the efforts of Garcés and the Franciscans, a succession of broken promises and political and military blunders so outraged the Quechan Indians that in 1781, they massacred the small settlement at the Crossing and ended any hope of a land passage from Arizona to Alta California for the remainder of the existence of Nueva España.

The Alta Pimeria was out of control, and something had to be done. Various administrators had tried and failed. Military experts inspected the northern presidios and found that everything about them was wrong. The soldiers' array of uniforms, armor, guns, powder and tactical instructions combined to produce a fighting force incapable of controlling or even catching up with the Yumans, much less the the Apaches, who by now were everybody's worst enemies. The man for the job emerged. Bernardo de Gálvez, the

new Viceroy of Nueva España, might have been the role model for Leo Durocher's "nice guys finish last." He didn't conquer the Indians, he outsnookered them.

In 1786, he wrote his *Instructions for the Governing of the Interior Provinces of New Spain*, declaring war on all Indians who didn't toe the line. Under the diabolical genius of his plan, once Indians were subdued, they were to be relocated in an easily supervised settlement and given gifts, obsolete firearms and all the *aguardiente*—the Mexican version of white lightning—that they could drink.

The reasoning went like this: All things considered, the Indians would find peace easier than war. They'd be delighted to get guns, which would put them at parity with the Spanish. The guns, of course, wouldn't work unless the Spanish repaired them, so they'd have to stay on the good side of the Spanish. And the aguardiente would solve whatever other problems might arise.

Conquered Apaches near Tucson were given weekly rations of food, tobacco, candy and aguardiente. They were also allowed to keep

their firearms and native religious customs.

The plan worked, much to the disgust of the Franciscans. Instead of good Christian ways, the Apaches at Tucson remained unashamedly pagan while, according to Padre Diego Bringas de Manzaneda, they learned "card playing, gambling, dancing, swearing and drunkenness."

There were compensations for the padres, however. The peace that Gálvez's scheme produced meant that at last, mining and farming could prosper, at least on a small scale, and ranching, the number one industry, could flourish. Peace and prosperity brought money to the church, and the Franciscans invested it in some of the most fabulous of all the mission churches.

Today, anyone who visits Tucson and fails to see San Xavier del Bac, the mission father Kino laid the foundations for in 1692, misses one of the all-time visual treats. Between 1783 and 1797, the Franciscans created the White Dove of the Desert at the then unheard-of cost of forty thousand pesos.

Words can't describe it. Just look at the pictures.

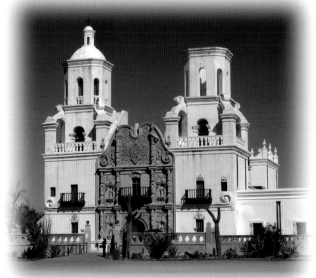

Tucson's San Xavier del Bac, the White Dove of the Desert. Though it was never quite finished, it remains the grandest of all the missions in Nueva España's northern provinces.

The interior of San Xavier del Bac, the ultimate triumph of the Franciscans, decorated, maintained and beloved by Spanish and O'odham alike.

California Happens

About the time Carlos III sent the Jesuits packing, events were unfolding rapidly out along the Pacific. News reached Madrid about Russian efforts to establish empire in Alaska and down the north coast. If the king were to hold California, he had to secure it militarily.

In 1769, Don Gaspar de Portolá, newly appointed Governor of California, set out from Baja California with an army of forty-one soldiers and two Franciscans to the known ports of San Diego and Monterey. He marched up the coast to San Diego, established a *presidio*, or fortified settlement, divided his forces, left behind one of the padres to establish a mission and continued on toward Monterey.

He somehow missed it, but beginner's luck gave him his place in history. He stumbled on San Francisco Bay, and the discovery excited the authorities so much that they ordered him to build a chain of eight missions and presidios between San Diego and San Francisco. These were to augment and extend an existing chain in Baja California.

The Baja missions were small and poor, and the initial expectations for the new ones in Alta, or Upper, California probably weren't particularly ambitious. However, the Franciscan whom Portolá left in San Diego was a man named Junipero Serra. He opened the first mission at San Diego in 1769, and eventually accomplished so much that today, it's impossible to spend a day or two along the California coast without encountering something named after him.

Controversy still revolves about him. In the 1960s, there was a strong movement within the church to canonize him, and he still stands one miracle short of sainthood. At the same time, articles in California newspapers focused on the mistreatment of Indians in the mission system and portrayed Serra as a Hitlerian autocrat.

Saint or sadist, Serra gets much of the credit for founding an empire. His record as a converter and savior of souls might be questioned, but as an effective implementer of Charles III's economic plan, his accomplishments were staggering. He laid the groundwork for what, cumulatively, became one of the biggest cattle ranches of all time. By the end of the eighteenth century, whether or not the California missions actually converted the heathens was of diminishing importance to the Spanish government. This was, after all, the Age of Enlightenment, and practical, secular matters were becoming the top priority. What Alta California really had to do was provide hides and tallow for Spain, and

California vaquero spur, made about 1800. The nasty looking rowels are nothing compared to the long, sharp spikes on a pair that a sixteenth-century Spanish conquistador would have worn.

THE MISSION TRAIL, WITH SERRA'S NINE MISSIONS IDENTIFIED

SAN FRANCISCO DE ASIS 1776
SANTA CLARA 1777
SAN CARLOS BORROMEO 1770
SAN ANTONIO 1771
SAN LUIS OBISPO 1772
SAN BUENAVENTURA 1786
SAN GABRIEL 1771
SAN JUAN CAPISTRANO 1776
SAN DIEGO 1769

NEVADA
CALIFORNIA

1769–1824

Serra's missions ultimately managed half a million head of cattle.

The job of wrangling these herds fell to the *vaqueros*, Spanish horsemen, literally *cow handlers*. Of course, there were nowhere near enough Spanish horsemen to handle five hundred thousand cows. Almost from the beginning, the job fell to the Mission Indians, who adapted so well that later Anglo cowpunchers aspired to become true buckaroos—a word that exists because the *Yanquis* couldn't pronounce *vaqueros*.

By the end of 1770, the Spanish had found Monterey Bay, and Serra opened mission San Carlos Borromeo in Carmel. Others followed quickly, and by the end of 1772, there were five missions in Alta California. At Serra's death in

1784, there were nine. Ultimately, the Franciscans built twenty-one California missions, seven of them in the southern portion between Santa Barbara and San Diego.

Not everyone appreciated what the padres achieved during California's mission years. There were rebellions, the first as early as 1775 in San Diego. And there was terrible international publicity. In this Age of Enlightenment, the rest of Europe saw Spain as the most unenlightened country of all and also the one that controlled the largest expanse of world real estate.

In 1786, Jean François de La Pérouse kept a journal of his visit to San Carlos Borromeo, which still attracts thousands of tourists yearly. On the whole, de La Pérouse was more restrained than most non-Spanish observers in

describing mission life, but he couldn't resist tossing a few barbs: "Corporal punishment is inflicted on the Indians of both sexes who neglect the exercises of piety, and many sins, which in Europe are left to divine justice, are here punished by irons and the stocks."

He explained that, once baptized, the Indian was a prisoner of the mission who, if he escaped, would be brought back to the mission by soldiers and given a prescribed number of lashes. Whipping also occurred if Indians were caught pilfering any of the barley used in the preparation of *atole*, their main food, a soup de La Pérouse described as a substance which, "would to us most certainly be an insipid mess."

He reported a double standard in whipping etiquette. "Women are never whipped in public, but in an enclosed and somewhat distant place that their cries may not incite a too lively compassion, which might cause the men to revolt. The latter, on the contrary, are exposed to the view of all their fellow citizens, that their punishment may serve as an example."

From the 1780s on, atrocity stories came one after another, sensational accounts written by French, English, Russian and American observers, each more dreadful in its description of Spanish barbarism than the one before, and each, most likely, with a suspect political agenda.

If world opinion could be rallied against Spain, shouldn't empire partitioning follow soon after?

An early twentieth-century postcard recreates where the spurs might have come from. By the time this postcard was made, we were already nostalgic for the good old days.

Spain Loses Its Grip: The Unconquered

Toward the end of the eighteenth century, Spain was on top of the world and in the process of falling off.

Its empire embraced tens of thousands of miles of frontier in Africa and the Americas, all of which needed attention. In North America alone, the north rim of the empire extended in an unbroken line from Florida to California. It doesn't require complex mathematics to understand that a country about three-quarters of the size of Texas would have found it difficult to send out enough soldiers, missionaries and support staff to manage an area that included most of the land in the western hemisphere.

The only way the system had a prayer of working was for Spain to enlist the natives as allies, which they did, and remarkably well considering the difficulty of the task. The selected manner of conscription, and the one that seemed to work best, was conversion to the Faith.

Across the whole Gran Chichimeca, the Spanish did occasionally gain Indian allies, but the alliances rarely held, largely thanks to Spanish attitudes towards the Indians. No matter how many high-sounding pronouncements came from Madrid, the soldiers and the nonclerical Spanish saw too many opportunities to convert those potential allies into potential slaves, and they treated the Indians accordingly.

The frontier padres did little better. They conducted mass baptisms, then demanded that the new converts discard and destroy all pagan idols, rituals and habits. Along the Colorado, these unbending standards created resentment, conflict and ultimate rejection.

In other areas, a few padres found that allowing the Indians to come to a comfortable blending of faiths worked better, but there weren't many of those tolerant clerics. Some started out with an open mind, but found it hard to stay mellow once they got in the field and experienced instant rejection based entirely on the behavior of their predecessors. Higher levels of acceptance on both sides were confined to sophisticated areas like Santa Fe and around the larger missions on Kino's trail.

The lessons were clear on both sides. To the Indians, the Spanish were best avoided and offers of friendship never to be trusted. To the Spanish, the Indians needed to be controlled, with force as necessary. In this context, the whole made-in-Madrid plan of missionary conquest of Alta California was on a shaky foundation.

When the exasperated Colorado River Indians did in Father Garcés and the rest of the missionaries, troops and settlers at the Yuma Crossing in 1781, it was a major blow. The government of New Spain couldn't tolerate the loss of the land route to California and took action, which cost lives and accomplished little. Seven years of bungled relations with the Yumans had gained the Spanish permanent enemies with a long history of standing their ground against all comers.

The principal Yuman tribe, the Quechan, normally allied themselves with the upriver Mojaves, and together they'd managed to display a lot of muscle. Earlier, in the 1600s, the Quechan and the Mojaves had driven the Maricopa east to the Gila River and into O'odham country. They also booted out three other Colorado River tribes, all of whom ended up with the Maricopa.

The Mojaves created another problem for the Spanish, who were convinced that a series of mid-1780s attacks on southern California missions by Yuman-speaking Indians were Mojave-supported.

Discipline was necessary, but not easily enforced. The first sorties against the Quechan

A modern replica of a 7½" long Yuman peacemaker, made of rock-hard mesquite. They'd poke the sharp part in an enemy's stomach, then whack him on the head with the other end.

at the Yuma Crossing had proved unsuccessful, so the Spanish tried a divide-and-conquer technique that they'd experimented with over the years. They worked a deal with the Halchidoma, another Yuman tribe who'd had issues with the Mojaves, and formed an alliance that, theoretically, would end the Quechan and Mojave nuisance once and for all.

As usual, the Quechan and the Mojaves sent them all running. The Spanish went back to Tucson with their tails between their legs, and the Halchidoma found themselves exiled to the Gila along with those other Colorado River tribes.

After that, the Spanish gave up on the Yuma Crossing, and anyone bringing goods to the California missions came by sea or brought a mule train along the new Spanish Trail, an inconvenient side trip from Santa Fe that wandered north across Utah and Southern Nevada. One side effect of the Quechan victory was that the displaced Yuman tribes found they got along just fine with the resident Akimel O'odham, and that alliance ultimately became more powerful than anything the Quechans and the Mojaves could muster.

In Yuma, old memories die hard. Now there's a Catholic church on Indian Hill by the Crossing, and there's a fine statue of Father Garcés standing before it. Quite a few Quechans would prefer it weren't there at all.

The original battleground:
The Yuma Crossing lies a few hundred feet north of Interstate 8. You can go to a museum and read about it, then walk to the river's edge and remind yourself that you're looking at a pivotal place in American history.

Adios, Nueva España

Down in Mexico City, things weren't going too well. By the early nineteenth century, the Age of Enlightenment, with its freethinking, anti-clerical principles, had evolved into the Age of Democratic Revolution. In 1810, it was Mexico's turn, and a padre named Miguel Hidalgo rallied the Mexican people to the cause of freedom. Hidalgo's insurrection failed, and he was executed, but the seed was planted. For the next eleven years, Mexico moved towards independence.

Meanwhile, the unrest had reached Spain as well. An 1812 military rebellion marched to Madrid and forced King Ferdinand VII to sign a bill of rights that gave sovereignty to the people and cut back the powers of the church. The confusion made Spain increasingly unable to control the western hemisphere, and in 1819, it gave up on Florida and ceded it to the United States in exchange for a boundary agreement on the western edge of the Louisiana Purchase.

As Spain's control weakened, the Mexican upper classes emerged as the strongest force for separation. They'd become powerful enough and rich enough to see the more egalitarian components of Spain's 1812 constitution as a threat rather than a benefit.

Mexico's old families, who claimed long ancestral lines back to Old Spain, were living quite well, and the saltillo textile below stands as a symbol of their status.

Saltillo is a town a couple of hundred miles south of Del Rio, Texas, in Coahuila, the Mexican state just east of Chihuahua. In the mid-eighteenth century, it had become a trading center for fine woolen textiles, so well made that the town's name became a synonym for the textiles themselves. The combination of fine weave, beautiful colors and elaborate geometric patterns made them so desirable and so expensive that they quickly became the property of the wealthy, and there were enough of the wealthy to keep the market for classic saltillos

active for more than a century.

The people who could afford saltillos weren't about to sit still for a ragtag democratic government, and they aligned themselves behind an aristocratic military man named Agustin de Iturbide, who combined his seditious efforts with those of a rough-hewn insurgent named Vicente Guerrero. In 1821, Iturbide and Guerrero signed the Plan of Iguala, assuring independence and equality for Mexico. The last viceroy acquiesced, Spain was officially out, and, in 1822, the patrician Iturbide became emperor of the sovereign state of Mexico.

He wasn't emperor for long. He was booted out within a year, and Mexico had a more liberal, federalist constitution

Opulence from the last days of the Empire: an eighteenth-century Spanish silver tureen. At 17" in diameter, it made quite a statement.

by 1824. It also had a string of *presidentes*-of-the-month, with the record-holder claiming a tenure of forty-five minutes. Finally, a strongman, Antonio Lopez de Santa Anna, took over and ran the new republic of Mexico for thirty years. There were fractious politics in Sonora and Sinaloa, the next states south of Arizona. One of the new government's early acts was to combine all territories north to the edge of the Mexican Empire into *El Estado Libre de Occidente.* This Free State of the West saw twenty-three governors over the next twenty-five years, and divided itself into the present-day Sonora and Sinaloa because the two districts couldn't get along. Arizona remained attached to Sonora, but, as one historian put it, few of its citizens

were "literate enough to care about the political system of the new Republic of Mexico or to inquire about their place in it." Tucson was its biggest city, with sixty-two in people 1819.

In California, the Mexican government relaxed trade restrictions, and ships from England and the United States started showing up at the missions near the Pacific. The new order, disorganized as it was, offered a golden opportunity for a growing segment of Alta California's population, the *Californios.* These were primarily but not exclusively Spanish settlers and landholders with no connection to the mission system. There had been a long-standing plan to secularize the missions' farm and range lands, and the Californios pushed for its enactment and the chance to grab some choice land for their own ranches.

Over in New Mexico and into Texas, life had been reasonably stable in the eighteenth century, but things were about to change there, too. The Santa Fe Trail opened in 1821, and English-speaking trappers and settlers flowed in from the east. The first hints of Yankee colonization were appearing in the Southwest. Right from the outset, events conspired to weaken the new Republic of Mexico's hold on its northern provinces.

A nineteenth-century saltillo fragment. It was originally about 3'8" x 5'8", and it undoubtedly cost its first owner a pretty peso.

Mexico's Tenure: The New Order

The Republic of Mexico started out with high hopes for a golden future. In 1821, the United States was absorbed with its own growing pains, and it still seemed possible for Mexico to take control as the dominant force in North America.

Reopening the land passage to Alta California would help. So far, the only expeditions that managed to make it across the Colorado were two led by Captain Juan Bautista de Anza and Father Garcés during the few months between 1773 and 1776 when the Spanish and Yumans got along.

In 1823, a padre named Félix Caballero somehow managed to get to Tucson from Baja California and met with Captain José Romero, commander of the Tucson presidio and deputy governor of an ill-defined and barely populated territory.

Romero and Caballero got permission from the commanding general to take ten soldiers and try their luck at getting to the mission in San Diego. Discretion being the better part of valor, they headed far south of the Yuma Crossing and came to the Colorado near its mouth. They found the natives there friendlier and talked them into helping the company cross the river. Despite the fact that the Indians stole most of their provisions, the expedition made it across with no casualties

and all arrived in San Diego alive and safe.

This was big news in Mexico City. Romero was hailed as the "new Anza" and promoted to lieutenant colonel, as his predecessor had been. However, because his company succeeded by sneaking around the Yumans rather than by overcoming them or befriending them, it didn't take long for the government to realize that the achievement was actually a non-event. Romero had described the trip from Tucson to San Diego as "not more than ten or eleven days walk, but there is the obstacle of the Colorado River." It remained an obstacle. It took Romero more than two years to figure out how to get back to Tucson.

As the Mexican Republic groped toward national stability, funding for the outlying provinces dried up. In 1831, the Apaches realized that the long-standing policy of keeping them pacified with gifts and aguardiente was coming to an end. They attacked, signaling the end of more than forty years of alcohol-marinated peace.

The local govenment in Sonora forgot all their recent lessons and reverted to the old ways. They set out to subdue the Apaches by force. Since they had no money to finance an army,

the governor passed the hat looking for public contributions, and when that failed, cut the salaries of all public officials.

In 1834, the Republic of Mexico passed a law secularizing all remaining missions. Tumacacori housed O'odham Indians until the governor's brother-in-law bought it at auction and put up a woolen mill.

In Alta California, the Californios took over the secularized mission lands. The original idea was that the Indians, now released from serfdom in the missions, would share in the land ownership, but the settlers found ways to grab virtually all of it. This left the Mission Indians displaced and no better off than they had been under the old system, while inland Indians who had escaped missionization continued to fight any and all Europeans and raid ranches and churches for livestock.

Nothing was working right anywhere in the northern provinces, and in 1838, Mexican authorities in some states made the cruelest and stupidest move of all. They reinstated an old Spanish practice, the scalp bounty system. If you brought in an Apache scalp, you got a hundred pesos. Since

Mangas Coloradas: a career begun.

Apache scalps looked like the scalps of all the rest of the Indians, and, for that matter, most Spaniards, bounty hunters had a field day. Shortly, almost all Chihuahuan and Sonoran Indian groups were at war with the government.

In 1837, a Yanqui named James Johnson went to an Apache village bearing gifts, including a cannon with a plugged barrel. As the citizens gathered around, Johnson lit the fuse and moved back in a hurry. The cannon blew up, killed most of the spectators, and gave Johnson a nice payday. He missed one, however.

Mangas Coloradas, a relative of the town's chief, escaped and eventually became one of the most feared players in the Indian wars in the decades that followed.

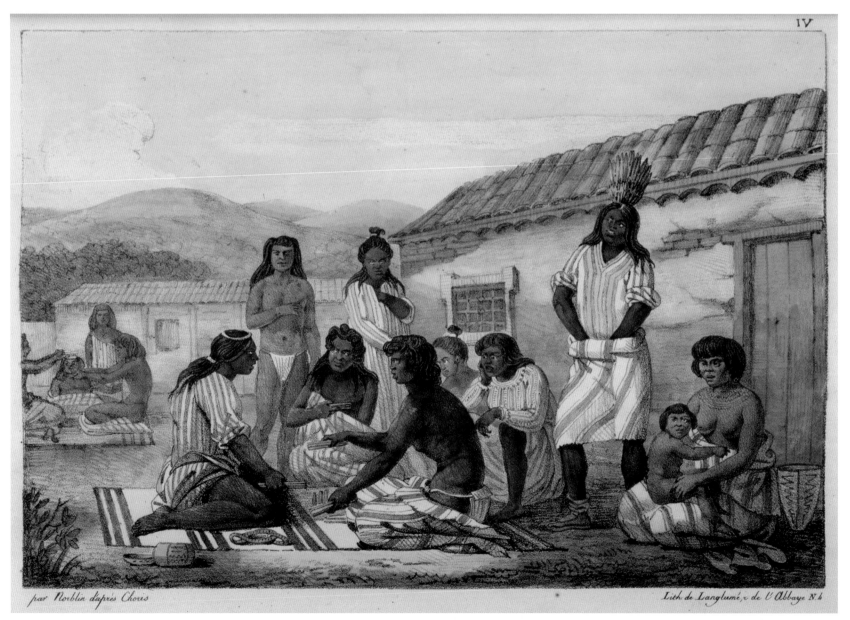

par Norblin d'après Choris Lith de Langlumé, x de l'Abbaye N.4

In 1822, a few years prior to secularization, the French artist Louis Choris visited California. He recorded this scene of Indian gaming, which indicates that mission Indians were allowed a little recreation. However, jollity was rare. Choris wrote, "I have never seen one laugh," and over the next few years, the Indians had even less to laugh about.

War with the Gringos

When William Becknell arrived in Santa Fe in 1821, his timing couldn't have been better. He found a new government run by a country that had only been in business for a few weeks, and one that was delighted to prosper from trade with the Yanquis to the east.

Becknell's Santa Fe Trail started two-way trade. Mexicans brought livestock to Missouri, and Yankees brought hard goods to New Mexico. Anglos poured into Texas, looking for wealth along the trail route. To the *Tejanos,* Mexican-Texan landholders of now-secularized mission properties, it seemed like a good way to develop the economy. San Antonio had been an established community since the mid-eighteenth century, and the success of its mission cattle ranches undoubtedly encouraged California's later cattle empire.

Mexico City disagreed. It saw the immigrants as a threat rather than as a boon and was quite aware that the United States had its eyes on Texas. President Andrew Jackson made a $5 million purchase offer in 1835, which the Mexicans rejected.

They should have taken it. In 1836, there were thirty-five thousand Anglo-Americans and their slaves in Texas, compared to less than four thousand Tejanos. And Mexico had its new leader and soon to become self-proclaimed dictator, General Santa Anna, who thought of himself as "the Napoleon of the West."

He'd had a good track record up to that point. He'd already thrown out a Spanish invading army determined to restore Mexico to the crown, and he brooked no nonsense. Neither did two Texans whose names are far better remembered in the United States: Sam Houston and Stephen F. Austin.

The rest is well-known and well-publicized history. The Alamo, Jim Bowie and Davy Crockett fell, but Houston's Texas volunteers ambushed and routed Santa Anna's forces at San Jacinto in a fight that took less than twenty minutes. They captured Santa Anna and made him sign a document ceding Texan independence. The Republic of Texas was born and the loss of Mexico's northern territories had begun.

Meanwhile, the United States was getting restless. In 1842, there were rumors that the English, who still had a claim on the Oregon Territory, were about to move on California. In 1844, the United States elected an obscure Tennessee politician named James K. Polk president, and the doctrine of Manifest Destiny, which assumed that the United States had an unarguable imperative to rule from sea to shining sea, held the national imagination.

Before Polk took office in 1845, his lame-duck predecessor, John Tyler, signed a bill

What's left of a nineteenth-century military powder horn—essential equipment for soldiers on both sides.

annexing Texas to the United States. Mexico objected in general and specifically to the fact that the United States had placed the border at the Rio Grande rather than 150 miles north where it had always been before.

Things came to a head in 1846. Polk sent General Zachary Taylor to Texas to set matters straight, and predictably, the Mexicans shot at Taylor's troops. This gave Polk all the excuse he needed to declare war.

California was the next large piece of real estate to fall. An irregular American military company led by John C. Frémont raised an American flag in Monterey, while a hoodlum rebellion under a hand-stitched Bear Flag captured the town of Sonoma and declared a California Republic. Frémont was delighted to learn a few weeks later that the United States had actually declared war, so he brought the bear flaggers under his wing and declared all of Alta California to be United States territory.

The United States wasn't content to stop there. Troops invaded Baja California as well, with less success.

The area between Texas and California followed soon after. It was an easy conquest, helped along by the fact that large groups of

Zachary Taylor ventures south of the Rio Grande and captures Monterrey, the first major victory of the new war. U.S. troops eventually went as far south as Vera Cruz and Mexico City.

Indians hated the Mexican government and consequently favored anyone who opposed them. The greatest plus for the Yanquis came through the support of the Pima-Maricopa Alliance. The displaced Yuman Maricopas had joined with the Akimel O'odham to create a defensive force mainly concerned with keeping the raiding Apaches at bay. They'd been so successful that, in the mid-nineteenth-century, they'd become the most formidable military force between Santa Fe and San Diego. They cast their lot with the Anglos and provided food and aid to the U.S. troops who crossed their lands.

In northern New Mexico, Puebloans had on-and-off problems with the Mexicans, and there'd been a revolt in Taos in 1837. Down south, Tyler's proclamation had attached El Paso to the United States, but when they came around to writing a treaty, it wasn't even clear exactly where El Paso was.

The official war ended in 1847, but there were still unanswered questions. It took a few more years to set the boundary.

Resolutions

The treaty of Guadalupe Hidalgo ended the Mexican-American war, but it didn't leave everybody satisfied about the boundary agreements.

President Polk wanted a boundary that included all of Baja California, and he wasn't an extremist. Some loud voices in the government wanted all of Mexico. Others, more concerned with the governing challenges involved, pushed for give-us-San Francisco-Bay-and-be-done-with-it. Building the American Empire took a lot of discussion and a lot of compromise.

Polk submitted the treaty to Congress less because he liked it than because of pressure to put an end to the unpleasantness. Under its terms, the United States paid Mexico $15 million for land acquisitions and agreed to forget $3 million in claims by U.S. citizens against Mexico.

The exact line of the boundary would be determined by a joint effort between an American commissioner, John Bartlett, and his Mexican counterpart, General Pedro Condé. They butted heads almost immediately.

In the kind of bureaucratic foul-up that

America celebrates President Polk: a 1938 stamp. He has the 11¢ stamp because he was the eleventh president. John Tyler is on the 10¢ and Zachary Taylor is on the 12¢.

makes us shake our heads everytime it happens (and makes us smile when teachers use "military intelligence" as the dictionary example of an oxymoron), they started with a gloriously inaccurate map. It put El Paso more than a hundred miles northeast of where it actually is.

General Condé felt that, whatever it said, the official map was the official map, and Mexico was entitled to the rich Mesilla Valley in what is now southern New Mexico.

The two commissioners hammered out an agreement, but the U.S. surveyor refused to sign it, claiming that Bartlett had just agreed to give Mexico 6,000 square miles of American territory. History books say that the Mexican-American war ended in 1847, but the boundary was up in the air for years after.

Commissioner Bartlett got tired of the whole business and went off on a tourist junket to Mexico, while Andrew Gray, the recalcitrant government surveyor, got stuck with the job of making a new survey.

Gray and a low-level military officer named Amiel Whipple slogged along the Gila until they ran out of supplies and money. Broke, tired

Camels on the Pecos: In 1855, the War Department decided that a camel cavalry could solve any desert logistical problems. Unfortunately, they scared horses and wouldn't walk on the rocks.

and hungry, they landed in Yuma on Christmas Day in 1851, where a young Yuman girl remembered that two years before, Whipple had found her lost in the desert and given her food and a small mirror. The Yumans gave them a hand and even helped them across the Colorado.

Meanwhile, the government got tired of Bartlett and sent him packing, but it still didn't produce an agreement.

By 1853, America and Mexico were about ready to go to war one more time. A new president, Franklin Pierce, stepped into the act. As a president, Pierce's career was even less distinguished than Polk's (his most famous quotation is, "After the presidency, there is little to do but drink"), but he found the man to take care of the problem.

He sent James Gadsden to Mexico with five different offers. The big one was a $50 million chunk that would have given Arizona a nice coastline and seaports. Mexico might have

gone for it if a bunch of American roughnecks under an adventurer named William Walker hadn't tried to invade Mexico a few months before. The Mexican party line was, don't give up the land route to Baja California, just give them enough land to build a railroad.

The Mexicans opted for Plan B and took the $10 million package. The two governments signed the Gadsden Purchase treaty in December 1853, and a divided Congress ratified it in 1854 (Southerners wanted more land below the Mason-Dixon line).

The survey was completed in 1855, and finally, in 1856, almost ten years after the treaty that was supposed to have ended the Mexican-American war, the presidio commander in Tucson lowered the Mexican flag and took his troops south.

The war was finally over. The forty-eight contiguous American states had the southern boundary that exists today. Mop-ups and grumbling persisted for a few more years, but by and large, Mexico was gone.

Now a new set of absentee landlords in Washington, D.C. had to figure out what to do with a vast land that few of them would ever see or begin to understand.

MAP OF PROPOSED ARIZONA TERRITORY
from explorations by A.B. Gray & others, to accompany memoir by Lieut. Mowry
U.S. Army, Delegate elect.

Opportunity beckoned on several fronts. The red ink on this 1855 map outlines what the Confederates hoped would become a separate, slaveholding Arizona. Look closely and you'll see a suggested railroad route over the Yuma Crossing. It took another twenty-six years before it actually happened.

4 The Anglos Follow

The old high school in Superior, Arizona, built in 1898 in what used to be Salado country.

Mountain Men

STARTING IN THE 1830s, Anglos trickled into the Southwestern desert. The first visitors probably weren't the sort of people you'd hope to have for next-door neighbors. Wild, unpopulated areas attract what polite accounts call adventurers.

The adventurers of the 1830s and the 1840s tended to be roughneck loners, looking for ways to make a living without a lot of concern for the animals or people who provided the source of it.

A classic example (probably dead center on what a contemporary cops-and-robbers TV show would call a profile) was a trapper and hunter named James Kirker. He picked up on the northern Mexican 1838 scalp bounty offer and turned them in in sufficient quantities to clear a reported $100,000 in a single year. To do it, he would have had to kill Indians, or people who had Indian-looking scalps, at the rate of three a day.

The mountain men flowed in on the Santa Fe Trail and scattered through the wilderness from Santa Fe to San Diego. They were looking for beaver, which had become a fashion requirement in the gentleman's hat market. The beavers had been hunted out in the eastern and Canadian woodlands, and the new Mexican government looked for any possible opportunity to encourage trade.

Taos and Santa Fe became Trapper Central, the Gila became the highway to beaver country, and the exits from that nineteenth-century freeway led to every stream in the mountains of Arizona, New Mexico and southern California.

Some of those mountain men left an indelible impression. Bill Williams gave his name to Bill Williams Mountain, the Bill Williams River and Williams, Arizona, which publicizes itself as "The Gateway to the Grand Canyon." He was almost a cariacature. He wore pelts, slept on the ground and showed up from time to time in Taos with a payload that financed a two-week binge.

The honor roll, if that's the right word, included names that still show up in accounts of the period. James Ohio Pattie dictated a best-selling version of his adventures. Paulino Weaver carved his name on the wall at Casa Grande on his way to California, found his way back to Prescott, Arizona, during the 1847 war and served as an army scout along with fellow trappers Baptiste Charbonneau and Antoine Leroux, guiding the Mormon Batallion across Arizona to Tucson.

Kit Carson was the most legendary of the lot. Among other feats, he helped Colonel Stephen Watts Kearny's Army of the West out of a tight spot near San Diego, saving Kearny a lot of embarrassment and perhaps even saving California for the Yankee forces. He

sneaked through the Mexican lines and summoned enough reinforcements to turn defeat into victory. A visit to Carson's home in Taos, now a museum, gives you an excellent one-hour history lesson. You'll be much smarter about what really happened out West in the troubled mid-nineteenth century.

Carson is a fascinating hero/villain. He had an Indian wife, he had great regard for the integrity and value of the Indians, yet, under orders, he starved out the Navajos at Canyon de Chelly in order to round them up for a march to a distant reservation. It was an act that generations of Indians will never forgive.

Killing and violence were an inescapable part of these men's lives. One historian described western life in the 1840s and 1850s just by saying, "It was a hard place." You survived by doing unto others before they did it to you, and once you did it, the land allowed you to run to places where no one would ever find you.

In *The West,* Geoffrey C. Ward quotes mountain man Jedediah Smith on hiring a crew for a trapping expedition: "I would most probably find men [in] grog shops and other sinks of degradation . . . A description of our crew I cannot give, but a Falstaff's Batallion was genteel in comparison."

A true mountain man's powder horn.
No fancy metalwork
like the ones the soldiers carried.
It's just a horn.

Between the Wars: Choosing Sides

Nothing really went smoothly across the desert in the ten years between 1845 and 1855. Everybody on both sides of the 1847 conflict agreed that it was in their nation's best interest to put as much real estate as possible under its own flag. Beyond that general principle, no high-ranking official cared much about what happened in the little pockets of settlement across the desert between west Texas and San Diego. They saw the land as little more than an inhospitable space that unfortunately

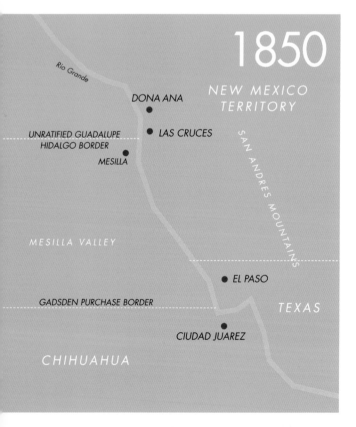

1850

NEW MEXICO TERRITORY

Rio Grande

DONA ANA

UNRATIFIED GUADALUPE HIDALGO BORDER

LAS CRUCES

MESILLA

SAN ANDRES MOUNTAINS

MESILLA VALLEY

EL PASO

GADSDEN PURCHASE BORDER

TEXAS

CIUDAD JUAREZ

CHIHUAHUA

happened to rest between what everybody agreed was desirable territory in Texas and desirable seaports in California.

However, a few settlers, both Hispanic and Anglo, were beginning to think otherwise. In 1848, the first wave of Anglos moved into the Mesilla Valley in southern New Mexico, looking to grab land away from the Mexicans who were already there.

In 1850, Lt. Delos Bennett Sackett of the First Dragoons of Company H, recently decamped from Fort Gibson, Oklahoma, drew the honor of attempting to restore order over a 40-mile-long strip of land along the Rio Grande from a little Hispanic town named Doña Ana south to El Paso. (Parenthetical note: It took three more years for Bartlett and Condé, the boundary negotiators, to agree enough to set a monument designating Doña Ana as the zero milepost for Andrew Gray's official survey.)

Don Pablo Melendez, who held the land grant to Doña Ana, had asked the U.S. Army for help. Sackett's answer was to take some rawhide ropes and stakes and lay out a new town with eighty-four city blocks, four lots to a block, five miles south of Doña Ana. He gathered 120 people and had them draw numbers out of a hat for homesites.

His irregularly platted streets quickly became impassable when the new property owners turned them into clay mines for adobe bricks. Despite the bumpy start, Las Cruces grew into a pleasant college town at the base of the San Andres Mountains.

Creating the new city might have cooled things down a bit, but it didn't leave the Mexican-leaning residents of Doña Ana satisfied. Sixty families packed up and moved across the Rio Grande to the Mexican side, where they could forget about the *gringos* altogether. They built the village of Mesilla and continued their Mexican way of life.

In 1854, the Gadsden Purchase made them U.S. citizens again. They coped with the situation by ignoring it. Not every inhabitant of the new U.S. territories embraced the American Dream right off.

Farther up the Rio Grande, Yankee troops and Yankee traders settled matters fairly quickly. The prospect of U.S. dollars adding more wealth to a less-than-flourishing economy forgave a lot. Even though U.S. troops invading Mexican territory in 1846 had blown up sixty Indians hiding inside the church at Taos and then, in a marvelous example of conqueror-think, had hung seven of the survivors for "treason," bygones became bygones. Santa Fe and Taos quickly and peacefully folded into the United States.

Transition wasn't quite as easy in the populated parts of southern California. The 1849 California gold rush brought a flood of immigrants to the north, bloating San Francisco's 1846 population of less than a thousand to one hundred thousand by January 1850. Not all the gold-seekers traveled north. A good number began following the Gila River on a route that Lt. Col. Philip St. George Cooke and the Mormon Battallion had followed on

their way to San Diego in 1846. The settlers bought food from the O'odham, bought passage across the Colorado from the Yumans and soon outnumbered Californios.

In the early 1850s, the United States passed a law requiring Californios to prove they owned their estates, mostly grabbed off during the mission secularization period. Pio Pico, the last governor of Mexican California and brother of the last military commander to win a battle with the Yankees, owned 133,000 acres of Mission San Juan Capistrano land, so much that he could ride all day without leaving his property. By the 1880s, he'd lost almost all of it in Yankee courtrooms. Other Mexican grant holders suffered similar fates, just on a smaller scale.

The Indians fared no better. Those few who hadn't been swindled out of their mission lands by the Californios saw the job completed by the Yankees. A new law required Native American landholders under the Mexican government to justify their land claims in court. No one bothered to notify the Indians of the law, hence no claims were filed, and white settlers grabbed their property.

Things were about to get even worse for the Indians. For a few hundred years, Spanish conquerors had seen the Indians as their rightful slaves and therefore of some value. The new Yankee conquerors disapproved of slavery and wanted to work the land themselves. Now the Indians were simply annoyances who, in lieu of any better suggestions, might just as well be eradicated.

Innocent bystanders: Tohono O'odham women harvesting saguaro cactus fruit, as portrayed in 1853. The O'odham tried to be everyone's friend during the years of unrest but kept a wary eye out for the Apaches.

Slavery or Not

In the 1760s, two English surveyors named Charles Mason and Jeremiah Dixon drew a line that separated Pennsylvania from Maryland, and for the next hundred years, that line served as the dividing line between the pro-slavery south and the increasingly pro-abolition north.

The end result was the War Between the States, and the desert couldn't remain clear of the conflict. The map below begins to explain why.

Going back to the 1820s and the opening of the Santa Fe Trail, southerners from the slave states had taken off for Texas in such large numbers that when people saw *G.T.T.* painted on the door of somebody's house, everybody knew the initials stood for Gone To Texas.

When Texas joined the Union in 1845, its new Anglo population made sure that it came in as a slave state. A few years earlier, Georgia,

The main force of immigration into the desert on the eve of the Civil War came from the slave states and slave-leaning territories. The South was moving west.

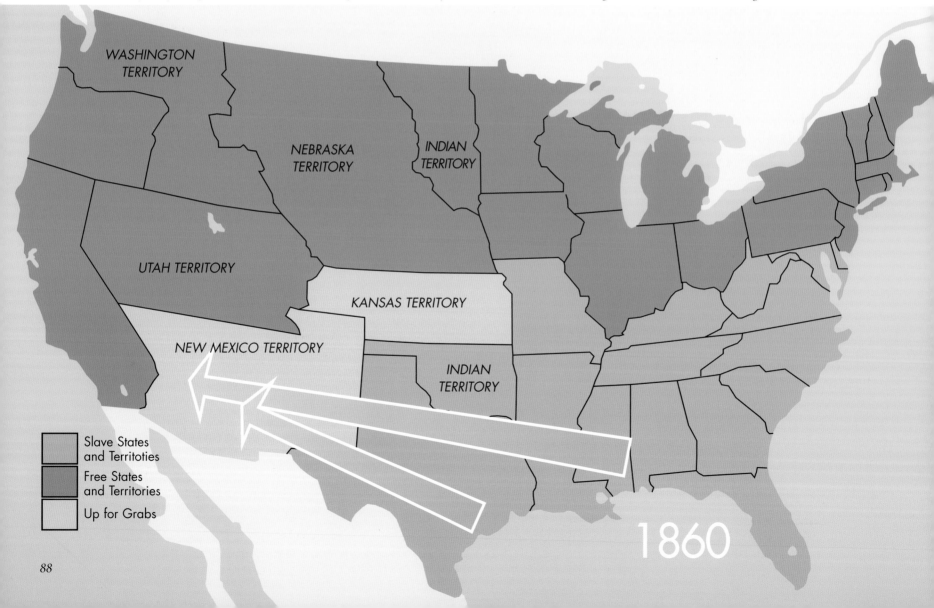

WASHINGTON TERRITORY

NEBRASKA TERRITORY

INDIAN TERRITORY

UTAH TERRITORY

KANSAS TERRITORY

NEW MEXICO TERRITORY

INDIAN TERRITORY

Slave States and Territoties

Free States and Territories

Up for Grabs

1860

with an eye on gold deposits on Cherokee land, had exiled the Cherokees to land west of the Mississippi. The United States made a land-swap deal and eventually marched the tribe on the "Trail of Tears" from North Carolina to Oklahoma, which Congress set aside as Indian Territory. The Cherokees were one of what became known as the "Five Civilized Tribes," along with the Creeks, Choctaws, Chickasaws and Seminoles. They were all southern landholders and slaveholders, and they brought their slaves with them. Oklahoma's Indians were Confederates at heart.

When the New Mexico Territory opened up after the Mexican War, it had virtually no non-Indian population outside of Taos and Santa Fe. In the 1850s, the Indians that came along with the new Territory not only weren't given any say in the political structure, they were lucky if nobody shot at them. Governmental decisions were made by a handful of rough-and-ready Anglo settlers, and legislation was enforced by the settlers' rifles, supported by whatever troops were around to back them up.

Across the desert to the Pacific, pro- and anti-slavery factions maneuvered to bring the new lands over to their side of the fence.

California chose sides early, for two reasons, one obvious and one less well-known. The population balance was heavily in the north, and most of Califonia's immigrants either came across the Sierras north of San Francisco or down from Oregon, which meant most of them were taking the shorter route from farms in the anti-slavery north.

At the other end of the state, California's free black population was growing. Southern California had become a haven for freed and escaped slaves, and by the 1840s, several prominent Californians, including San Francisco merchant William Leidesdorff and Southern Californian Pio Pico, the last Mexican governor, had black ancestry. In 1850, the population of Los Angeles was reportedly 40 percent African American.

The humanitarian aspects of the abolitionist movement weren't necessarily the governing principles in California's rejection of slavery. An 1848 editorial in the *Californian*, a San Francisco newspaper, explained the attitudes of the day. It listed nine reasons why California should resist a congressional effort to incorporate it in the Union as a slave state. The the first six displayed fairly predictable sentiments of truth, beauty, love and motherhood. However, the editorial then showed the writer's true feelings:

SEVENTH—We desire only a white population in California, even the Indians amongst us, as far as we have seen, are more of a nuisance than a benefit to the country; we would like to get rid of them.

He wrapped up his argument this way:

NINTH—In conclusion, we dearly love the "Union," but declare our positive preference for an independent condition of California to the establishment of any degree of slavery, or even the importation of free blacks.

Pio Pico:
a representative of one of the reasons—
but far from the only reason—
why California never went pro-slavery.

Although nobody in the United States seats of power really cared about the Territory of New Mexico, neither slavers nor abolitionists wanted the other side to claim its real estate.

At the outbreak of the Civil War, the smart money would have been on New Mexico's going Confederate. After all, Texas was just down the Rio Grande from the populated areas, and there were troops in Texas. There were no troops to speak of in southern California, which was separated from populated New Mexico by mountains, the Colorado and the old Camino del Diablo. Even if the Yumans relaxed and let significant numbers of Yankee troops from California across the Colorado, they'd be at the wrong end of the Territory with a ferocious journey ahead.

Holding New Mexico for the Union wouldn't be easy.

New Opportunities: The Union Triumphs

The battle for the New Mexico Territory began in 1861, and it began pretty much as everyone expected. Rebel troops took Fort Bliss in El Paso easily and claimed the southern half of New Mexico as the Confederate Territory of Arizona. The real campaign started in 1862, when Sibley's Battallion, under Confederate Brigadier Henry Sibley, set out on a simple quest: Go up the Rio Grande, take Santa Fe and Taos, then move up to the newly opened Colorado goldfields, and from there, go west and capture San Francisco.

Considering the state of the Union forces in the west, it didn't seem an unreasonable goal. Sibley moved north while a Union force of equal size, but woefully undertrained, waited for him. Edward Canby, the Union commander, was a good friend of his, and Sibley drew the unpleasant task of facing his West Point classmate on the battlefield.

Canby figured his odds, then guessed wrong. Afraid that Sibley would bypass him, he pulled his troops out of the safety of his fort and met the Confederates on Valverde Mesa,

about 90 miles south of Albuquerque.

It was a disaster, and after two days of heavy fighting, Sibley drove the tattered remnants of the Union force back to their fort while he continued north. The victory wasn't without cost, however.

Sibley was short of supplies, and the volunteers he expected to join his forces didn't show up. The Hispanics who populated the area didn't like the Rebels any better than they liked the Yankees.

Neither problem seemed to be a factor. He took Albuquerque and Santa Fe, and, if he could get past the detachment at Fort Union, a few miles east along the Santa Fe Trail, the road was clear to Colorado.

Sibley sent an advance detachment to secure Apache Canyon, the first stop on the road to the next day's victory. They didn't expect the First Colorado Volunteers and a two-gun-toting Methodist minister, Colonel John M. Chivington,

The Volunteers weren't really a military force. They were four hundred hard-drinking miners who didn't play by the proper rules of West Point tactical warfare, and Chivington was their ideal leader.

The Rebels fired, and the Volunteers fell back, but a group climbed up the canyon walls so they

could fire down on the Confederate troops. Chivington's cavalry swarmed in ferociously, seemingly bullet-proof, and the Rebels withdrew.

The next day, the real battle began in Glorietta Canyon, steep-walled with a one-lane wagon road at the bottom. The fighting raged for five hours, neither side gaining, both firing at each other from behind rocks, until the Confederates suddenly surrendered.

Chivington's men had administered the coup de grace. Mountain men who understood that sort of thing, they'd gone to the canyon rim and rapelled down its walls behind the Confederate troops. They chased off the guards, burned all eighty-five supply wagons and killed five hundred horses and mules. Whether Sibley won or lost no longer mattered. His campaign was doomed. His only hope was to try to get back home. He'd started with thirty-seven hundred men and had hoped to build the number with volunteers along the way. When he finally got back to Texas, he brought fewer than fifteen hundred soldiers with him. New Mexico Territory was secured for the Union.

Three years later, parson Chivington took it on himself to rid Colorado territory of the Indian Menace, and picked a fight with a group of Cheyennes once led by Lean Bear, who wore a peace medal given him by Abraham Lincoln. He slaughtered a hundred women, children and old men in what's remembered as the Sand Creek Massacre, and his actions drove the Cheyenne into a bloody five-year war of retribution against the Anglo settlers.

The Civil War was over. But in the West, much of the gunfire was still to come.

Sibley *Chivington*

Where the West Was Lost: Sibley's Waterloo began at Apache Canyon, the entrance to Glorietta Pass. It's not quite so difficult a passage today. Just take I-25 east from Santa Fe.

Carleton Finds Work

Getting California troops to the New Mexico battlefront was difficult but not impossible. During the days when Sibley's Battalion marched up the Rio Grande, the beleaguered Colonel Canby sent a desperate message to his superiors pleading for support, and the High Command picked a cavalry major named James Carleton to muster a troop of California volunteers. Carleton pulled four thousand men together, and in 1862, as the newly minted colonel of the First California Volunteer Infantry, he led eleven companies of infantry, two of cavalry and two batteries across the Arizona desert.

By the time he got to New Mexico, the war for New Mexico was over, and once Sibley heard of Carleton's imminent arrival, he pulled what was left of his troops out of El Paso and headed deeper into Texas.

To a less-dedicated warrior, that might have brought a sigh of relief, but Carleton commanded a hard-drinking, rough-edged army with nobody to fight. He had to fight somebody, and the opportunity came quickly.

In honor of his heroic march, Carleton got bumped up to brigadier general, replaced Canby in command of the New Mexico forces and turned his attention to the Indian problem.

The Apaches and Navajos had stepped up their anti-settler activities while the

General Carleton: "All men are to be killed, wherever you find them."

troops were occupied on the Rio Grande. That was enough for Carleton, and besides, they'd taken a few potshots at his troops on their march across the territory.

He combined his California Volunteers with what was left of Canby's New Mexico forces and Chivington's Coloradoans and went after the Mescalero Apaches in the southern New Mexico mountains, assisted by his secret weapon, field commander Colonel Kit Carson, late of the First New Mexico Cavalry.

It was a one-sided fight. No one knew the Indians better than mountain man and Indian scout Carson. Acting under

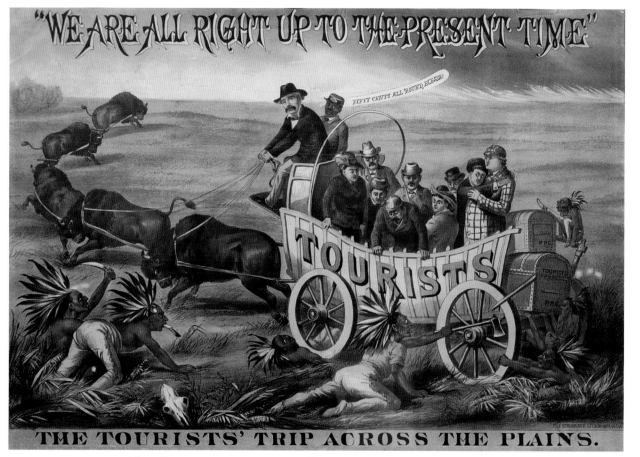

The Indian menace out west, as perceived by easterners who weren't about to go there.

*Colonel Carson:
"I done what I thought
was best."*

Carleton's orders, Carson did much of what he'd been told to do.

Carleton didn't want to waste any time, and his orders were clear and simple. Carson was to kill all Mescalero men, whenever, wherever and however he found them. If the Indians came in under a white flag, Carson was to inform them that he'd been sent to punish them for their treason and crimes and to act accordingly.

Carleton's ideal solution would simply be to kill them all.

This had to be unpalatable for a man whom Indians called Father Kit. His compromise was to round up four hundred prisoners, both men and women, bring them to nearby Fort Stanton, a hundred miles south of Albuquerque and 70 miles east of the Rio Grande, and to take four chiefs to Carleton in a surrender party. Carleton was ruthless, but he was no Chivington. Instead of shooting them all, he chose Plan B.

He marched them to Bosque Redondo, a patch of ground on the Pecos 80 miles northeast of Fort Stanton. It was newly commissioned as Fort Sumner and, to Carleton's way of thinking, it seemed like an ideal place to deposit all those Indians he didn't like.

His next project was to send Carson after the Navajos, who, among other offenses, occupied some potential gold-mining properties he had his eye on. Rather than shooting the Navajos, Carson chose to capture them by starving them out. His troops eventually brought perhaps nine thousand Navajos to Bosque Redondo. It still rankles the Navajos, who remember it as the "Long Walk."

Bosque Redondo was a disaster, and before Fort Sumner shut down in 1869, more than two thousand Indians imprisoned there had died.

Historic accounts stress General Carleton's cruelty and portray him as something of a scoundrel. However, the California Military Museum states in his biographical sketch that, although strong on discipline, he was "a faithful and beloved husband and father."

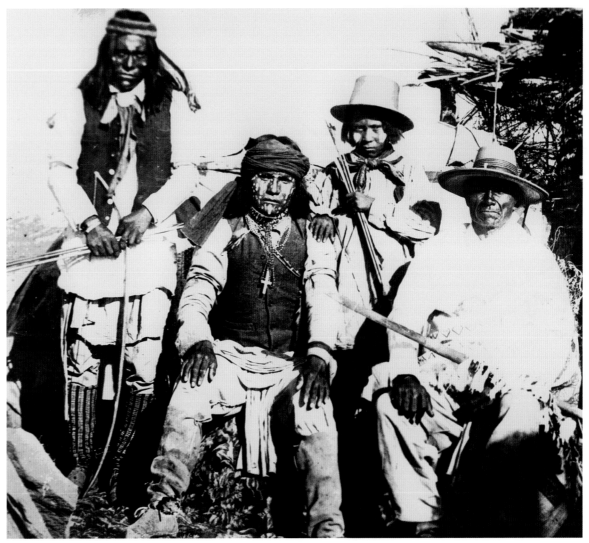

Carleton's enemies. His strategy was simple: Send out the whole army, and if no Indians survive, so much the better.

The Boom Begins

In 1863, Congress cut New Mexico Territory in half, not north and south as the Confederates had intended, but east and west, into Arizona and New Mexico.

Both territories were poised for post-war expansion, but development didn't happen right away. Even though New Mexico, along with Florida and Virginia, had been one of the first of the fifty states to have a permanent non-Indian population, it was one of the last to gain statehood.

The bursts of activity happened on either side of the newly divided territories. Texas had a long history of cattle ranching inherited from Spanish days. In *The Southwest, Old and New*, W. Eugene Hollon pointed out that the basic vocabulary of cattle ranching came from the Spanish (*rancho* = ranch, *lazo* = lasso, *chapero* = chaps, *mesteño* = mustang, and so forth).

After the war, several events inflated the Texas cattle industry. Easterners developed a taste for beef, the war had depleted the eastern cattle supply, meat packers (including two named Swift and Armour) had moved to Chicago to be closer to the new southwestern rangelands and, in 1867, the railroad reached Abilene, Kansas. The cross-country cattle drive beloved of Western movies started bringing big money to Texas.

Meanwhile, the California boom was turning into an unstoppable force. Few of the forty-niners who came to California looking for gold got rich, but the merchants and manufacturers who supplied them made fortunes that persist to the present. Levi Strauss made sturdy pants for working miners, and his company still makes them for the world.

In 1869, Leland Stanford drove the gold spike at Promontory Point in Utah (actually, his swing missed), joining the Central Pacific and Union Pacific railroads, and California boosters were quick to capitalize on the connection. In a great public relations move, Charles Crocker, one of the four principal shareholders of the Central Pacific, immediately took a four-day trip from San Francisco to New York on the train, a passage that would have taken four months by sea. He came bearing gifts for the East: strawberries, cherries, oranges and roses kept fresh on beds of ice brought down from Alaska.

The effect was as dramatic as he'd hoped. The promise of California was obvious, and between 1860 and 1870, the population of California increased by half.

By this time, the Mother Lode in the Sierra foothills that had sparked the gold rush of 1849 was largely played out, but the Comstock Lode on the Nevada side of the mountains in Virginia City began producing both silver and gold in the mid-1860s. San Francisco-based mining companies were far from out of business.

The new population needed to be fed, and California's central valley, deep in alluvial soils, proved an ideal location for the cultivation of the easiest agricultural crop of all, wheat. In 1860, California wheat farmers produced six million bushels, and in 1870, production topped twenty-two million. This provided another boon to California. The burgeoning population needed coal and iron for its new industries, and in 1860, ships bringing them into San Francisco left empty. By 1870, they left fully loaded, bound for England and the Liverpool wheat markets, and the resulting lower freight rates raised profits and

There were fortunes made during the post-war immigration boom. But they were mainly made by the people who provisioned the immigrants, like San Francisco pants-maker Levi Strauss and Sacramento shopkeeper Leland Stanford.

Main Street in 1870, when Los Angeles still had quite a way to go. Over the next thirty years, it would change into a small city.

lowered prices for all three commodities.

Meanwhile, southern California was beginning to stir. In the last half of the nineteenth century, the populated part of California still looked on the part of the state south of the Tehachapi Mountains as the "cow counties," with an economy built on the remnants of the old Mission, Mexican and Californio ranches.

San Diego, the first of Serra's missions, had an early start, but real growth took a long time coming. The arrival of the Mormon Battalion in 1847 changed its character and turned it into a military town but not a big one. San Diego County had a population of 798 in 1850 (the census didn't bother counting Indians), and in 1860, still had only forty-three hundred people.

The Pueblo of Los Angeles, established in 1781 north of Mission San Gabriel, began as a provisioning site for the Spanish presidio and became a trading center for the cattle industry.

It too had more than four thousand people by 1860, but the rest of California wasn't ready to pay much attention to the cow counties. The power was up north in San Francisco and Sacramento.

Ten years later, in Texas and California, settlers continued to trickle in. In the land between, it would take a few years longer. The conquerors still had the problem of a few thousand highly unconquered Indians.

The West Turns Wild

In the underveloped territories of Arizona and New Mexico, the U.S. Army was the biggest business concern around, and its biggest expenditure was for food. Soldiers had to eat, and they needed a constant supply of beef. Dry rations like bread and wheat could be stored, but in a world without refrigeration, good meat had to be fresh and available year-round.

The Spanish and the Mexicans had pretty much given up on Arizona and southern New Mexico by the Mexican War, and what cattle ranches there were had been abandoned. By the end of the Civil War, the cattle were gone, and the rich grasslands of eastern New Mexico were empty except for the occasional marauding band of Mescalero Apache.

Once Kit Carson and Carleton had confined a good number of Mescaleros at Bosque Redondo, the area was reasonably pacified, and a Texan named John Chisum brought Texas-style ranching to the territories. He started in Paris, Texas, and drove somewhere between five hundred and a thousand head of cattle more than 500 miles west to Fort Sumner.

When his herd arrived in 1867, they were half-starved and had gone three days without water, but they'd made it. (His route has been referred to as the "Chisum Trail." The more celebrated *Chisholm* Trail, also opened in 1867. It was named for Oklahoma trader Jesse Chisholm, and ran from Caldwell County, Texas, north to Abilene, Kansas, and the railroad.)

In 1873, John Chisum had enough cattle, enough money and enough of a developed market with the Indian-fighting military to move permanently to New Mexico, where he grazed eighty thousand head.

Chisum lived a gentleman's life, with Axminster carpets on the floor of his home but had increasing difficulties with his neighbors. Hispanic farmers and Texas cowboys didn't coexist comfortably, and now even more Texas homesteaders were bringing herds into the valley. Mixed herds created ownership disputes, and Chisum protected his property the way Texans normally did back then: Shoot first and don't bother with questions.

Many of these homesteaders were true outlaws. According to Thomas E. Sheridan's *A History of the Southwest*, they were "one step ahead of the Texas Rangers." They contributed mightily to one of the wildest episodes in the romanticized Wild West, the Lincoln County Wars. So did John Chisum.

Lincoln County covered most of southeastern New Mexico. In 1873, three Texas thugs shot up a bar in Lincoln, the little county seat, and by the time the smoke had cleared, the three Texans and the Hispanic sheriff were dead. One of the shooters had four brothers who kept shooting until they'd killed ten more Hispanics, and the war had begun.

In this violent context, politics was as you'd expect. Three Irish immigrants with connections to corrupt politicians in Santa Fe controlled government contracts and did what they could to swindle small landholders out of their property.

In 1877, newcomers John Tunstall and Alexander McSween made a move to take over from the Irishmen, with Chisum's backing.

The branding iron, symbol of the Old West. Not all cattle were firebranded. Chisum's "Jinglebob" brand was a slit ear. While the cattle moved, a third of the ear stood upright while two-thirds jingled and bobbed.

The incumbents ambushed and killed Tunstall, and Tunstall's supporters responded by ambushing and killing the current sheriff. Three days later, a Tunstall supporter died in a gunfight at the Mescalero Indian agency, and shortly afterwards, McSween and three others met their end in a five-day siege at McSween's home. That ended the war, but not before it created enough material for countless movie Westerns.

Ironically, one of the survivors of the war was an unpleasant young man, a Tunstead supporter named William Bonney who gained dime-novel notoriety as Billy the Kid. He spent the next four years gunfighting and rustling cattle, until sheriff Pat Garrett gunned him down or didn't, depending on which legend you choose to believe.

Driving the cattle in for a dip, nineteenth-century style.

Paydirt

Most of the thousands who came to California in the gold rush looked to make their fortunes from the earth. And mining fortunes were made, but not necessarily in California, and not necessarily from gold.

All over the Southwest, prospectors made strikes and mining companies followed. Indians had been mining in the desert long before the Spanish came, and in the years after the Mexican War, Mexicans taught the gringos how to mine.

After the Gadsden Purchase, the first skilled work force in territorial mines came up from Magdalena in Sonora, a mining center for more than a century. It took a few more years

for modern mining to come to the desert. It came in the person of Charles Poston, who took over the old Spanish presidio at Tubac and developed silver mines in the surrounding hills. By 1857, a thousand people lived in and around Poston's central hacienda.

In *The Great Southwest*, Edna Bakker and Richard Lillard quote Poston saying, "We had no law but love, no occupation but labor. No government, no taxes, no public debt, no politics. It was a community in a perfect state of nature." In other words, it was a perfect company town, at least until the Apaches took care of it. By 1870, Tubac was a ruin again.

The word to get out fast. The ore strikes came one after another, from California's southern Sierra to far into Texas. It wasn't just gold, silver and copper. It was coal in Gallup, mercury in Texas and borax in California's

Mojave Desert, with site after site passing through the strike/boom/bust/ghost town cycle. Mining turned into serious business and people with money started noticing the desert.

Henry Wickenburg opened the Vulture Mine during the Civil War, and it produced for years following. Across the territories, others made or invested parts of great fortunes in mining. Two names stand out because of their importance in other contexts, and especially because of the celebrity of their relatives.

Senator George Hearst mined silver in Piños Altos, just up the hill from Silver City, New Mexico, and it contributed to a fortune that his son William Randolph Hearst expanded mightily.

Meanwhile, Black Jack Jerome mined copper in the town in Arizona that bears his name. Although he may never have reached Hearst's level of gentility, a cousin of his named Jenny Jerome married a well-connected Englishman named Randolph Churchill. She gave birth to a son named Winston, who made quite a mark for himself.

In 1877, a prospector named Ed Schieffelin went out on patrol with troops from Fort Huachaca looking for Apache, but when the troops went home, he stayed. As the story goes, when Schieffelin told a soldier he expected to find something, the soldier said, "You'll find your tombstone."

He turned up a good-looking silver claim and named it Tombstone. He brought in partners and developed mines, and by 1881, Tombstone was entering its boom cycle.

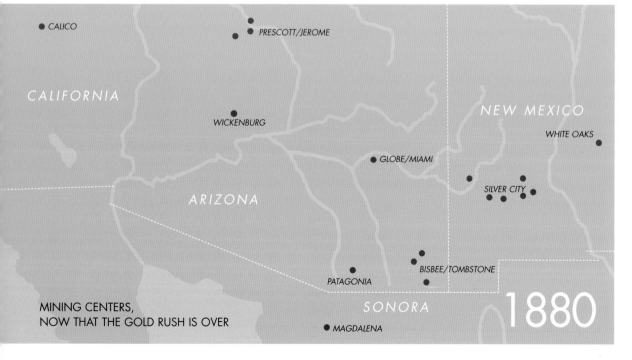

CALICO

PRESCOTT/JEROME

CALIFORNIA

WICKENBURG

NEW MEXICO

WHITE OAKS

GLOBE/MIAMI

SILVER CITY

ARIZONA

PATAGONIA

BISBEE/TOMBSTONE

SONORA

1880

MINING CENTERS,
NOW THAT THE GOLD RUSH IS OVER

MAGDALENA

It incorporated and became the county seat. In 1883, it had a population of seven thousand and real estate valued at more than a million dollars. Bakker and Lillard listed the amenities available in Tombstone as "livery stables, stores, banks, fraternal halls, shops for dark suits and derby hats" as well as "the city hall, the county courthouse, a Chinese laundry, the C.S. Fly Photography Studio, Hart's Gun Shop and the newspaper offices of the *Epitaph*."

The churches, however, didn't do so well. They suffered light attendance, probably because of the hot summers and warm winters. The townspeople claimed that during winter, heaven had nothing to offer and during summer, hell had nothing to fear.

Mine shafts and workings popped up all through the middle of town, and architecture appeared in between. It ranged from an elegant wooden complex that served as the mule barn down to huts and tents for the mine workers, who spent their workdays underground. Tombstone's initial boom was relatively short-lived, however.

Forget the O.K. Corral. This is what Tombstone was really all about: mining, money and real life pursuits such as the Memorial Day Parade, the local ball club and the Cozy Rest Cafe.

In the late 1880s, water seeped into the mine shafts, and as the silver became more expensive to extract, operations shut down. After 1900, mining activity had almost ended, but the town didn't die.

Today, Tombstone is booming, so much so that, in 2005, the National Trust for Historic Preservation announced that if the town didn't correct its theme-park version of history, it might lose its Historic Landmark status.

The Railroads Arrive

Even before the Mexican War, a few Anglos and Mexicans in the territories had set aside their ethnic differences and had gone into business together. Some of these partnerships grew into significant enterprises, even by eastern standards.

The big business opportunities were in freighting, and the routes followed the Santa Fe Trail between St. Louis and the west. From 1821 to 1880, horse-drawn and mule-drawn trains pulling Murphy wagons the size of modern moving vans carried tons of goods on thousand-mile journeys.

Thomas E. Sheridan's *A History of the Southwest* tells the story of Tully, Ochoa & Company, freighters whose partnership predated the Civil War and who faced a difficult moment when Rebel troops took temporary custody of Tucson and told them to swear an oath to the Confederacy.

The company's lifeblood was its contracts with the Union Army, and Ochoa refused, ducking out to Mesilla, which remained Hispanic and above such issues. Fortunately for Ochoa, he picked the right side, and he was back in business with Tully a few months later. By 1880, Tully & Ochoa had diversified into mining and retailing, had hundreds of employees and were as close to a megacorporation as anything in the Southwest.

Rich and vital as the freighters were, they were dinosaurs. Horses with wheels were coming. The first transcontinental railroad happened when the Central Pacific and the Union Pacific met at Promontory Point in Utah in 1869, and it was only a matter of time before routes crossed farther south.

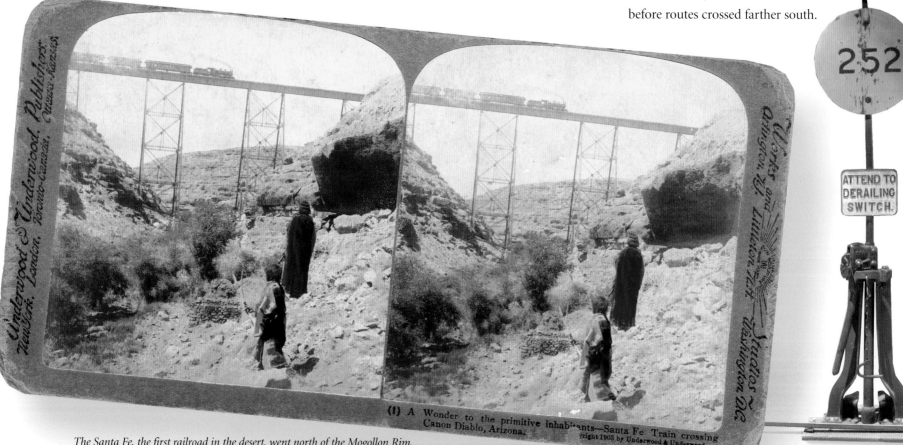

(1) A Wonder to the primitive inhabitants—Santa Fe Train crossing Cañon Diablo, Arizona.
Copyright 1903 by Underwood & Underwood.

The Santa Fe, the first railroad in the desert, went north of the Mogollon Rim, through Navajo country. Cañon Diablo, shown on this 1903 stereopticon slide, is a few miles east of Flagstaff. The trestle is long gone.

In 1879, the Santa Fe crossed New Mexico and Arizona on a route above the Mogollon Rim that roughly follows I-40 and the old Route 66. (Think of the song: "Flagstaff Arizona, don't forget Winona …" and you've got it. The canyon below is 60 miles west of Flagstaff, the one on the opposite page is a half-day hike from Winona.)

Trains didn't arrive in the desert until the next year, and they came from California. The lords of the Central Pacific now owned the Southern Pacific, and in 1876, according to one story, talked Los Angeles into blowing up its seaport in exchange for first crack at a rail line. True or not, the railroad went through Los Angeles and gave it a jump on San Diego that San Diego never did overcome.

Four years later, Charles Crocker, he who brought the iced strawberries to New York, brought the Southern Pacific across the Yuma Crossing to Tucson, effectively erasing the last trace of the desert frontier.

This page from a 1926 Fred Harvey promotional piece shows two things: why building a railroad was hard, and how quickly we can forget someone who gave his name to a landmark.

As Sheridan relates, the change made itself felt within weeks. In November 1880, a Southern Pacific locomotive bumped into two Tully & Ochoa freight wagons, knocking them aside and pushing the desert into the future.

The train finally comes to Tucson, and the day of the freighters comes to an end.

IN years long past, a day's journey by Overland stage lay between points now passed in a half hour's ride on the California Limited. Then, prominent landmarks were usually associated with the adventures of certain local characters. This doubtless explains how the picturesque gorge a few miles west of Williams got its name.

JOHNSON'S CANYON
ARIZONA

The Apaches Get Special Attention

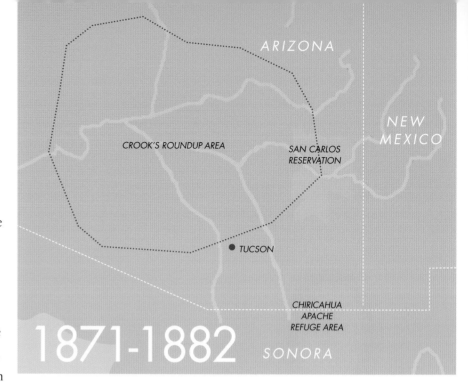

ARIZONA

NEW MEXICO

CROOK'S ROUNDUP AREA

SAN CARLOS RESERVATION

TUCSON

CHIRICAHUA APACHE REFUGE AREA

1871-1882

SONORA

After the Mexican and Civil Wars, the first Anglo settlers in the desert were soldiers, who mainly kept within the increasing number of forts and posts scattered through the region, and drifters who'd most likely been in and out of the army. They were poor, battle-hardened loners, and the opportunity to make a living in a generally lawless society seemed more attractive than returning to the proper, law-abiding East.

The transcontinental railroads brought new settlers with different requirements. Now there were better-dressed easterners looking to build polite new towns like the ones they left behind.

When Indians raided, the older settlers simply shot at them, and what soldiers were in the Territory did pretty much the same. This was nowhere near good enough for the newcomers. They wanted safe streets, and they wanted the army to make them safe.

In the 1870s, territorial, state and federal governments agreed that something more enlightened had to be done about the Apache problem. Spanish, Mexicans, Yankees and other Indians had been fighting them for more than two hundred years, and Washington and the settlers had been trying to wipe them out ever since the Mexican War.

This was the decade of the Indian Wars. It was the time of Custer and Crazy Horse in the Dakotas and of General Miles's campaign against Chief Joseph in the Northwest.

Although many of the desert's early settlers would have agreed with Union General and Indian fighter Philip Sheridan's opinion that "the only good Indian is a dead Indian," the official party line was, at least in intent, gentler.

What had begun thirty-five years earlier when the government moved the Southeastern tribes to Oklahoma now became universal policy. Indians, whether or not they caused trouble, were to be rounded up, placed on reservations located on land nobody else wanted, subjected to schooling and Protestant missionaries and converted into good taxpaying citizens.

The phrase "the vanishing race" kept cropping up in writing about Indians, and the people who shaped the national policies surrounding Indian affairs probably liked the sound of it. The real hope was that the Indians would just go away, and even if no one actually believed it was possible, peaceful assimilation seemed like a nice idea and a good way to make Indians disappear.

In 1871, the army sent General George Crook to gather up the Western Apache and the Yavapai. He did his job well, and his troops confined the Indians in small reservations near their own lands.

However, the government had already set aside a chunk of unoccupied land in the eastern Arizona mountains in what used to be Salado country and created the San Carlos Reservation. In 1874, orders came to move everybody to San Carlos, and the army sent Crook off to fight the Sioux in the Dakotas.

San Carlos wasn't a particularly pleasant place. In *An Apache Campaign*, first published in 1886, Capt. John G. Bourke, Crook's aide-de-camp and no fan of the way things were done in Crook's absence, described how he saw it:

When they went upon the reservations, rations in abundance were promised for themselves and families. A difference of

opinion soon arose with the agent as to what constituted a ration, the wicked Indians laboring under the delusion that it was enough food to keep the recipient from starving to death, and objecting to an issue of supplies based upon the principle according to which grumbling Jack Tars used to say that prize money was formerly apportioned—that is, by being thrown through the rungs of a ladder—what stuck being the share of the Indian, and what fell to the ground being the share of the agent. To the credit of the agent it must be said that he made a praiseworthy but ineffectual effort to alleviate the pangs of hunger by a liberal distribution of hymn-books among his wards.

Things went from bad to worse at San Carlos, and the Chiricahua Apache decided that reservation life wasn't for them. The incident that blew things apart took place in 1882. The agent sent his chief of police to arrest a Chiricahua for a minor wrongdoing, the Indian ran, the policeman shot at him and killed an innocent Chiricahua woman instead. The Chiricahua were so annoyed they ambushed the chief of police, killed him, cut off his head and played football with it. That night, the entire band of 710 men, women and children ran for the Mexican border 150 miles south.

The last great Indian campaign was about to begin.

Fun at San Carlos: Apaches while away idle moments in a hoop game, undoubtedly posed for the visiting photographer.

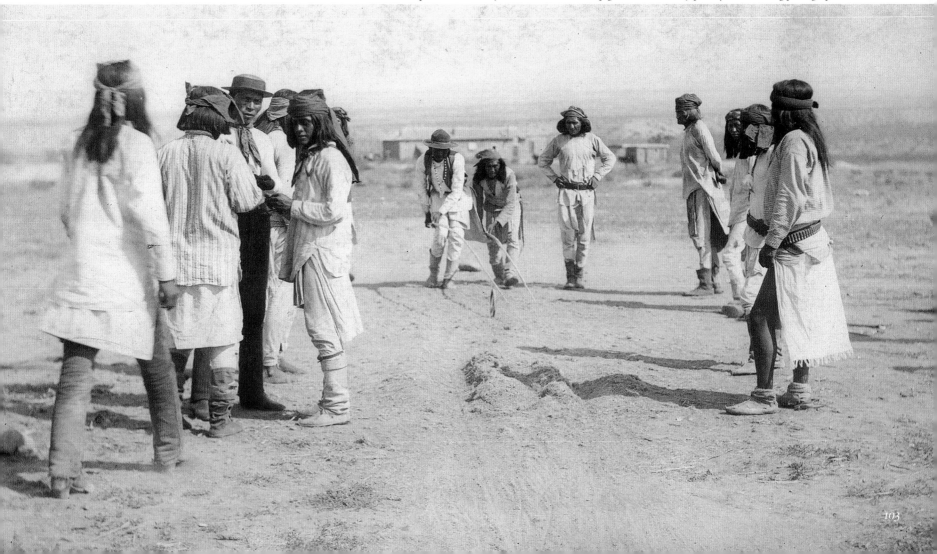

The End of the Trail

Between 1882 and 1884, the four determined-looking men pictured here took part in a drama that still resonates in the attitudes of Indians and Anglos alike.

The action played against a backdrop of a still-simmering war of extermination against the Apache. Hatreds had become so fierce that, in 1871, a Tucson mob had massacred eighty-five Aravaipa Apache who had put themselves under the protection of the Tucson Army garrison. The jury deliberated for only half an hour before they acquitted the lot of them.

General Crook was a different breed, but he left the scene early. His careful, considerate roundup in the early 1870s had been so successful that he'd been sent off to fight the Sioux in the Dakotas in 1874, and the territorial governor issued a proclamation that it was "almost a certainty that no general Indian war will ever occur again."

The Chiricahua never heard that speech. Cochise, perhaps the greatest Chiricuaha chief, died in peace on a reservation in 1874, but by the next year, splinter bands were raiding on both sides of the border. When the Chiricahua bolted from the San Carlos reservation in 1882, they ran to Mexico. They were shot at by U.S. Army troops, by angry settlers, and before they even reached

Geronimo

Victorio

Naiche

Crook

the border, by a column of Mexican troops.

The Indians fled into the Sierra Madre wilderness and attempted to negotiate an armistice with the Mexicans. The talks ended with Apaches being killed and the survivors swearing vengeance on Mexicans and Americans alike.

This was the situation Crook found when the army

recalled him to Arizona duty. He tried to call in all his old markers with Apaches throughout the territory who remembered him well, but it didn't work with the Chiricahua.

They launched a reign of terror that extended east into New Mexico. Their forays went as far as 800 miles from their strongholds and avoided as many as five thousand Mexican and American troops.

Three years earlier, in 1879, Victorio, an Apache chief, had a shaman named Geronimo at his side (old accounts often spelled it *Heronimo*, which indicates the correct pronunciation). Victorio had decided that U.S. authorities would never tolerate his band in their homeland in New Mexico's Mimbres country. Victorio's band ran to the Chiricahua mountains and raided, fought and eluded the U.S. Army for three years until new players, a Texas African-American unit known as the Buffalo Soldiers, drove them back into Mexico, where he met his end at the hands of a band of Chihuahuans and Tarahumara Indians. In their pursuit of freedom to roam the land, Apache raids made enemies wherever they went.

After Victorio's death, and after more months of conflict, new Chiricahua leaders emerged. Now Geronimo, Victorio's shaman, and Naiche, Cochise's son, led the principal arm of the Apache resistance.

Mexico and the United States decided the Apache problem was

Geronimo's rifle now rests safely in Tucson, in the basement of the Arizona Historical Society Museum.

becoming desperate. They agreed to let U.S. troops cross the border in pursuit, and Crook took a force of fifty U.S. soldiers and two hundred Quechan, Mojave and Apache scouts into the Sierra Madre.

Once again, Crook demonstrated that he knew what he was doing. In February 1884, his scouts found Geronimo and Naiche. They quietly brought the Chiricahuas back to the reservation.

As always, the San Carlos agents blew it. After fifteen months, an exasperated Geronimo, Naiche and 172 Chiricahuas escaped back into the Sierra Madre. Crook went after them, found them and, under orders, demanded unconditional surrender. The Apaches refused, and the army replaced Crook with General Nelson Miles, recently done with harrying Chief Joseph and the Nez Perce Indians across Montana to Oregon.

Many pages were written about the patience and forbearance of Miles, but he was no Crook. He sent out a quarter of the U.S. Army against those 172 Apaches with little success. Finally, in 1886, two

Chiracahua scouts and a U.S. lieutenant found Geronimo, who surrendered for the fourth time.

This time, there was no San Carlos. Miles loaded Geronimo and his people into railroad cars and sent them to prisons in Florida. For good measure, and to make sure that the Indian problem was ended for once and for all, Miles was thorough. He put all the Indian scouts who had helped Crook capture the Chiricahua on the train as well.

Crook was infuriated. He spent his last years lobbying on the behalf of the Apache, and even made a pilgrimage to a compound in Alabama, where they'd been relocated after a quarter of them had died in the diseased Florida jails.

Crook died in 1891, while the Apaches still languished in Alabama. It wasn't until 1913 that the last of the Chiricahua could return to the mountains of Arizona and New Mexico.

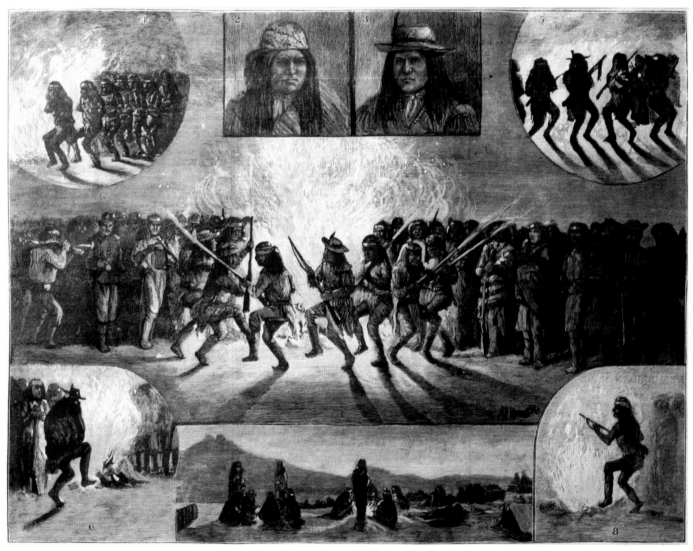

"War Dance of General Crook's Apache Scouts—From a Sketch by A.F. Harper." This engraving from Harper's Weekly *reflects General Miles's attitude toward the Apaches. These scouts brought in Geronimo, but Miles dismissed them as "disreputable."*

Romancing the West: Mission Bells

Once the Indian threat was no longer an issue, the new immigrants could set about the business at hand. There was a vast new land to be exploited, and it was time that the exploitation be removed from the hands of hooligans and given over to more polished practitioners.

The age of the real estate developer had begun. The word *progress* became fashionable, and it remained the driving force across the desert for most of the next century.

In southern California, progress got an initial boost from an unlikely source. In much the same way that Harriett Beecher Stowe's *Uncle Tom's Cabin* crystallized anti-slavery attitudes before the Civil War, Helen Hunt Jackson's 1884 sentimental best seller *Ramona* not only created sympathy for California Indians, it glamorized the mission years and the idyllic times when the kindly padres brought peace and contentment to the Indians.

Within months, the media barrage was under way. Since the Mexican secularization,

the mission buildings had lain untended, gloomy and crumbling. Mid-nineteenth-century observers had commented on the foreboding, sinister character of the mission ruins and mostly portrayed them as evil symbols of man's inhumanity to man.

Ramona worked its magic on the popular consciousness almost overnight. The book's presentation of the missions gave would-be developers a hook for their promotions. "Mission" cottages and

History rewritten, attitudes reshaped: Helen Hunt Jackson's 1884 Ramona *and a basket made from instructions in George Wharton James's book.*

"Mission" furniture followed in short order, all to be had in the peaceful lands where those beautiful garden communities had once cast their benign influence over the countryside.

The book also contributed to a new interest in things Indian. In 1879, the Bureau of Ethnology of the Smithsonian Institution began publishing its annual reports, and collectors started to notice Indian art. As far back as the eighteenth century, Russian traders had become the first Europeans to value the work of American Indians. They had seen the quality of California Indian basketry and brought examples back to the Hermitage in St. Petersburg. When scholars say that California Indians made the finest baskets in the world, nobody laughs them off the stage.

By the 1890s, eastern collectors were searching out California baskets, and great collections found their way to the basements of important eastern museums.

Originally, the passion was rarefied, but it quickly turned popular. In 1896, a Methodist minister named George Wharton James wrote *Indian Basketry*, following up on his popular 1892 *In and Out of the Old Missions of*

California. In *Indian Basketry* and in the later *How to Make Indian and Other Baskets,* he launched a craze. Southern California ladies began turning out baskets like the one in the picture on the previous page, made from whatever materials were handy that looked like the materials the Indians used.

Now, southern California had a persona. It became the sun-blessed land of the mission padres, where peaceful Indians grew fruits and flowers, and that image triggered the first

bursts of real growth. In 1880, Los Angeles had a population of eleven thousand. In 1890, it had grown to fifty thousand. By 1900, it was 102,000, and San Francisco began to notice that significant competition for control of the state was developing down south.

It took about fifteen minutes for the commercially minded to grab hold of the romance of the missions as a marketing tool. These orange crate labels date from the early twentieth century.

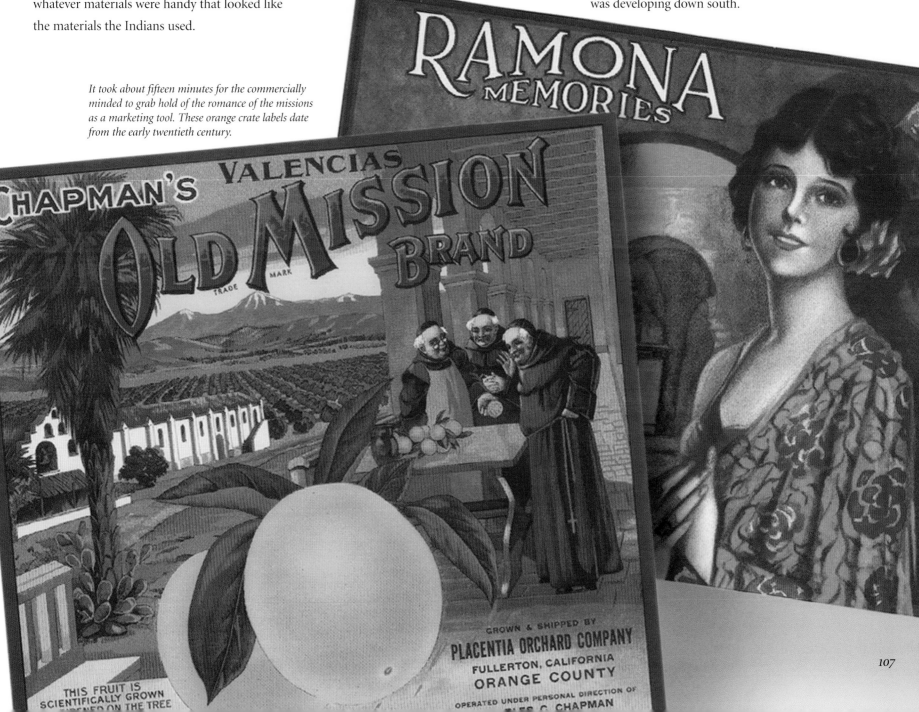

107

Dime-Novel Desperadoes

Back east, stories about the doings in the territories started finding their way into the popular press, and many of the media darlings of the midcentury attained their celebrity through reporting of their heroic feats or their criminal deeds, or both.

Thanks to media coverage, helped along by the fact that he was the son-in-law of a U.S. senator, John C. Frémont became known to the whole country as "The Great Explorer" in the early 1840s, and, during the Mexican war, as "The Conqueror of California." He was a man of considerable accomplishment, but both titles were more media hype than accurate description.

Over the next decades, a string of westerners of varying degrees of respectability became national figures. Every American schoolchild knew the names of frontier scouts like Kit Carson, Indians like Geronimo and soldiers like Custer. For a hundred years after, kids played Cowboys and Indians, and no kid—even, we're told, *Indian* kids—wanted to be the Indians.

Nobody captured the national imagination like the badmen, however. Names like Jesse James, Black Bart and Billy the Kid struck fear into the hearts of respectable people all over the nation.

The Wild West existed, and it was truly a hard place, but it never existed quite like it was portrayed. The legendary badmen, for the most part, were an unglamorous lot. If you look at the usual photograph of Billy the Kid and try to read the character of the fellow staring back at you, you feel more sorry for him than afraid.

Billy

That's not how the write-ups went, however. The picture on the next page is from an 1882 issue of *Harper's Weekly*, and the accompanying article gave the full eastern slant on the West That Never Was. It begins by describing "certain active members of frontier society known popularly as 'Cow-boys.'" The information continues colorfully, if inaccurately: "They make the field of their operations, for the most part, in the county of Cachise (so named from a whitish stone found in the silver mines) and their head-quarters are in the town with the highly characteristic title of Tombstone."

It tells us that "these free-riders of the mountains have a special fondness for cattle and very little scruple to the herds from which they take them. This life is toilsome and adventurous, but irregular, and the "Cow-Boys" seek relief from it in the drinking saloons, gambling halls and brothels of the Tombstone politicians, and

Crime paid back then, too.
The Great Train Robbery was the first movie western, and it owed a lot to history as portrayed by Buffalo Bill.

in now and again taking part in the political struggles of the community. By means of their liberal expenditures, and the more or less clandestine relations they maintain with the trades-people of the town, they exert considerable influence, and, as is not an unknown practice in the more settled sections, the ambitious find their account in propitiating rather than in seeking to punish the law-breakers.

"The alternation of adventure and ease, the dash, the danger, and the triumph of successful operations, followed by the wild debauch, and the intervals of loafing, appeal to the disordered passions and ill-regulated energies of the border."

There you have it. Aside from confusing *Cochise* with *caliche*, no supermarket tabloid could have spun it out better.

The Cow-Boys of Arizona, sketched by Frederick Remington for Harper's Weekly *in 1882. The reporter thought* cowboy *meant* cattle rustler, *and described them as citizens of considerable importance.*

Copper:
Enter Big Business

Back east, big things were happening, and the world was changing. Samuel F. B. Morse invented the telegraph and Thomas Edison invented the lightbulb.

Suddenly, America wanted copper wires—thousands of miles of them. Before 1880, miners in the desert had looked for silver and gold and had settled for copper as a poor third choice, a mineral whose main use was to make pennies. Now copper stepped forward, and the desert had what the country needed.

At first, prospectors looked for high-grade ore that could be mined easily, but the nation couldn't wait for copper to dribble out from small operations. It needed copper by the ton, and it needed people with the resources to deliver it.

Quickly, mining became big business. Now it involved cutting away whole mountains, moving them to mills and smelters and building railroads to ship their production to cities, towns and factories all over America. New town names appeared: Bisbee, Douglas, Morenci, Globe, Miami, Jerome and many more. By 1887, five major railroads converged on El Paso, primarily to serve the new El Paso Smelter Company.

Bisbee's story is typical. It was empty land until the 1870s, when the first claims were posted, and the Copper Queen claims looked promising. By 1880, it was a town but not much of one. Then engineers showed how to mine copper on a large scale, and eastern investors stepped in.

Money flowed into Bisbee, including some from a trading company named Phelps Dodge, a name that would move mountains, both literally and politically, for decades to come in Arizona.

Bisbee needed miners to work the mines and houses to put them in, and the town sprawled up the hillsides. Ore came up from the pits in wagons hauled by twenty-mule teams, and slapped-together smelters poured fumes into the air toxic enough to kill most of the local vegetation.

Bisbee quickly became a cosmopolis, or perhaps more accurately, a mini Babel. There were U.S. natives and Mexicans, but there were also recent immigrant Irishmen, Germans, Italians, Spaniards, Serbs and, thanks to Charles Crocker's discovery of a previously untapped workforce in building the Central Pacific, quite a few Chinese.

The various ethnic groups didn't always live together in sweet harmony, and words like *Mick, Spic, Kraut, Dago, Bohunk* and *Chink* rattled back and forth between them.

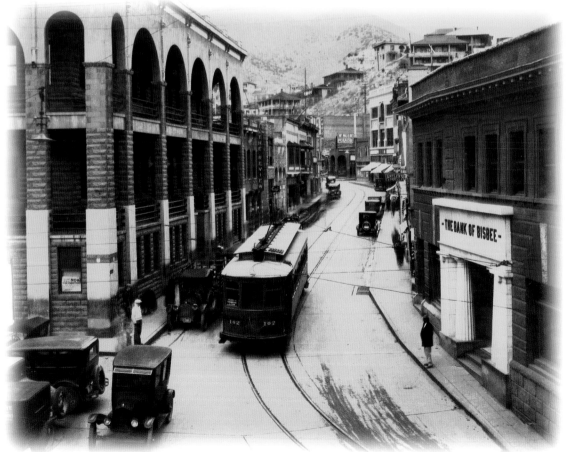

Bisbee at its peak in 1910: There was more to it than Brewery Gulch.

Management did little to help the ethnic groups get along. Whenever one group got restless over conditions, the mine operators would use another as strikebreakers, which didn't make things any more pleasant.

Some workers, of course, got the short end of the stick. Anglos got higher wages than Mexicans, while the Chinese weren't even allowed to live in the town.

There was employment, however. Employment meant money, and money did dress up the town a bit, as the picture at left attests. Bisbee also attracted its share of gamblers, painted ladies and cowboys of the sort that caught the attention of the *Harper's Weekly* reporter on the previous pages. They congregated in a section of town called Brewery Gulch and turned Bisbee into the kind of town that produced a celebrated lynching in 1883 and a five-man public hanging in 1884.

Mining, unfortunately, is what has been described as a "self-terminating activity," and Bisbee wasn't immune. In the 1900s, the new Silver Queen Smelter opened in the town of Douglas 20 miles down the road. Bisbee's mining activity slowed down, and its air quality took a turn for the better.

Despite Bisbee's setback, the future was taking shape. The desert was turning into what Thomas E. Sheridan described as "an extractive colony of industrial America."

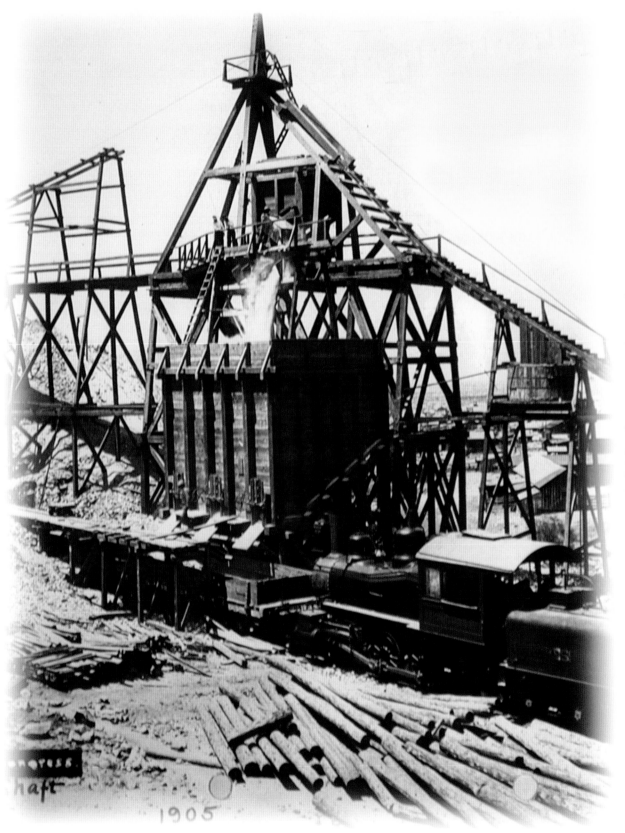

No more pick-and-shovel. In the 1880s, mining turned serious.

Phelps Dodge

Today, if you go to the Phelps Dodge website, you'll see about what you'd expect from a big U.S. corporation. There's a section that lists its current North American mining operations, and it lists name after name of historic copper mining towns of the desert: Globe, Miami, Morenci and Green Valley in Arizona and Hurley, Santa Rita and Tyrone in New Mexico.

The site tells us that Morenci is the largest copper-producing operation in North America and that Tyrone is the safest open-pit mine anywhere. It talks about Phelps Dodge's considerable efforts to damage the environment as little as possible and reminds us that, in

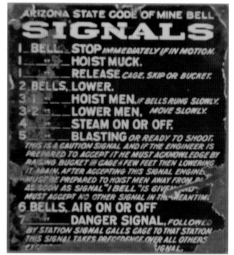

The miners had a point. There were definite occupational hazards.

Arizona and New Mexico alone, the company has nearly five thousand employees. Mining may be a self-terminating endeavor, but Phelps Dodge is still some distance from termination in the desert.

The road to its present eminence and stability has hardly been smooth. The first big miner's strike in the territories happened at Phelps Dodge's Clifton-Morenci mines in 1903. It was triggered by the Arizona Territorial Legislature's passage of a law limiting the workday to eight hours.

Progressive as the legislation was, it was aimed straight at immigrant (read Mexican) workers at Clifton-

Morenci, the only major mines that worked ten-hour shifts. Clifton-Morenci hired Mexicans and Italians who worked longer hours and for less than union scale.

Phelps Dodge first challenged the legislation and fought the Western Federation of Miners, then got around the law by switching to eight-hour shifts at a 10 percent pay cut.

This didn't sit well with the Clifton-Morenci workforce, foreigners or not. Four Mexicans and an Italian organized the workers and called a strike. Annoyed, management convinced the governor to send in sheriff's deputies, the Arizona Rangers, the Arizona National Guard and a U.S. Cavalry Unit.

The armies managed to capture ten strike leaders, all Mexican or Italian, who were speedily convicted of inciting to riot and sent off to territorial prison. That was the end of the strike.

One thing came out of it for Clifton-Morenci workers. The Western Federation of Miners started bringing Mexicans into the union, despite resistance from the higher-paid Anglo/Irish. The union's answer was to push for legislation declaring that 80 percent of any business's workforce had to be English-speaking citizens, and although the territorial legislature voted it down, it resurfaced in 1912

Strikers at Clifton-Morenci in 1903: The signs were eloquent, but the largest military force in Arizona since the Indian wars ended the debate.

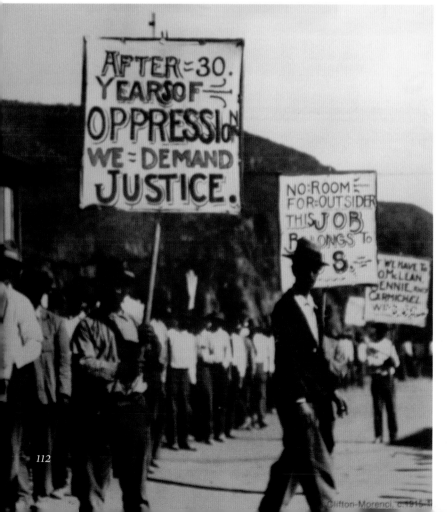

as an iniative when Arizona obtained statehood. The Supreme Court threw it out in 1915, but the point was made.

In 1915, war was festering in Europe, copper prices were climbing, and mine workers finally won a few strikes. By 1917, Phelps Dodge management had determined that employees who contributed to labor unrest were in league with the German enemy and reacted accordingly

when another strike broke out. After a stirring speech by a Phelps Dodge vice president, the sheriff of Bisbee and two thousand deputies broke down doors and hauled two thousand strikers over to the town ballpark, offering them the option of behaving or shipping out.

Twelve hundred opted for the train ride, and fifteen hours later, they were dumped in the New Mexico desert, miles from nowhere.

The action reverberated all the way up to Washington, and in 1918, the sheriff of Bisbee and the patriotic Phelps Dodge vice president faced federal charges of conspiracy and kidnapping. The trials were held in Arizona, and the acquittals came quickly.

The issues were settled. There were no more strikes at Phelps Dodge for another thirty years.

The 1917 Bisbee strike comes to an end, and twelve hundred ex-employees enjoy a free train ride.

Settlement: Sheep

In the opening pages of Zane Grey's 1921 western thriller *To the Last Man*, the aging cattle baron writes his son, "Lately we have been losing stock. But that is not all nor so bad. Sheepmen have moved into the Tonto and are grazing down on Grass Valley. Cattlemen and sheepmen can never bide in this country. We have bad times ahead."

The book was shoot-em-up fiction, but the events that inspired it were real. Between 1887 and 1892, perhaps as many as twenty cattlemen and sheepmen died feuding over grazing lands in Pleasant Valley, an idyllic grassy meadow in the middle of Arizona's Tonto Forest.

There was more to the Pleasant Valley War than disagreement over grazing rights, but the fact remains that sheep and cattle don't coexist kindly, and that the land doesn't do all that well with either.

Sheep first came to the desert with the Spanish, but the herds were small and apparently didn't create overgrazing problems.

Compared to cattle ranching, sheep ranching was of relatively minor importance below the Mogollon Rim. Up north, sheep provided, and still provide, a major source of income for the Navajo nation.

However, sheep left their mark on the desert. In the 1850s, half a million sheep ate their way across New Mexico and Arizona on their way to California. There was a brief sheep boom in Los Angeles in the early 1870s, but it crashed in 1873. By the 1880s, the Cienega Ranch east of Tucson boasted a thousand head of cattle and twenty-three thousand sheep, and Don Solomon Luna was building a vast sheep ranching empire in southwestern New Mexico that lasted into the early twentieth century. Meanwhile, Basque sheepherders had introduced herds along the Gila and had received a welcome unfriendly enough and occasionally lethal enough to convince them to move on to the area around Winnemuca, Nevada. Grazing wasn't as lush, but fewer settlers greeted them with shotguns.

This lack of acceptance had a basis. Zane Grey's hero saw it this way, and his reaction was probably fairly true to life and the times. "To be sure, he had been prepared to dislike sheep . . . this band of sheep had left a broad bare swath, weedless, grassless, flowerless, in their wake. Where sheep grazed they destroyed." In *Gila: the Life and Death of an American River*, Gregory McNamee felt so strongly about the ecological impact of sheep ranching that he referred to them as "hooved locusts." Fortunately for the ecology of the desert, sheep ranching never really took hold. By the mid-twentieth century, there were more than ten million sheep in Texas, but they'd largely disappeared from southern New Mexico, Arizona and California.

In much the same way Helen Hunt Jackson's Ramona *established the popular perception of the California missions, Zane Grey's novel and the Hollywood version that followed immediately after its publication introduced and implanted range wars into America's Wild West mythology.*

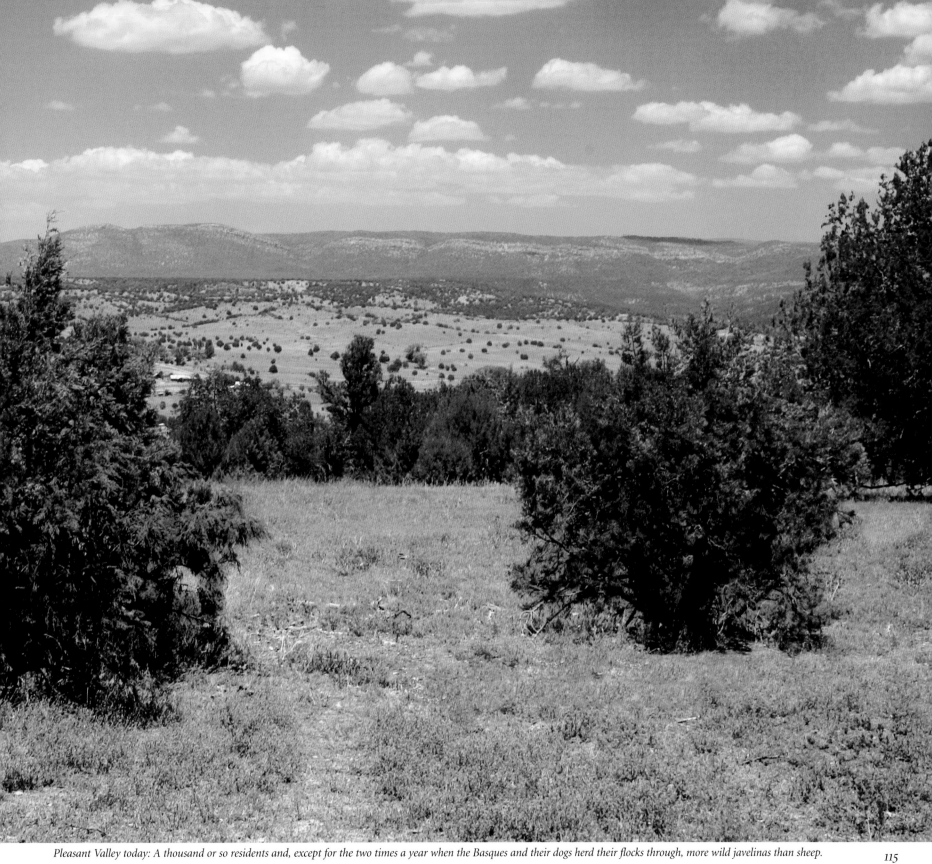

Pleasant Valley today: A thousand or so residents and, except for the two times a year when the Basques and their dogs herd their flocks through, more wild javelinas than sheep.

The Mormon Conquest

Once the Latter-Day Saints reached Salt Lake City and a safe haven after years of persecution in the midwest, they looked for new areas of colonization. Their first exposure to the desert had come years before their pilgrimage, and it was a by-product of the Mexican War.

In 1847, Lt. Philip St. George Cooke recruited for the Mormon Battalion in Illinois, and Mormons marched across the desert from Santa Fe through Tucson, avoiding combat until they faced an Arizona skirmish with stampeding longhorn cattle. They escaped with minor casualties in their "Battle of Bull Run," more true to the name than the famous one to come in the Civil War. Despite hardships, they became the first to get a wagon train past the Yuma Crossing and into California. Some of the battalion members appreciated what they saw in the desert enough to return to the Tucson area after the war and settle.

The major Mormon colonization in Arizona came after the Civil War, spreading south from Mormon settlements north of the Mogollon Rim. The impetus was an 1862 act of Congress outlawing polygamy which the Mormon leadership saw as a declaration of war on the sect. Brigham Young ordered his followers to lay out towns a day's ride apart north and south from Salt Lake City with the thought that they'd provide a ready-made escape route north to Canada or south to Mexico if needed.

By the 1870s, the Mormons had established settlements in the Arizona desert, first at Safford and Florence, then Mesa and, as the last outpost on the desert escape route, at St. David, within 50 miles of the Mexican border.

The Mormons had had their eye on the desert for some time. Years before, a Mormon emissary named Orson Hyde had toured the Mediterranean and the Near East studying irrigation methods, and reports from the Mormon Battalion about the canals along the Gila aligned with Hyde's reports of Moorish irrigation in Spain.

Once they arrived, the Mormons set out to grow as much food as they could to support their expanding colonies. Every piece of property had its own canal and dam. The community Water Master established a schedule of "water turns," and the law-abiding settlers all held tight to their rationing schedules, knowing that if they didn't, they'd suffer dire punishment. If the crime were serious enough, it could be a capital offense.

These schedules, of course, were to benefit Mormons only, and others in the area found their water sources drying up.

In 1873, the Akimel O'odham, who seven years earlier had grown enough food to provision the U.S. Army, had to petition President Grant for aid from famine. The Mormons at Safford and Florence had dammed the Gila, and no water came to Sacaton and the old Hohokam lands in the Phoenix Basin.

Arizona finally cracked down on polygamy in the mid-1880s, and a good number of Mormons did defect to Mexico, at least until 1910 and the Mexican revolution, when a large number came back north.

If you need proof of the importance of the Latter-Day Saints in Arizona history, you only have to look at Mesa. Today, it's easy to view it as one of the larger elements of Greater Phoenix and let it go at that, but it's much more. It was established in 1877 by colonists sent by the church leaders in Salt Lake City, and it got off to a bumpy start.

The first group established Utah City, then changed its name to Johnsonville, then to Lehi, which still exists, but only as a neighborhood in

Philip St. George Cooke signs up the Mormon Battalion, as portrayed in Tucson's Civic Center.

Mesa. Three months after the Utah City group arrived, a second wave of settlers founded what became modern Mesa a few miles over, and it flourished.

By the 1920s, Mesa had a giant Mormon temple. Today, it's swallowed Lehi and has more than 250,000 people, and when you drive the 202 freeway, you see a sign that says MESA NEXT 15 EXITS. Of that quarter of a million population, fifty thousand are Mormons.

As late as the 1960s, Navajo children conscripted into Bureau of Indian Affairs boarding schools in Arizona were given good American names, were prohibited from speaking their native languages and, surprisingly, in light of the constitutional provisions that separate church and state, were assigned to a specific non-Indian religion. In 1997, a Navajo alumna who kept her BIA-assigned name of "Betty Reid" described those days in a series of articles in the *Arizona Republic*. She was assigned Presbyterian, but she envied the kids who drew Mormon. They got bigger bags of candy and treats.

A gathering at the Mormon temple in Mesa, ca. 1930. By then, the conquest was complete.

Phoenix Rising

The "Father of Phoenix" hardly rates a marble monument. Jack Swilling was a drunk, a laudanum addict and, ultimately, when he ran out of money, a convicted stagecoach robber who died in prison.

But he, more than any other man, deserves credit for founding America's seventh largest city. In the 1860s, he noticed that the Hohokam's ditches were actually irrigation canals and restored several miles of them to sell to new settlers. By the time the Mormons opened the old canals 40 miles to the southeast at Florence, Phoenix was already on its way.

The water brought buyers to the land but not immediately. In 1870, this new canal city, this Venice of the West, had a population of 235, and it wasn't named Phoenix, it was named Pumpkinville, then Swilling's Mill, then Mill City. Swilling, a loyal Confederate, liked the name "Stonewall," in honor of Stonewall Jackson. Someone else suggested "Salina," after the Salt River. But one citizen pointed out that their new community rose from the ruins of an ancient civilization, and his suggestion carried the day. Phoenix it was.

In 1873, the *Prescott Miner* announced a "Great Sale of Lots at Phoenix, Arizona," and the rush began. Settlers bought sixty-one lots at an average price of $48 each, giving speculators a tidy profit. The official value of the entire 320-acre town had been recorded at $550.

At the time, Tucson was Arizona's leading metropolis. It had three thousand citizens and, according to Odie Faulk, was "cosmopolitan in language, food, dress, amusements, holidays, ceremonials and religious exercises," but its days as the leading city in Arizona were numbered. It didn't have Jack Swilling to open its canals.

Jack Swilling, in better days.

One year after the land sale, Phoenix had a telegraph line, operated by Morris Goldwater, the son of a local storekeeper. After another year, according to the official city history, it had sixteen saloons, four dance halls, two monte banks and a faro table.

By 1878, Jack Swilling was in jail and forgotten, but the mischief he began had a life of its own. The flowing water kept Phoenix growing, despite the fact that both transcontinental rail lines bypassed it. The Southern Pacific went through Tucson, while the Santa Fe went north through Flagstaff.

The year Swilling went to jail, *The Salt River Valley Herald* first appeared. It eventually became today's *Arizona Republic*. In 1880, Phoenix claimed 2,435 residents. By the end of the next year, Phoenix was on its way up. The city was incorporated and had a brand new ice plant.

Phoenix started small. This is the Presbyterian Church at Third and Washington in 1879.

Other things came to Phoenix as well. The thirteenth Territorial Legislature (referred to in contemporary accounts as the "Thieving Thirteenth") distributed spoils throughout the state. In 1885, the town of Tempe, a few miles south of Phoenix, got an appropriation for a new Normal School, which ultimately became Arizona State University. Prescott got the state capitol, Florence got a bridge over the Gila, and Tucson got the University of Arizona, an award that carried an appropriation of $25,000.

At the time, Tucson wasn't as thrilled with the award as it perhaps should have been. Its citizens were outraged because Phoenix got the State Insane Asylum, and that brought a $100,000 appropriation. When their legislators returned home, Tucson residents greeted them by pelting them with dead cats.

Despite the reaction down in Tucson, the days of Wild West fooling around were ending rapidly. By 1887, Phoenix had a streetcar line, and, more important, a rail connection with the Southern Pacific. The next year, it served notice that the old days were gone forever. It established a chamber of commerce.

In 1889, more political logrolling ended Prescott's tenure as the territorial capital. As the new capital, Phoenix was now, by definition, an important city, and progress ran rampant. Two years later, it had a telephone system, and in another two years, the streetcars ran on electricity. Next, there was a Phoenix Country Club and a Phoenix Women's Club. In 1901, the territorial capital got a permanent home, ten acres on Washington Street near the Presbyterian church's ramada in the rustic scene at left. The magnificent new capitol cost the Territory of Arizona the handsome sum of $150,000, a fitting expenditure for a community and a government so obviously on the rise.

For Phoenix, even disaster was no more than a bump in the road. All the dams that Jack Swilling, his successors and the Mormons built weren't enough to hold the floods of 1891, the worst in anyone's memory, but once again Phoenix came out on top. In 1902, Theodore Roosevelt signed the National Reclamation Act. Four years later, crews broke ground for Roosevelt Dam, the first of the great dams of the twentieth century.

Phoenix had won the biggest prize of all.

By the 1890s, Phoenix was on the rise. Here, a resident shows his pride in the magnificent new Arizona State Hospital for the Insane.

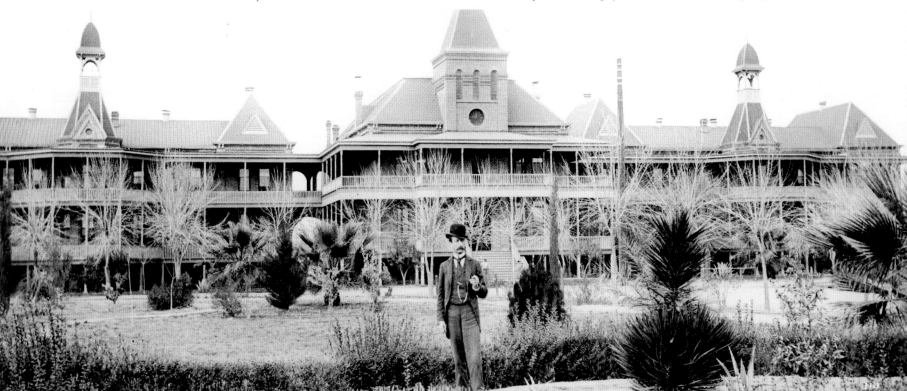

Watering the Desert: Roosevelt Dam

At 5:48 p.m. on March 18, 1911, an eleven-gun salute and the cheers of a thousand spectators encouraged Theodore Roosevelt to push the button that opened the floodgates that released the first water from the new lake that bore his name.

Roosevelt Lake and its accompanying dam were the first big projects of the National Reclamation Act, legislation so important that Roosevelt put it alongside the Panama Canal as one of the two great achievements of his administration. The dam, which engineers describe as a "unique cyclopean thick-arch design," was seen as one of the prime engineering marvels of an age when "engineering marvels" happened regularly. It's now listed on the National Register of Historic Places. In 1971, it received a National Historic Engineering Landmark Award.

This massive structure was 280 feet high, which qualified it at the time as the world's tallest masonry dam. It's since received updated engineering, another 450,000 cubic yards of concrete and another 77 feet in height. Behind it lies Arizona's largest lake, 30 square miles and 1.6 million acre feet of water storage, 76 miles east of Phoenix.

Roosevelt Lake fills a deep gorge below the confluence of the Salt and Tonto Rivers. Before dam construction began, there was nothing there except for a few Salado ruins in an area where ruins were common. Nobody thought much about them until 1925, when drought lowered the lake level. Armer Ruin peeped above the surface, and a *New York Times* reporter wrote about a five-thousand-year-old ruin with apartment houses larger than Park Avenue's. The ruin wasn't much more than five hundred years old and nowhere near that big, but the publicity focused attention on the area and caused archaeologists to take a second look and, a few years later, to identify the Salado as a separate culture.

The real impact of Roosevelt Lake, Roosevelt Dam and what came to be known as the Salt River Project (today, simply "SRP") had nothing to do with archaeology and happened almost immediately after it opened. As before, Phoenix continued to lead a charmed life. Opportunity knocked, and thanks to the dam, it was ready.

America was quickly converting to the automobile, and World War I was on the horizon. Both events created a new demand, and Salt River water put Phoenix in a position to deliver what the nation needed: long staple cotton for military uniforms, as the fabric bond in automobile tires, and, soon after, for shirts from fancy clothing stores. Today, millions of us wear Pima Cotton shirts without a clue as to where the name came from.

In 1916, Phoenix had seven thousand acres planted in long staple cotton. In 1920, nourished by SRP water, it had 180,000 acres.

As the final affirmation of Phoenix's emergence as a modern metropolis and the

Roosevelt Dam as it looks today: 77 feet taller than it was when they first built it.

territory's development into an area to be taken seriously, Arizona achieved statehood on Valentine's Day, 1912. It was the forty-eighth and last of the contiguous states to gain full status in the Union. New Mexico was the forty-seventh, beating Arizona by only a few months.

Now, with enough water to support a million or so city dwellers, Phoenix could build a real city. It took a few more years to achieve that goal. In 1920, Phoenix's population still hadn't reached thirty thousand.

Cars came to Roosevelt Lake early. Back then, you drove over the dam. Now there's a big bridge just above it.

Roosevelt Lake, where no lake existed before 1913. The saguaro cactus along its shoreline reveal the true nature of the terrain.

121

Owens Lake

The next big water project happened in California. An October 2002 article in *Smithsonian* magazine pointed out that Los Angeles "sits on a semiarid coastal plain, with desert on three sides and the Pacific Ocean on the left" with fresh water limited to "the meager flow of the Los Angeles River, now a much-maligned concrete channel, and the paltry 15" of rain that the area averages a year."

In that unappetizing location, you'll find, against all odds, America's second-largest city, still largely watered by what, a hundred years ago, was a 110-square-mile lake. In 1913, the city opened the Los Angeles Aqueduct, and now, on a good day, it pours more than three hundred million gallons of water into the city.

If you've caught up with the 1970s movie *Chinatown*, Jack Nicholson's difficulties with John Huston and Faye Dunaway all grew out of the intrigues surrounding the Owens Valley and the Los Angeles Aqueduct. The movie was fiction, but it was based heavily on facts that were almost as dramatic as what you saw on the screen.

The aqueduct happened because two men who worked for the Los Angeles Water Company realized that local real estate promoters had done too good a job for the Los Angeles River. Population had doubled to 102,000 between 1890 and 1900, and by 1904, it had almost doubled again. By 1910, it was 319,000.

Fred Eaton, a well-educated, politically connected Los Angeles native, had been the water company superintendent, and by 1898, had become the mayor of Los Angeles. He and his number two man at the water company, a rough-edged, self-taught hydraulic engineer named William Mulholland, went on a quest for alternative water sources. Eaton found the answer.

Owens Lake, 200 miles to the north, in a remote area of the southern Sierras, had a lot of water. In Eaton's vision, all the city had to do was divert the Owens River before it reached the lake, dig a few canals, run some pipes and let gravity do the rest. Eaton took Mulholland to the Owens Valley in 1904, and the two men started an evangelical campaign for the aqueduct. Eaton also started buying up land and water rights in the valley. Commerce and the opportunity for profit was never too far removed from the motives of the men who watered Los Angeles.

Supported by a $1.5 million bond issue that Eaton had helped sell to the Los Angeles electorate, construction began in 1907. It was a miserable task. They built roads, laid pipe, ran telephone and telegraph lines, and they did it in the Mojave Desert in hellish summer and bitter winter weather. After six years of construction, forty-one workers

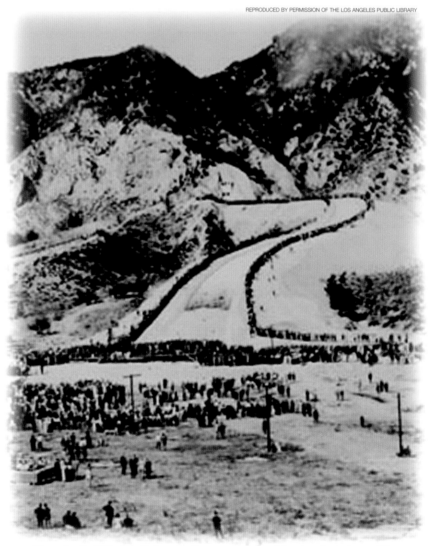

November 5, 1913: A puff of smoke, the water flows, and Los Angeles is changed forever.

Owens Lake: It has its own beauty today, but water has little to do with it. When you drive by on U.S. 395 at the right time of year, you'll see the pink salt-loving bacteria on the lake bed.

had died on the job. Since that number represented less than 1 percent of the total force of five thousand workers, it's been said that, in light of the working conditions, Mulholland's crews had an excellent safety record.

The aqueduct opened in 1913, and an estimated seventy-five thousand citizens of Los Angeles turned out for the event. Civic officials gave long speeches, bands played, fireworks exploded, and as the gates opened, Mulholland said all there was to say: "There it is. Take it."

Book after book has been written about the financial shenanigans and the insider land speculation that surrounded the building of the aqueduct, but today, none of that really matters. What does matter is that, in 1920, seven years after the aqueduct opened, the population of Los Angeles reached 577,000. It had passed San Francisco, and there was no turning back.

Owens Lake hasn't fared as well. Los Angeles is currently taking measures to reduce the intensity of the toxic salt-dust storms that blow across its dry surface, spurred on by the Environmental Protection Agency's finding that the Owens Lake bed is the single largest source of particulate pollution in America.

Ethnologists and Archaeologists: Indians, Up Close

In the middle of the nineteenth century, America's academia decided that Native Americans were worth study. Attitudes varied. Some seemed driven by respect for Indian art, culture and achievements, while others demonstrated the impersonal curiosity one applies to the study of botanical specimens. The ones who made the biggest impact were a colorful group of movers and shakers.

The first important ethnological examinations in the West began with John Wesley Powell. Powell, like many early archaeologists and anthropologists, was largely self-taught. He was a schoolteacher, a museum curator with a specialty in mollusk shells, a Civil War hero who rose from private to brevet colonel, a college professor (although apparently not a graduate) and, most famously, an explorer.

His harrowing 1869 exploration of the Colorado River accompanied by a nine-man crew (only six of the ten made it out) made him a national figure. He insisted that the trip be viewed as a scientific expedition rather than be publicized as a great adventure, but it was a losing battle. He'd lost a forearm in the Civil War and, despite the handicap, he'd achieved a feat that seemed impossible.

His explorations continued through 1872, and in 1875, the Smithsonian published his massive report. The hundreds of stereoscopic slides he gathered brought not only the Grand Canyon but the Indians of the Southwest into eastern living rooms.

Powell's Indian research led to the creation of the Bureau of Ethnology, devoted to recording the events of the last days of the "Vanishing Americans." He became its first director and held the post for life.

In 1888, Powell was elected president of the American Association for the Advancement of Science, the highest honor a scientist could achieve at that time— quite an achievement for a self-taught anthropologist working in areas of science that had yet to be fully defined.

Powell was the first, but others were right behind. A Swiss immigrant named Adolph Bandelier had even less formal training than

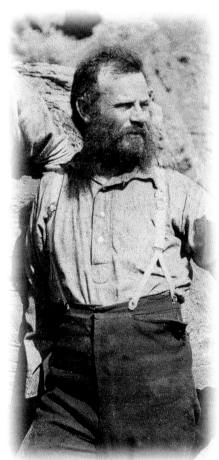

Powell

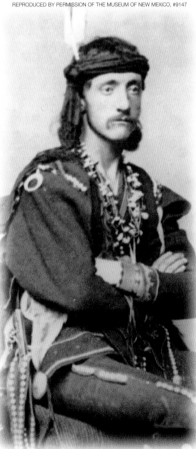

Cushing

Lummis

Powell. He learned about Indians by living with them and studying their artifacts and culture. He explored ruins across the Southwest (Bandelier Ruin north of Santa Fe is named after him) and studied Hohokam sites before anyone other than the local Indians had put a name to the culture.

Frank Hamilton Cushing also came down to Hohokam country, but he made his name at Zuni. Powell took him there as a 22-year-old assistant in 1879. Fascinated by Zuni culture, he got permission to stay behind and study. His technique was to "go native" to an extent that dismayed his colleagues. He moved into the pueblo, adopted the dress, learned the language and gained initiation into a secret priesthood, something normally closed to everyone but tribal members.

In 1882, he brought a group of Zunis east to show them his culture as they had shown him theirs. The trip created a popular sensation, but his Zuni costume made him even more of an academic outcast. In 1884, he took the Zuni side in a conflict with the Navajo, and the Bureau recalled him to the east.

He did make it back to the Southwest two years later, but his health was failing and he'd made his main contribution. He narrowed the gulf between academic study and Indian culture.

Charles Fletcher Lummis, another amateur anthropologist, decided in 1884 to walk from Ohio across the Southwest to his new job as a reporter for the *Los Angeles Times*. On the way, he fell deeply in love with the Southwest.

In 1886, he suffered a stroke and left Los Angeles to recuperate near Albuquerque at Isleta Pueblo, where he turned into an Indian rights activist. He befriended Bandelier, and they went on an expedition to Peru together in 1893. Broke by 1894, Lummis returned to Los Angeles and journalism, organized the western branch of the Archeological Institute of America and started a crusade to build a museum, largely to house his now great collection of Indian artifacts. The result was the Southwest Museum, one of the first important museums devoted primarily to Native American culture.

These pioneers had made their point. By 1900, America was interested in its Indians. The photographer Edward Curtis did his monumental twenty-volume *The North American Indian*, and industrialist Andrew Carnegie put up the money to publish it.

The establishment was taking notice, and attitudes were beginning to change.

Lummis's legacy: The Southwest Museum was built in 1914 on a knoll that overlooked a cow pasture between Los Angeles and Pasadena.

War and Change: Villa Meets Pershing

History books tell us that the First World War started in Europe in 1914 and that the United States didn't step in until 1917.

In fact, the United States got ready for war a year earlier and went to school on the subject in the desert. The classroom was the Mexican Revolution of the early twentieth century, and the most influential professor was an insurgent who went by the name of Pancho Villa.

The first shots of the revolution date back to 1906, when U.S.-based company thugs suppressed a Sonoran mine riot. Until that incident, troopers loyal to Porfirio Diaz, an elderly dictator who had held power for nearly half a century, had kept dissatisfied peasants—Emiliano Zapata's *descamiados*, or shirtless ones—under control.

The Sonoran riot launched a parade of incidents that led to a major uprising in 1910. Francisco Madero, who lost a rigged election to Diaz, enlisted peasants, foreign idealists (including Ambrose Bierce and the journalist John Reed, portrayed by Warren Beatty in the movie *Reds*) and anybody looking for a fight. By 1911, he had an army of seventeen thousand, and

in May, his troops occupied Ciudad Juarez and forced a treaty, the first major victory for the insurgents. Diaz fled to exile in France, and a few weeks later, Madero was president.

It was a brief administration, ending in assassination. The Mexican Revolution was a messy affair, with dissatisfaction with the status quo crossing all economic and political lines. Forces splintered and betrayal and internal conflict contributed to the confusion.

After Madero, a moderate, Venustiano Carranza took over. Almost immediately, one of Madero's lieutenants, a young Chihuahuan outlaw born Doroteo Arango, started building his own army. Arango took the name of Francisco Villa, or Pancho to the rest of the world.

By 1913, Victoriano Huerto, the man who had murdered Madero and opened the door for Carranzo, was holed up with an army of *Federales*—government troops—in a town named Ojinaga near the Texas border. Villa's citizen army,

supported at the time by U.S. supplies, drove the Federales across to Presidio, Texas, and imprisonment by a surprised U.S. government that couldn't think of anything better to do with them.

Villa's affection for the United States and its military supplies didn't last. By 1916, he was convinced that Carranza's government had sold Mexico to the United States, and his rage against his northern neighbors intensified, exacerbated by a deal that according to legend led to a military defeat because an American arms dealer named Sam Ravel sold him movie blanks rather than real bullets.

A vicious anti-Mexican mob uprising in El Paso was the last straw. On March 9, 1916, Villa launched the first foreign military attack on U.S. soil since the War of 1812. Four hundred Mexicans made a middle-of-the-night raid on Columbus, New Mexico, Sam Ravel's home town. Fortunately for Ravel, he'd gone to El Paso for a doctor's appointment, but his luck didn't extend to the rest of Columbus. Villa's raiders caught everyone asleep, including a six hundred–man U.S. military garrison. In a few hours, they shot up the town, burned some buildings and were back in Mexico before the U.S. troops could take control..

At this point, an insulted America started practicing for World War I in earnest. President Wilson sent five thousand

If you find yourself in Columbus, New Mexico, look for a life-size rusted steel 1916 Flying Jenny U.S. Army fighter plane mounted on a concrete plinth in a private airport just north of town.

troops under General John J. Pershing, the man who ultimately became World War I's Supreme Commander of Allied Forces, to invade Mexico in a "punitive expedition."

It wasn't just Pershing and the troops. It was airplanes, armored vehicles and all the weapons of modern warfare in the U.S. arsenal, and they quickly moved 350 miles into Chihuahua, pursuing Villa's force of four hundred *soldados*.

The Carranza government was rooting for a quick capture of Villa, but the opposite occurred. Pershing's armies and their vehicles kicked up huge dust clouds wherever they went, and Villa's men simply avoided them. The U.S. presence (and lack of success) in Mexico became embarrassing, and Wilson pulled Pershing back to northern Chihuahua, freeing Villa to act the hero and rebuild his support.

By September of 1916, the United States had poured thousands of troops into Mexico. Even so, two thousand of Villa's soldiers were able to attack the prison in Ciudad Chihuahua and free the prisoners, most of whom were his supporters, while ten thousand American and nine thousand Carranza troops were in the city.

The great invasion ended with little fanfare. Villa eventually made peace with the Mexican government and lived happily until 1923, when he, too, was assassinated.

Black Jack Pershing, meanwhile, had taken the first steps towards becoming a great military hero. And Columbus, New Mexico, had a brief moment of celebrity as America's first military air base.

Pershing, with his modern army.

Villa, with his men, women and children. It was an inconclusive war.

The Desert Reshapes

In 1915, San Diego, now dwarfed by Los Angeles and San Francisco, made noises to assert its importance. Inspired by and a bit envious of the attention given to San Francisco's newly created Golden Gate Park, San Diego built Balboa Park, a 2-square-mile garden on a mesa above the city. Even today it's impressive enough to support its claim as "America's largest urban cultural center."

As the park neared completion, San Diego opened The Panama-California Exposition, competing head-to-head with San Francisco's Panama-Pacific International Exposition, both events honoring the opening of the Panama Canal. The fair told the world that this town of seventy-five thousand had high aspirations despite the fact that its economy had no stable industrial, agricultural or commercial base.

The Panama-California Exposition received rave notices, and visitors had the exotic option of visiting the Mexican border town of Tijuana, just 15 miles south. The Exposition buildings remain a national treasure, but after the fair closed in 1916, San Diego's population shrank, and a boisterous mayoral election defined the central issue as "smokestacks vs. geraniums."

The smokestack candidate won, but the economy got worse until Washington noticed that San Diego's year-round benign climate and quiet water lent itself to cost-effective military bases. By the end of World War I, the Pacific Fleet and the navy's new aviation arm were looking hard at San Diego Harbor. It was returning to its roots as a military town, which gave its economy new hope even if it didn't provide the desired smokestacks.

Los Angeles was on a different career path. The first great epic movie, D.W. Griffith's *Birth of a Nation,* came out in 1914, and the neighboring town of Hollywood stepped forward as the motion picture capital of the world. In 1917, Los Angeles passed San Francisco in population, and in 1919, Shell Oil started drilling on Signal Hill in Long Beach. Two years later, Union Oil was drilling a few miles inland in Rancho Santa Fe. By 1924, a million people lived in Los Angeles County, and according to the city's website, forty-three thousand of them were real estate agents. The boom was on, and it continued unchecked through the next decade.

In 1905, the Southern Pacific had linked Salt Lake City with southern California, and a little oasis town named Las Vegas became a logical refueling and rest stop for the railroad. Fifty years earlier, Brigham Young had sent missionaries to settle the water-rich site, but the Paiutes had driven them off. In the 1880s, mining came to the area and a state land act offered sections at $1.25 an acre. Farmers moved in, and it remained a farm town until

A 1915 postcard of San Diego's Panama-California Exposition "looks into the jungle from a pergola." Its version of Spanish Colonial architecture inspired bungalows, gas stations and movie theaters for years to come.

the railroad arrived. By 1930, Las Vegas population had grown to a comfortable five thousand, and civilization was creeping into yet another portion of the desert.

Tucson had managed a little growth spurt in the early twentieth century by marketing itself as the prime destination of the "Sunshine State." It attracted tuberculosis sufferers from all over the country (the natives called them "lungers") and the sanitorium industry had a brief boom.

The industry that shaped modern Tucson made its first appearance in 1915, when the city received its first airmail delivery. In 1919, Tucson opened America's first municipally owned airport, and later renamed it after two Tucson-born pilots who died in separate military air accidents. In 1927, Charles Lindbergh flew the Spirit of St. Louis direct from its transatlantic crossing to Tucson to dedicate Davis-Monthan Field, then the largest municipal airport in the country. For the next three-quarters of a century, Tucson's economy would be linked to the aircraft industry.

In 1920, Phoenix was less than half the size of San Diego, but on a far different growth curve. It put up more than a thousand buildings that year, including the Heard Building, Arizona's first skyscraper.

As water flowed into Phoenix from the new Roosevelt Dam system, effectively using up all the water in the Salt and Verde Rivers, the authorities started looking at the next river south. Mormon settlers had dammed the Gila since the nineteenth century, and the Indians who relied on its waters had had complained for years. In the early 1920s, the Bureau of Indian Affairs created its own engineering marvel on the San Carlos Apache Reservation east of Phoenix. Coolidge Dam, begun in 1924 and completed in 1928, finished off the Gila as a river.

Lake San Carlos, behind the dam, was supposed to rival Roosevelt Lake, but the Gila never quite cooperated. It poured in mud and silt, and, in dry years, not enough water to fill it. When Will Rogers made the dedication speech in 1930, it was so low that he couldn't resist commenting, "If this was my lake, I'd mow it." (Calvin Coolidge was also present, but never left the train that brought him. Apparently all the Indians who showed up for the ceremonies made him nervous.) The new lake managed to flood good farming land on the Apache Reservation behind the dam, but it never managed to deliver a consistent water supply to the Akimel O'odham downstream.

Through all this, Phoenix kept sending Pima cotton to the world. As its farms grew, the role of Phoenix as a distribution center grew, and the thirst for water grew. By 1930, Phoenix had a new pipeline to the Verde River and a population of nearly fifty thousand.

The town that Jack Swilling envisioned fifty years before was starting to look like a city.

Another postcard reporting the joys of San Diego. On the back, the sender wrote "Today we went to Tijuana, Mexico, then to Coronado, later to Ramona's marriage place."

Depression

On a grim morning in October 1929, America woke up to find itself in the Great Depression. Its repercussions stretched across the desert but not with equal impact in all areas.

Throughout the dark years, Los Angeles continued to lead a charmed life, at least in comparison to the other cities in the desert. In 1932, the world convened in the glittering new Los Angeles Coliseum for the Tenth Olympic Games while the rest of America found escape at the movies. Hollywood royalty lived lives that fed the nation's fantasies, and Los Angeles became a magnet for the hopeful. In 1936, with little regard for legal niceties, Los Angeles sent more than one hundred police officers nearly 300 miles to the Nevada border on a simple mission: to intercept migrant hitchhikers and send them back to wherever they came from.

Down the road in San Diego, things weren't going so well. The smokestacks never materialized, and the city needed other sources of income. In the 1920s, San Diego tried the fishing industry. In 1925, the albacore tuna catch was over twenty million pounds, and America was beginning to discover tuna sandwiches.

Unfortunately, the tuna swam away. In 1926, the catch dropped to two million pounds, and by 1928, it was under half a million pounds. Equal to the challenge, San Diego developed a long-range fishing fleet. By 1935, San Diego's eight canneries had their busiest year, but success came with a price. Of the original fleet of fifty long-range craft, almost half were lost at sea by the mid-1930s.

The rest of the news was much worse. By the depths of the depression, there were nearly a quarter of a million people in the San Diego area, and 10 percent of them were unemployed. The glorious buildings of Balboa Park were crumbling, and the city ordered them condemned. The county assessor attempted to auction off the animals in the San Diego Zoo for back taxes, but nobody showed up to bid.

Citizens groups ultimately bailed out Balboa Park and the zoo, but San Diego was a long way from recovery.

Over in Arizona, things were tough. The Civilian Conservation Corps, or CCC, one of new President Franklin Roosevelt's depression-fighting, three-initial New Deal programs helped. (There were also the WPA, or Works Progress Administration, and the NRA, or National Recovery Act.) CCC camps put the unemployed to building roads, bridges and parks but not enough of them to turn the economy around. In 1933, cotton prices plummeted to four cents a pound, and wool prices sank to one-third of their 1929 levels.

Meanwhile, Dust Bowl transients who didn't make it to California were crowding Arizona schools, which were cutting back on teachers in order to save costs. There was even talk of closing down Arizona State University in Tempe until times got better. Granted, it wasn't the mighty institution of today. It was a small teachers' college, far overshadowed by the University of Arizona down in Tucson.

Arizona did get a couple of good breaks. In 1931, two University of Arizona professors drew up plans for a cooling device that used an electric fan and a garden hose, and the swamp cooler was born. By 1939, five companies made them, and ten thousand Arizona homes had them. The age of air-conditioning had begun.

Then, in 1932, construction of America's largest dam started on the Colorado River. Hoover Dam opened in 1936, and everybody, especially Los Angeles, got more water and more power. Arizona was the only one of a seven-state compact that objected to the deal. California, Colorado, Utah, Nevada, New Mexico and Wyoming all wanted it.

Perhaps the greatest ultimate beneficiary

was that little railroad town in Nevada called Las Vegas. Once construction started on the dam, workers boosted the town's population and the local economy.

Meanwhile, Nevada found another source of quick tourism income, and Las Vegas was in the right place. The state liberalized its divorce laws, and quickie Nevada divorces became a staple in the movie colony and in the more rarefied sectors of sophisticated America. Dude ranches whose main function was to provide an address for the state's six-week residency requirement sprang up. Since Las Vegas was the nearest Nevada town of any size to Hollywood, its dude ranch industry flourished for decades.

These were still depression years, however, and the real boom was yet to begin. Despite the facts that Hoover Dam had created a great recreational lake, Lake Mead, less than 20 miles from downtown, and Nevada had legalized gambling in 1931, Las Vegas still had only eighty-four hundred people in 1940, a growth of barely more than three thousand citizens since the 1930 census.

Then, on December 7, 1941, everything changed. The Japanese bombed Pearl Harbor, and the desert would never be the same again.

Twenty-five years before the depression, the Santa Fe railroad paid Maynard Dixon to paint murals for the Tucson Depot. Romantic images like this in magazines and on movie screens helped make dude ranches an attractive place for the rich and famous to wait out their divorces.

WW II

Until 1940, the desert, and most of the West for that matter, served as a cattle, farm and raw materials colony for the industrial East. That relationship was about to change dramatically.

Once the Second World War began, the military needed all of America's manufacturing capacity and more. Shortages made life uncomfortable on the Home Front. You couldn't buy meat, sugar, coffee, gasoline or tires until you'd saved up enough of your precious ration stamps. Production had to expand, and the most space (and, undoubtedly, the cheapest real estate) for expansion was out west. Between 1941 and 1945, Uncle Sam poured $40 billion in federal funds into the western states, and dirt roads suddenly turned into high-speed highways. Tony Hillerman has written about the excellent roads in New Mexico, and he attributes them largely to the efforts surrounding Los Alamos, White Sands and the development of the atomic bomb.

In the desert, there was a lot more than the bomb. There were aircraft plants, shipyards, rubber plants and science laboratories—direct ancestors of the electronics and research industries that developed the computer technology that surrounds us today.

As it all happened, the desert prospered. In 1939, New Mexico's total manufacturing output was under a million dollars. In 1947, it was $55 million. Tucson's population doubled between 1940 and 1946. Phoenix got a vast new Goodyear rubber plant that worked night and day making tires for the military while the rest of America ran on retreads and bald tires. Arizona's Pima cotton went into the new, lightweight khaki military uniforms, and the desert's copper mines had their last great burst of activity. Copper was so needed during the war that 1943 pennies were a silver-colored zinc alloy and 1944 pennies were melted-down casings from spent shells.

Las Vegas took a jump during the war as well, and the first big boost came from a magnesium plant. The city's real future also took shape. It didn't take long for southern California to notice where the nearest wide-open gambling town was. Several casinos opened, and right after the war, a mob-connected promoter named Bugsy Siegel opened a flashy luxury casino named the Flamingo. Bugsy ended up full of bullets, but not before he'd changed Las Vegas forever.

The desert's most dramatic population increases happened in southern California, where the war seemed much closer than it did farther inland. In the predawn hours of February 27, 1942, Los Angeles awoke to screaming air raid sirens and fifteen hundred rounds of antiaircraft fire. The shells dropped back down on buildings and created considerable damage, but nobody ever figured out exactly what they were supposed to hit. There was no question about who they were shooting at, however. In February 1942, it was easy to believe that a Japanese invasion force was lying offshore, and blackouts policed by neighborhood air raid wardens had everybody ready for imminent attack.

The Battle of Los Angeles was the only significant military action to occur in or over a

TODAY'S FRONT-LINE TRENCHES

This 1941 Chicago Daily News *editorial cartoon echoed America's first priority. Thanks to the war effort, San Diego would finally get some smokestacks.*

U.S. mainland metropolitan area during the entire war, and the fact that there was no enemy present at the time did little to make anyone feel much better about it.

San Diego's economic woes vanished with the war. By 1940, its population had reached 200,000. Four years later, it was 380,000 plus 130,000 military. As an old military town used to sudden influxes, San Diego handled the growth with ease.

The Los Angeles metropolitan area had reached 2.9 million by 1940, and three years later, it had almost half a million more. It also had Douglas Aircraft, Lockheed Aircraft, Hughes Aircraft and North American Aviation, plus Kaiser Steel in Fontana and Kaiser Shipyards at Terminal Island. In 1943, it was the first city to experience a phenomenon of the latter half of the American twentieth century: serious smog.

Today, it's hard to grasp how deeply the second World War permeated daily life in the desert and, for that matter, all of America. One example illustrates how pervasive the war effort had become. Perhaps the highest-level football game played in 1945 took place at a packed Los Angeles Coliseum. It featured two teams loaded with future college and professional Hall of Fame players. One came from the El Toro Marine Base in San Diego, and the other represented a long-since decommissioned naval base near San Francisco.

The Fleet City Bluejackets beat the El Toro Marines 45-28, making sports page headlines all over America.

Where the atomic age began: Two days a year, tourists can come into the White Sands Missile Range in the southwestern New Mexico desert and see the obelisk at Trinity Site. It marks Ground Zero, the exact spot where the first atom bomb exploded. A few days later, the bomb ended the war and gave the world something to worry about ever since.

Megalopolis

After the Second World War, the die was cast. The desert was now officially a desirable place to live, and people swarmed in from all over.

Anybody who's followed *Arizona Highways* in recent years knows that the magazine issues a monthly siren call for tourism by showing sumptuous photos of the Arizona landscape.

It wasn't always like that. It started out as the Arizona Highway Department's house organ and carried ads for asphalt contractors. By the 1960s, it had evolved into something close to its present form, but the transition wasn't total. The June 1969 issue reverted to its roots. It was entirely dedicated to the completion of I-17, the freeway that connects Phoenix and Flagstaff, and yet another Arizona engineering marvel. The magazine featured aerial photographs of every interchange and cloverleaf over the entire length of the highway.

The issue served as a symbol for the New Desert and its full membership in the post-war American mainstream. Progress was on a roll, and it's been rolling ever since. Today 98 percent of the homes in metropolitan Phoenix have air-conditioning or evaporative coolers.

According to the 2000 census, Los Angeles, Phoenix and San Diego are the second, sixth and seventh largest cities in America, with metropolitan areas that total 21.7 million people.

Tucson was the 30th-largest city in 2000, but it's coming up fast. It grew 20 percent between 1990 and 2000, and even though it's still a bit under half a million in population,

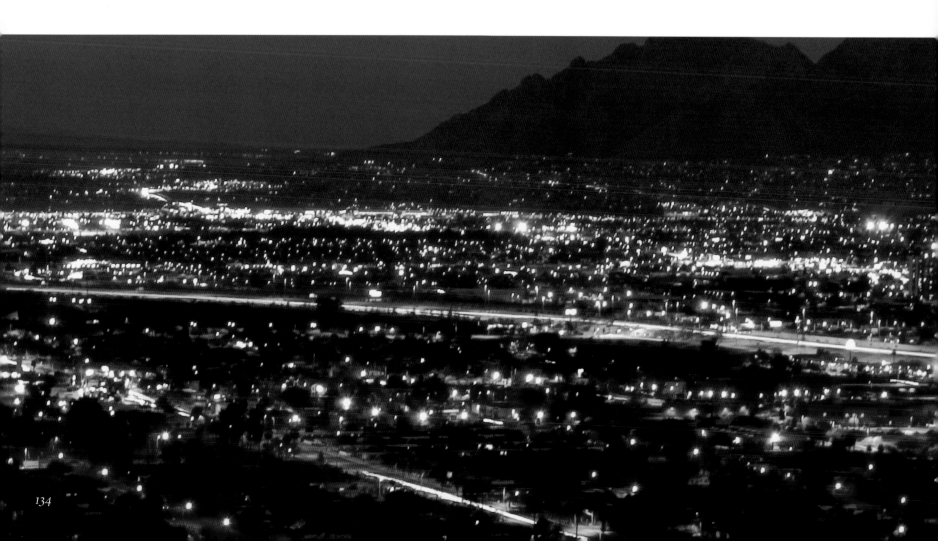

anyone who's driven north and east into Tucson's outlying areas lately gets a definite feeling that a million-plus is closer to the truth. Las Vegas, on the other hand, ranks thirty-second, which bears no resemblance to reality. In the 2000 census, its metro area population was 1.6 million, and it's generally conceded to be America's fastest-growing city.

Meanwhile, the specter of running out of water hangs over the desert, and the full-speed-ahead mentality of developers and boosters creates more than a bit of concern among the conservation-minded.

For years, California took more than its share of Colorado River water simply because the slower-growing states in the original compact never insisted on their full entitlement. In 2003, as the other states began to claim their allotments, California faced a reduced allocation, and a frightened San Diego had to surrender some of its rights in a compromise with the farmers in the Imperial Valley.

It's not that everyone is oblivious to the problem. Tucson's conservation programs have produced a 20 percent per-capita drop in water consumption since the 1970s, and Las Vegas is

admitting that there's a limit to the number of golf courses the water supply can tolerate.

It's important to note that the only thing that's new about all this growth and development is the scale of the achievement. Those prehistoric Indians really started something when they built the first canals.

Today, their descendants remain a minority in the land their ancestors invented, but the good news is that the minority isn't swallowed up. On the next pages, we'll look at how the Indians handled the last century and a half, and how things are finally on the upswing.

This is the upper-left-hand corner of Tucson. Shift the mountains a bit, and it could be Los Angeles. Or San Diego. Or Phoenix. Or Las Vegas. Or Tokyo.

5

The Indians Adapt

*Symbols of survival, both agricultural and economic:
The irrigated fields of the Ak-Chin O'odham reservation
surround Harrah's Ak-Chin Casino.*

The Yumans

UNTIL THE MEXICAN WAR OF 1847, the Quechan Indians kept a tight control on the Yuma Crossing, as they had for centuries.

It all changed quickly. Philip St. George Cooke's Mormon Battalion made it down the Gila and across the Colorado. Newspapers hailed the feat, and "Cooke's Trail" became the standard southern route to California. Shortly after, soldiers built a rope ferry at the Crossing to accommodate the American and Mexican Boundary Commission.

The army ran the ferry until the commission was done, then moved on, but the gold rush of 1849 had begun. A man named Able Lincoln discovered more gold at the Yuma Crossing than he'd ever find in the mines of California. He set up his own private ferry company and wrote in April 1850 that, in the three months since he began, he'd taken in more than $60,000 carrying gold seekers across the Colorado.

His success didn't go unnoticed. An old scalp hunter named John Glanton showed up and told Lincoln he needed a partner, or else. Glanton had more men and more guns than Lincoln, and the ferry company had a new CEO.

Soon stories began to circulate about price gouging, mistreatment of the Indians and robbery and murder along the trail.

Meanwhile, the Quechan started running their own ferry downstream and brought in an American engineer named Callahan. Glanton disliked competition, and a few days later, somebody shot Callahan and cut the ferry loose. When the Quechan chief came to negotiate, Glanton kicked him out of the building and hit him with a club, which proved a major mistake.

The Quechan ambushed and killed eleven ferrymen, including Lincoln and Glanton, took their bags of money and assumed they'd ended the matter.

Unfortunately for the Quechan, three ferrymen escaped and reached San Diego, where they told how, despite all their kindnesses to the natives and to passing travelers, the vile and treacherous Indians had martyred their brave company.

Their stories were fearsome enough to convince the California governor's office that the oncoming waves of immigrants would be at peril. The state militia organized a Yuma expedition under the command of a General Morehead.

By the time Morehead got his troops assembled and over the mountains to Yuma, things had cooled down and a new, well-organized company was building a new ferry. Morehead, however, couldn't leave well enough alone. He threatened to attack the Quechan unless they produced eleven hostages and $10,000, the amount he thought they owed the old ferry company.

Instead, the Quechan attacked Morehead and nearly wiped out his army. Ultimately, Morehead went back to San Diego having accomplished nothing. The expedition cost California $113,000, which was more than the state had in its treasury.

Sweet as the victory was for the Quechan, it wasn't enough. Three weeks after Morehead went home, three columns of infantry under the command of a relentless captain named Samuel P. Heintzelman arrived at Fort Yuma. The captain was no friend of the Indians, and his scorched-earth policy ended the resistance. In a series of surprise raids, he

Quechan effigy jars from the last half of the nineteenth century. The fellow at left, who has another face on the back of his head, is 6" high; the lady in front (a rattle) is 2¾" tall; and the person at right is 5½" high.

went after the Quechan *rancherias* and crops.

The Quechan warriors were used to winning, but years of battle with their Indian neighbors had weakened them to the point where they could no longer cope with organized attacks by companies of trained soldiers.

After 1852, Indian control of the river was history. The new ferry company held its ground, and before long steamboats were running up the Colorado.

Heintzelman kicked out the Quechan chief and installed a new one, who, though he was respected among the Quechan, had the clear job of implementing the U.S. government's wishes.

Any thoughts the Quechan might have kept about rising up and taking over again ended in 1857, and this time it wasn't U.S. or Mexican troops who finished them off. Instead, their old enemies, the Maricopa-Akimel O'odham alliance, wiped out the remnants of the

This February 1940 magazine article featured the work of Hav-Cho-Cha, the leading Quechan potter of the day. The Quechan had abandoned their pottery tradition so completely by then that she borrowed her designs from the Hopi.

Quechan fighting force in a battle on the Gila.

With the Gadsden Purchase, more Quechan land fell within the U.S. border, and a town started to grow at the crossing. It became a stop on the Butterfield Stage Route, a short-lived desert counterpart of the Pony Express. Things quieted to the point where, in 1884, the government decided the Yuma were no longer a threat to decent Americans, pulled the troops out and established the Fort Yuma Reservation on the California side of the river.

Sister Mary and the BIA Now that the Quechan were safely placed on the reservation under the care of the Bureau of Indian Affairs, supervision fell to the district office, which was 200 miles away in California. The BIA established a boarding school on the reservation and appointed Sister Mary O'Neil, a Catholic nun, as its superintendent.

She was more than equal to the task. She not only ran the

school, she ran the reservation with an iron hand, appointing chiefs, organizing a police force and doing everything she could to control tribal politics.

By the turn of the century, Sister Mary's day was done, but the new order she and Heintzelman had created colored Quechan lives for years after. Despite the BIA's effort to keep the Quechan on the reservation, many went into the town of Yuma and worked as unskilled labor.

During the first two-thirds of the twentieth century, state and national government policies and actions diminished their tribal authority, and the Quechan grew poorer and poorer. Things looked brighter for a while in the 1960s during Lyndon Johnson's War on Poverty, but slid backwards again. Today, only the casinos seem to promise better times.

An Almost Forgotten Art The Quechan had a long pottery tradition, inherited from the Patayan. They made large storage vessels capable of floating food and goods across the Colorado. In the twentieth century, metal pans and washtubs replaced the pots, and Quechan pottery, as the picture on the right indicates, became tourist-oriented.

For a while, they made little souvenirs to sell at the railroad station. Sometimes the little pots reflected their hundreds of years of tradition, and sometimes they simply reflected whatever was easy to make and sell. But even quick little pots are a lot of work, and as far as we know, nobody makes them any more.

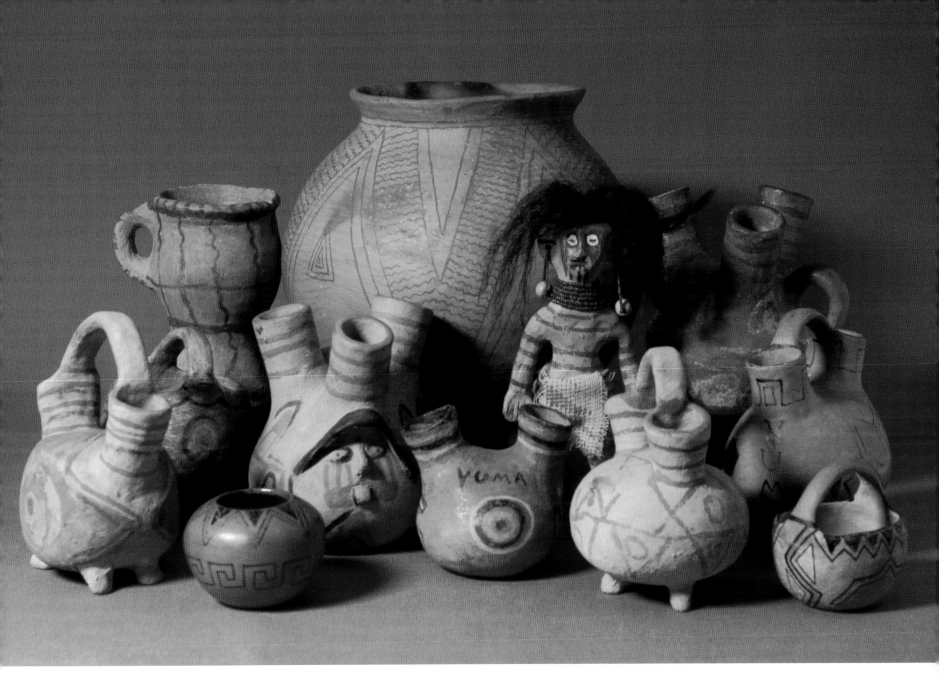

BACK ROW: *Black-on-buff cup, 5⅜" high, ca. 1920; Red-on-buff olla, 9¾" diameter, ca. 1920; Polychrome effigy figure, 7½" high, ca. 1970; Polychrome three-spouted jar, ca. 1910, 5½" high.*
MIDDLE ROW: *Polychrome basket, 4" high, ca. 1920; Polychrome three-spouted effigy jar, 5½" high, ca. 1930; Polychrome wedding vase, 5" high, ca. 1930.*
FRONT ROW: *Polychrome wedding vase,*

6" high, ca. 1900; Black-on-red jar, 4" diameter, ca. 1935; Polychrome wedding vase, 3½" high, ca. 1930; Red-on-buff footed wedding vase, 5½" high, ca. 1910; Polychrome basket, 2¾" high, ca. 1935.

Identifying Quechan pottery isn't easy. Mojave pottery follows a clear tradition, but latter-day Quechan pottery was eclectic —not surprising, considering the cross-

country traffic that passed through the Fort Yuma Reservation. The multiple-spouted pieces at the top right, far left and left center seem to be the least-diluted examples of Quechan work, and the tourist souvenir at front center has a similar look.

Other pieces aren't as obvious. The cup on the left has a Mojave feel. The footed wedding vase at front right looks more like California Indian work. The big jar in back,

the basket at front right and the wedding vase at right all look Tohono O'odham. The round little jar at front left looks pure Tohono, except that, like two other pieces in the picture, it says "YUMA" in fired-on letters.

It would be nice to think that the doll represents a return to the roots of the art, but it was made of commercial modeling clay, perhaps at the urging of an Anglo teacher in art class at the BIA school.

The Mojave

About 150 miles north of Yuma on the Colorado, the army built Fort Mojave in 1859. Back then, it was spelled "Mohave," and Arizona still has a Mohave County, but California has the Mojave Desert. In the 1970s, the Tribal Council at the Fort Mojave Reservation decided to go with California's spelling.

Fort Mojave happened because the government decided that a transcontinental railroad should cross the Colorado at what is now Needles, and this went through Mojave Indian country. Although the Mojaves were interested in commerce and the potential income, they didn't suffer interlopers lightly, and a wagon train massacre or two was enough to convince the army to build a fort.

The expected shootout with the Mojave never happened, but there was enough conflict with the neighboring Paiutes to keep the fort running until 1870, after which the government set up the Fort Mojave Reservation.

Official attitudes toward the Mojaves were pretty much like official attitudes everywhere else. In *The Mojaves*, Gerald A. Smith writes that in 1877, Lt. A. G. Tassin, who was stationed at nearby Camp Mohave, wrote that they were the finest Indians to be found on the American continent, docile and powerful, and that the women were chaste. On the other hand, the 1879 BIA report placed "Colorado River Indians among the lowest in scale of civilization. The reservation since its establishment has done little for the elevation of the Indians. No real efforts at Christianization or education."

Progress came to Needles in 1883 when the railroad arrived, and jobs for the Mojave men followed. A contemporary account praised the physical capacity of the Mojave men, offering the startling statistic that they were capable of lifting "200 or 300 pounds." (We should also report that Lt. Tassin wrote that early Spanish explorers encountering the Mojave saw "men and women of splendid physique, being nearly eight feet in height.")

The Fort Mojave School opened in 1890, and by all accounts, it seems little different

Where Plains Indians carried infants on a cradle board, California Indians wove cradle baskets. This 4¾" long baby was made ca. 1880. He not only has a high-end basket, he already has tattoos and face paint, and sports the blue and white beads that adorned Colorado River pottery dolls for more than a century.

A typical anatomically explicit nineteenth-century Mojave doll. He lost his legs long ago, along with his clothing, bead necklace and earrings. What's left of him is 6¾" tall.

from all the other BIA schools— children taken arbitrarily from their families, given Anglo names, punished for speaking their native language and Christianized whether they liked it or not.

However, if Smith has it right in his book, the school met its goals far better at Fort Mojave than it did on other reservations. He says, "By the early 1900s, most of the younger members of the once-great Mojave nation could read, write and converse in English. The boys were particularly expert in writing, and the girls could run the sewing machine and make their own clothing."

Apparently, despite their historic reputation for ferocity, the Mojaves learned to coexist in the Anglo world earlier and more comfortably than most other tribes in the desert. They also managed to keep their art reasonably intact through most of the twentieth century. Unlike their Quechan neighbors to the south, the Mojave held tight to their ancient pottery tradition, with its Patayan and Hohokam overtones. Here, you don't see any pieces that might be from the O'odham or from anyone else. Even teacups and cream pitchers made to please Anglo tastes remain pure, instantly recognizable Mojave.

BACK ROW: *Red-on-buff four-spouted jar, 6"* *high, ca. 1910; Red-on-buff pitcher, 10" high,* *ca. 1900; Red-on-buff pitcher, 5" high, ca.* *1930; Red-on-buff pitcher, 4⅛" high, ca. 1920.* MIDDLE ROW: *Red-on-buff teapot, 4⅜" high,* *ca. 1900; Red-on-buff dish fragment,* *8¾" wide, ca. 1900; Red-on-buff pitcher,* *4¾" high, ca. 1890; Red-on-buff cup,* *4⅛" diameter, ca. 1920.*

FRONT ROW: *Red-on-buff jar, 3" diameter,* *ca. 1920; Red-on-buff wedding vase,* *5½" wide, ca. 1920; Red-on-buff four-* *spouted effigy jar, 5½" high, ca. 1880;* *Red-on-buff cup, 3¼" diameter, ca. 1910.*

The railroad came to Needles in 1883, and *Mojave tourist pottery followed right away.* *It's easy to picture traders showing potters*

the china of the day, saying, "Make things *like these." Below, you see creamers, teacups,* *a water pitcher and a teapot. But you also* *see Mojave originals: jars with four spouts* *usually made with elaborate loop handles,* *sometimes made with an effigy head,* *sometimes without.*

Mojave pottery designs were mostly *consistent and traditional. The checkerboard*

pitcher is something of a surprise, but the *dish in the second row tells the real story. It* *has a design that shows up on several other* *pieces in the picture. When we bought it, it* *came with a card that reads, "Found south* *east of Needles, California, in the bank of the* *Colorado River. The design on the piece is* *known to living Mojave Indians as 'Rain on* *the Cottonwood Tree Leaves.'"*

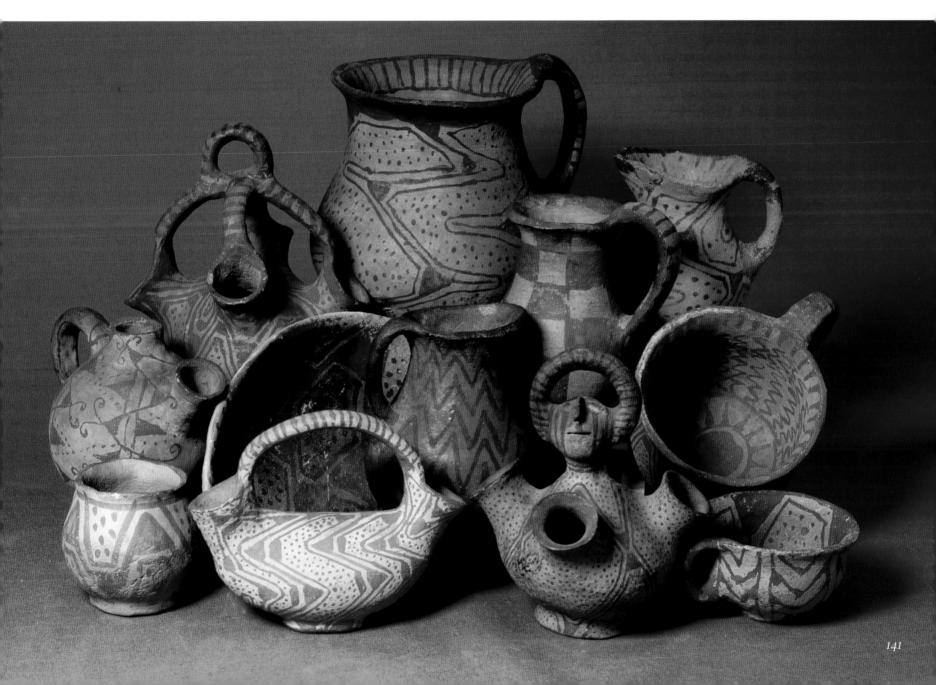

Annie, Elmer and Betty

Mojave pottery remained vital for most of the twentieth century, kept alive by a steady flow of tourists through Needles, first by train and later by Route 66 and I-40. In the second half of the century, three potters produced most of it.

Not that there were ever a lot of artists before then, either. In her book *Mojave Pottery, Mojave People,* Jill Leslie Furst points out that Malcom Rogers wrote that in the 1920s, only two or three Mojave women still made pottery.

One of them would have been Annie Fields, who lived in Needles and died in 1971 at the age of 87. It wouldn't be much of a stretch to attribute some of the pieces on the previous page to her.

However, the work that made her famous came in the 1960s. When an interested Anglo talked her into returning to pottery-making in the 1950s, she started making the pieces that brought Mojave pottery to the attention of the outside world

Elmer Gates died in 1990 at 61. He lived 60 miles south of Needles on the multitribe Colorado River Indian Reservation, somewhat removed from the center of tribal life at Fort Mojave. Most of his best work dates from the 1970s and 1980s.

After taking a few years off while she raised her family, Betty Barrackman is active again, making pottery and doing traditional Mojave beadwork. If you find a Mojave piece signed "B" or signed "Norge," you're seeing Betty's work, and no, she's not Norwegian. Norge is her clan name.

Today, Betty is the only active traditional Mojave potter, and she and her husband Lew have a strong voice in maintaining traditions. Lew is a tribal historian and has served terms as Tribal Chairman. We got some measure of their importance when we passed Barrackman Court on the way to their home. We asked Lew if it was named after him, and he said, no, it was named after a relative, but Barrackman Road on the other side of the Colorado River was.

When we met with the Barrackmans in 1998, Betty made it clear how much she admired Annie Fields and also let us know that, for her tastes, Elmer Gates wasn't anywhere near traditional enough. Her appreciation of Annie Fields shows in her work. In fact, if you're not attuned to some subtle differences, you could easily confuse one of Betty's pieces for one of Annie's.

Elmer Gates's work, on the other hand, doesn't look like any other Mojave pottery. His clay is finer, more like Quechan ware, and his pieces are more carefully finished. Most are painted more accurately than any but the finest pieces from a hundred years earlier.

Untraditional though his work may appear, he made all the traditional forms. All three potters, Annie, Elmer and Betty, made four-spouted jars, either with effigy heads like the one by Elmer Gates on the page opposite, or with loop handles, like the one at top left on the previous page. They made dolls, standing or seated, dressed them in traditional clothing and adorned them with blue and white beads. And they made pipes and cloud blowers, smoking tubes like the Mojave had used for centuries.

With Betty, there's still a link to the Mojave pottery past. A few young potters experiment with not-quite-traditional forms, but as Betty told us, making pottery is hard and digging and working the clay is even harder. These days, young Mojaves would rather work in the casinos than go to all that trouble.

Annie Fields made countless frogs, all around 6" long, in the 1960s. Betty Barrackman told us how, according to Mojave legend, the frog carried a firebrand in its mouth and brought them the gift of fire. Annie Fields's cigarlike firebrands started a new tradition.

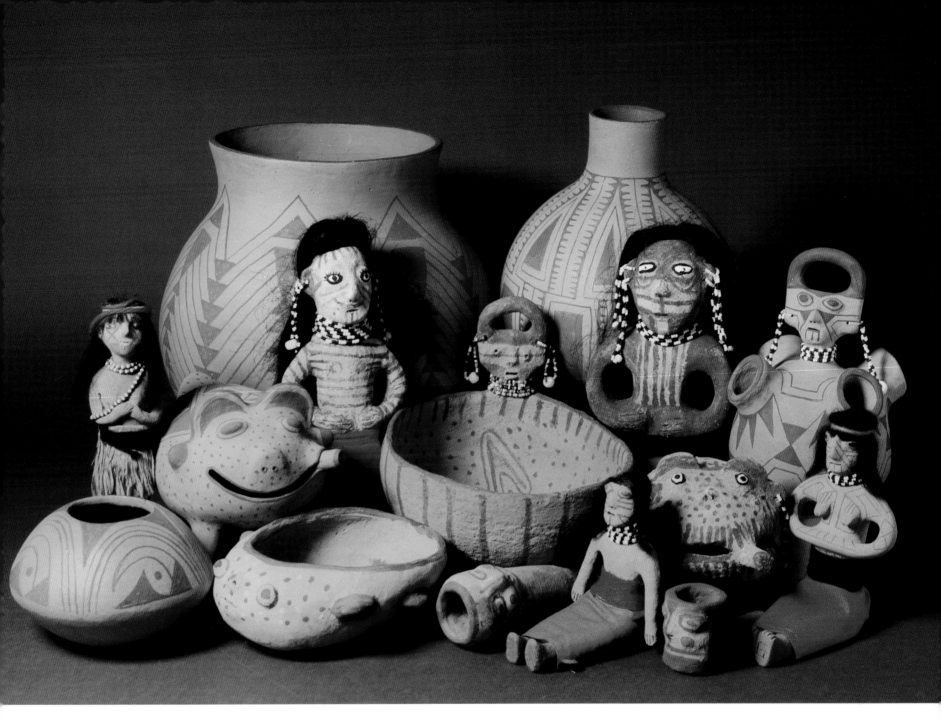

BACK ROW: *Red-on-buff olla, Elmer Gates, 10½" high, ca. 1980; Red-on-buff water jar, Elmer Gates, 8½" high, ca. 1980.*
MIDDLE ROW: *Polychrome standing doll, probably Elmer Gates, 7¼" high, ca. 1985; Red-on-buff frog figurine, Elmer Gates, 6½" long, ca. 1980; Polychrome doll, Betty Barrackman, 9" high, 1998;*

Polychrome effigy bowl, Betty Barrackman, 7¼" diameter, ca. 1970; Polychrome doll, Betty Barrackman, 8" high, ca. 1995; Red-on-buff four-spouted effigy jar, Elmer Gates, 7¼" high, ca. 1985.
FRONT ROW: *Red-on-buff jar, Elmer Gates, 4½" diameter, ca. 1975; Polychrome fish effigy bowl, Annie Fields, 6⅜" long,*

ca. 1965; Red-on-buff cloud blower, Annie Fields, 7" long, ca. 1960; Red-on-buff seated doll, Elmer Gates, 4⅜" long, ca. 1970; Red-on-buff pipe, Annie Fields, 4¼" long, ca. 1960; Red-on-buff frog figurine, Betty Barrackman, 4¾" long, ca. 1995; Red-on-buff seated doll, Elmer Gates, 5⅞" high, ca. 1980.

Here they all are, with firebrand-bearing frogs, four-spouted effigies and dolls. We have our fingers crossed on one of them, however. The smaller standing doll in the middle row might be by Matt Brenner, who worked in Elmer Gates's studio. Otherwise, it's all Annie, Elmer and Betty in the second half of the twentieth century.

The Maricopa

The Mojave kicked out their eastern Yuman cousins, the Maricopa, four hundred years ago. The Maricopa, however, had the last laugh.

On August 31, 1857, a band of Colorado River Indians attacked a Maricopa village on the Gila not far from what had once been Snaketown and set their homes on fire. According to a company of U.S. mail carriers who saw the whole thing, there was no sound of firearms. The battle was fought on foot with clubs and bows and arrows, but the Maricopa had horses and some rode out to alert their Akimel O'odham (Pima) allies in villages to the north.

Meanwhile, the Yuman contingent of Mojaves and Quechans lingered to celebrate their victory, which was a bad idea. The ensuing battle pitted, according to the mail carriers' estimate, about a hundred Yuman invaders against a now-reinforced company of as many as a thousand Akimel O'odham and Maricopa.

It was a slaughter. According to witness Isaiah Woods, as quoted by Clifton Kroeber and Bernard Fontana in *Massacre on the Gila*, "One hundred and four Yumas left their villages at the junction of the Gila and the Colorado, led on by a young and ambitious chief, whose new dignity required some striking act to dazzle his people. He and ninety-three of his warriors were killed within half an hour, on the side of a hill in plain view from the spot where I was reclining under a tree."

That battle ended Indian vs. Indian war in the desert, and the Maricopa and the Akimel O'odham have been joined at the hip by the U.S. government ever since. Even though they speak different languages, have different customs and create different art, they share two reservations, one south of Phoenix that includes Snaketown and one east of Scottsdale in the Phoenix metropolitan area.

The confusion persisted through the twentieth century, and it was so ingrained in thinking that the excellent *Indians in North America* series of books issued in the 1990s includes a well-researched volume titled *The Pima-Maricopa*.

In *Dirt for Making Things*, Mary Fernald and Janet Stoeppelmann recorded a 1970 quote from Maricopa potter Mabel Sunn on the subject: "Nobody knows about Maricopa. Maricopa are always lumped together with the Pima, and they call Maricopa pottery Pima pottery. But Pima don't make pottery now."

The Maricopa have made distinctive pottery for about a century and a half, but whether they can claim it as their own is another question. The Tohono O'odham (Papago) to the south made the black on red Maricopa style first, and they made quite a bit of it well into the twentieth century. The early cream-colored pottery is usually Maricopa, but the Akimel made cream-colored pottery as well.

On an early piece, it becomes difficult to say for sure whether it's Tohono, Maricopa or Akimel, and even an early provenance won't be airtight. We're calling the grandmother at the left Maricopa, as would most other observers, but it could easily be Akimel.

After the mid-nineteenth century and especially after the railroads came, there was plenty of movement back and forth between the Tucson-area Tohono and the south-of-Phoenix Maricopa and Akimel. And, of course, a lot of trading among the people who sold Indian souvenirs. This isn't just a Maricopa/O'odham problem. There's not a lot of in-depth research on any of the desert pottery made after the Spanish came. Whether the pottery is Yuman, Mojave, Maricopa, Tohono or Californian, anyone who makes a call on precise dates and points of origin is on thin ice.

This 7⅛" tall, late nineteenth-century lady demonstrates the confusion. She looks Maricopa, but she has a lot in common with the O'odham effigy jars on pages 156 and 157.

BACK ROW: *Black-on-red jar, 5¼" diameter, ca. 1900; Brown-on-tan dish, 10¾" diameter, ca. 1880; Brown-on-tan longneck pitcher, 12" high, ca. 1900.*

MIDDLE ROW: *Brown-on-tan jar, 7⅛" diameter, ca. 1890; Black-on-tan tall jar, 8½" high, ca. 1885; Black-on-red canteen, 5⅜" high, ca. 1890; Black-on-red bowl, 5¼" diameter, ca. 1870; Black-on-red two-handled jar, 6¼" high, ca. 1900.*

FRONT ROW: *Red-on-buff hooded effigy, 5" high, ca. 1870; Polychrome snake effigy jar, 6¼" high, ca. 1880; Black-on-red-horned toad figurine, 6" long, ca. 1890; Black-on-red circular canteen, 5" diameter, ca. 1860; Brown-on-tan turtle effigy, 5¼" long, ca. 1900; Black-on-red jar, 3" high, ca. 1890; Black-on-red jar, 2¾" high, ca. 1900.*

Once again dating is a problem. With prehistoric pots, scholars place type examples in tree-ring-dated ruins and agree on fairly accurate dates. After 1700, pottery loses its connection to excavated sites, and dating depends on early accounts and fill-in-the-blanks assumptions. For instance, Leslie Spier, in the authoritative 1933 Yuman Tribes of the Gila River, *said the Maricopa copied all early designs from Hohokam sherds. Hohokam elements show up in the designs* below, but so do a Paquimé-style hooded effigy and a doughnut canteen like the Anasazi made.

Spier also said that the Maricopa made no polychromes until later, but what's later? A 1907 photograph in Mary Fernald's book clearly shows polychromes.

The dates for all the pieces in this chapter made between 1850 and 1930 are no more than our best guesses.

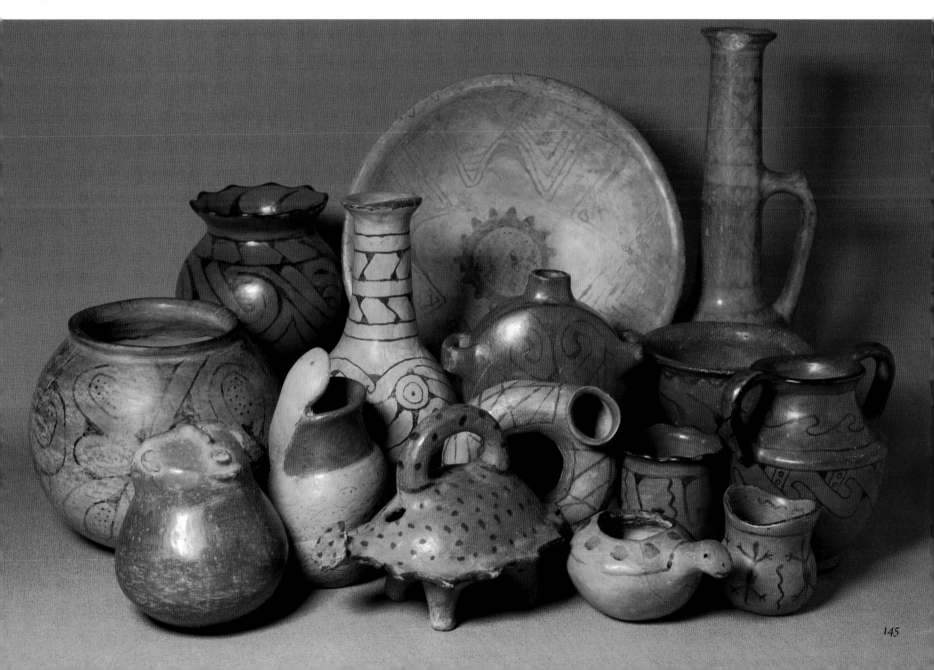

Phoenix and Tourists

At the beginning of the twentieth century, Phoenix was turning into a modern city with electric lights and paved streets.

Just down the road, meanwhile, the Maricopa and the Akimel O'odham were still trying to live pretty much the way they had since the Spanish showed up two hundred years before. Their homes had evolved a bit from the pithouses favored by the Hohokam, but if you look at the picture below and the recreated Hohokam house on page 14, it's not hard to see similarities.

Unfortunately, keeping up the lifestyle wasn't easy. During the last half of the nineteenth century, the government set aside larger and larger tracts of land for the Gila River and Salt River Reservations. They also allowed non-Indian developers in Phoenix to buy up the surrounding lands and pull off as much water as they could from the two rivers.

As far as water use went, the law was on the side of the Indians, and fair-minded people like General McDowell, the area's military commander during the 1870s, pointed out that the Maricopa and the Akimel had prior rights to the river water.

The courts agreed, but nobody cared much about court decisions, and the farms grew drier and poorer with each passing year. Sympathetic Indian agents moved on, and bureaucrats took their place. The once-proud Pima-Maricopa Confederation, the most powerful military force in the Southwest and the alliance that fed forty-niners and U.S. troops through two wars, was reduced to poverty.

The government compounded the decline with what, in retrospect, was a truly stupid move. A tuberculosis epidemic, brought in by a wave of European immigrants, hit the nation in the 1880s. Doctors preached the curative powers of the Southwest climate, and the BIA assigned its diseased employees to posts in the desert. The TB bacillus spread like wildfire among the undernourshed Akimel and

A Classic Period Hohokam touch picked up by the Maricopa: linear designs on the back of plates and shallow bowls. The other side of this dish is in the picture on the next page.

Maricopa, and the population took a nosedive.

As things worsened, the women stepped forward. Without water from the river, the people needed money. They couldn't grow cotton, and they couldn't grow food crops. Now they had to buy clothing, canned goods and flour. In the old lifestyle, women gathered brush for firewood, but starting around 1890, they had a new job. They had to make pots and baskets to sell to tourists.

By 1900, tourist pottery was a major industry among the Maricopa. They took the designs from what the Hohokam left behind in their backyards and combined them with the black on red style that the Tohono O'odham down south had made for years, then added a high polish that few Southwestern potters have achieved before or since.

They also found a light tan slip. By 1900, and probably before, the Maricopa were making highly polished polychrome pieces that used red, tan and a black that, depending on the firing and how well the potter had boiled down her plants to create it, ranged from a pale brown barely discernable on a tan background to a deep, positive black.

The Maricopa potters may have borrowed the Tohono black on red style, but they took the idea and ran with it. By 1920, Maricopa potters had left the Tohono far behind.

Despite their proximity to the lights of Phoenix, nothing much had changed for the Maricopa or the Akimel at the turn of the twentieth century. This painting of A Pima Household *dates from 1901.*

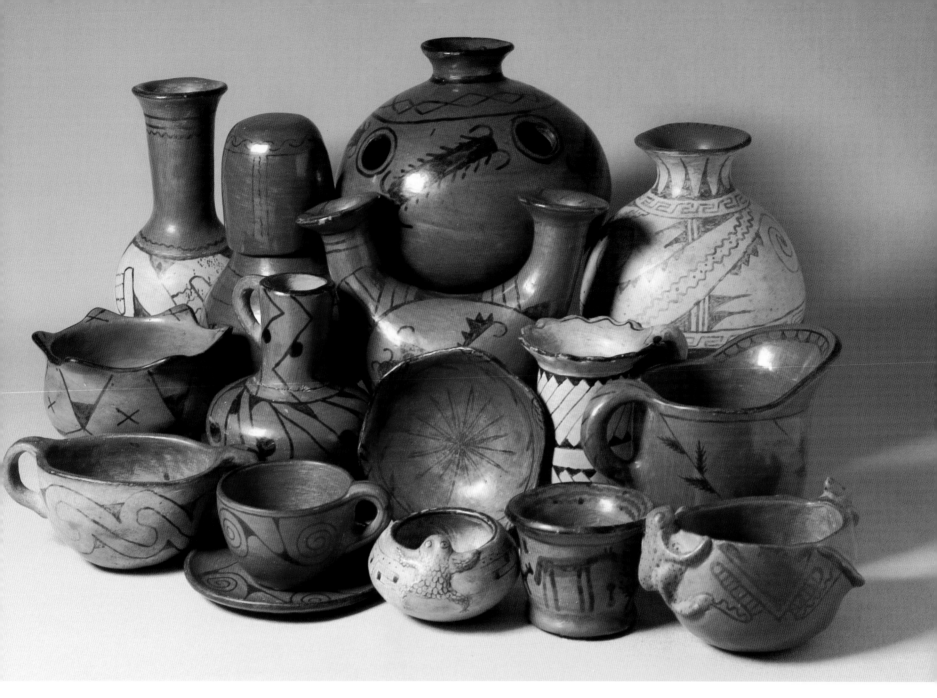

BACK ROW: *Polychrome tall jar, 8" high, ca. 1910; Black-on-red carafe and cup, 6½" high, ca. 1920; Black-on-red two-spouted vase, 8" wide, ca. 1910; Black-on-red four-hole jar, 7⅜" diameter, ca. 1920; Polychrome jar, 7½" high, ca. 1910.*

MIDDLE ROW: *Black-on-red bowl, 4½" diameter, ca. 1910; Black-on-red pitcher, 5" high, ca. 1920; Black-on-red dish,*

5½" diameter, ca. 1910; Black-on-tan cup, 5" high, ca. 1900; Black-on-red pitcher, 4" diameter, ca. 1910.

FRONT ROW: *Polychrome sugar bowl, 6¼" wide, ca. 1910; Black-on-red cup and saucer, 5" diameter, ca. 1910; Black-on-tan frog effigy bowl, 3½" diameter, ca. 1910; Black-on-red jar, 2½" high, ca. 1900; Black-on-red effigy bowl, 5½" wide, ca. 1910.*

Maricopa pottery matured rapidly in the early twentieth century. They experimented, playing around with scalloped rims and odd shapes, and they produced pots never seen before or since. When their Mojave cousins made little cups and pitchers for the tourists, they stayed with European shapes. To the Maricopa, those shapes were just the starting point. They made ordinary cups and

saucers, but they also made cups like the tan one in the middle row and sugar bowls with attacking frogs and lizards like the one at bottom right.

We've never seen another carafe and cup like the one in the top row. And we've seen a lot of four-spouted jars from the Mojave, but we've never seen another four-holer like the one at top center.

Lena, Ida and Mary

"Almost anyone, who has once seen her work, can go into a room half full of Indian art, and pick out the work of Lena Mesquerre." Those words came from *The Pima and His Basket*, written in 1923 by J. F. Breazeale.

He'd driven to "the land of the Maricopas" and sought out Lena, who was "probably the best pottery maker of her tribe." She blew him away with her presence. Before he got to baskets, he wrote three pages about her, beginning with: "You have heard of the downtrodden Indian, but this was not Lena, she swept in with the grace and dignity of a highborn. With the alkalai still between her bare toes, I, for one, felt my inferiority."

Confusion made official: identification sticker, 1930s.

Breazeale was almost unique among observers of his day. He not only appreciated Lena Mesquerre's art, he recognized her as a Maricopa and saw what Mabel Sunn later complained about: that the Maricopa made pots and the Pima made baskets, something dealers remained oblivious to some years later when they put their sticker on the big Mary Juan bowl in the picture on the next page.

Ironically, Breazeale wasn't immune to the confusion. We were surprised to learn that, according to one of her descendants, Lena was actually a married-in Pima, living in the Maricopa manner.

Maricopa or not, Lena Mesquerre was an exceptional potter, and Breazeale felt she was the equal of Nampeyo at Hopi, the first Native American potter to gain celebrity. Today, Lena is almost forgotten. Her eclipse was foreshadowed by another book, another writer and another potter.

In 1933, Leslie Spier wrote *Yuman Tribes of the Gila River*, and it became the definitive book on the Maricopa. Spier spent the months between 1929 and 1932 at Maricopa, and his principal interpreter was Ida Redbird. Although he devoted seven of his four-hundred-plus pages and three plates to a discussion of Maricopa pottery, and though he acknowledged that the line drawings of Maricopa pottery designs were "drawn by Mrs. Redbird," he never got around to mentioning that Ida Redbird was, by then, the preeminent Maricopa potter.

Lena Mesquerre was uncomfortable with the English language and, according to Breazeale, pretended not to understand it. Ida Redbird, on the other hand, was outgoing, charismatic and comfortable with English and the Anglo world. It didn't take long for dealers and curators to look to her as their first Maricopa contact.

Neither she nor Lena Mesquerre had an ironclad claim on being the "best," however. The best may have been Ida's cousin Mary Juan.

Lena, Ida and Mary played to the tourists. Here, signed pieces by each, ca. 1940. Mary Juan made the bowl, Lena Mesquerre did the shoe ashtrays, and Ida Redbird did the red ashtray.

Like Lena, she was less comfortable with English and with putting herself forward to the public.

When seventeen Maricopa potters formed the Maricopa Pottery Cooperative in 1937, Ida Redbird was the logical choice to front the group. The cooperative happened because Elizabeth Hart, the United States Indian Service Home Extension Agent, Pima Division, Sacaton, Arizona, noticed that Maricopa potters were only getting a nickel for well-made pots and decided to do something about it.

Hart wrote letters to the directors of three major museums, and by 1938, the pottery cooperative (including Mary Juan and Lena Mesquerre) had weekly showings at the Pueblo Grande Museum in Phoenix. They dressed in native costumes, did demonstrations and sold pottery. Ida later told Mary Fernald that they could have done without the costumes, but the good news was that they got to set their own prices, sell their own pots and keep the money.

It didn't last. Getting to Phoenix with a load of pots was no easy trip, and when Elizabeth Hart died in 1941 and World War II began shortly after, the cooperative fell apart.

Elizabeth's legacy lived on. She wrote a ten-point quality standard that influenced potters for years after. There were fewer potters after the war, but Maricopa pottery held to the high standards.

BACK ROW: *Black-on-red wedding vase, Ida Redbird, 7¾" wide, ca. 1950; Black-on-red pitcher, Mary Juan, 9¾" high, ca. 1940; Polychrome longneck jar, Ida Redbird, 9¾" high, ca. 1930; Black-on-red tall jar, Ida Redbird, 10" high, ca. 1955.*
MIDDLE ROW: *Polychrome bowl, Lena Mesquerre, 6" diameter, ca. 1940; Black-on-red pitcher, Ida Redbird, 7" high, ca. 1940; Polychrome bowl, Lena Mesquerre, 6¾" diameter, ca. 1920; Black-on-red bowl, Mary Juan, 7¾" diameter, ca. 1935.*
FRONT ROW: *Polychrome jar, 3-1/8" diameter, ca. 1925; Polychrome wedding vase, Lena Mesquerre, 6" wide, ca. 1940; Black-on-tan moccasin, 4" long, ca. 1930;*

Polychrome jar, 4¼" high, ca. 1940; Polychrome bowl, Mary Juan, 4½" diameter, ca. 1935; Polychrome wedding vase, 5¼" wide, ca. 1940; Polychrome pig bank, Lena Mesquerre, 3½" long, ca. 1940.

We're pretty sure the unattributed pieces in this picture are by one of the three. Since no early Maricopa pieces were signed, we based our attributions on comparison with known examples. Signatures were probably Elizabeth Hart's idea for the cooperative and were rare until the 1970s. The LM on the shoes on the opposite page was a surprise. We've never seen another signed Lena Mesquerre piece.

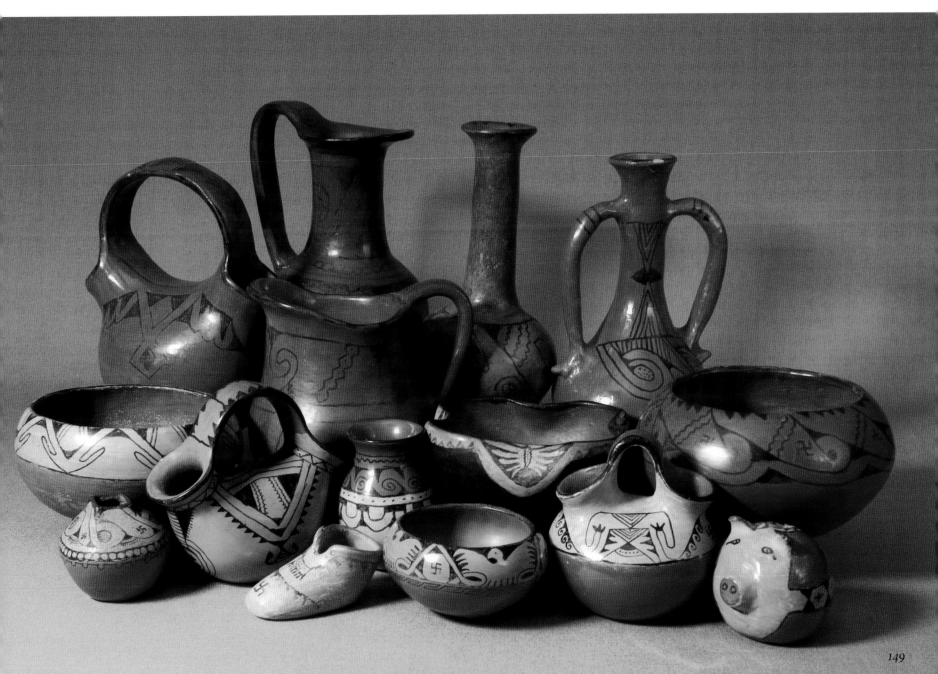

149

The Other Good Ones

Lena Mesquerre, Ida Redbird and Mary Juan weren't the only good potters in the Maricopa Pottery Cooperative.

In *Dirt for Making Things*, Janet Stoeppelmann and Mary Fernald quoted Ida Redbird rattling off the names of Lena, Mary and fourteen others: Pearl Miller, Sallie McKinley, Maggie Colt, Agnes and Josephine Bread, Cora and Mabel Sunn, Alma Lawrence, Lula Young, Mary Loring, Ruth Anton, Lou Johnson, Grace Perchero and Susie Sundust.

There were more. Grace Monahan, Claudia Kavoka, Vesta and Loretta Bread and, later, the next generation: Malinda and Anita Redbird and Mabel Sunn's daughters Barbara Johnson and Gertrude Stevens.

Some retained a place in history, or at least a tenuous toehold. Today, even casual collectors pay big prices for a Mabel Sunn. Sophisticates look for Alma Lawrence and Vesta Bread, and the really knowledgable want Grace Monahan.

The rest hover between virtually and totally forgotten, brought back only as a line of type or the odd example in *Dirt for Making Things* or some other book.

Forgotten master, circa 1940: two exceptional pieces by Lula Young. The tall vase is 11¼" high.

These two pages show the narrowness of the gap between the acknowledged masters and others who plied the craft. It doesn't diminish our appreciation of Lena, Ida and Mary to recognize the brilliance of those who followed.

Even though Ida Redbird lumped Lula Young with those who "weren't as active" as the central figures in the collective, she once told Mary Fernald that "the two best potters are Lula Young and Mary Juan." The pieces at left are two of the finest Maricopa pieces we've ever seen. The whirling logs put a prewar date on the big one. Potters had to stop using the old Hohokam design after World War II began. Buyers wouldn't touch anything with what had become Nazi Germany's national symbol.

Vesta Bread's work was as good as anyone's. To appreciate her skills, just look at the shallow bowl with the eagle on the next page. If it weren't signed, we'd easily have attributed it to Mary Juan.

Mabel Sunn holds a special place on the honor roll, and not just because she was the principal source for *Dirt for Making Things*. She was a master potter who taught two daughters the craft and served as a central figure in a second revival of Maricopa pottery around 1970. Her work stretched the traditional limits.

When a Phoenix dealer asked her to make Mojave-like effigies, she did, despite the fact that a social worker told her she should confine her art to traditional Maricopa forms. Mabel's definition of traditional was more correct than the social worker's, since, after all, the Maricopa *were* Mojave, in language and heritage, and besides, her Red on buff effigies owed as much to the Hohokam as they did to the Mojave. The one on the next page won a first prize at the Gallup Inter-Tribal Ceremonial in 1970.

Mojave-style red on buff effigies weren't Mabel's only contribution to the Maricopa repertory. Her snake bowls were originals, and the three family examples in the picture to the right, one by Mabel and one by each of her daughters, manage to be both innovative and clearly recognizable as Maricopa pottery. The one at front left shows how Vesta Bread picked up the idea.

There were talented potters among the Maricopa in the last half of the twentieth century. And they made some wonderful pots.

Not-quite-so-forgotten master, ca. 1970: two exceptional pieces by Alma Lawrence. The bowl in back is 8¼" in diameter.

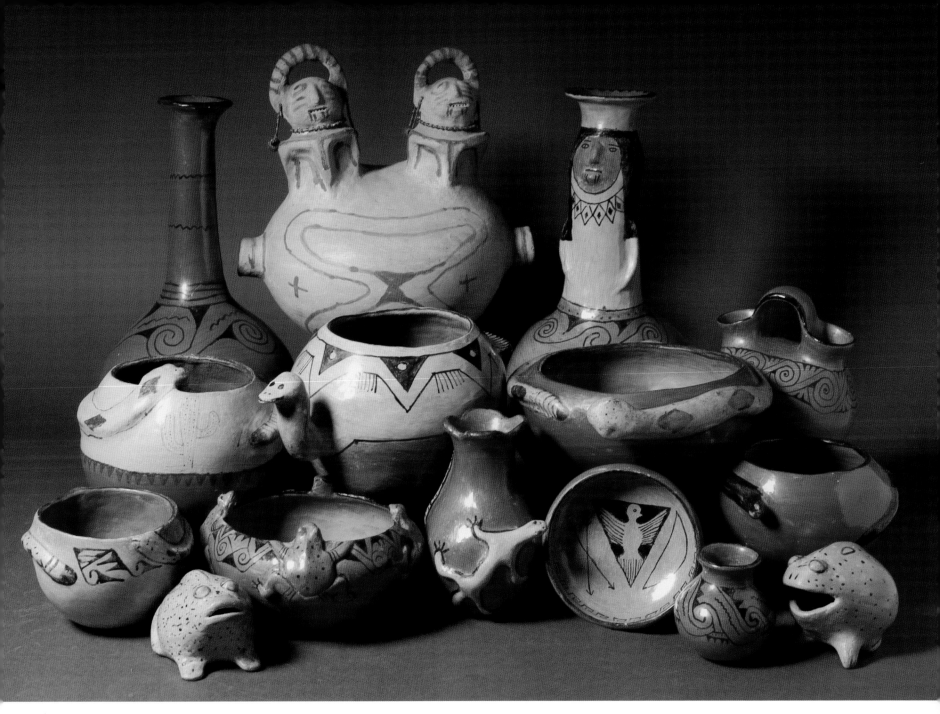

BACK ROW: *Black-on-red tall jar, Mabel Sunn, 12¾" high, ca. 1970; Red-on-buff effigy jar, Mabel Sunn, 12" high, 1970; Polychrome effigy jar, Vesta Bread, 14" high, ca. 1950.*
MIDDLE ROW: *Polychrome snake effigy bowl, Gertrude Stevens, 6¾" diameter, ca. 1970; Polychrome duck effigy bowl, Vesta Bread, 8" diameter, ca. 1960; Polychrome snake effigy*

bowl, Mabel Sunn, 9¼" diameter, ca. 1970; Black-on-red wedding vase, Grace Monahan, 6¼" high, ca. 1950.
FRONT ROW: *Black-on-tan snake effigy bowl, Vesta Bread, 5⅛" diameter, ca. 1960; Black-on-tan frog figurine, Barbara Johnson, 3⅛" long, ca. 1960; Black-on-red frog effigy bowl, Grace Monahan, 8¼" diameter,*

ca. 1960; Polychrome lizard jar, Barbara Johnson, 6¾" high, ca. 1980; Polychrome dish, Vesta Bread, 5¼" diameter, ca. 1950; Black-on-red jar, Grace Monahan, 3¼" high, ca. 1960; Black-on-red snake effigy jar, Barbara Johnson, 6" diameter, ca. 1980; Black-on-tan frog figurine, Mabel Sunn, 3½" long, ca. 1960.

Here, five potters show skill, experimentation and respect for tradition, as well as affection for the desert's animal life. Frogs, lizards and insects show up over and over on Maricopa pottery, and rattlesnakes, prominent in Maricopa and O'odham legend, were nothing new. You can see a rattlesnake from a hundred years earlier on page 145.

The Inheritors

After the flurry of the 1970 pottery revival, concerned observers lamented the rapid decline and impending disappearance of Maricopa pottery. Perhaps if the observers had looked a bit deeper, they might have held off writing the obituaries.

Yes, there's been a quantity decline in the last twenty years. And yes, the Maricopa haven't made many pots that look like the great ones from the first half of the twentieth century. But Maricopa pottery has remained alive, taken new forms and resurrected ancient ones. Older potters teach the young ones, just as they always have.

On a summer 2002 visit to the Hoo-Hoogam-Ki Museum on the Salt River Reservation east of Scottsdale, we saw a bright young Native American curator reorganizing a collection of Hohokam pieces found on the reservation, and his burst of activity sent us a message about pride in heritage and real hope for the future of the art.

During the Maricopa pottery resurgence of the 1970s, there were carryover names from the glory days like Ida Redbird, Mabel Sunn and Alma Lawrence, and new ones as well.

There were Ida's daughter Malinda and her daughter-in-law Anita, both capable of important pieces that really did look like those wonderful old ones. After Ida's death, Malinda Redbird learned from Mary Juan, and you can see the result on the next page. Her longneck jar—a shape that shows up often in Maricopa pottery and seldom anywhere else—could easily pass for Mary's work.

Others followed right behind, and several of today's most influential potters started their careers in the 1980s and 1990s.

Perhaps the most influential has been Vesta Bread's daughter and Mabel Sunn's in-law, Phyllis Cerna, who taught her own daughter, Avis Pinon, and then her granddaughter, Antoinette Pinon. She also taught a group of young interested potters in the mid-1990s in classes at the Hoo-Hoogam-Ki Museum.

Theroline Bread, Susie Sundust's granddaughter, produced an important body of work between 1980 and 2000. There were also Barbara Johnson's daughter, Vickie Johnson Howard and Vesta Bread's daughter, the second Loretta Bread to make Maricopa pottery

Dorothea Sun makes miniature Mojave-style effigies that look like the ones Mabel Sunn made. She also makes effigies like the one on the left, which look like the ones the Hohokam made a thousand years ago. She made these in 1997 and 2001. The little one is about the size you see it here, 2¼" tall.

(the first was active in the 1930s). Now we have Theroline's daughter, Dorothea Sun, her son, Kermit Bread Jr., and her nephew, David Soke. We have Matillas Howard whose work was so good as a teenager that the *Arizona Republic* devoted half a page to him in 2002.

And there are some non-Maricopas—Akimel O'odham potters Warren Oliver and Clayton Wahpeta and the late Tobias Manuel. They explored, and explore, the full vocabulary of their neighborhood pottery, from the Hohokam to the late Maricopa.

Because they're O'odham, we've put their work further on in the book, on page 161, but since Wally Oliver especially has made so many pieces that fall under the Maricopa umbrella, we could just as well have shown his work here.

Maricopa pottery is alive and well, but this may be one of the last books to call it that. Like other Southwestern tribes, the Maricopa are in the process of dumping their old, Spanish-imposed name.

Their neighbors in Phoenix and Tucson aren't the Pima and the Papago any longer, they're the Akimel and Tohono O'odham. Granted, the old names die hard. There's an Arizona Historical Society Museum in Papago Park, acreage that covers parts of Phoenix, Tempe and Scottsdale, while Tucson rests in Pima County. Indian art dealers everywhere still sell Papago and Pima baskets.

Now, all of us who admire Maricopa pottery will have to learn a new name. Make a note of it: The Maricopa are now the PeePosh, pronounced as it's spelled.

BACK ROW: *Black-on-tan jar (experimental firing), Matillas Howard, 7" high, 2003; Polychrome tall jar, Malinda Redbird, 12" high, ca. 1975; Red-on-buff effigy jar, 8" high, Theroline Bread, ca. 1969.*
MIDDLE ROW: *Polychrome wedding vase, Dorothea Sun, 5¼" high, 2003; Black-on-red jar, Anita Redbird, 4¾" diameter, ca. 1980;*

Black-on-red effigy jar, Phyllis Cerna, 6¾" high, ca. 1985; Black-on-red snake effigy jar, Phyllis Cerna, 4¾" diameter, 1993; Black-on-red jar, Malinda Redbird, 4¼" diameter, ca. 1975.
FRONT ROW: *Black-on-red pig bank, Loretta Bread II, 2¾" long, ca. 1985; Polychrome scorpion dish, Kermit Bread, 4¼" diameter, 2003; Black-on-red miniature olla, Theroline*

Bread, 2¼" high, 1998; Polychrome snake effigy jar, Dorothea Sun; 3¼" high, 2003, Black-on-red jar, Phyllis Cerna; 4¼" diameter, 1992, Black-on-red bird effigy dish; Anita Redbird, 5½" long, ca. 1980; Black-on-tan pig bank, Antoinette Pinon, 2¼" long, ca. 1990.

This latter-generation work offers hope for the

future. Most of these are small tourist pieces, but what else is new? Maricopa pottery has mostly been small tourist pieces ever since 1880. The two major efforts in the picture, Malinda Redbird's tall jar and Theroline Bread's red on buff effigy, hold their own against the best work from any period, as do Dorothea Sun's two small polychrome pieces from 2003.

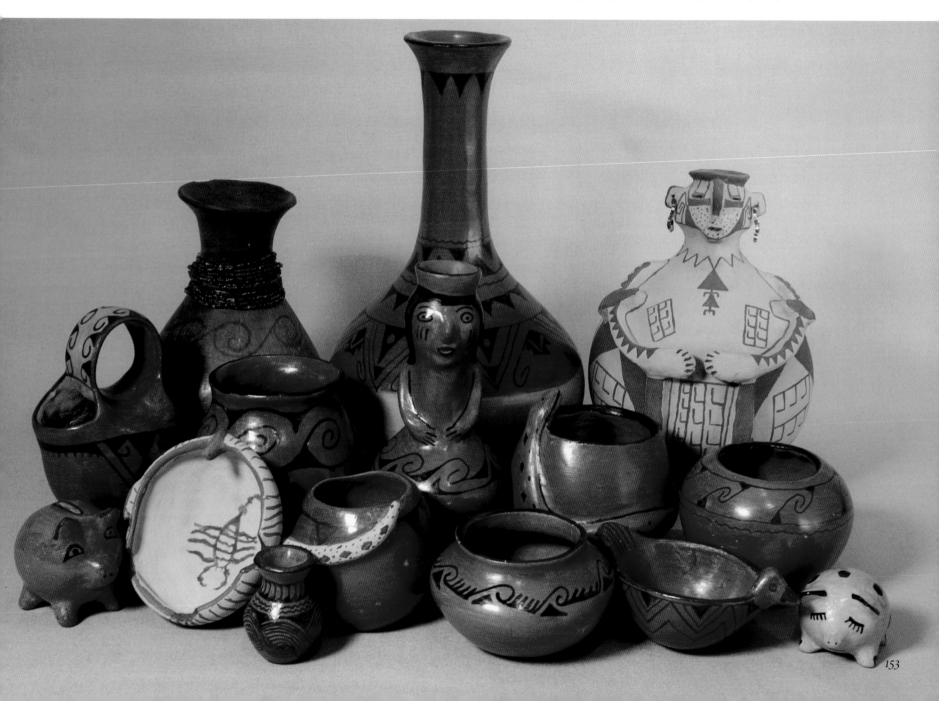

153

The O'odham

As Mabel Sunn insisted, pottery was the Maricopa craft of choice, but the Akimel and the Tohono O'odham concentrated on basketry. Today, they still do, and there's a thriving collector's market for Pima and Papago baskets.

Originally, baskets, like pottery, were totally utilitarian, and they started making them before they started making pots. Surviving Hohokam baskets go back more than twelve hundred years, and the Hohokam and their predecessor farmers probably made them long before that. Baskets, unfortunately, biodegrade, while fired pots live for the ages, which explains why you see so many more pictures of old pots in books like this as opposed to pictures of old baskets.

In his 1979 *The Papago Indians and Their Basketry*, Terry DeWald wrote about how basketry evolved from the basic forms used for storage and transport:

These soon led the art down other paths, including winnowing, parching, clothing (woven sandals), mats for sleeping, cradles, strainers (for wine), medicine and trinket baskets, and cooking containers (by dropping

They made big ones. This is an O'odham kiaha, *or burden basket, ca. 1900, decorated with red and black paint, probably Tohono and 21" in diameter, not counting the horsehair-wrapped poles. In The Papago Indians and Their Basketry, there's a photo of two turn-of-the-century Tohono women, each carrying one of these on her back filled with what looks to be 50 pounds of pottery.*

heated stones into wet corn or grain meal inside a basket). Records indicate that Papago baskets have been used to water horses, remove dirt from irrigation ditches, draw water from wells, and act as drums for ceremonies.

O'odham basketry already had an extensive vocabulary when the hard times hit in the late nineteenth century. According to DeWald, there was little difference in technique between baskets made a thousand years ago and modern ones.

Things did change, however. In old Tohono baskets, light design elements were willow, while the dark ones were made of devil's claw, the fiber from the seedpod of a shrub that grows throughout the Southwest. Willow was hard to come by for the Tohono, who lacked the creeks where willows grew, so dark elements tended to predominate. When they started making baskets in quantity for tourists,

they used easier-to-find yucca leaf instead of willow.

And, DeWald tells us, they started making baskets in shapes that pleased the marketplace. Now they put lids on them, put birds, turtles and lizards in the design and wove in words like "Tucson" or "God Bless America."

They made little ones, too. These horsehair baskets from the 1990s include a human effigy. The tray is 1¼" across.

The depression slowed the Indian art market, but it didn't stifle O'odham basketry. Bernard Fontana tells us that in the depression, a trader named Goldie Richmond shipped baskets by the thousands to large commercial retailers. In 1979, DeWald wrote that "the Papagos still produce more baskets than all other American tribes combined."

While the basketmaking remained prolific, the O'odham also made pottery. They were making it when the Spanish arrived, and they're still making it today.

Unlike the basketry, the pottery never attracted much attention. In fact, there hasn't been a book devoted to O'odham pottery for more than forty years.

We'll try to remedy the slight by devoting the next pages to letting pottery tell us as much as it can about the O'odham.

O'odham baskets from the late nineteenth century to the present, in split willow, yucca leaf, yucca root, devil's claw and, in one case, steel wire.
BACK ROW: *Akimel wall basket, 10¾" high, ca. 1975; Tohono tray, 15" diameter, ca. 1900.*
MIDDLE ROW: *Akimel wine basket, 15" diameter, ca. 1885; Tohono horse and rider, Frederick Cruz, 8½" high, 2003; Akimel willow basket, 10½" diameter, ca. 1910; Akimel tray, 12" diameter, ca. 1890; Tohono mouse basket, 9¼" high, ca. 1965.*
FRONT ROW: *Tohono saguaro picker, Delia Cruz, 7¼" high, 2003; Tohono rattlesnake tray, Delores Stevens, 7½" diameter, 2003; Tohono beaded tray, 3½" diameter, ca. 1995; Akimel tray, 9" diameter, ca. 1895; Tohono man-in-maze tray, Delores Stevens, 8" diameter, 2003; Tohono wire basket, 3½" diameter, Wayne Pedro, 2003; Akimel basket, 7" diameter, ca. 1950.*

Early Reports

We know that the Akimel, the "River People," made pots early because in 1698, Diego Carrasco wrote, "They brought water in jars from the Gila River to meet a party approaching."

In 1849, an observer named Robert Eccleston visited San Xavier del Bac, the fabulous mission near Tucson that, since 1874, has been part of the Tohono O'odham Reservation. He graciously reported that the Indian women were at work making earthen pots, "& the perfection to which they bring this art shows they are not altogether devoid of ingenuity or talent."

Three years later, John R. Bartlett visited the Akimel O'odham and Maricopa up north along the Gila and wrote "the pottery made by these tribes is all red or dark brown. . . . All these vessels are painted or ornamented with black lines arranged in geometrical figures."

Jumping forty years to 1892, D. D. Gaillard took time off from a boundary survey to observe that the Tohono made "water jars and cooking vessels of pottery of excellent quality and of a dark red color with black markings. I have never observed any cream colored pottery, like that common among the Pimas and Maricopas."

In 1934, Ralph Beals commented on these observations and decided that, if all Gaillard and the others said were true, "the [Pimas and

*In the nineteenth century,
the O'odham worked big.
Here, the biggest storage jar is 15¼" high,
the smallest is 11" high, and the lady is 15¼" tall.*

Maricopas] have copied their modern pottery from the Papagos."

For years, people have confused the Akimel O'odham with the Maricopa. It can be even harder to keep the Akimel O'odham and the Tohono O'odham straight. Attributing early work between the three groups takes a bit of research, and it's an inexact science.

In 1962, Bernard Fontana, William Robinson, Charles Cormack and Ernest Levitt wrote the scholarly *Papago Indian Pottery*, to which we owe the foregoing historic quotes. They concluded from their historic research that Maricopa decorated pottery was actually Papago Black-on-red "brought to perfection."

By *perfection*, the authors probably referred to the high polish that became the Maricopa specialty. On early pieces, a soft luster rather

than a hard high shine leads us to assign early tourist pieces like the ones on the next page to the O'odham.

All three groups made a lot of small pottery pieces after the railroads came through in the 1880s. They learned, as had the potters in the northern pueblos, that big pieces like the four to the left didn't fit inside tourists' suitcases.

Big storage jars were an O'odham specialty. All three have a satin rather than gloss luster and were obviously made for serious storage, and two of them have spent enough time around fires to show that they were used rather than admired. It's probably fairly safe to say that the two big ones are Tohono and the smaller one is Akimel. One study reports that, in the early days, the Akimel preferred elongated shapes like the jar on the left and that they learned the shape from the Kohatks, a southern Akimel group who lived in Tohono country since the early eighteenth cenury. The word survives as the name of a town on the Tohono Reservation.

It's tough to make a call on the effigy jars. We're leaning towards Tohono on the lady on this page and towards Akimel on the tourist-sized lady on the next.

Those tourists didn't make things easier when they wrote on the bottom of their pots in pencil. We have a large Maricopa jar that says "Santa Dominga" and a smaller one that says "Made by Zuni Indians."

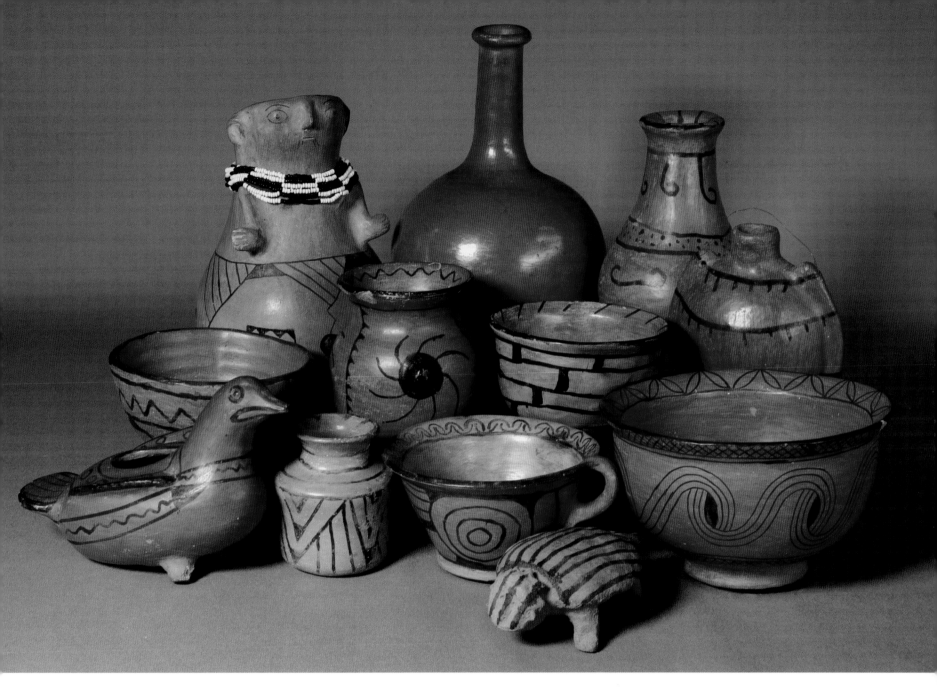

BACK ROW: *Black-on-red effigy jar, 10" high, ca. 1880; Redware canteen, 9¾" high, ca. 1900; Black-on-red tall jar, 6¼" high, ca. 1890.*

MIDDLE ROW: *Black-on-red bowl, 5¾" diameter, ca. 1910; Black-on-red jar, 4⅛" diameter, ca. 1910; Black-on-red bowl, 4¼" diameter, ca. 1890; Black-on-red canteen, 5⅞" diameter, ca. 1915.*

FRONT ROW: *Black-on-red dove effigy,* 7½" *long, ca. 1890; Black-on-red jar, 3⅜" high, ca. 1900; Black-on-red cup, 5⅜" diameter, ca. 1890; Black-on-red horned toad figurine, 5½" long, ca. 1915; Black-on-red footed bowl, 7" diameter, ca. 1900.*

This array sums up what we think we've learned about early O'odham pottery. The one thing we'll hold back on is trying to decide which of these pieces are Tohono and which are Akimel. They're all small, nonutilitarian pieces, all probably made for the tourists except one—the early-style bottle-shaped canteen at top center, which owes its luster to a coat of varnish provided by a helpful latter-day collector.

The hooded effigy at top left has beadwork and trade cloth that experts who know more than we do have dated at 1880. Its surface is satin-finished and in one of the shades of the almost indescribable off-red that shows up on the small jar in the front row, the cup next to it, the "brickwork" bowl in the middle row and the horned toad from a dated collection. To us, these pieces say that, at least in the early days, the O'odham made refined pottery and that they were as skilled as the Maricopa. Few nineteenth century Maricopa pieces can compete with the cup and the footed bowl.

Evolution

The differences between the Akimel and the Tohono began to widen in the middle of the nineteenth century. They shared their Piman language, but their second languages diverged.

In *The Papago and Pima Indians of Arizona*, written before the Second World War, Ruth Underhill pointed out that when the gold rush migrants came across the desert, they went north through Akimel country because they could get water from the Salt and the Gila. As a result, the Akimel went Anglo while the Tohono, who'd had years of exposure to and comfortable coexistence with the missions, stayed Spanish. The Akimel took Anglo names, wore Anglo clothes and grew wheat while the Tohono stayed with the traditional trio of corn, beans and squash.

During the last half of the nineteenth century, the more visible Akimel got larger and larger riverfront acreage for their reservations. The easier-to-ignore Tohono got their little San Xavier Reservation along the Santa Cruz river near Tucson in 1874, a little one near Gila Bend eight years later and the little Ak-Chin Reservation in 1912. Finally, in 1917, they got the Sells Reservation, one of the largest pieces of Indian real estate in America,

Today, most Tohono live on the Sells Reservation, but it's hardly rich land. It's more like what Washington would call "surplus land," with no year-round rivers running through. It does get a bit of rain, and it has some decent grazing land. In the early twentieth century, the Tohono turned to cattle raising.

They also continued to make pottery, but never attracted much attention for it. The 1962 *Papago Indian Pottery* by Bernard Fontana and his coauthors is, so far as we've found, the only book devoted exclusively to Tohono pottery. The authors ran into some of the problems we faced in sorting out its development.

They concluded it was "abundantly clear that by the late 1800s and the early 1900s, Papagos,

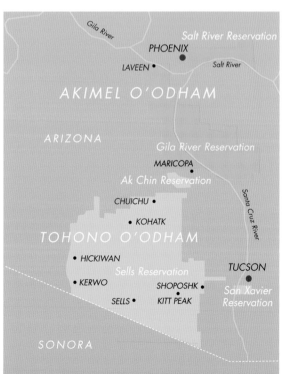

Ee-ee toys from the 1930s. The 9½" diameter jar at left held a card from trader Goldie Richmond, attributing it to Frances Montaña and dating it 1932.

Pimas and Kohatks were making black on red." The Kohatks, the eighteenth-century Akimel-to-Tohono migrants, don't show up in many books, but despite their anonymity, they played a vital role in the development of O'odham and perhaps even Maricopa pottery.

In 1908, Frank Russell, who spelled it *Kwahadk*, wrote that, "As a tribe, the Pimas are not skillful potters. . . . It is probable that the best potters of the Pimas are of Kwahadk descent, or have learned the art from that tribe."

By the early 1900s, the Maricopas were making cream-colored and polychrome pots, and it didn't take the O'odham long to look beyond black on red. On the next page, there's everything from black on dark red to black on pure white, with all shades in between. *Papago Indian Pottery* questions whether the Tohono made any white or cream ware before 1930. If the early jar on the opposite page is O'odham, it's Akimel and, considering the Kohatk-Akimel-Maricopa connection, possibly Kohatk.

Gila River
Salt River Reservation
PHOENIX
LAVEEN
Salt River
AKIMEL O'ODHAM
ARIZONA
Gila River Reservation
MARICOPA
Ak Chin Reservation
CHUICHU
KOHATK
TOHONO O'ODHAM
HICKIWAN
Santa Cruz River
Sells Reservation
TUCSON
KERWO
SHOPOSHK
San Xavier Reservation
SELLS
KITT PEAK
SONORA

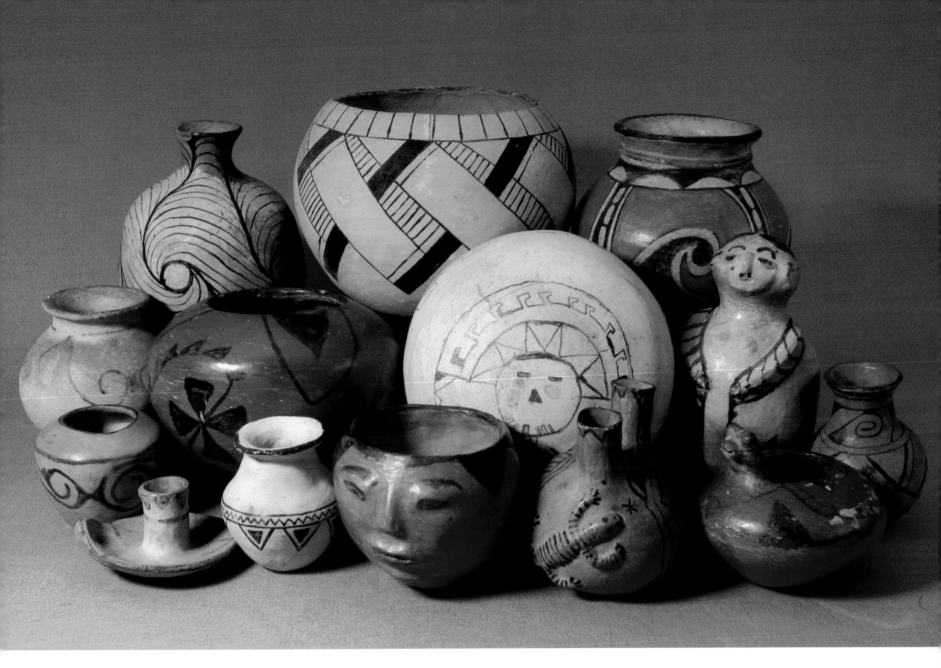

BACK ROW: *Brown-on-cream jar, 7¾" high, ca. 1915; Black-on-cream olla, 10" diameter, ca. 1940; Polychrome jar, 7⅛" diameter, ca. 1920.*

MIDDLE ROW: *Brown-on-tan jar, 5¼" diameter, ca. 1920; Black-on-red seed jar, 7½" high, ca. 1920; Black-on-white bowl, 8" diameter, ca. 1950; Black-on-cream effigy bank, 7¼" high, ca. 1930.*

FRONT ROW: *Polychrome jar, 3¼" diameter, ca. 1930; Brown-on-tan candle holder,*

4" diameter, ca. 1930; Black-on-white jar, 3¾" high, ca. 1945; Black-on-red effigy bowl, 5⅛" diameter, ca. 1950; Black-on-red double-spouted jar, 5¼" high, ca. 1920; Black-on-red effigy jar, 5⅜" diameter, ca. 1920; Black-on-tan jar, 4½" high, ca. 1930.

Papago Indian Pottery *helped us sort out many of the pieces in this picture. The figurine coin bank at center right and the*

effigy jar in the bottom row must be products of the Montaña family, who had made these "ee-ee-toy" figures for "four or five generations" at the time the book was written. (It's also easy to think of an earlier generation Montaña for the important lady on the front cover and on page 156.)

The white bowl and the little white jar in the front are Tohono. By midcentury, Tohono potters in the western end of the Sells Reservation had begun using a pure

white slip, and cream-colored pottery faded from the O'odham repertory.

We're still puzzling about the polychrome jar in the top row. It seems to date from early in the last century. However, the authors of Papago Indian Pottery believed the Tohono didn't make polychromes until after World War II. This pot isn't Akimel or Maricopa, and similar designs show up on later Tohono pottery.

For the moment, it's a mystery.

Regional Styles

It's easy to think of the O'odham as one big homogenous community, but their pots seem almost as individually localized as the carefully categorized pueblo pottery from Northern New Mexico.

Between Taos and Albuquerque, the pueblos are really just medium to small towns, but each has its own artistic identity. Even though they're only a few miles apart, anyone who's spent a couple of days studying and holding some typical examples has no problem telling a Taos pot from a Santa Clara pot from a Cochiti pot. The local traditions that dictate what each pot looks like have held for centuries.

Something similar seems to have happened across the miles of

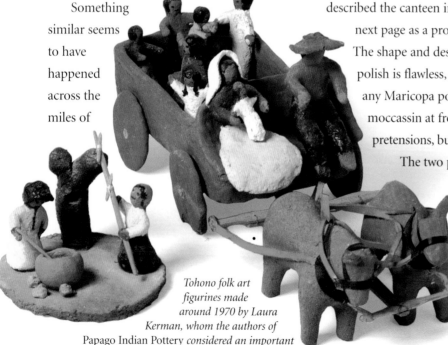

Tohono folk art figurines made around 1970 by Laura Kerman, whom the authors of Papago Indian Pottery *considered an important innovator. The saguaro harvesters are 6" in diameter, the family cart is 17" long.*

the four Tohono reservations. *Papago Indian Pottery* discussed the influence of the Kohatk potters at some length, crediting them with influencing not only the Akimel but the Maricopa as well. The authors even pointed out that Ida Redbird learned pottery-making not from the Maricopas but from her Kohatk mother.

One reason that Fontana and his coauthors thought so highly of Kohatk work is that they polished their pots better—at best, as well as the finest Maricopa. Tohono expert Rick Rosenthal described the canteen in the picture on the next page as a prototypical Kohatk pot. The shape and design are Tohono, but the polish is flawless, perfect enough to do any Maricopa potter proud. The little moccassin at front left has no pretensions, but it has a Kohatk finish. The two pots above represent another clear regional style. They were made at Shoposk in the White Horse Pass area in the northeast Sells Reservation by sisters Sally Havier and Lena Albert.

In the mid-century, Tohono potters had formal outlets. These pieces by Lena Albert and Sally Havier are ca. 1960, and both have tags identifying the potter and Kitt Peak, Arizona, at the east end of the Sells reservation, as the place where they were sold. The bird bowl is 4⅛" high.

The slip and clay colors are identical, and both have an obviously striated, obviously un-Kohatk polish that serves as a first clue that they're Tohono rather than Maricopa.

The most easily recognized O'odham regional style came from Hickiwan in the western Sells Reservation. Potters worked with white clay and gradually developed a polychrome style that now represents the major portion of O'odham pottery. You can see three examples on the next page.

There were others. The Manuel family has worked in a variety of styles for years, and today, Billy and his sister Annie mainly work in a matte finish and make highly individual pieces that often show more connection to the ancient Hohokam than they do to modern O'odham work.

Meanwhile, Akimel have been learning from the Maricopas. Dorothea Sun spent seven years teaching Warren Oliver, who began making typical Maricopa Black-on-red and has been branching out ever since. The late Tobias Manuel made matte-finished homages to the Hohokam, and new Akimel potters such as Clayton Wahpeta appear from time to time.

BACK ROW: *Black-on-white olla 9½" diameter, ca. 1965 (?); Black-on-white olla, 9¾" diameter, ca. 1965 (?); Polychrome bowl, 8½" diameter, ca. 1970.*

MIDDLE ROW: *Polychrome effigy jar, Billy Manuel, 7¼" high, 2003; Red-on-buff dish, Tobias Manuel, 7⅜" diameter, 1997; Black-on-white jar, Cross Antone, 5" diameter, ca. 1975; Polychrome jar, Juanita Antone, 8¼" high, ca. 1975; Polychrome effigy wedding vase, Annie Manuel, 9" high, 1998; Black-on-red canteen, possibly Susie Miguel, 8¼" high, ca. 1975.*

FRONT ROW: *Black-on-red moccasin, Pearl Norris, 4¼" long, ca. 1970; White-on-red bowl, Clayton Wahpeta, 3½" diameter, 2003; Redware bird figurine, Billy Manuel, 5¼" high, 2003; Black-on-white jar, Cross Antone, 2½" diameter, ca. 1975; Red-on-buff bowl, Tobias Manuel, 7½" diameter, 1999; Red-on-buff bowl, Warren Oliver, 5½" diameter, 1998.*

The polychrome bowl at top right and the polychrome jar in the middle foreshadow work to come. They bring to mind the later work from the Angea family of Hickiwan, a town in the western part of the reservation (there's a lot of it on the next two pages), and the pure white color suggests the clay deposits not far from Hickiwan. The jar is signed by Juanita Antone, a known Hickiwan potter, and was part of the inventory of a trading post that went out of business in 1979.

Judging by what Papago Indian Pottery had to say about white clay and polychromes, these pieces were probably made after the book came out in 1962. The same holds for the two ollas in the back row, yet the large black on buff olla on page 159 seems to have been made by the same hand, and when Mollie Poupenay bought it in the early 1970s, it was already old, probably pre-World War II.

O'odham pottery has explored many avenues since the mid-twentieth century. You can see the range in the current work of Billy Manuel—everything from an effigy jar that looks almost like the Angeas made it to a matte redware bird that evokes the Hohokam bird on page 5 and that only he could have made.

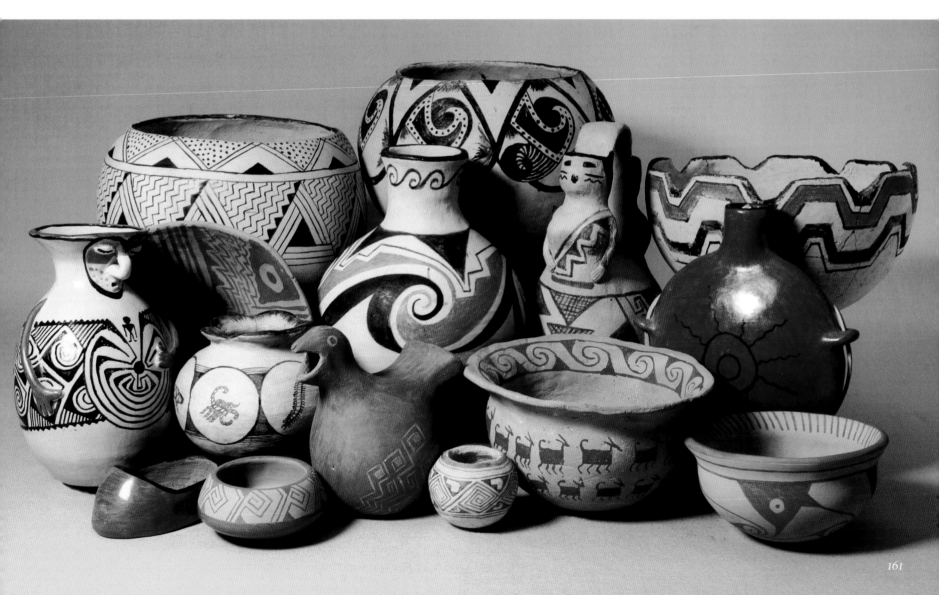

Angea

The style that now dominates O'odham pottery developed out west in Hickiwan, not far from Stoa Pitk, a place whose name means "white clay." When you see pure white on a Southwestern pot, it's because the potter had a kaolin-based clay like what the Hickiwan potters found a few miles north.

By the late twentieth century, one Hickiwan family had become far and away the best-known O'odham potters. The Angea family turned pottery-making into a craft industry to the point where, if you unknowingly set out to buy a Tohono pot, you'd almost certainly end up with an Angea piece, and it would probably be a friendship jar.

Like musicians who vault to the top of the charts with one hit song, the Angeas made it big with an original design that tourists couldn't keep from buying. The friendship jar (there's one second from right in the middle row on the opposite page) features a circle of dancers, usually four of them as in this example, but eight or more on bigger pieces. The dancers face the inside of the jar and have their arms around each other's shoulders.

You see their faces painted on the inside of the jar. To complete the effect, the jar has cutouts under the arms of the dancers. The result is a pure crowd-pleaser, the type of art that makes purists shudder and souvenir-hunters applaud.

The success of the friendship jar has probably kept the Angeas from getting all the recognition they deserve. Curators, upper-end gallery owners and collectors tend to dismiss the too popular and the too easily available as not worth serious consideration.

That's too bad, because there's far more to Angea pottery than friendship jars. The family tradition follows a classic pattern. Originally, one family member creates an experiment that appeals to buyers, and, as demand increases, relatives join in to help with production.

Almost without exception, important Southwestern pottery artists—Nampeyo of Hopi, Maria Martinez of San Ildefonso, Lucy Lewis of Acoma, Juan Quezada of Mata Ortiz and many others—had, or have, family members who continue to work in the family's personal style.

The Angea family style predates the friendship jar by many years, and almost certainly owes its origins to the work of Hickiwan artists of thirty, forty and

The Angea polychrome look didn't happen immediately. This 5" diameter jar dates from about 1950 and is attributed to Joe Angea Sr.

more years ago. The swirls on the polychrome jar on the right end of the middle row on the next page, on Juanita Antone's jar on the previous page and on the old polychrome jar on page 159 show that the Angea's distinctive look is a result of evolution rather than a break from tradition.

The jar at top left and the small jar in the front row on the opposite page use designs borrowed from basketry, as do the four pieces that incorporate the Tohono "man-in-maze" design that appears on a tray on page 155 and, for that matter, on the tribal logo.

Putting basket designs on pots is a long-standing Tohono O'odham design practice, one that goes back almost as far as the Hohokam designs that decorated the first O'odham and Maricopa Black-on-reds.

Within the Angea family, the quality of work has steadily improved over the years. Dismissing their work as mass-produced or tourist curios isn't fair.

One thing that doesn't help the Angeas overcome this attitude is the fact that most pieces, and almost all current ones, are simply signed *Angea*. This gives an unfair impression of production by a family factory rather than of careful work by individual artists. The next page presents a truer picture of what the Angeas have brought to contemporary O'odham art.

Thanks to the Angeas, the Manuels and the young Akimel potters who work with the Maricopa in Laveen on the Gila Reservation, O'odham pottery remains alive.

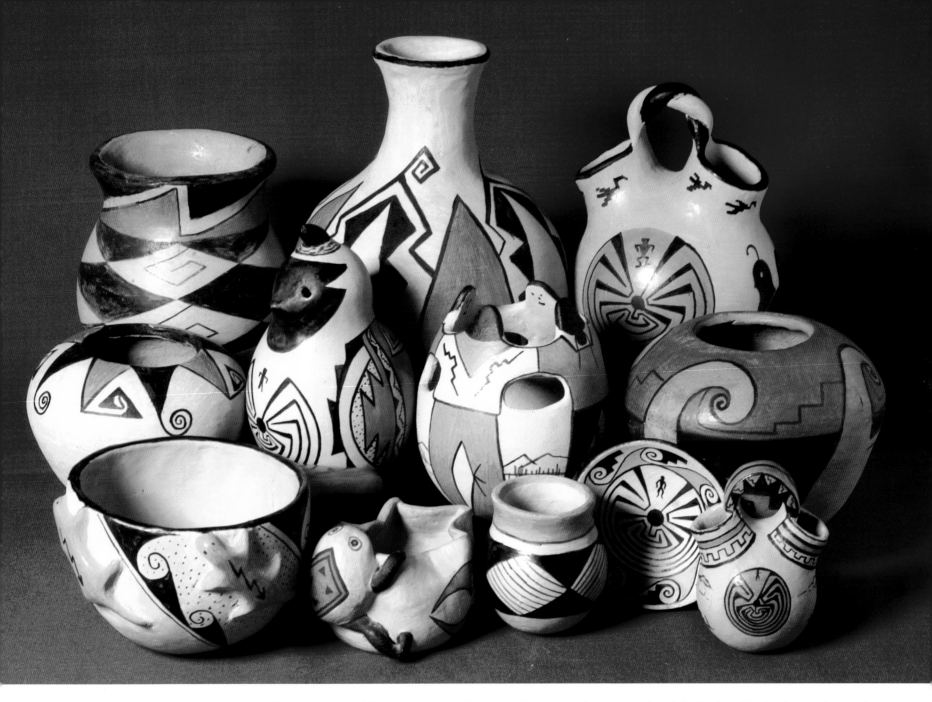

BACK ROW: *Polychrome jar, Rupert Angea, 6¼" high, ca. 1980; Polychrome jar, Joe Angea Jr., 9½" high, ca. 1990; Polychrome wedding vase, Avela Angea, 6½" high, 1997.*

MIDDLE ROW: *Polychrome seed jar, Angea, 5¼" diameter, ca. 1985; Polychrome quail figurine, Gladys Angea, 1997; Polychrome friendship jar, Angea, 5⅛" high, 2001;*

Polychrome jar, Angea, 6¼" diameter, ca. 1975.

FRONT ROW: *Polychrome lizard effigy bowl, Rupert Angea, 5¾" diameter, ca. 1985; Polychrome frog effigy bowl, NA, 4½" long, ca. 1990; Polychrome jar, Angea, 3⅛" high, 1992; Polychrome man-in-maze dish, Gladys Angea, 3½" diameter, 1998; Polychrome wedding vase, Gladys Angea, 4" high, 1999.*

The pots on this page trace the evolution of Angea polychrome ware from the earliest hard attributions we can come by to the present. We feel it could go back further, based on older unsigned pieces that look to be within the family tradition. The big polychrome jar on page 159 has been dated at 1900 by experts. Our own call is a more conservative 1920, but we've been fooled

before by the quick aging that casual care and exposure can give a pot. We have a sneaking feeling it could be quite a bit later, and might even belong on this page instead. Likewise, the ollas and the polychrome bowl on page 161. In any event, the Angea family by now has achieved an unmistakeable look—one that goes way beyond the ubiquitous friendship jar.

The Apaches

When the U.S. government freed the last of the Apaches from military prisons in 1913, they could return to their ancestral lands, or at least the ancestral lands that Washington saw fit to set aside for reservations. The land allotments were hardly the choice tracts that developers had their eyes on, but they weren't exactly meager. The Fort Apache, San Carlos and Tonto Reservations in Arizona are mostly piney woods in the White Mountains and the Tonto

A 14" high three-rod coiled western Apache olla made in about 1915. The baskets on these two pages are the classics that collectors dig deep to buy.

Forest of central Arizona, and there are more than 5,000 square miles of them. The Mescalero Reservation in southwest New Mexico and the Jicarilla Reservation north of Santa Fe add another 2,000 square miles.

Fewer than thirty thousand Apaches populate this real estate, and twenty thousand of them live in Arizona. How well they adapted depends on who's telling the story. In 1937, Frank C. Lockwood wrote a book called *The Apache Indians*, and it was important enough to be reprinted fifty years later in the 1980s. He thought the Apaches were doing just fine, and he applauded progress on the Mescalero reservation, describing "one hundred and fifty new, up-to-date little four-room frame houses with adjoining barn, chicken house and privy."

This progress led him to say, "At present, on all the reservations, the Apaches are industrious and prosperous. In consequence of the somewhat too lavish expenditures of federal money at this time, no one is without a job who is able and willing to work." The prosperity didn't last. In the 1970s, a survey found 83 percent of the homes on the San Carlos reservation unfit for habitation.

In the mid-1990s, sixty years after Lockwood's book, we got a firsthand report from a friend in Globe, Arizona. She was an alcohol and drug rehabilitation counselor working with teenagers on the San Carlos Apache Reservation, and she told us it was "the poorest Indian Reservation in America."

Today, things are on the upswing. It started in 1975, when the Mescalero built a golf and ski complex called the Inn of the Mountain Gods on their southwest New Mexico reservation. It's doing well enough for them to call it "The Southwest's Best All-Season Resort™," and other Apache reservations have added casinos.

Like other Southwestern groups, the Apache contributed important art. From prehistoric times, or at least from long before anyone started writing about it, the Apaches have made pottery and baskets. The pottery has been almost entirely utilitarian plainware, although in recent years, work by the Jicarilla Apache in northern New Mexico has attracted collector interest.

The baskets are something else, and have been all along. Look at the big prehistoric basket on page 52. It's tightly woven, symmetrical and as sturdy as the finest modern specimen, with as much attention to design as you see in these examples. If it were a twentieth century basket, complete and in good condition, and you wanted to buy it, it'd cost you several thousand dollars.

Like all Indian arts, Apache basketry began as a purely utilitarian craft, and it

flowered as an art form fed by collector's money in the late nineteenth and early twentieth century. It also lost its utilitarian role. Why spend days making a fabulous olla when the trading post sells cheap buckets that do the same thing?

The 1930s depression dried up the collector money, and the employment enjoyed by the industrious Apaches Lockwood admired didn't leave them with enough time or energy to make beautiful large baskets.

Today, Apache artists still make baskets, but they don't make elaborate three-rod coiled ones like these. They confine themselves to easier-to-make twined open-weave burden baskets.

Perhaps someday we'll see more baskets like the ones that made the Apache famous, but we'll have to wait for more leisurely times.

TOP ROW: *Tray, 19½" diameter, ca. 1910; Tray, 17" diameter, ca. 1920.*
BOTTOM ROW: *Bowl, 12¼" diameter, ca. 1920; Bowl 10½" diameter, ca. 1920; Fully beaded miniature cradle basket with doll, 11" long, ca. 1900; olla, 6" high, ca. 1925.*

165

The Barely Noticed

Almost all the Indians who live below the Mogollon Rim in Arizona and New Mexico are Yuman, O'odham or Apache.

The key word is almost. There are other cultures, mostly centered in the northern Sonoran Desert. In the United States, the Yaqui are the most visible, mainly because they have a small but well-publicized reservation near Tucson. Their ancestral home is more than 300 miles south, below Hermosillo on the Sonoran coast, and south of the ancestral home of another Sonoran coastal tribe, the Seri.

The Yaqui lived in a string of eight pueblos along the Yaqui river where it feeds into the Sea of Cortez. A series of floods and a bit of ethnic cleansing by the Mexican government in the late nineteenth century scattered them. A few stayed in the old pueblos, others were deported all the way across Mexico to Yucatan and many others went north along a Southern Pacific feeder line toward the U.S. border.

The ones who made it across got enough attention by 1964 to get the government to establish the 200-acre Pasqua Yaqui Reservation just north of San Xavier del Bac and just west of Tucson. Over the years, they managed to add a bit more land, but land hasn't been the secret of survival for the U.S. Yaquis. Way back in 1983, they dipped their toes into Indian gaming when they opened the Yaqui Bingo Hall. Today, their reservation holdings are still under 2 square miles, but they include two large casinos and an outdoor amphitheater that serves as a venue for concerts by major artists.

Tribal boundaries don't always follow the neat dotted lines on your map. The Yaqui aren't the only binational group. Tohono O'odham live on both sides of the border, as do the Kumeyaay in California and the Cocopa along the Colorado. In an effort to give this book something resembling a balanced overview, we felt compelled to present work by these other tribes, and because the art in this book is mostly pottery, we gathered items as we ran across them.

Instead of a neatly organized array of definitive work, we found ourselves with a small and scattered collection from hard-to-pin-down points along the southern boundary of our Little Chichimeca.

We've been told that the little black jar on the left below is Yaqui from the mid-twentieth century, and it displays a sophisticated technique unlike anything else we've ever seen in our pursuit of Indian pottery. It's perfectly formed, eggshell thin and has a velvety surface that separates it from all other Southwestern blackware.

We have one other piece in this array that we know is Yaqui, perhaps a few years newer than the black jar. It's the polychrome cup at right, which bears no resemblance to the jar. It's thick, polished and decorated in commercial paint like standard Mexican tourist pottery. It's rather like the little red on buff pitcher behind the black jar, and it's very much like the bemusing pitcher to its immediate left. That pitcher looks like a hybrid prehistoric, Salado red in the body and Hohokam red on buff above the neck.

The three "prehistoric" pieces bunched together in the center of the picture raise all kinds of conjecture. Were they made as fakes, or were they simply made and

decorated to be like the remnants the potters found in the area? There's certainly precedent for honest replication. Potters have done it for hundreds of years, and they're still doing it.

The O'odham decorated their pottery with Hohokam designs perhaps as far back as the seventeenth century. Potters at Acoma Pueblo in New Mexico have used designs taken from Tularosa Black-on-white fragments for almost as long. For a more current example,

one only has to look at Mata Ortiz, a town in northern Chihuahua and the subject of this book's next chapter. There, in the 1960s, a man named Juan Quezada looked at Ramos Polychrome fragments from Paquimé and tried to make pots that looked like what he found. What he began evolved into a regional art movement admired all over the world.

Seven pots made somewhere around the border, some time in the last one hundred-plus years. The black one on the left is Yaqui, perhaps made in Arizona, ca. 1950. The little pitcher and the turtle are unidentified, probably made between 1920 and 1960. The three "Hohokam" pieces (the pitcher definitely has a touch of Salado) probably came from the same broad period and were made in northern Sonora. The little polychrome cup is Yaqui, ca. 1960. The big Red-on-buff bowl is 13" in diameter, the little black jar is 3¼".

Meanwhile, Out in California

West of the Colorado and out to the Pacific Ocean, there was virtually no European influence until Portolá and Serra came to call in the 1770s. Compared to other native groups in the Southwest, California Indians had a couple of extra centuries in which to live their lives and pursue their traditional arts and crafts pretty much undisturbed.

Once their grace period ended, and the Europeans made contact, everything changed rapidly. The three left-hand pots below tell an eloquent story. The one on the left is a typical Diegueño (Kumeyaay) water jar. So is the one next to it, but with a big difference. There's a Spaniard on horseback riding across its midbody—an image that, in real life, couldn't have helped but make a giant impression on artists who'd never seen a horse until the Spanish came.

The one to its right is even more remarkable. It's probably earlier than the first two, and it came from closer to the Colorado River. It's a brownware pitcher that the potter strengthened with

what might have seemed a magical design element: rivets, as seen on Spanish armor.

Once Serra began building missions, life changed rapidly. Pottery had already submerged as an art form, but basketry flourished. By the early twentieth century, thanks in no small part to *Ramona* and the books of George Wharton James, collecting "mission" baskets was a national pastime.

These baskets did, in fact, come from groups who were heavily influenced by the missions and by European contact. The Indians on opposite sides of the Colorado River had different attitudes. To the east, the Yumans resisted contact through much of the nineteenth century, while the groups to the west, the Kumeyaay, the Chemehuevi, the Cahuilla and others, were forced into the missions by the Spanish. Eventually, many adopted European dress, spoke Spanish, remained Catholic and worked on Spanish farms and ranches. The Cahuilla became so

comfortable with Spanish life that they fought on the losing side of the 1847 Mexican war.

In *The Cahuilla*, Lowell John Bean and Lisa Bourgeault wrote, "Women made fine coiled baskets for ceremonies and gifts, as well as those used for cooking, storing and serving foods. . . . Basketry drew on Cahuilla women's creativity, and the ability to make fine baskets earned them wealth as well as prestige."

As with the Apache baskets, it was an art form subsidized and encouraged by the collector market, and, as with the Apache baskets, the art took a backseat to survival during the depression years. Today, basketry is coming back, and contemporary southern California basketmakers are starting to produce work that approaches the quality of the ones on the next page.

During the intervening years, Mission Indians had more than baskets to think about. By the 1870s, they had reservation lands and, with their ability to coexist with Europeans, began to blend into Anglo society.

To some extent, Anglos have had to learn to coexist as well. Thanks to reservation boundaries and population growth, the Cahuilla now own a large chunk of Palm Springs.

Tradition and contact, left to right: A traditional eighteenth or early nineteenth century southern California water jar; another one that has a little Spanish horseman riding around its middle; a Cahuilla or Kumeyaay jar that shows a fascination with the rivets on Spanish metalwork; and a Kumeyyay jar from the 1920s. The tallest is 17" high.

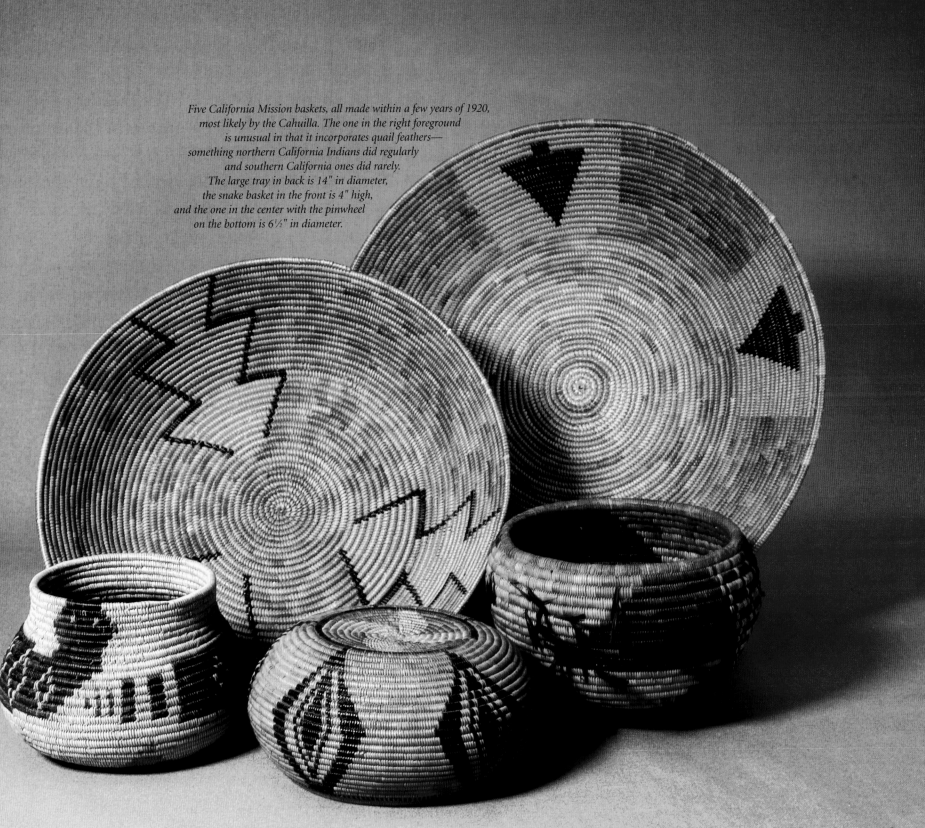

Five California Mission baskets, all made within a few years of 1920, most likely by the Cahuilla. The one in the right foreground is unusual in that it incorporates quail feathers— something northern California Indians did regularly and southern California ones did rarely. The large tray in back is 14" in diameter, the snake basket in the front is 4" high, and the one in the center with the pinwheel on the bottom is 6½" in diameter.

Pottery Survives

During the mission years, pottery virtually vanished west of the Colorado. The Yumans and Mojaves kept making it, but California's Mission Indians were increasingly pushed towards the buckets, pans and crockery of European life.

We saw a Kumeyaay pottery exhibition at the Phoebe Hearst Museum on the University of California Berkeley campus a few years back, and what we remember most was how few examples came from much past the turn of the twentieth century, how large the time gaps were between examples and how few potters were known or represented.

At the time, *Kumeyaay* was a new word to us. It replaced the old mission name Diegueño which lumped the Kamia, Ipai and Tipai California/Mexico border tribes.

The name has been in the Anglo vocabulary for a while. In 1977, Gena Van Kamp wrote a slim, now-rare book called *Kumeyaay Pottery.* The fact that such a book exists at all is remarkable, simply because the Kumeyaay and other southern California Indian groups have been far more concerned with survival than with art.

Sporadic government policies gave them land that couldn't support them, then foreclosed for back taxes. In the 1950s and 1960s, government experiments took Indians off their tribal lands and moved them to multitribal reservations or, worse, to cities, a policy called "termination and relocation."

The blunders weren't confined to the federal government. There have been thousands of words written by hundreds of critics sniping at the policies of the BIA and how they harmed the lives of Indians. There's been relatively little written about what happened when the BIA disappeared from the picture. In 1954, California righted an old wrong and made all Indians California citizens, which created as many problems as it solved. The gesture meant that all California Indians were suddenly thrown into the state welfare system and deprived of BIA services—health care, education and job training. Since no one bothered to tell the Indians how to apply for aid under the new system, most went without services.

California got around to recognizing the problem in 1960 and set up housing and education programs specifically for Indians, but most rancherias were too small to qualify for aid. The only way out was for the tribes to take matters into their own hands, a move that began in the 1960s. The end product was self-advocacy and self-government that today shows up in a new independence, often supported by large casinos. One side effect of this new attitude adjustment was an increased interest in tribal traditions, and along with it, renewed interest in creating tribal art.

For more than a century, California and the U.S. government dealt the Indians lemons. On the next page, you're looking at one way they managed to make lemonade.

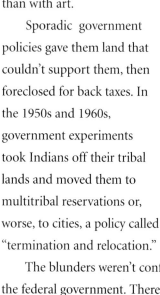

There are still old-style figurines. Here, a 10" long flat Colorado River-style figurine with coffee-bean eyes, made by the Cupeño potter Willie Pink in 1985, flanked by two Mojave-type dolls by Kumeyaay potter and basketmaker Eva Salazar, made in 2000.

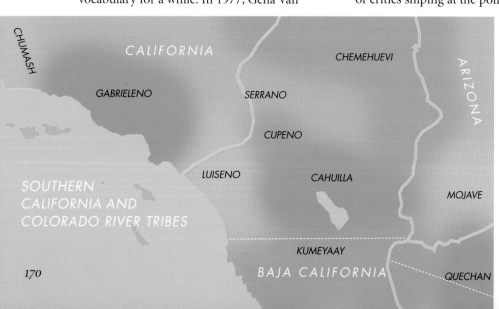

CHUMASH

CALIFORNIA

CHEMEHUEVI

ARIZONA

GABRIELENO

SERRANO

CUPENO

LUISENO

CAHUILLA

MOJAVE

SOUTHERN CALIFORNIA AND COLORADO RIVER TRIBES

KUMEYAAY

BAJA CALIFORNIA

QUECHAN

BACK ROW: *Cupeño, Red-on-buff bowl, Willie Pink, 10" diameter, ca. 1980; Cahuilla, Red-on-buff olla, Tony Soares, 9½" high, 1998.*
MIDDLE ROW: *Kumeyaay, Redware jar, Martina Flores, 8½" diameter, 2001; Kumeyaay, Black-on-buff jar, Kenneth Banks, 6½" diameter, 2001; Kumeyaay, Micaceous jar, Teresa Castro, 5¼" high, 1997; Cupeño, Black-on-red figurine, Willie Pink,* 7¾" *high, 2002; Cahuilla, Redware jar, Tony Soares, 7½" diameter, 1993.*
FRONT ROW: *Cahuilla, Red-on-buff jar, Tony Soares, 3¼" high, 1999; Black-on-red three-spouted jar, probably Kumeyaay, 5¼" diameter, ca. 1920; Kumeyaay, Brownware pitcher, Maricella Castro, 3⅝" high, 1998; Kumeyaay, Brownware doll, Celia Silva, 6-3/4" high, 2001;* *Cahuilla, Red-on-buff jar, Tony Soares, 3½" high, 1999; Kumeyaay, Micaceous wedding vase, Mamuela Aguilar, 4¾" diameter, 1997.*

With one exception, this array represents southern California Indian pottery at the turn of the millennium. The odd Red on black three-spouted jar in the front row *comes from an earlier time and reflects the cross-culturation that existed on either side of the Colorado River before pottery-making virtually disappeared in the second quarter of the twentieth century. Aside from that piece and one 1980 example by the Cupeño potter Willie Pink, it all dates from the mid-1990s and later, including Pink's figurine made in 2002.*

The Casinos

Since Indian gaming became a fact of life, the arguments have continued nonstop. On the one hand, those who disapprove of gambling see the casinos as one of its worst manifestations, in that they not only bring large-scale, Las Vegas–style gambling into the native communities, they bring it right next door to millions of people in major cities who, in earlier days, had to travel to some other state to find it.

The negative social side effects of more accessible gaming are obvious and don't need another repetition. The fact remains that most Indian tribal governments support the casinos, and they have some strong arguments in favor of their position.

A 2002 article in *Native Peoples* magazine quoted Joseph Kalt of the Harvard Project on American Indian Economic Development as saying, "We cannot find a single case in Indian Country when federal planning, programs and management of the reservation economy has produced sustained economic development and social well-being. The only thing that is working is self-determination and self-government. Tribal gaming operations are the epitome of self-determination and self-government."

One thing is certain. Because of gaming, the tribes are building facilities they never would have built otherwise. The Pasqua Yaqui built their Casino of the Sun in the early days of Indian gaming, and it's a nice enough building. Right next door, they built their Administration Center, and it's equally nice. When we last visited, there was an electronic sign in front with rotating messages announcing enrollment in Adult/GED classes, recruiting three-to-five-year-olds for the Head Start program and asking for volunteers for the Foster Care Program.

Behind its impressive facade and trim-looking civic architecture, it overflowed into a city block filled with temporary buildings, each housing another tribal department: behavioral health, auditing and so forth. Meanwhile, in the mid-1990s, the Pasqua

The McKellips Road Casino Arizona on the Salt River Reservation. Its lavish architecture isn't unusual.
Many casinos throughout the desert are equally impressive. About this one, a local resident told us, "Forget the gambling. It's one of the best places in Phoenix to have dinner."

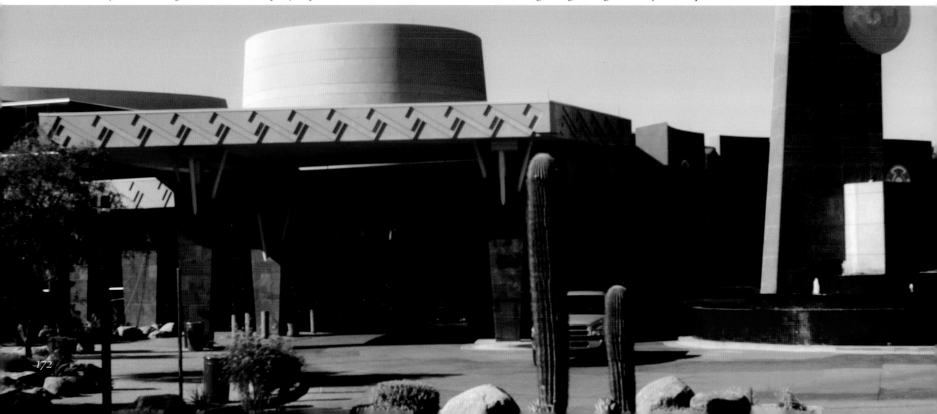

Yaquis built the much larger, more lavish Casino del Sol down the road. On the same visit, we found it undergoing expansion, and we were told that the old casino was slated for destruction. On our next visit, we look forward to finding the administration center housed in a far larger permanent complex, using all the land that once held the Casino of the Sun.

We found similar evidences of progress across the desert. At the Ak Chin Him Dak Museum, we learned that casino monies were supporting health care, education and senior citizens. Up the road at the Hoo-Hoogam-Ki Museum on the Salt River Reservation, we were told a similar story: that casino money helped children and senior citizens, and some of that money came back to their little museum.

These reports weren't unanimous. At a nonprofit arts cooperative on another reservation, we were told that the casinos ignored them and the arts in general, preferring to support only the agencies that the tribal government considered politically important.

This early twenty-first century mini-survey showed us both sides of the issue. There's a huge benefit to the tribes from the money the casinos generate. And there's a clear downside created by the pressures and problems that all that money creates.

We won't understand the full effect of the casinos for years to come. The jury is still out.

Evidences of success, clockwise from top right: the health Clinic on the Pasqua Yaqui Reservation, the Ak Chin Him Dak Museum on the Ak Chin Reservation and the Huhugam Heritage Center on the Gila River Reservation. None could have been built or maintained without significant contributions from the nearby casinos.

6
Mata Ortiz

A remote hamlet in Chihuahua in the shadow of a mountain called El Indio—
a town in transition and a phenomenon the whole world is watching, as it existed in 2003.

Rediscovering Paquimé

THE MATA ORTIZ PHENOMENON is evolving so rapidly that it's almost impossible to stay current. Until recently, it was so far off the beaten path that only the hardy attempted the journey. Now the tour buses come daily.

When we went there in 2003, we were faced with an interminable drive across empty desert on roads spattered with cavernous, tire-eating chuckholes. Once we came to the city of Nuevo Casas Grandes, a few miles northeast of the the ruins of Paquimé, and the commerce center for a 100-mile radius of ranching country in central Chihuahua, we started the hard part of the trip.

Back then, we went past the turnoff to the ruins, then another ten miles to Colonia Juarez, past the big Mormon temple on the hill, across a dry wash without benefit of bridge, and on for 12 unmarked miles on a dirt road. When we crossed the last cattle guard, we'd finally arrived. A year later, there was a new road, built by a

The Pearson Super: reminder of prepottery Mata Ortiz.

French engineering company, and it may be the finest highway in all of Chihuahua. It takes you directly through the burgeoning Casas Grandes cultural area and past the impressive museum at Paquimé.

It took five hundred years for this cultural rebirth to happen. Now it only takes twenty minutes to get from the Paquimé ruins to the little town that brought that rebirth to the world's attention.

After the fall of Paquimé in the fifteenth century, nobody thought much about northern Chihuahua beyond the occasional visiting Apache. It got brief attention in 1864, when Mexican conservatives cut a deal with Napoleon III, brought in French troops, set up the puppet Emperor Maximilian and drove Benito Juarez to El Paso and a government in exile. By 1867, Maximilian and his Empire were gone and Juarez was back in Mexico City.

In the late nineteenth century, far more cattle than people wandered through the hills, mostly the property of Don Luis Terrazas, who built the Hacienda San Diego 6 miles north of what became Mata Ortiz. Despite its magnificence, it was only a minor outpost in his 20,000-square-mile empire.

In 1910, the railroad came through, and a consortium headed by a son-in-law of Don Luis and a Canadian named Pearson built a giant sawmill and a

company town on the site of the present Mata Ortiz. It grew fast and disappeared fast. Don Luis lost his empire to Pancho Villa's raiders, who harassed the new town of Pearson with equal, nonpartisan vigor. In 1925, with the revolution cooled down, Mexican officials built a railroad repair facility and renamed the town after an officer named Juan Mata Ortiz who'd helped General Crook subdue the Apaches forty years earlier. The town did fine until 1960, when the railroad moved the repair work to Nuevo Casas Grandes. By the 1970s, Mata Ortiz was remote, isolated, dirt poor and in the process of drying up and blowing away.

Meanwhile, in the 1950s, Charles Di Peso and the Amerind Foundation had done their excavations at Paquimé, and news of the new interest in pottery had spread through the area. At the same time, down the road in Mata Ortiz, a young boy and future railroad worker named Juan Quezada was already fascinated by the Casas Grandes pottery sherds that littered the area around his hometown.

He reasoned that if people managed to make beautiful pottery hundreds of years earlier, he probably could, too.

The Hacienda San Diego: reminder of presawmill Mata Ortiz.

Juan and Spencer

In 1976, a Princeton-educated anthropologist named Spencer MacCallum found himself in Deming, New Mexico, with some time on his hands. He wandered into Bob's Swap Shop, spotted three excellent and apparently prehistoric pots on a shelf and asked the owner about them.

She told him they weren't prehistoric, they were new, and that some poor people had brought them in to trade for used clothing.

He bought the pots and took them home to California, and the more he looked at them, the more they challenged his curiosity. They were too good to remain unattributed. He wanted to know who made them and where. A month later, he was back in Bob's Swap Shop. The owner had no idea where the pots came from, but suggested he might try Mexico.

Spencer MacCallum is not the kind of man to be satisfied with a vague answer. Armed with pictures of the pots, he went on a quest, crossing the border at Columbus, showing photographs and asking everyone he saw if they knew anything about the potter who made the three pots from Deming. (In *The Miracle of Mata Ortiz*, Walter Parks reports that "everyone" included a shoe-shine boy and the cop who gave him a speeding ticket.)

He kept going south until he'd traveled the 150 miles to Nuevo Casas Grandes, where someone directed him to a potter named Manuel Olivas. Olivas said, no, those weren't his, but he'd gladly make some like them. After more questions, Olivas suggested that he try the town of Mata Ortiz. Spencer braved the dirt roads, which back then were an

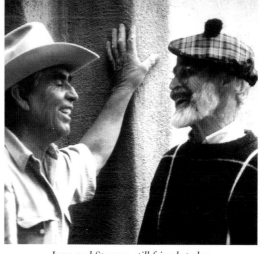

Juan and Spencer, still friends today.

adventure in themselves, asked more questions and finally found his potter, Juan Quezada.

Juan had no idea that any *Norteamericano* could be the least bit interested in what he did, let alone drive a couple of hundred rough miles just to find him. He told Spencer that the pots he had weren't his best work and that he could do better.

Spencer challenged him to do his best and promised to return in two months and buy whatever he made.

Two months later, Spencer came back to find ten pots, none any better than what he'd seen before. But Spencer had brought a photographer, so Juan agreed to be photographed making a pot the next day. With an audience, Juan rose to the occasion and made a pot so quickly and deftly that Spencer knew he'd found a major talent.

He'd also found a unique talent, because no one had taught Juan Quezada how to make beautiful jars in the Ramos Polychrome style. He figured out the process all by himself, through sixteen years of experimentation. He searched the prehistoric irrigation ditches in the nearby hills and brought home sherds, studied them and, through trial-and-error, learned about preparing clay, adding temper, shaping the bases in a bowl, forming the body from a clay doughnut, grinding the local

The kind of pot that caught Spencer's eye. A 12" high olla that Bob and Pat Brown bought in Deming in the early 1970s.

minerals into paints, making paintbrushes from his children's hair and firing with cow chips.

He taught himself well enough that, a year before he met Spencer, he left his railroad job in Nuevo Casas Grandes and began earning a modest living as a potter.

Local traders were buying his pieces, scuffing them up and passing them off as prehistoric. Someone told him about a famous Pueblo potter to the north who signed her work, so he started signing his pots, with the immediate result that sales dropped off.

Sales picked up again when traders took to sanding off the signature. At Spencer's suggestion, Juan started incising instead of painting his signatures, and the idea caught on.

Today, almost every Mata Ortiz potter uses an incised signature.

As he began supporting himself with pottery, Juan began teaching his art to family members. According to Spencer's current memory, ten potters were active in Mata Ortiz in 1976: Juan, five others in Juan's family, a young woman who was taught by Juan and three potters in the nearby barrio of Porvenir with no family connection to Juan.

On Spencer's first few trips, he bought everything Juan produced, but soon saw that by buying it all, he encouraged high production rather than careful work. So instead, he offered Juan a flat $300 a month, removing the financial pressure and allowing

Juan to create anything he pleased, pottery or not. In this new climate of artistic freedom, Juan's work grew finer and more varied, and Spencer turned evangelist, promoting Juan to the world.

By 1978, Spencer had arranged for shows of Juan's pottery at the Heard Museum in Phoenix and at the Arizona State Museum in Tucson, and soon after, Juan and Spencer were doing demonstration tours on both coasts.

When Spencer and Juan ended their financial arrangement in 1983, Juan was on the verge of world fame, and Spencer's seven years of advocacy had brought major recognition to Mata Ortiz pottery. It was now important regional art.

Neither man ever forgot the other. Each changed the other's life forever, and their friendship holds to this day.

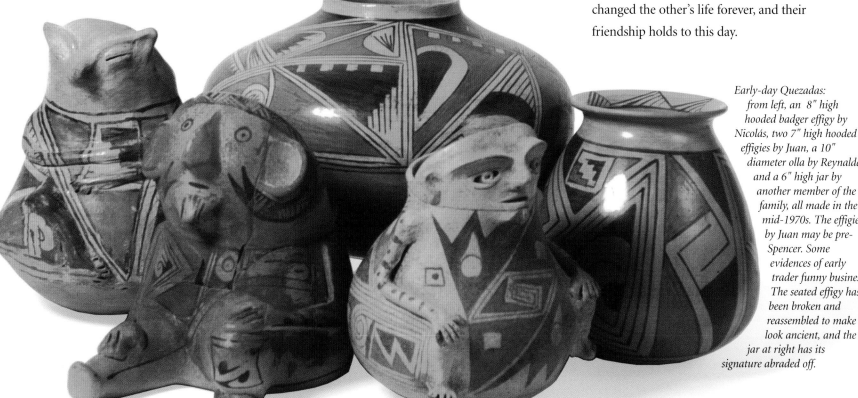

Early-day Quezadas: from left, an 8" high hooded badger effigy by Nicolás, two 7" high hooded effigies by Juan, a 10" diameter olla by Reynalda and a 6" high jar by another member of the family, all made in the mid-1970s. The effigies by Juan may be pre-Spencer. Some evidences of early trader funny business: The seated effigy has been broken and reassembled to make it look ancient, and the jar at right has its signature abraded off.

Contact and Explosion

As his celebrity increased, Juan Quezada caught the attention of the Anglo art establishment. For eight years, starting in 1982, he taught sessions at the Idyllwild School of Music and the Arts, a prestigious institution in the mountains above Palm Springs, sharing teaching time with potters as important as Lucy Lewis of Acoma and Maria Martinez of San Ildefonso.

The rest of the potters in Mata Ortiz were far less celebrated, even though some, especially Juan's sister Lydia and his brothers Reynaldo and Nicolás, were producing work that nearly equaled Juan's. Despite the growth of skills in the tight group of potters surrounding Juan, the number of potters remained small. By 1980, few potters had joined the original group of ten that were working when Spencer MacCallum first met Juan Quezada.

To Spencer and Juan, this didn't compute. The town was poor, jobs were nonexistent, and pottery offered a chance to earn a real living. Spencer thought the fact that few others took up the craft might have been because learning how to do it took too long. With 20/20 hindsight, it seems that it was more a matter of a snowball effect. By 1990, there were perhaps three hundred potters

working in Mata Ortiz, making pots at all levels.

Much of it was made across a wash on the other side of town. Felix Ortiz, one of the original ten and one of the few not taught by Juan, introduced a slightly different and somewhat more forceful design style that his family members and neighbors in the Porvenir barrio took up.

In the mid-to-late 1980s, "Casas Grandes" pottery turned into an industry, and giant retail outlets like the El Paso Saddle Blanket Company in El Paso and Jackalope in Santa Fe (slogan: "Folk art by the truckload") arrayed hundreds of $10 to $25 pots on their shelves, most of them in the Porvenir style.

As Walter Parks describes it in *The Miracle of Mata Ortiz*, the potters had fallen into the trap of lowering their prices in order to make sales and having to increase output in order to make enough money to eat.

Commercial ware from the early 1990s. Clockwise from the top, jars by San Be, 1990; Beto Tena, 1990; Trini Silvera, 1992; and Gerardo Tena, 1991. The big jar is 8½" in diameter.

Whatever the reason, cheap Casas Grandes pottery glutted the market, giving a general impression of a second-class art form, seemingly far inferior to the finer Pueblo pottery produced above the border.

Powerful economic forces in the Southwest lined up to defend against the Mata Ortiz assault. Pueblo potters and dealers felt threatened by blackware with a low two-figure price tag that, to the untrained eye, looked similar to Pueblo pieces that sold for hundreds and sometimes thousands of dollars. In the early 1990s, no self-respecting Santa Fe dealer would be disloyal enough to sell Mata Ortiz pottery.

The prejudice broke down as Mata Ortiz quality lost its derivative Casas Grandes character and became an art form unto itself. By the mid-1990s, prestigious galleries sold high-end Mata Ortiz ware.

The prejudice didn't extend overseas. In 1990, the Bishop of Chihuahua commissioned Juan to make a pot for presentation to the Pope, and a Japanese businesswoman saw a picture of it. Within a few weeks, Juan had a deal giving her first right of refusal on all his pots and all pots made by his children. She intended to build a museum and exhibit them in Japan. The deal fell apart the next year, but the implications were clear. Juan Quezada now belonged to the world, and Mata Ortiz pottery had become a major force in Southwestern art.

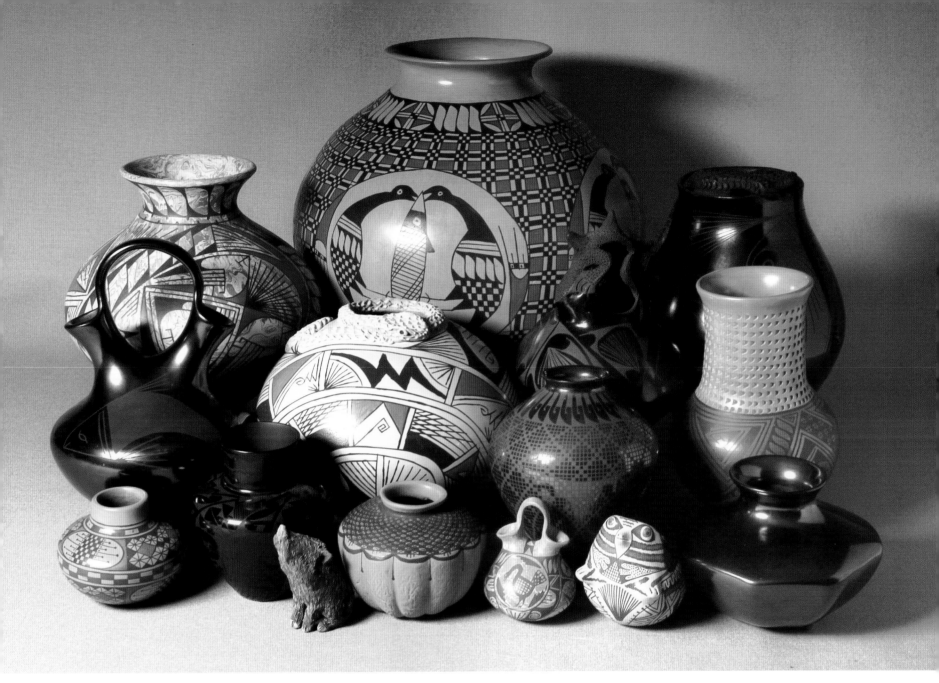

BACK ROW: *Polychrome jar, Oscar Quezada, 7⅛" high, ca. 1994; Polychrome olla, Miguel Bugarini, 11¾" diameter, 1999; Black-on-black lizard effigy jar, José Quezada, 6¾" high, 1997; Black-on-black jar, Rito Talavera, 8¾" high, 1999.*

MIDDLE ROW: *Black-on-black wedding vase, Martín Olivas, 7½" high, 1996; Polychrome lizard jar, Manuela Dominguez, 7¼" diameter, 1998; Black-on-black jar, G. Miguel,*

4¾" high, 1998; Polychrome punctate neck jar, Tavo Silvera, 6¾" high, 1999.

FRONT ROW: *Polychrome jar, Enrique Pedregón Ortiz, 3½" diameter, 1998; Black-on-black jar, Salvador Baca, 4" high, 1999; Blackware javelina figurine, Debi Flanigan, 2¾" high, 1998; Black-on-red jar, Tere Rodriguez, 3⅞" diameter, 1996; Polychrome wedding vase, Anita Trillo, 3¼" high, 1997; Polychrome owl effigy,*

Juan Quezada Jr., 3¼" high, 1997; Gunmetal Blackware jar, José Martínez, 5½" diameter, 1999.

In the 1990s, Mata Ortiz pottery moved towards high art with varying degrees of success. Work ranged from the elegantly simple, like José Martínez's octagonal gunmetal black jar at right front, to the almost painfully intricate, like the black

geometric jar in the middle row at right center. It also ranged from the experimental, like José Quezada's black lizard effigy jar in the back row, to the highly traditional, like Juan Quezada Jr.'s resurrection of the Paquimé hooded effigy in the front row. And it had a few surprises, like Debi Flanigan's endearing matte-finished javelina. And yes, despite the name, she's an authentic married-in Mata Ortiz potter.

The Twenty-First Century

When we visited Mata Ortiz in 2003, we found striking contrasts. There were five hundred potters in the town, all of whom recognized that the whole world knows and wants their work. Well-placed dealers were pushing the prices for Juan Quezada's finer pieces toward the $10,000-and-up category, and other potters like Nicolás Ortiz weren't far behind.

Yet there was no feeling of affluence. The homes had electricity and nicer kitchens, but the streets were still dirt, there were no street lights, and the homes looked on the outside much as they must have thirty years ago. There were no fancy stores, no hospital, no services.

The impressive home built by Juan's son Noé wasn't universally admired within the community. Not that Noé hasn't earned it—he's been a fine potter since the mid-1980s. The problem was that almost every other home in Mata Ortiz looked a lot more like the Pearson Super on page 175 than it looked like the home at right.

Also, not all the potters were getting rich. The 2003 asking price for the elegant little black bottle in the front row on the opposite page was just $10.

Progress: Noé Quezada's new home in Mata Ortiz. Walter Parks called it "the house that pottery built."

The fact that a potter who could do such beautiful work felt she could only ask $10 for it said a lot about how high the standards were getting.

After nearly thirty years of watching Mata Ortiz, concerned *Norteamericanos* set out to help any way they could. Walter Parks and a group of collectors and traders formed the Mata Ortiz Foundation, and they collected enough money to build a library and to finance other needed civic projects.

Since that 2003 visit, Mata Ortiz has been on the move. With the new road in place, more restaurants and galleries have opened, and busloads of tourists come daily.

An exceptional man who grew up in and around Zuni Pueblo in New Mexico has taken on the most ambitious project. Micky Vanderwagen's Dutch immigrant grandfather set up a trading post at Zuni and had more to do with making Zuni jewelry a commercially desirable product than any other man. Micky grew up in the family

Progress: the old sawmill on its way to becoming Micky Vanderwagen's craft center.

business, and as his grandfather neared the end, he pulled the young Micky aside and told him, "I've spent my life trying to get Zuni jewelry into curio shops. I want you to spend yours getting it out of curio shops and into fine jewelry stores."

That task is largely behind him now, and Micky has room in his life for a second project: extending Mata Ortiz art into other forms. He bought the old sawmill and he converted it into a major craft center with equipment for making jewelry, ceramic tiles and more. His goal is to give Mata Ortiz art a broader economic base.

Today, the center is under way and classes are running. Next, we'll be looking for Mata Ortiz jewelry.

To us, the Mata Ortiz phenomenon is a product of every page in this book up to this one. It couldn't have occurred if the Indians who ultimately built Paquimé hadn't built the culture that inspired it. It couldn't have happened without the Spanish and what they did to that culture. And it couldn't have happened without the Anglos, their money, their worldwide communications and their zeal in promoting the art.

If you want to see the culmination of those four thousand years, look at the next page.

BACK ROW: *Polychrome olla, Jorge Quintana, 12" high, 2003; Blackware jar, Reynaldo Quezada, 13¼" high, 2003; Gray-on-red jar, Gloria Hernández, 9½" high, 2002.*

MIDDLE ROW: *White-on-red olla, Ivone Olivas, 13" high, 2003; Black-on-red jar, Yolanda Quezada, 11" diameter, 2003; Polychrome olla, Jorge Quintana, 9¾" high, 2003.*

FRONT ROW: *Black-on-black jar, Aurelia Aldovaz de López, 3½" high, 2003;*

Polychrome seed jar, Adán Villa, 2" diameter, 2001; Gray-on-red dish, Luís López, 5½" diameter, 2001; Polychrome seed jar, Lourdes López, 2½" diameter, 2000; Polychrome gunmetal jar, Jesús Navarete, 4½" high, 1999; Polychrome seed jar, Salvador Baca, 4¼" diameter, 2001; Polychrome jar, Guadalupe Gallegos, 5" high, 1997; Polychrome gunmetal jar, Verónica Ramírez, 5¼" high, 2002.

The common thread between the fourteen pieces below is simple quality. Fineness of finish, fineness of painting, fineness of shape. They're all thin, some so light in weight you're surprised when you pick them up. Their thicknesses are uniform. Their designs vary—abstract or figurative, traditional or innovative, repetitive or random—yet all are instantly recognizable as within the Mata Ortiz tradition. This marks a significant

evolutionary step. During the eighties and into the nineties, some potters borrowed geometric patterns that were already signature designs for famous Pueblo potters. For example, the knifewing you see around the neck of the blackware jar in the middle row on page 179 is characteristic of Maria Martinez's prized blackware from San Ildefonso. Today, the designs of Mata Ortiz stand on their own.

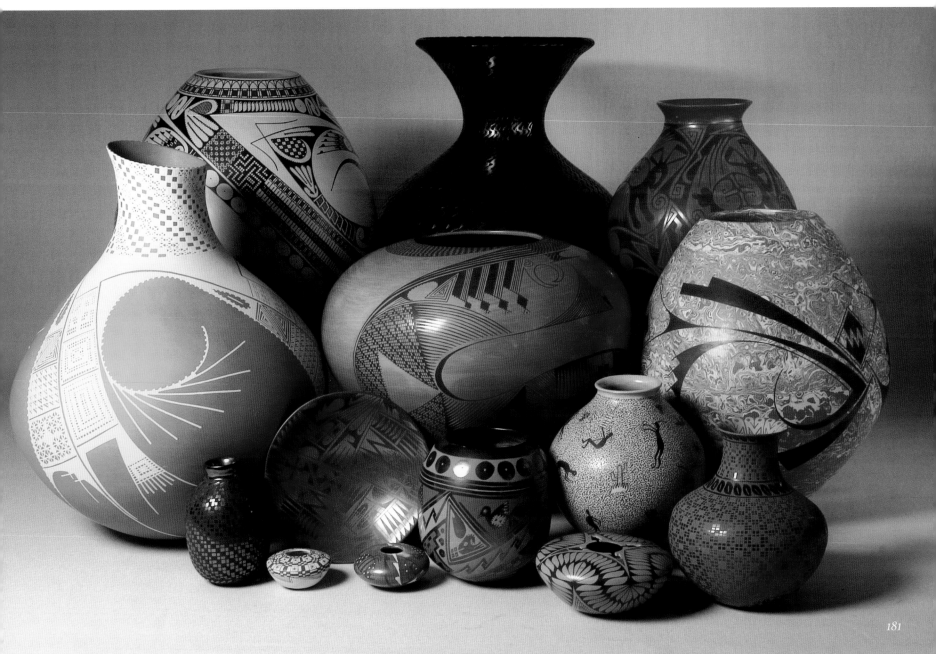

181

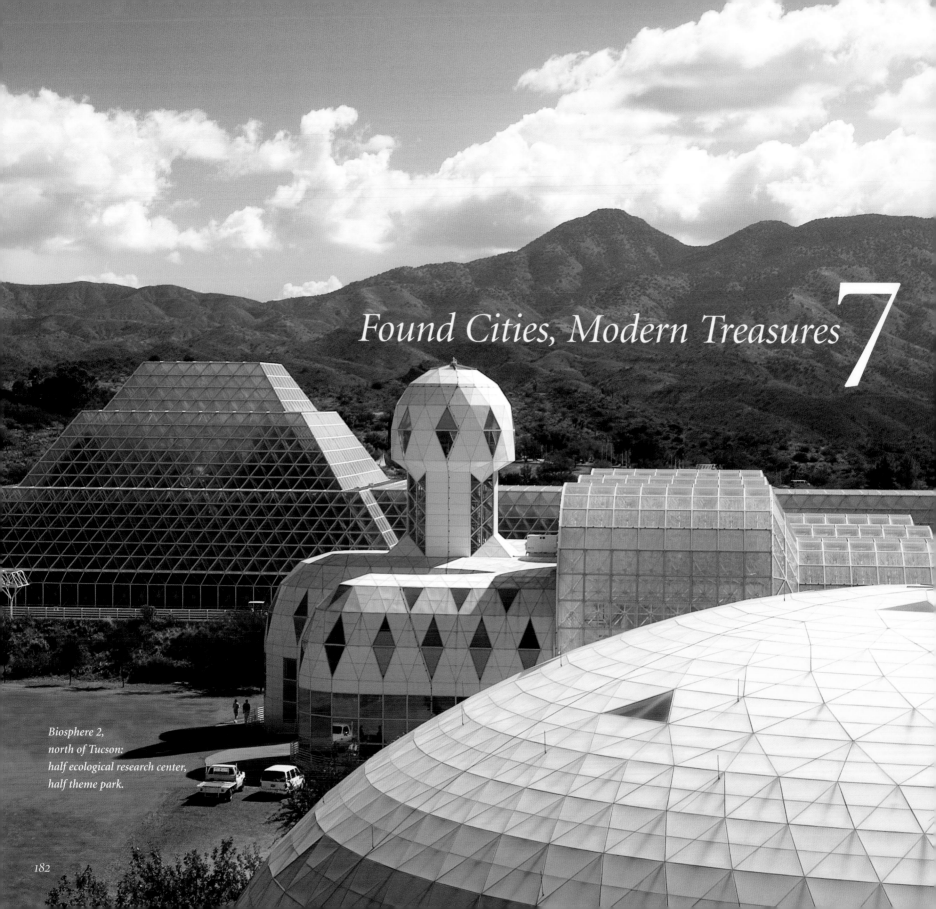

Found Cities, Modern Treasures 7

Biosphere 2,
north of Tucson:
half ecological research center,
half theme park.

FOR THE LAST FEW YEARS, we've been on our own quiet search for the magic land of Aztlan, that legendary home of the Aztecs north in the land of the Chichimecs.

And we think we might have found it, although we never went to the trouble of turning ourselves into birds like the emissaries of the emperor Moctezuma Ihuilcamina had to do in the early 1400s.

It's not that modern air travel has made that drastic step unnecessary. Flying over the desert at 30,000 feet tells you next to nothing. It just tells you that you're looking at the occasional settlement built here and there over miles of wasteland and that some of those settlements are much bigger than you would have guessed. Instead, our search has taken us over thousands of miles on bumpy desert roads that the AAA Western States map doesn't bother showing.

We've learned this much. The secret of the paradise of Aztlan has little to do with the land itself. It has everything to do with the people who chose to live there and with the amazing things they did to make it habitable. For thousands of years, they reclaimed the land, destroyed it and reclaimed it again, only to destroy it again, and there's no indication the cycle is coming to an end.

As we neared completion of this book, we were driving north on Oracle Road through Tucson's ever-expanding urban sprawl when John Blom looked around and mused, "I wonder, will all this still be here in another two hundred years?"

It's a good question, and it doesn't require a long period of deep observation before it springs to mind. It's quite easy for gloom-and-doom ecologists to point out that there simply isn't enough water in the Colorado River and in the underground aquifers to sustain the kind of growth the desert is currently experiencing.

For proof, they can take you to Palm Springs and drive you down Highway 111 through Indian Wells, Rancho Mirage and the other contiguous cities that stretch for 50 miles south. You can look at acres of manicured lawn that stretch as far as you can see, and if you still don't get the message, you can contemplate the water pouring down the gutters whenever the thousands of sprinklers are running.

However, it's also true that the same ecologists were shaking their heads over the

If you don't care for Biosphere 2, try a different kind of theme park. Go visit a black bear in his manmade habitat at the Arizona Desert Museum, also in Tucson.

same things thirty years ago, and somehow the golf courses are still being watered and the swimming pools are still being filled.

It's often said that Mother Nature always wins in the end, and maybe the defiance of that rule is a clue to the true miracle of Aztlan. Somehow, across this desert, her victory seems to be in semipermanent suspension. Perhaps, instead of a Hohokam-style abandonment, the modern residents of Aztlan will continue to find ways to support their proliferation.

John's 200-years-in-the-future might look more like one of those old covers on *Popular Science* magazine that showed us what the world was going to look like in 1980 when we'd all commute to work in our flying automobiles. It may be that the mysterious 411th Avenue exit off I-10, miles west of Phoenix in the uncharted desert, will be as much part of its urban sprawl as 11th Avenue is today. And living may be like Biosphere 2, the photo on the opposite page. (Biosphere 1, in the original plan, represented our own planet. Biosphere 2 was intended to be an alternate environment.)

We offer it as the first of our modern treasures of the desert, and it underscores the paradox. When it opened in 1991, it was offered as a scientific experiment. The idea was that a team of researchers could live within a sealed environment for twenty-four months as proof that the environment could sustain them indefinitely, that the vegetation within the structure would create sufficient oxygen to offset the carbon dioxide exhaled by the inhabitants and that they could create a perfect,

self-sustaining world to serve as a model for future development on this planet, on the moon and everywhere else.

However, it never really was a pure scientific experiment. The project included an adjacent hotel, a full-service restaurarant and gift shops to accomodate the tourists who came to watch the researchers researching.

Also, the experiment didn't work. The building leaked. The oxygen levels dropped. The researchers squabbled, and the increasing air and water pollution ultimately made everyone realize that the sealed world was rapidly becoming uninhabitable. When the first group finished

Urban treasure: San Diego's Balboa Park, relic of a small town's struggle for recognition and now home of five museums and a world-class zoo.

its 1993 tour of duty, no second group followed.

In the late 1990s, the original developers sold it to Columbia University at what we've heard described as fire-sale prices. Now you pay $19.95 and go through it on a guided tour. It's still supposed to serve as a research center, but as of September 2005, it was in business but for sale again and with an uncertain future.

To us, it represents the fantastic nature of much that's happened across the desert. We get the same feeling when we visit Balboa Park in San Diego, the remnants of an idea so ambitious it seems quixotic in retrospect. It's a fabulous facility, and you can spend days exploring its

treasures. It reminds us of visiting the Capitol Mall in Washington. There's not as much there, of course, but it gives you the same feeling of never having enough time to see everything you think you ought to see.

Yet, if anyone had had any common sense at the time, it never would have been built. The then much larger city of San Francisco, recovered from its 1906 earthquake and fire, decided to put on a fair in honor of the opening of the Panama Canal. The struggling town of San Diego, against all odds, decided to go into head-to-head competition and put on its own 1915 Panama-Canal-Opening fair. Somehow, San Diego managed to build something so magnificent that, unlike other great fairs of the twentieth century, its buildings remain standing, still preserved and serving the public as its website claims, and as we mentioned earlier, "America's largest urban cultural center."

Monuments of Arrogance, Cherished

Many of the treasures of the desert happened in much the same way Biosphere 2 and Balboa Park happened. They exist because the people who built them wanted to do something more spectacular and more creative than anything that had gone before, in spite of any realities that might impede their creation.

You see this impulse in the Hohokam canals, in the ruin of Casa Grande, in the mission of San Xavier del Bac, in the giant open pits of the copper mines, in the great dams, in the watered lawns of Palm Springs

and in the each-one-grander-than-the-last casinos springing up among the Indian nations.

It's almost as if there's an underlying drive to prove that, no matter how hostile the land may appear, man can conquer it, ultimately reversing the axiom and defeating nature in the end.

The town of Bisbee in the remote southeast corner of Arizona serves as testimony. A hundred years ago, it was a booming copper complex and an ecological disaster surrounded by dead vegetation. Its massive open pit still yawns in the center of town. By rights, if nature were to win out, it should have been abandoned and allowed to decay when the mining shut down. Instead, it's been gentrified, prettied up and turned into a chic and once again verdant art-and-antiques community with real estate that, in today's dollars, is climbing toward its comparative values when Bisbee was a boom town.

Some of these efforts to conquer the hardships of the land are highly personal. In Phoenix, you can visit Frank Lloyd Wright's Taliesin West, another effort to build a perfect environment. He protected it so ferociously that when he saw a distant power pole encroach on his otherwise unspoiled view in the early 1950s, Wright called President Truman in an effort to have it removed.

After Taliesin, you can drive up I-17 toward Flagstaff and visit the hillside sprawl of architect Paolo Soleri's Arcosante. He built it in the 1970s as an attempt to make what

people who rather disapprove of the idea call an "alternate lifestyle" into a functioning community that could compete and coexist with mainstream society. Like Biosphere 2, it never quite worked, but it struggles on, maintained by loyalists who believe in its message.

Other remarkable places happened as a result of collective effort. Drive a bit farther up I-17, and you come to Sedona, a town first created to capture the magic of a spectacular stretch of red-rock scenery and later to capitalize on the New Age power of the local magnetic vortexes. Everything is there to please tourists and recent arrivals, who can stay in one of its 55 AAA-listed inns and resorts. It's a playground for grownups

revealed through balloon rides and Pink Jeep Tours. Tlaquepaque, a shopping center named after a 450-year-old tourist-attraction suburb of Guadalajara, offers a recreation of a pretty little Mexican village complete with its own miniature mission.

It's unfair, of course, to pick on Sedona, when the prototype for all such efforts exists a bit north and to the west in a much more barren patch of desert.

It's called Las Vegas.

The Attraction As we began this project, we asked a friend why so many people wanted to live in such an unfriendly landscape. He gave us a one-word answer: "Sun."

That's a lot of the truth, and explains why

Remote but hardly undiscovered treasure: Bisbee, home of a dozen or so bed-and-breakfasts in historic buildings and a gigantic, unforgettable open pit from copper-mining days.

the snowbirds flock there in the winter and, depending on their pocketbooks, eventually retire in Sun City or Green Valley or Palm Springs. It's not the whole truth, however. There's something about the desert that infects people who spend enough time in it. Part of it is what seems to be a common denominator in the lifestyle—an easy acceptance of differing attitudes and a strong reluctance to pay attention to anyone who pushes for conformity.

In the desert, you find them all. Indians, Hispanics and Anglos. Asians, Africans and Arabs. Jews, Catholics, Mormons and Presbyterians. Rednecks, Home-Schooling Fundamentalists and Left-Edge Liberals, and few of them seem particularly focused on changing anyone else's point of view.

In other parts of America, Indians rediscovering their Indian-ness is a recent phenomenon. In the desert Southwest, it's never been an issue. Yes, some tribes have turned a bit prickly in their effort to reverse older injustices, but new, less docile behavior shouldn't be confused with an effort to regain identity. They've had it all along.

When we first visited the desert, we felt it was the closest thing to a foreign country we'd ever found within the United States, and, in retrospect, what made us feel that way was its emotional distance from the concerns of mainstream America. When we visit a reservation in Arizona or a Hispanic village in New Mexico, it doesn't take long for white-bread suburbs and urban rage to become irrelevant.

In other parts of America, nobody talks to you if you belong to the wrong church or the wrong gang. Here, for the most part, it's different.

Years of Study There's not another area of the United States that's been examined more thoroughly by archaeologists and anthropologists than the Southwest. In the early nineteenth century, the desert was part of the great American wilderness, and the explorers who put the maps together kept finding things that needed investigation.

When John Wesley Powell went down the Colorado in 1869 and reported his findings back to the Smithsonian, he turned the spigot on what became a constant and ever-increasing flow of research.

Some of it was done by proper academicians, but a great deal of it was done by people like Powell: lightly credentialed or completely uncredentialed amateurs who came in from somewhere else, looked around and became fascinated by what they saw. (We justify our own lack of credentials and our audacity in writing this book by pointing out that we're part of a long-standing tradition.)

Much of what these amateurs accomplished was of lasting value and

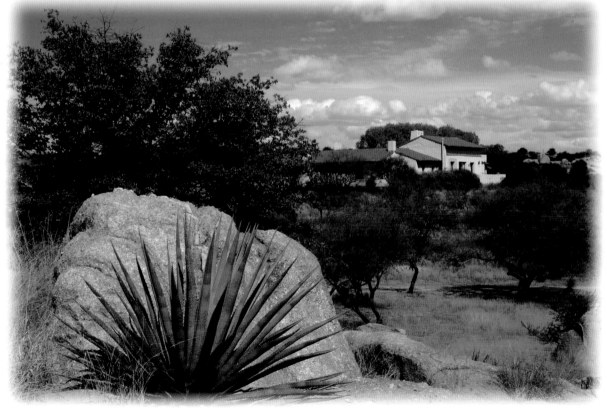

World-famed research center: the Amerind Foundation. In the 1930s, the Fultons left Connecticut, moved to Texas Canyon east of Tucson and let the desert infect their lives forever. This is what happened.

Barely noticed research center: the Museum of the University of Western New Mexico.
In this slightly shabby building on what looks like a backwater campus, an important center for archaeological scholarship.

provided the basis for subsequent research. The Wetherill brothers, cowboy traders, discovered the Anasazi ruins of Mesa Verde in the late nineteenth century, and they measured, cataloged and documented their findings so meticulously that archaeologists still use their journals as primary research.

The amateurs who contributed to scholarship didn't always coexist comfortably with the academic establishment. Edward Curtis, whose photographs serve as the most complete pictorial record of eighty late nineteenth and early twentieth century American tribes and whose formal education ended with grammar school, had little time for what he called "the scientificos." In 1908, he

wrote his editor about Dr. Robert Stewart Culen, the director of the Brooklyn Museum. "You may be able to win him over; certainly if anyone can, it is you, but I fear in attempting to do so you are using good ammunition on small game. The beginning of the good Doctor's critical attitude was from my failing to comprehend his personal deification."

The first important research center in the desert southwest was founded by another amateur. Harold Gladwin was a hobbyist archaeologist who got so deep into his hobby that he sold his seat on the New York Stock Exchange in 1922 and moved west to take up archaeology full time. He met A. V. Kidder, the leading southwestern archaeologist of the day,

and prompted by Kidder, started on the biggest thing around, excavating and restoring the crumbling ruin at Casa Grande.

In 1928, he bought a ruin in Globe, Arizona, and established the Gila Pueblo Archaeological Foundation. Under Gladwin, the Foundation studied the "red on buff" cultures of the Southwest and distinguished between the Hohokam, Mogollon and Salado. Emil Haury went to work there in 1930, and along with Gladwin, conducted the first excavations at Snaketown in 1934.

Another pair of amateur easterners, Harold Colton and his wife, artist Mary-Russell Ferrell Colton, established the Museum of Northern Arizona in Flagstaff in 1928. Colton was trained as a biologist, and he was comfortable with the way biologists classified life forms into phylum, class, order, genus and species. Today, almost all known southwestern pottery has a place in the ware-series-type classification system that Colton developed.

If the Gran Chichimecha has a capitol building, it's The Amerind Foundation, started by yet another of those amateurs. William Shirley Fulton became so entranced with archaeology that he retired from his job as president of the Waterbury Farrell Foundry and Machine Corporation and moved his family, his New England antiques and his horses from Connecticut to the remote ranching settlement of Dragoon, Arizona. Fulton and his wife Rose excavated in Texas Canyon in 1933 and published a paper introducing the "Dragoon Culture" the

Unique treasure: the park at the Gila Cultural Center on the Gila River Reservation south of Phoenix. It features recreations of early habitats. Here, a nineteenth century Akimel O'odham corral.

following year. As had Gladwin and Colton, Fulton hired university-trained assistants, first an archaeology student named Carr Tuthill, who left in 1948 to follow Malcom Rogers at the Museum of Man in San Diego.

After Tuthill, Fulton hired another University of Arizona graduate student, Charles Di Peso, who, in the late 1950s, talked the directors of the Amerind into letting him do a full-scale study of the ruins at Paquimé. The excavations led to his great theory of the Gran Chichimeca, and his definition of it expanded into its full eight-volumes at Fulton's Amerind Foundation.

Where We Ended Up This book began because Carol felt we should write something on the under-researched Indian pottery of southern Arizona. What happened to us was something like what happened to a New Yorker named Alex Shoumatoff when he wrote *Legends of the American Desert* in 1997. Twelve years earlier, he'd started to write a book on water rights in the desert and ended up with a far-ranging anecdotal volume, a twenty-thousand-year romp through an area that stretches from Texas to California and from Colorado to Mexico City. According to the jacket, it travels "from the Biosphere to the Mormons, from the deadly world of narco-traffickers to the secret lives of the covertly Jewish *conversos.*"

Though on a much smaller scale, Shoumatoff's experience, or ours, is not that much different from what happened to Harold Gladwin, the Coltons and the Fultons. The desert has a way of blindsiding you. You think you've found something that helps make what you've seen make sense, and then you turn it over and find something else under it that starts you off in another direction.

We really tried to write a book about Maricopa pottery, but everywhere we looked, we kept finding other stories that demanded to be told.

We found the ancient. We learned about, saw and touched pottery that was twice as ancient as anything anyone knew existed back when we started this book. At one point, it passed through the hands of a publisher whose offices are within walking distance of where the Tucson farmers made that pottery four thousand years ago.

Right alongside the ancient, we found the new and unexpected, and sometimes that new and unexpected was created by contemporary artists using techniques that were old when the oldest items in the book were made.

Did we find Aztlan? Of course we did. It's everywhere across the desert, in a Palm Springs resort, in a high-rise in Phoenix and under a ramada on the Sells Reservation. Then, near the end of our journey, we found what, to us, seems as close to its spiritual center as we'll ever get.

We took a picture of it. It's on the next page.

What goes around comes around. When Akimel O'odham artist Timothy H. Tenny, Jr. made this pendant in 2001, he used exactly the same acid etching technique the Hohokam used to decorate shell jewelry fifteen hundred years ago.

Collection Credits

Much of the material in this book, including many of the prehistoric items, is from the collections of Allan and Carol Hayes and John and Brenda Blom. This points directly to the concern that many sincere, informed people have about the private collection of prehistoric artifacts. A 1999 pamphlet from the Southwestern Parks and Monuments Association stated one side of the issue: "Ancient pottery and other artifacts give us valuable knowledge about the past. Federal, state, and local laws protect these artifacts and prohibit people from collecting them. For your own protection, do not remove any sherds or other materials you may find and do not attempt to buy any ancient ceramics. You may be prosecuted, imprisoned, and fined up to $20,000."

This is all true. However, as legal, moral and practical advice, it falls somewhere between "Never exceed the posted speed limit" and "Do not remove this tag." There are thousands of prehistoric pots in private collections that were bought and sold legally and openly, and excavation of prehistoric pottery for sale is still conducted legally on private land in Arizona and New Mexico.

It's also conducted illegally, even on private land, and gravesites are still being desecrated. Archeologists and law enforcement officials wage a constant battle against looting and don't have to look far to justify their assault. One example: The three-hundred-room Garcia Ruin on the Arizona-New Mexico border has been mined to the point of obliteration, both legally and illegally.

The true warning is this: Don't bypass the system. People still sell illegal pots. If you buy a prehistoric item, buy it from a reputable dealer on the open market, pay by check or credit card, and insist on a receipt and a document that tells how it was obtained. Buy it in a formal transaction, don't accept any excuse for not providing proper paperwork, and perhaps most important, don't buy it unless it feels right, because there's still a good chance it isn't. Once you buy it, you're legally responsible.

Materials and images from other sources

Frontispiece, 7th from left: *Apache olla courtesy of Sandra Horn, Mill Valley, California*

Page vi: *O'odham women postcard courtesy of Jerry Weisberg, El Cerrito, California*

Page 12: *artifacts courtesy of Jonathan Mabry and Desert Archeology, Inc., Tucson*

Page 13: *Arizona Historical Society, Tucson PC111-95636-P17*

Page 33: *Large jar and bowl at left courtesy of Bob Brown, Silver City, New Mexico*

Pages 34–35: *all courtesy of the Deming-Luna Museum, Deming, New Mexico*

Pages 39–43: *the following pieces are courtesy of the Babcock Collection, on loan to the Marin Museum of the American Indian, Novato, California. Page 39, badger effigy and Playas Incised jar at right front. Page 40, Ramos Polychrome jar. Page 41, Ramos Polychrome jar in back row and Escondida and Ramos Polychrome pieces at left of middle row. Page 43, Escondida Polychrome jars at top right and second from right, front row.*

Page 46: *courtesy of Gran Quivira National Monument, New Mexico*

Page 47: *all except bowl second from right in middle row courtesy of Forrest Fenn, Santa Fe*

Page 49: *photo courtesy of Bureau of Land Management*

Page 50: *photo by Claire Demaray*

Page 51: *all courtesy of the Imperial Valley College Desert Museum, Ocotillo, California*

Page 52: *courtesy of Forrest Fenn, Santa Fe*

Page 53: *Arizona Historical Society, Tucson 8138 (detail)*

Page 64–65: *courtesy of Arizona Historical Society, Tucson*

Pages 72–73: *courtesy of Ned and Jody Martin. Photo on page 72 by Ned Martin.*

Page 74: *Arizona Historical Society, Yuma*

Page 77: *silver tureen courtesy of Arizona Historical Society, Tucson*

Page 78: *Arizona Historical Society, Tucson 41147*

Page 79: *California Historical Society, North Baker Research Library, Templeton Crocker Collection TN-0341*

Page 81: *Arizona Historical Society, Tucson*

Pages 82–83: *camel painting and map courtesy of Arizona Historical Society, Tucson*

Page 87: *Arizona Historical Society, Tucson*

Page 89: *reproduced by permission of The Huntington Library, San Marino CA (detail)*

Page 90: *Sibley, courtesy Museum of New Mexico negative 49201, Chivington, courtesy Museum of New Mexico negative 9829*

Page 92: *Carleton, Arizona Historical Society 41550 (detail), "We are all right" illustration, Arizona Historical Society*

Page 93: *Arizona Historical Society, Tucson, Carson 41547, Apaches 46806*

Page 95: *Security Pacific Collection/Los Angeles Public Library*

Page 97: *Arizona Historical Society, Tucson 50981*

Page 99: *photographs of historic Tombstone scenes, Arizona Historical Society, Tucson, Parade 538, Ball Team 3783, Cafe 18339, rephotographed by John Blom*

Page 100: *Switch, Arizona Historical Society, Tucson*

Page 101: *Tucson train, Arizona Historical Society, Tucson*

Page 103: *Arizona Historical Society, Tucson 30412*

Page 104: *rifle courtesy of Arizona Historical Society, Tucson, portraits (all details) Arizona Historical Society, Tucson, Geronimo 30374, Victorio 30371, Naiche 25635, Crook 24850*

Page 105: *Arizona Historical Society, Tucson*

Page 106: *Ramona courtesy of Margot Timberlake, Kentfield, California, George Wharton James book courtesy of Sandra Horn, Mill Valley California*

Page 108: *poster, Buffalo Bill Historical Center, Cody WY 1.69.50, Billy, Arizona Historical Society, Tucson 11882 (detail)*

Page 110: *Arizona Historical Society, Tucson 20656*

Page 111: *Arizona Historical Society, Tucson*

Pages 112–113: *Arizona Historical Society, Tucson*

Page 117: *Arizona Historical Society, Tempe 75.37.142*

Page 118: *Arizona Historical Society, Tucson, Swilling 18127 (detail), Ramada church 588*

Page 119: *Arizona Historical Society, Tempe 79.95.134*

Page 121: *old car image, Arizona Historical Society, Tucson 61143*

Page 122: *Security Pacific Collection/Los Angeles Public Library*

Page 124: *Powell, Arizona Historical Society, Tucson 49893 (detail), Cushing, James W. Black photo courtesy Museum of New Mexico negative 9147 (detail), Lummis, by permission of The Huntington Library, San Marino CA (detail)*

Page 127: *courtesy of Pancho Villa State Park, Columbus, New Mexico*

Pages 130–131: *courtesy of Arizona Historical Society, Tucson*

Page 133: *courtesy of White Sands Missile Range*

Page 146: *historic painting courtesy of Arizona Historical Society, Tucson*

Page 154: *burden basket courtesy of Arizona Historical Society, Tucson*

Pages 154–155: *basket grouping courtesy of Rick and Mary Beth Rosenthal, Morning Star Traders, Tucson*

Page 161: *Juanita Antone jar in middle row courtesy of Victor Ochoa, Casa Grande, Arizona*

Page 164: *Olla at left courtesy of Sandra Horn, Mill Valley, California*

Pages 164–165: *basket grouping courtesy of John Rauzy, Orangevale, California except for small olla on right, courtesy of Jerry Weisberg, El Cerrito, California*

Page 168: *the two jars on the left are courtesy of the Heritage of the Americas Museum, El Cajon, California. The jar second from right is courtesy of the Imperial Valley College Desert Museum, Ocotillo, California.*

Page 169: *basket grouping courtesy of Sandra Horn, Mill Valley, California*

Page 174: *Photograph of Spencer MacCallum and Juan Quezada by Sara Taft. Juan Quezada jar courtesy of Bob Brown, Silver City, New Mexico*

Page 175: *Juan Quezada hooded effigy at left, Reynalda Quezada jar and smaller unattributed jar courtesy of Don Colby, Rohnert Park, California*

Page 177: *jar by Trini Silvera courtesy of Mark Hayes, San Francisco*

Page 178: *Rito Talavera jar in back row, jars by G. Miguel and Tavo Silvera in middle row and jars by Enrique Pedregón Ortiz, Salvador Baca and José Martinez in the front row courtesy of Mark Hayes, San Francisco*

Page 179: *jar by Gloria Hernandez in the back row and dish by Luis López, seed jars by Adán Villa, Lourdes López and Salvador Baca and jar by Verónica Ramirez courtesy of Mark Hayes, San Francisco*

Page 194: *Sally Havier photo courtesy of Victor Ochoa*

Page 198: *Arizona Historical Society, Yuma*

NOTE: Images from Arizona Historical Society negatives have A.H.S. file numbers. Arizona Historical Society images without file numbers were photographed by John Blom.

Bibliography

Alvarez de Williams, Anita, *The Cocopah People*, Phoenix, Indian Tribal Series, 1974

————*Travelers Among the Cucapá*, Los Angeles, Dawson's Book Shop, 1975

Bakker, Elma and Richard G. Willard, *The Great Southwest: The Story of the Land and Its People*, Palo Alto CA, American West Publishing, 1972

Barry, John W., *American Indian Pottery, 2nd Edition*, Florence AL, Books Americana, 1984

Barstad, Jan, *Hohokam Pottery*, Tucson, Southwest Parks and Monuments Association, 1999

Bean, Lowell John and Lisa Bourgeault, *The Cahuilla*, New York, Chelsea House, 1989

Bee, Robert L., *The Yuma*, New York, Chelsea House Publishers, 1989

Beebe, Rose Marie and Robert W. Senkewicz (editors), *Lands of Promise and Despair: Chronicles of Early California, 1535–1846*, Santa Clara CA, Santa Clara University and Heyday Press, Berkeley CA, 2001

Benson, Arlene, *The Noontide Sun: The Field Journals of the Reverend Stephen Bowers, Pioneer California Archaeologist*, Menlo Park CA, Ballena Press, 1997

Bolton, Herbert Eugene, *The Padre on Horseback*, San Francisco, The Sonora Press 1932, reissued by The Friends of the Bancroft Library, 1976

————*Rim of Christendom, A Biography of Eusebio Francisco Kino*, New York, The Macmillan Company, 1936

Bourke, John G., *An Apache Campaign in the Sierra Madre*, New York, Charles Scribner Sons, 1958

Boyle, Robert H., "Life or Death—for the Salton Sea?" *Smithsonian*, Volume 27, Number 3, Washington DC, June 1996

Breazeale, J.F., *The Pima and His Basket*, Tucson, Arizona Historical Society, 1923 (modern reprint, N.D.)

Cahill, Rick, *The Story of Casas Grandes Pottery*, Tucson, Boojum Books, 1991

Chávez, Thomas E., *Quest for Quivira: Spanish Explorers on the Great Plains, 1540–1821*, Tucson, Southwest Parks and Monuments, 1992

Choate, H.S., *The Yaqui: A Celebration*, San Francisco, Whitewing Press, 1997

Clark, Jeffery J., *Tracking Prehistoric Migration: Pueblo Settlers Among the Tonto Basin Hohokam*, Tucson, University of Arizona Press, 2001

Colton, Harold S., Robert Euler, Henry Dobyns and A.H. Schroeder, *Pottery Types of the Southwest Museum of Northern Arizona Ceramic Series No. 3D*, Flagstaff AZ, Society of Science and Art, 1958

Cordell, Linda S. and George J. Gumerman, *Dynamics of Southwest Prehistory*, Washington DC, Smithsonian Institution Press, 1989

Crown, Patricia L., *Ceramics & Ideology: Salado Polychrome Pottery*, Albuquerque, University of New Mexico Press, 1994

Cushing, Frank Hamilton, edited by Jesse Green, *Cushing at Zuni: The Correspondence and Journals of Frank Hamilton Cushing, 1879–1884*, Albuquerque, University of New Mexico Press, 1990

————*My Adventures in Zuñi*, Palmer Lake CO, Filter Press, 1967 (reprinted from articles in Century Magazine, 1882–1883)

Davis, Nancy Yaw, *The Zuni Enigma*, New York, W.W. Norton & Co., 2000

Deuel, Leo, *Conquistadors Without Swords: Archeologists in the Americas*, New York, Schocken Books, 1967

Margolin, Malcom, *Life in a California Mission, Monterey in 1786: The Journals of Jean François de La Pérouse*, Berkeley CA, Heyday Books, 1989

de Madariaga, Salvador, *The Rise of the Spanish American Empire*, New York, The Free Press, 1947

DeWald, Terry, *The Papago Indians and Their Basketry*, Tucson, Terry DeWald, 1979

Di Peso, Charles C. *The Amerind Foundation*, Dragoon AZ, The Amerind Foundation, N.D.

————, John B. Rinaldo and Gloria J. Fenner, *Casas Grandes: A Fallen Trading Center of the Gran Chichimeca*, 8 volumes, Flagstaff AZ, Northland Press, 1974

———— and Spencer Heath MacCallum, *Juan Quezada and the New Tradition*, Washington DC, National Endowment for the Arts, 1979

Dittert, Alfred E. and Fred Plog, Generations in Clay: Pueblo Pottery of the American Southwest, Flagstaff AZ, Northland Publishing, 1980

Dobyns, Henry F., *The Pima-Maricopa*, New York, Chelsea House Publishers, 1989

Dutton, Bertha P., *Indians of the American Southwest*, Englewood Cliffs NJ, Prentice-Hall, 1975

Evans, Roy H., R. Evelyn and Lyle Ross, *Mimbres Indian Treasure in the Land of Baca*, Kansas City, The Lowell Press, 1985

Fane, Diana, Ira Jacknis and Lise M. Breen, *Objects of Myth and Memory: American Indian Art at the Brooklyn Museum*, Seattle, The University of Washington Press, 1991

Faulk, Odie B., *Arizona, A Short History*, Norman OK, University of Oklahoma Press, 1970

Feest, Christian F. (editor), The Cultures of Native North Americans, Cologne, Germany, Könemann Verlagsgesellschaft mbH, 2000

Fehrenbacher, Don E. and Norman E. Tutorow, *California: An Illustrated History*, New York, D. Van Nostrand Company, 1968

Fields, Virginia M. and Victor Zamudio-Taylor (editors), *The Road to Aztlan: Art from a Mythic Homeland*, Los Angeles, Los Angeles County Museum of Art, 2001

Fontana, Bernard, William C. Robinson, Charles W. Cormack and Ernest E. Leavitt, Jr. *Papago Indian Pottery*, Seattle, University of Washington Press, 1962

Fritz, Gordon L. *The Ecological Significance of Early Piman Immigration to Southern Arizona*, Tucson, unpublished thesis, 1977

Fulton, William Shirley and Carr Tuthill, *An Archeological Site Near Gleeson, Arizona*, Dragoon AZ, The Amerind Foundation, 1940

Furst, Jill Leslie, *Mojave Pottery, Mojave People: The Dillingham Collection of Mojave Ceramics*, Santa Fe, School of American Research Press, 2001

Garrard, Lewis H., *Wah-To-Yah & the Taos Trail*, Palo Alto CA, American West Publishing Company, 1968

Giametti, Victor Michael and Nancy Greer Reichert, *Art of a Vanished Race: The Mimbres Classic Black-on-White*, Silver City NM, Dillon-Tyler Publishers, 1975

Gilbert, Bill (editor), *The Potters of Mata Ortiz: Transforming a Tradition*, Albuquerque, University of New Mexico Art Museum, 1995

———*The Potters of Mata Ortiz: Five Barrios, Seven Families*, Albuquerque, University of New Mexico Art Museum, 1999

Gibson, Daniel, "Indian Gaming: Transforming Native Life," *Native Peoples Art and Lifeways*, Volume 15, Number 6, Phoenix, Media Concepts Group, 2002

Graybill, Florence Curtis and Victor Boesen, *Edward Sheriff Curtis: Visions of a Vanishing Race*, New York, American Legacy Press, 1976

Gregonis, Linda M. and Karl J. Reinhard, *Hohokam Indians of the Tucson Basin*, Tucson, University of Arizona Press, 1979 (4th printing 1988)

Grey, Zane, *To the Last Man*, New York, Grosset & Dunlap, 1922

Haury, Emil W., *The Hohokam, Desert Farmers and Craftsmen: Excavations at Snaketown 1964-1965*, Tucson, University of Arizona Press, 1976

Hawley, Florence M., *Field Manual of Southwestern Pottery Types*, Bulletin No. 291, University of New Mexico, Albuquerque, University of New Mexico Press, 1936

Hayes, Alden, *Excavation of Mound 7, Gran Quivira National Monument*, New Mexico, National Park Service, U.S. Department of the Interior, Washington DC, U.S. Government Printing Office, 1981

Hayes, Allan and Blom, John, *Collections of Southwestern Pottery*, Flagstaff AZ, Northland Publishing, 1998

———*Southwestern Pottery: Anasazi to Zuni*, Flagstaff AZ, Northland Publishing, 1996

Hays-Gilpin, Kelley and Eric van Hartesveldt, *Prehistoric Ceramics of the Puerco Valley*, Museum of Northern Arizona Ceramic Series #7, Flagstaff AZ, Museum of Northern Arizona, 1998

Hazen-Hammond, Susan and John Hart, "Jesuit Missionaries," *Arizona Highways*, Volume 73, Number 12, Phoenix, December 1997

Heckman, Robert A., Barbara K. Montgomery and Stephanie M. Whittlesey, *Prehistoric Painted Pottery of Southeastern Arizona*, Tucson, SRI Press, 2000

Hickerson, Nancy Parrott, *The Jumanos: Hunters and Traders of the South Plains*, Austin, University of Texas Press, 1994

Hodge, Frederick Webb (editor), *Handbook of American Indians North of Mexico*, Washington DC, U.S. Printing Office, 1912

Hohenthal, William D., Jr., *Tipai Ethnographic Notes: A Baja California Indian Community at Mid-Century*, Novato CA, Ballena Press, 2001

Hollon, W. Eugene, *The Southwest: Old and New*, Lincoln NE, University of Nebraska Press, 1961

Johnson, Paul C., *Pictorial History of California*, New York, Bonanza Books, 1970

Josephy, Alvin M. Jr., (editor), *The American Heritage Book of Indians*, New York, American Heritage Publishing, 1961

Kennedy, John G., *The Tarahumara*, New York, Chelsea House Publishers, 1990

Kopper, Philip, *The Smithsonian Book of North American Indians Before the Coming of the Europeans*, Washington DC, Smithsonian Books, 1986

Kroeber, A.L. and Michael J. Harner, *Mohave Pottery*, Anthropological Records, Volume 16, Number One, Berkeley, University of California Press, 1955

Kroeber, Clifton B. and Bernard L. Fontana, *Massacre on the Gila*, Tucson, University of Arizona Press, 1986

Lacy, Alberto Ruy Sánchez, Beatriz Braniff Cornejo, Walter P. Parks, Spencer H. MacCallum, Bill Gilbert, Marta Turok and Jim Hill, *Ceramica de Mata Ortiz*, Colonia Roma, D.F., Mexico, Artes de Mexico No. 45, 1999

La Farge, Oliver, *A Pictorial History of the American Indian*, New York, Crown Publishers, 1956

Lavender, David, *California: A Bicentennial History*, New York, W.W. Norton & Co., 1976

LeBlanc, Steven A., *Prehistoric Warfare in the American Southwest*, Salt Lake City, University of Utah Press, 1999

Lekson, Stephen H., *Mimbres Archaeology of the Upper Gila, New Mexico*, Tucson, University of Arizona Press, 1990

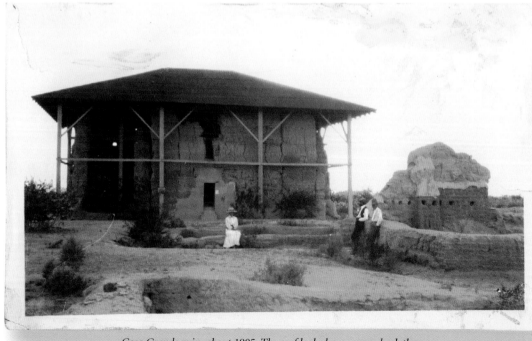

Casa Grande ruin, about 1905. The roof looked even worse back then.

Lemke, Nancy, *Missions of the Southern Coast*, Minneapolis, Lerner Publications, 1996

Lewis, Oscar, The Big Four: *The Story of Huntington, Stanford, Hopkins, and Crocker, and of the Building of the Central Pacific*, New York, Alfred A. Knopf, 1938

Lister, Robert H. and Florence C. Lister, *Anasazi Pottery*, Albuquerque, Maxwell Museum of Anthropology, 1978

Lockwood, Frank C, *The Apache Indians*, Lincoln NE, University of Nebraska Press, 1987 (originally published New York, The Macmillan Co., 1938)

Lowell, Susan, Jim Hills, Jorge Quintana Rodriguez, Walter Parks and Michael Wisner, *The Many Faces of Mata Ortiz*, Tucson, Treasure Chest Books, 1999

Lummis, Charles R., *General Crook and the Apache Wars*, Flagstaff AZ, Northland Press, 1985

MacCallum, Spencer Heath, "Pioneering an Art Movement in Northern New Mexico: The Potters of Mata Ortiz," *Kiva* 60 No. 1, Tucson, Arizona Archeological and Historical Society, 1994

MacMillan, Dianne, *Missions of the Los Angeles Area*, Minneapolis, Lerner Publications Company, 1996

Martin, Douglas D., *Yuma Crossing*, Yuma AZ, The Yuma Crossing Press, 1995 (originally published by the University of New Mexico Press, 1954)

Martin, Paul S. and Elizabeth S. Willis, *Anasazi Painted Pottery in Field Museum of Natural History*, Amthropology Memoirs, Field Museum of Natural History, Volume 5, Chicago, Field Museum of Natural History, 1940 (facsimile reprint)

McNamee, Gregory, *Gila: The Life and Death of an American River*, Albuquerque, University of New Mexico Press, 1994

Mednick, Christina Singleton, *San Cristóbal: Voices and Visions of the Galisteo Basin*, Santa Fe, Office of Archaeological Studies, Museum of New Mexico, 1996

Meinig, D.W., *Southwest: Three Peoples in Geographical Change, 1600–1970*, New York, Oxford University Press, 1971

Moulard, Barbara L., *Within the Underworld Sky: Mimbres Ceramic Art in Context*, Pasadena, Twelvetrees Press, 1984
——— *Recreating the Word, Painted Ceramics of the Prehistoric Southwest: The Bill Schenck Collection*, Santa Fe, Schenck Southwest Publishing, 2003

Murphy, Dan, *Salinas Pueblo Missions*, Southwest Parks and Monuments Association, Salt Lake City, Lorraine Press, 1993

Nelson, Margaret C., *Mimbres During the Twelfth Century: Abandonment, Continuity, and Reorganization*, Tucson, The University of Arizona Press, 1999

Noble, David Grant (editor), *The Hohokam, Ancient People of the Desert*, Santa Fe, School of American Research Press, 1993
——— (editor), *Zuni El Morro, Past & Present*, Santa Fe, Exploration (School of American Research Annual Bulletin), 1983
——— *Salinas: Archaeology, History, and Prehistory*, Santa Fe, Ancient City Press, 1982 (originally published by School of American Research, 1982)

O'Crouley, Don Pedro Alonso, *The Kingdom of New Spain.* translated and edited by Seán Galvin, San Francisco, John Howell Books, 1972

Parks, Walter P., *The Miracle of Mata Ortiz: Juan Quezada and the Pottery of Northern Chihuahua*, Riverside CA, The Coulter Press, 1993

Peckham, Stewart, *From This Earth: The Ancient Art of Pueblo Pottery*, Santa Fe, Museum of New Mexico Press, 1990

Pourade, Richard F., *Gold in the Sun*, San Diego, sandiegohistory.org (originally published San Diego, Copley Press, 1965)
——— *The Rising Tide*, San Diego, sandiegohistory.org (originally published San Diego, Copley Press, 1967)
——— *The Silver Dons*, San Diego, sandiegohistory.org (originally published San Diego, Copley Press, 1963)

Prehistoric Cultures of the Southwest: Anasazi, Hohokam, Mogollon, Salado and Sinagua (series of five pamphlets) Tucson, Southwest Parks and Monuments Association, 1992

Rawls, James J., *Indians of California: The Changing Image*, Norman OK, University of Oklahoma Press, 1984

Reid, Betty, "At the age of seven, Betty Reid saw the sun set on her Navajo life," Gallup NM, *The Indian Trader*, July 1997 (reprinted from *Arizona Republic* ©1997)

Reid, Jefferson and Stephanie Whittlesey, *The Archeology of Ancient Arizona*, Tucson, The University of Arizona Press, 1997

Ryerson, Scott H. "The Potters of Porvenir: The Lesser-Known Artisans of Mata Ortiz," *Kiva* 60 No. 1, Tucson, Arizona Archeological and Historical Society, 1994

Schaaf, Gregory, *Ancient Ancestors of the Southwest*, Santa Fe, Graphic Arts Center Publishing, 1996

Sheridan, Thomas E., *A History of the Southwest: The Land and Its People*, Tucson, Southwest Parks and Monuments Association, 1998

Shoumatoff, Alex, *Legends of the American Desert*, New York, Knopf, Inc., 1997

Smith, Gerald A. *The Mojaves*, San Bernardino CA, The San Bernardino County Museum Association, reprinted 1977

Snow, Dean R., *The Archeology of North America*, New York, Philadelphia, Chelsea House Publishers, 1989

Spier, Leslie, *Yuman Tribes of the Gila River*, Chicago, University of Chicago Press, 1933, reprinted New York, Dover Publication Inc., 1978

Stoeppelmann, Janet and Mary Fernald, *Dirt for Making Things: An Apprenticeship in Maricopa Pottery*, Flagstaff AZ, Northland Publishing, 1995

Stuhr, Joanne (editor), *Talking Birds, Plumed Serpents and Painted Women: The Ceramics of Casas Grandes*, Tucson, Tucson Museum of Art, 2002

Stuart, David E., *The Magic of Bandelier*, Santa Fe, Ancient City Press, 1989

Thomas, Bob, "Prehistoric Fortress of the Desert," Phoenix, *Arizona Highways*, November 1997

Trimble, Marshall, *Arizona: A Cavalcade of History*, Tucson, Treasure Chest Publications, 1989

Underhill, Ruth M., *The Papago (Tohono O'odham) and Pima Indians of Arizona*, Palmer Lake CO, Filter Press, 2000 (originally published as *The Papago Indians and Their Relatives, the Pima*, U.S. Bureau of Indian Affairs, Washington DC, 1941)

Walker, Dale L., *Bear Flag Rising: The Conquest of California, 1846*; New York, Tom Doherty Associates, 1999

Ward, Geoffrey C., *The West: An Illustrated History*, Boston, Little, Brown & Company, 1996

Whalen, Michael E. and Paul E. Minnis, *Casas Grandes and Its Hinterland: Prehistoric Regional Organization in Northwest Mexico*, Tucson, The University of Arizona Press, 2001

Wheeler, Mark, "California Scheming," *Smithsonian*, Volume 33, Number 7, Washington DC, October 2002

Whittlesey, Stephanie (editor), *Sixty Years of Mogollon Archaeology: Papers from the Ninth Mogollon Conference*, Tucson, SRI Press, 1999

Wood, J. Scott, *Checklist of Pottery Types for the Tonto National Forest*, Phoenix, Arizona Archeological Society, 1991

Woosley, Anne I. and Allan J. McIntyre, *Mimbres Mogollon Archeology*, Amerind Foundation, Inc., Albuquerque, University of New Mexico Press, 1996
——— and John C. Ravesloot (editors), *Culture and Contact: Charles C. Di Peso's Gran Chichimeca*, Albuquerque, University of New Mexico Press, 1993

Wormington, H.M., *Prehistoric Indians of the Southwest*, Denver, The Denver Museum of Natural History, 1977 (13th printing)

Worthington, Tom, "Pottery of the Yumas," *The Desert Magazine*, Volume 3, Number 4, El Centro CA, Desert Publishing Company, 1940

Index

Sally Havier at O'Odham Tash – 2/72

Betty Barnackman
Needles Calif May 98

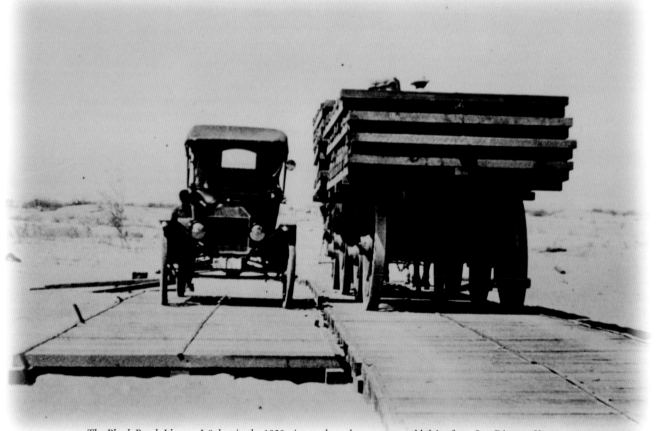

The Plank Road: It's now I-8, but in the 1920s, it was the only way you could drive from San Diego to Yuma.

The items pictured on the front and back covers came almost entirely from the Hayes and Blom households. Most of the pottery pictured is shown elsewhere in the book, with a few exceptions: the small Tohono O'odham redware bowl holding the jewelry dates from about 1960, the Maricopa pitcher on the spine dates from about 1930, and the major Mata Ortiz jar on the back cover was made by Damien Quezada in 2003.

The people in the pictures are assorted relatives and ancestors, mostly belonging to Carol Hayes. Carol thinks the Victorian lady in the gold frame is either her grandmother or her great-grandmother. The Civil War sword belonged to Al's great-grandfather, and the gold watch belonged to Carol's grandfather.

We'd like to thank Jerry Weisberg for four borrowed items: the Apache basket on the back cover and the three postcards on the front cover.

All the rest are from our attics.